Aisha's Cushion

Aisha's Cushion

RELIGIOUS ART, PERCEPTION, AND PRACTICE IN ISLAM

Jamal J. Elias

HARVARD UNIVERSITY PRESS
Cambridge, Massachusetts
London, England
2012

PRINTED IN THE UNITED STATES OF AMERICA

Library of Congress Cataloging-in-Publication Data

Elias, Jamal J.
Aisha's cushion : religious art, perception, and practice in Islam / Jamal J. Elias.
p. cm.
Includes bibliographical references and index.
ISBN 978-0-674-05806-4 (alk. paper)
1. Islam and art. I. Title.
BP190.5.A7E45 2012
297.2'67—dc23 2012019627

baraye Mehrin

for Mir

Contents

Preface on Abbreviations and Conventions

One of the goals of this book is to make a broad range of Islamic writing accessible to a nonspecialist audience; with that in mind, I have used a simplified system of rendering the languages of Islamic scholarship into English. Personal names and other terms from languages normally written in the Latin script retain their own orthography. For other languages, I have not used any diacritical marks or special characters in personal names, with the exception of the Arabic *hamza* and *'ayn,* unless the names appear in a quotation or are used by the individuals themselves. For technical terms, book titles, and so on, I have used a simplified system of transliteration favored by some academic journals and familiar to scholars in the field. I trust that specialists in Islamic studies will have no trouble identifying the original words, and it will make for easier reading for others.

I have tried to follow the convention of distinguishing between the use of the adjectives *Islamic* and *Muslim,* with the former connoting things that are civilizational and shared by all citizens of the Islamic ecumenae regardless of religion (Islamic art, for example); the latter connotes things that are specifically religious even within a

civilizational context (Muslim law, for example). In addition, I have used the term *Persianate* to designate those sections of the Islamic world that share cultural features of Persian civilization, even when the Persian language is not or was not spoken there. This realm comprises modern Iran and Afghanistan, but also the rest of Central Asia, Islamic South Asia, and—at various times—the non-Arab parts of the Ottoman Empire.

Aisha's Cushion

Prologue: The Promise of a Meaningful Image

Look at this Persian miniature
... in margins of gold
verses wear bracelets of paisleys
tied into golden knots of Arabic...
On a tree a giant spider
its legs sharpened into pencils
presses their lead into a cobra's crown
The earth is a calligraphy of coils...
—AGHA SHAHID ALI, *A Nostalgist's Map of America*

A famous hadith account describes how Muhammad's wife, 'A'isha, acquired a tapestry with images on it which she hung on a wall in their home while the Prophet was out of the house. When he protested to the tapestry on his return, 'A'isha cut up the fabric and used it to make cushions, which subsequently were used in their home without any objection from him. Accounts of the Muslim conquest of Mecca in 630 CE relate how, when the Ka'ba was being emptied of its idols and images at Muhammad's command, he placed his hand over a painting of the Virgin and Child to make sure it was spared. Neither of these

reports explicates why Muhammad treated the images the way he did, but one can conclude reasonably that the stories exist to demonstrate, through the Prophet's reactions, that the presence of the image itself was not objectionable; rather, the image's status was determined both by its content and the specific context in which it appeared.

It is often claimed that Muslims do not have icons, idols, or pictures of God or religious heroes; indeed, in modern times, there undoubtedly appears to be a widespread Islamic cultural opposition to depicting human religious figures as well as God in visual form. One need only recall the publicity surrounding the making and release of *The Message* in 1976—a film about the birth of Islam in which none of the primary characters appears on screen out of concern for Muslim sensibilities. Similarly, one might look to the intermittent controversies over the American comedy cartoon *South Park*'s allusions to depicting Muhammad beginning in 2005 and culminating in threats against the makers of the series in 2010, causing them to self-censor airings of the relevant episodes.[1] And although the Taliban do not represent a widespread Muslim ideal, their destruction of the Bamiyan Buddhas in March 2001 was religiously motivated to some degree, and religiously justified to every extent. More recently, the (at times violent) indignation following the publication of caricatures of Muhammad in a Danish newspaper in 2005, and the reaction to instances, threats, and rumors of the desecration of the Qur'an in the United States or in U.S. detention centers in Afghanistan, Iraq, and Cuba, underscore the obvious fact that Muslims hold complex attitudes toward religious images and objects, and that these attitudes do not reflect worldviews that are either naively unaware of or religiously oblivious to the power of images.

In fact, Muslim attitudes toward religious images and objects display apparent contradictions that not only are shared with Islam's sister religions of Christianity and Judaism, but also are apparent in the history of image-rich religions like Buddhism and Hinduism. On the one hand, Muslims display a widespread (though not comprehensive) taboo on religious depictions, and a narrower—but still prevalent—distrust of treating material objects as supernatural or divine. On the other, they embrace a religious culture that is rich in images, reacts to the images of others in complex ways, and is spatially focused around

an object—the Ka'ba building in Mecca—and its associated primary ritual of pilgrimage, which incorporates somatic engagement with material objects such as stones and pillars.

It is my purpose in this book to explore Muslim attitudes toward visual images and to suggest strategies of conceptualizing the nature of perception and the ways in which visual objects and images have been and continue to be understood in various Muslim contexts. I am concerned with what people see and perceive when they are confronted with a visual religious object, and with how they respond to it. In the course of the book I offer explanations for the nature of perception within contexts where Muslims consciously believe that they have no representational religious art and, on the basis of that analysis, I theorize about larger issues concerning the relationships among religion, art, and perception. My starting thesis is relatively straightforward and not especially innovative: there is a common understanding that the only broadly acceptable forms of Islamic visual religious arts are architecture and calligraphy. With the notable exceptions of some illustrated books on the life of Muhammad, the tradition of pictorial representation of religious personages in the Persianate world, and the decoration of a few well-known mosques, such a view suggests that there is little pictorial religious art in the Islamic world. Nevertheless, even though Muslims would deny that the divine inheres in objects of human manufacture, visual religious arts (of which pictorial arts are a subset) remain widespread in Islamic society. Modern scholarship has recognized this phenomenon, but it has failed to explore adequately the historical and philosophical reasons underlying it. I would argue that, in fact, Muslim thinkers have developed systematic and advanced theories of representation and signification, and that many of these theories have been internalized by Islamic society at large and continue to inform cultural attitudes toward the visual arts. These discussions are not found in the same contexts as they are in Christendom—the history of which provides a basis not just for academic understandings of Islam but also of art—because of the different evolution of the two religious civilizations.

My contention is that Islamic theories regarding representation and perception should not to be sought in theological writings or in those

directly concerned with aesthetics or art production. On the contrary, preliminary answers to these questions are found in scientific works on alchemy (how one thing can be made to appear as another), optics (addressing questions of vision and how the perception of an object affects the perceiver), dreaming (addressing issues of imagination and psychology), and in philosophical writings, particularly of the kind belonging to the Sufi metaphysical tradition. Since I am interested in understanding the nature of popular perception, I focus my analysis on readings of important religious, philosophical, and scientific thinkers with a mass appeal rather than works by very interesting but esoteric writers who failed to have a substantial impact on mainstream Islamic society. This constitutes a significant difference between my book and existing studies on religion and art in the Islamic world.

Muhammad and Buddha, Statues and Lampoons

On February 26, 2001, Mullah 'Umar, the supreme leader of the Taliban militia ruling most of Afghanistan at the time, ordered the destruction of all statues in areas under Taliban control. Starting on March 2, the Taliban embarked on an extended campaign using dynamite, anti-aircraft guns, and other heavy weapons to destroy the two best-known pre-Islamic objects in the country, the Buddha statues of Bamiyan. Their construction had begun in the second century CE under the Buddhist king Kanishka, and was probably completed in the fifth century. The taller, at 55 meters (175 feet), is believed to have been the largest statue of the Buddha in the world; the smaller statue, at 38 meters (115 feet) tall, also ranked among the largest surviving images of the Buddha. Through a thousand years of Islamic rule the statues had suffered only sporadic, isolated attempts at their destruction by particularly zealous iconoclasts. More recently, they had been viewed as the centerpiece of Afghanistan's tourist industry and were promoted as a symbol of the country's long heritage, appearing on postage stamps and state-produced cultural publications before the Soviet invasion of Afghanistan in 1979.

The obliteration of the Bamiyan Buddhas was accompanied by the destruction of most of the Buddhist figural art left in Taliban-controlled Afghanistan after two decades of looting and bombing over the course of the Soviet occupation and the subsequent civil war. The six-week-long saga—beginning on February 12, 2001, with the announcement of the planned destruction of the Buddhas and ending shortly after the confirmation of their destruction on March 26—unfolded amid a massive international campaign to save the statues. Their destruction was widely condemned in the Western world, in countries with Buddhist and Hindu populations, as well as in Muslim-majority countries such as Afghanistan's neighbors Iran and Pakistan.[2]

When the demolition was complete, the Taliban sacrificed one hundred cows to atone for the collective Muslim sin of not having destroyed these idols sooner, and invited the Qatar-based television channel Al Jazeera to document the destruction. A few days later, the Taliban escorted twenty foreign journalists on a visit of the site. They were flown from Kabul to Bamiyan and then taken to the razed statues in trucks. On March 22, 2001, the Taliban again took journalists on a tour of the Kabul museum to show the systematic destruction of all the Buddhist statues and images the museum had previously housed.

The Taliban's destruction of the Bamiyan Buddhas is not representative of a majority attitude toward religious images among the Muslims of today or of the past. Not even during the Taliban's first conquest of Bamiyan in 1998 were the Buddhas the sustained objects of attack, and the damage done to the statues at that time paled in comparison to the comprehensive violence perpetrated against the persons, livestock, and property of the living population of the area. The implications of the well-publicized sacrifice of atonement after the destruction of 2001 are important, since they would imply that all the Muslims who had preceded the Taliban in Afghanistan were deficient for having failed to destroy the statues sooner. According to the revisionist views of the Taliban and the theological school to which they belong, Islamic society has been headed down an erroneous and degenerate path since shortly after the death of Muhammad; salvation is to be attained through an embracing—in word, thought, and deed—of a "pure" and

"authentic" Islam modeled on an imagined utopian seventh-century life. That Afghans before the arrival of the Taliban were religiously deficient is a comprehensible accusation. But what of Afghan society once it was ruled by the Taliban? Mullah 'Umar's decree for the destruction of Buddhist statues was justified on the basis of the *possibility* that they might be worshipped again; the return of idolatry to Afghanistan could only happen if the self-styled Taliban rule over Afghanistan was to end, marking a reversal of the positive turn in Islamic revisionist history that they saw themselves as representing.[3] Styled in this way, the Buddhas were definitively cast as idols to be destroyed rather than as historical objects to be cherished for aesthetic and cultural reasons by a variety of people around the world. The Buddhas had been worshipped in the past, and they possessed the potential of being worshipped in the future. The latent power of the Buddhas necessitated a double sacrifice, the first the sacrifice of the false gods themselves and the second the expiatory sacrifice of the cows to atone for a collective Muslim tolerance of idols in their midst.[4]

The theatrical manner in which the obliteration of the Buddhas of Bamiyan unfolded in the glaring light of television notwithstanding, their destruction was neither part of a preconceived plan based in an uncompromising and anachronistic view of Islam, nor a petulant political reaction to the isolation and rejection of the Taliban by the world community. On the contrary, throughout the weeks in question, the Taliban leadership was sensitive to both international and local public opinion; the discursive process surrounding their pronouncements concerning the Buddhas, and others' reactions to them, played a large part in shaping the Taliban's self-understanding. Although it was not representative of an uncompromising and one-dimensional Muslim attitude toward images and "idols," the Taliban's reaction was part of a long tradition among many, if not all, religious cultures of manipulating the status of images for specific sociopolitical ends.

Perhaps the most significant aspect of the Taliban's rhetorical position immediately before and following the destruction of the Buddhas—and one completely missed by commentators at the time—was the way in which they conceived of and articulated the present in terms of an Islamic past. The Taliban's destruction of the Buddhas in February and

March of 2001 coincided with one of the holiest periods in the lunar Islamic year. The Hajj pilgrimage, a central ritual that culminates on Eid al-Adha, fell on March 3–6, and it was this Abrahamic moment that shaped the public representation of the iconoclastic act.[5] Eid al-Adha commemorates Abraham's willingness to sacrifice his son and is widely understood as a reminder to all Muslims to be ready to sacrifice all that is dear to them at God's command. Mullah 'Umar's choice of occasion can hardly be considered accidental, since the other major act for which Abraham is remembered is his decision to break from the idolatry of his father and ancestors, an obvious precedent on which the Taliban modeled their decision to right the wrongs of their forefathers in Afghanistan and destroy idols that they openly acknowledged were part of Afghanistan's pre-Islamic heritage.

When Mullah 'Umar rhetorically asked the Afghan people and Muslims all over the world if they would rather be the smashers of idols or the sellers of them, he was clearly referring back to Sultan Mahmud of Ghazna, the Afghan iconoclast of myth and legend who sacked the Shiva temple at Somnath, Gujarat, in 1025. The local priests and rulers allegedly offered a treasure to ransom the main idols from the temple complex, and Mahmud is storied for having replied that he was a smasher of idols, not a seller of them.[6] But Mullah 'Umar was also referring to the prophet Abraham's break with the religion of his father Azar, a maker and seller of idols, and it was this latter claim that resonated in the local press and was applauded by Taliban sympathizers as a revitalization of the "Tradition of Abraham *(sunnat-i Ibrahimi)*."[7]

Almost a corollary of the Taliban's destruction of the Bamiyan Buddhas is found in a more recent incident, wherein the religious images are Muslim in association, but the agents of their manipulation non-Muslim. On September 30, 2005, the Danish newspaper *Jyllands-Posten* published a set of one dozen caricatures of Muhammad under the banner "The Face of Muhammad." Their publication as well as initial commissioning was motivated to some extent by a hostility to Muslim cultural values as putatively represented by a stereotyped clerical leadership, a point made clearly by the newspaper's editor in his 700-word editorial accusing Muslims of suffering from a "sickly oversensitivity" to criticism: "Any provocation against one of these self-important

imams or mad mullahs is instantly interpreted as a provocation against the Prophet himself or the holy book, the Koran, and then trouble ensues. The Islamic spiritual leaders feel called upon to gripe and an army of intellectually underequipped followers respond and do what is interpreted as the Prophet's command and ultimately kill the offenders."[8] The Muslim leadership in question was accused of constituting a voice from "a dark and violent middle age," and the editorial expressed hope that the occasion of the caricatures' publication would help the silent Muslim majority in rejecting "stubborn adherence to a dark past."[9]

A week after the caricatures of Muhammad were published, a group of local Muslim religious leaders publicly called on the newspaper to "retract" some of the more offensive cartoons and also to apologize to the Muslim community; a few days later, a delegation made up of ambassadors from Muslim-majority countries called on the Danish government to reprimand the newspaper and the cartoonists. The reaction across the Islamic world grew stronger as the months progressed, with sometimes violent demonstrations and boycotts of Danish goods occurring broadly and with such regularity that it gave the false impression of being a closely coordinated movement. Perhaps the most organized aspect of the whole affair was the role played by a group of five imams from Denmark, who went to Cairo and presented the Secretary-General of the Arab League with a dossier containing the twelve cartoons together with three other, substantially more offensive, caricatures of Muhammad that someone had downloaded from the Internet but that had never been published by *Jyllands-Posten* (nor, almost surely, had they been made by a Danish cartoonist). The dossier was found sufficiently offensive to warrant an emergency meeting of the Organization of the Islamic Conference (OIC), where the images were circulated, and it was after this occasion that widespread responses to the cartoons that caricatured Muhammad broke out.

The Muslim reaction to the Danish cartoons was explained broadly in the television and written media of the Western world as being based in the fact that Islam prohibited religious images (or all images, or images of Muhammad), rather than by a different explanation obvious to anyone who bothered to read or hear what Muslims were actu-

ally saying: that they saw behind the caricatures the *intention* to cause offense to their prophet and their religion, and that they were rallying in defense. In point of fact, as with the international uproar following the destruction of the Bamiyan Buddhas, the cartoon controversy showcased important shared gaps of trust and understanding (as well as outright hostility) between the West and the Islamic world in which issues of immigration, imperial legacies, and cultural chauvinisms played no small part. But in both cases, it is a religious image and the issue of what it represents in context that plays the central role.[10]

Cushions and Tapestries, Angels and Dogs

The power of the image is not new to Muslim society; in fact this power is evident at the society's very formation. The *Sahīh* of al-Bukhari (d. 870)—a compendium of formal accounts (hadith) about the prophet Muhammad, and considered second in religious authority only to the Qur'an by the majority of Muslims—contains a very interesting reference to an event in Muhammad's life with direct bearing on questions of visual representation. The hadith account is related in several significant variants; according to one version, Muhammad's wife 'A'isha recollected: "I stuffed a cushion *(wisāda)* which looked like a *namruqa* (a small pillow), decorated with images, for the Prophet. He came and stood in the doorway with a disturbed look on his face. I said, 'O Messenger of God! What's wrong?' He said, 'What is this cushion?' [I said], 'I've made this cushion for you, so that you may recline on it.' He said, 'Do you not know that angels do not enter a house containing images; and whosoever makes an image will be punished on the Day of Resurrection and it will be said to them, 'Bring to life what you have created!' "[11]

In another variant, it is not a cushion but a tapestry: "The Messenger of God returned from a journey when I had placed a curtain with images over a room of mine. When the Messenger of God saw it, he tore it down and said, 'The people who will receive the severest punishment on the Day of Resurrection will be those who try to make the like of Allah's creations!' So we turned [the curtain] into one or two cushions."[12]

These hadiths are fascinating on several accounts, not the least of which is the suggestion, in the case of the tapestry converted into cushions, that it is not the images themselves that cause offense but rather their context: converted into utility items, or perhaps when the image is cut up so as to be unrecognizable, a textile with images does not signify the same thing as it does when it hangs on a wall in one piece. But it would be misleading to draw definitive conclusions concerning the nature of images or of signification from this one hadith, since all of these accounts form part of a larger group of traditions in the *Sahīh al-Bukhārī* addressing the religious place of imaged forms, in which not only images but also their manufacturers are condemned. In the first place, images are represented as unclean (like a dog) in a way that renders a house impure and prevents angels from entering it: "[on the authority of ʿAbd Allah ibn ʿUmar]: Once Gabriel promised to visit the Prophet but he was late and the Prophet became concerned. At last the Prophet, may peace be upon him, went outside and found Gabriel, and complained to him of his concern. Gabriel said to him, 'We [angels] do not enter a home in which there is a picture or a dog.'"[13]

Or as stated unequivocally by Muhammad himself (on the authority of Abu Talha): "Angels do not enter a house which has either a dog or a picture in it."[14]

Elsewhere, the condemnation of images is explicitly religious and echoes polemical concerns over the representation of biblical figures (most probably by Christians, a topic discussed at length in Chapters 3 and 4): "The Prophet entered the House [of the Kaʿba] and found in it images of Abraham and Mary. He exclaimed: 'What is the matter with them? They have already heard that angels do not enter a house in which there is an image, yet here is an image of Abraham! And why is he depicted with divining arrows [an activity mentioned explicitly as a sin in the Qurʾan]?'"[15] Or in a variant that also associates the representation of religious figures with attributing sinful behavior to the personages depicted in the images: "When the Prophet saw images in the House [of the Kaʿba], he did not enter it until he had ordered them erased. When he saw Abraham and Ismaʿil with divining arrows, he said, 'May Allah curse [those responsible for the images]! Indeed, neither Abraham nor Ismaʿil practiced divination!'"[16]

Muhammad's complete opposition to images, and their association with Christians, is also attested to by his wife 'A'isha, who states, "The Prophet would not leave anything bearing images of crosses in the house without breaking it."[17] In other hadith accounts, it is not the image that is condemned but its maker, sometimes unequivocally and elsewhere with an explanation of why this must be so. "[Muslim said]: We were with Masruq at the home of Yasar ibn Numayr when [Masruq] saw images on his terrace and said: 'I heard 'Abd Allah say that he heard the Prophet say, "The people who will receive the harshest punishment from God on the Day of Resurrection will be the image-makers."'"[18] Image-making is likened to attempting to usurp God's prerogative of being the sole creator of beings, as narrated in a hadith: "The Messenger of God, may peace be upon him, said, 'those who make images will be punished on the Day of Resurrection, and it will be said to them, "bring to life what you have created!"'"[19]

In other instances, images are treated as objects of ambivalent status. In one version of the hadith in which Muhammad declares that angels do not enter houses containing images, a companion of his declares that their status depends on their context, and images on textiles are permissible: "Then Zayd fell sick and we paid him a visit. There, hanging at his door, was a curtain adorned with an image. I said to 'Ubayd Allah, the step-son of Maymuna, wife of the Prophet, 'Did Zayd not tell us about the image the day before yesterday?' 'Ubayd Allah said, 'Did you not hear him when he said: "except a design on a garment"?'"[20]

Similarly, in the following hadith (narrated by S. ibn Abi'l-Hasan), a distinction is made between the representation of animals and people on the one hand and that of plants and inanimate matter on the other: "Once when I was with Ibn 'Abbas, a man came and said, 'O Abu 'Abbas! My livelihood is from my handiwork, and I make these images!' Ibn 'Abbas said, 'I tell you only what I heard from the Messenger of God whom I heard say, "Whoever makes an image will be punished until he breathes life into it, but he will never be able to breathe life into it."' The man sighed deeply and turned pale; then Ibn 'Abbas said to him, 'A shame! If you insist on making images, make images of trees and any other inanimate things.'"[21]

The distinction between images on textiles and those on buildings or religious structures is made again in a hadith account similar to the one quoted above: "Zayd narrated . . . that the Prophet said, 'Angels do not enter a house in which there is an image.' Busr said, 'Later on Zayd ibn Khalid fell sick and we visited him, but when we entered his house [we saw] a curtain covered with images. I said to 'Ubayd Allah al-Khawlani, 'Did he not tell us about images?' He said, 'But he exempted patterns on garments, did you not hear him?' I said, 'No,' he said, 'Yes, he said so.'"[22]

The ambivalent nature of images brings us back to the question of 'A'isha's cushion, which may or may not have started out as a tapestry. Versions of the hadith draw together the various threads of attitudes toward images expressed in al-Bukhari's important collection: "['A'isha said she had bought a cushion with images on it]. When the Prophet saw it he stood by the door but did not enter. I said, 'I seek repentance for what I have done!' He said, 'What is this cushion?' I said, 'It is for you to sit on and recline on.' He said, 'The makers of these images will be punished on the Day of Resurrection and it will be said to them, "Bring to life what you have created! And furthermore, angels do not enter a house where there are images."'"[23]

It is beyond the scope of this discussion to go into the lengthy scholarly debates on the nature of hadith and the degree to which these accounts reflect actual events in Muhammad's life or even the consensus of the Muslim community at the time of al-Bukhari. What is certainly the case is that the hadiths recorded by al-Bukhari form a crucial part of the bedrock of ethics and practice among the majority of the Sunni Muslim community. As such, the overwhelmingly negative attitudes toward images reflected in this collection of hadith cannot help but manifest themselves in the views of those Muslims who consider it canonical. At the same time, one cannot dismiss outright the nuanced attitude toward images reflected here, nor help but speculate about the contestation over religious images that underlies some of the important differences between individual hadith accounts on this topic. Thus, images in real life might be problematic, but those seen in a dream are not: "['A'isha said] the Prophet said to her, 'You have been shown to me twice

in my dream. I saw you pictured on a piece of silk, and someone said, "This is your wife." When I uncovered the picture, I saw it was of you, and I said. 'If this is from God, it shall be so.' "[24] Furthermore, not only could a tapestry be refashioned into cushions, but the reason why the object was objectionable to begin with was not the impropriety of imaged form in and of itself but rather its threat as a distraction, such that (according to one hadith account), when Muhammad saw the tapestry hanging in 'A'isha's chambers, he said: "Remove it from my sight, because its images keep coming to my mind in my prayers!"[25]

The above examples—drawn from the formative period of Muslim society, doctrine, and ritual as well as from our contemporary world—by no means span the entirety of attitudes toward images in Islamic social history. I mention them here to underscore two important points: first, that what is, in the final analysis, a negative-leaning ambivalence toward visual images exists in foundational Sunni texts, if not in the Qur'an (but this attitude is characterized less by its negativity than by its ambivalence on the categories of sanctioned and condemned images). Second, a complex attitude toward images, and religious images in particular, continues in Muslim society to this day, such that it is impossible to speak in terms of comprehensive and pervasive perspectives on religious images, be they of Muslim or non-Muslim origin or content.

The Chapters

The chapters of this book progress in groups. In this prologue, I use contemporary examples of art-related controversies to stress the continued importance of the visual image in Muslim societies and sensibilities, after which I go into a brief discussion of the nature of images and ways of thinking about them. Chapter 1 continues this theoretical discussion with a focus on the nature of representation and resemblance, proceeding from a broader look at issues of representation and religion in a comparative religious perspective to a concluding focus on Islam.

The next three chapters deal with images and religion, specifically with the notion of idolatry as it relates to the imagined religious practice of communities other than one's own. Chapter 2 provides a brief overview of the varied attitudes toward images in Late Antique paganism and Judaism, then goes into a more sustained outline of Christian attitudes toward images, image veneration, and idolatry in the Orthodox Church as well as in Western Christianity before and during the Protestant Reformation. This discussion leads into a focus on images and Islam in Chapter 3, contrasting the use of broad strokes to categorize other religious groups as idolaters and polytheists with narrative accounts from the classical and medieval periods that make it clear that many Muslims had a sophisticated knowledge of the nature of images, in particular that of icons in the Orthodox Church. Chapter 4 broadens the discussion of Islam and religious images by examining the representation of idolatry in early Muslim sources and the construction of Islam as an anti-idolatrous religion on an Abrahamic model. It then proceeds to explore the representation of Indian religiosity—often treated in Muslim sources as the paradigm of idolatrous practice as well as the world origin of idolatry—to show not only that Muslim attitudes toward Indian religions were not homogenous, but also that Muslim rulers and writers displayed varying attitudes toward Indian images. Furthermore, the manipulation of images, idols, and their use—including acts of exploitation, confiscation, and destruction—were part of an ongoing indigenous discourse of symbolic authority and kingship.

Chapter 5 marks a transition to the next section of the book, which deals with the arenas of Muslim thought and scholarly writing relevant to the understanding of visual religious art. In part, it comprises a critique of the use of aesthetics as a method of assigning value to Islamic art, demonstrating that it is more appropriate to align aesthetics with notions of virtue in an Islamic context. It then proceeds to explore the religious functions of amazement, and the place of beauty and of visual objects therein. Chapters 6, 7, and 8 continue the exploration of philosophical and scientific traditions as they relate to visual representation, beginning with alchemy and continuing on to optics and perception, dreaming and its relationship to the imagination,

then on to a brief exploration of philosophical notions of the imagination and imagining, which leads into a detailed discussion of imaginal existence and its resemblance to physical existence in Sufi metaphysics in Chapter 8.

Chapters 9 and 10 shift focus from Islamic theories concerning the visual image and resemblance to an exploration of specific examples of visual art, in particular of writing, both in architectural settings and in the nonmonumental scale of the written page. Chapter 9 concentrates on monumental epigraphy, arguing through a study of the nature of writing and of literacy that public religious inscriptions necessarily operate at several registers for their varying audiences, some of which treat the written word as a visual image or sign. This is followed by a discussion of the nature of Arabic calligraphy, one of the signature visual art forms of Islamic civilization. Chapter 10 simultaneously narrows the discussion by focusing on writing as image and on text as icon, and broadens it by bringing modern examples into the analysis, connecting them to traditions of visual signification in the Middle Ages and in the early modern period. The Epilogue attempts to link this exploration of religious images in Muslim culture with the broader discussion from the beginning of the book on the nature of images and their appreciation, with the hope of providing plausible insights into the place of the visual image in Muslim religious life in the past as well as today.

Images and Their Methods

Throughout this book, I have intentionally blurred the distinction between so-called representational images and other forms of visual art. For one thing, as Mitchell has pointed out, claims of representational realism or literalism in images usually relate to their degree of conformity to traditional European artistic conventions.[26] And in a departure from the majority of works on the subject of Islam and images, I have eschewed all sustained discussion of those traditions of image-making and image-viewing that would be seen as exclusively "high culture," most significant among which is the well-studied and

widely published subject of book illustration (and related arts of min-
iature painting). There is a long tradition of manuscript illustration in
Islamic culture, with the earliest examples of illustrated Arabic works
being scientific in nature, such as the *Book of Fixed Stars* (*Kitāb suwar
al-kawākib al-thābita*) of 'Abd al-Rahman ibn 'Umar al-Sufi (d. 986), of
which a manuscript dated 1009–1010 still survives.[27] The much better
known tradition of manuscripts illustrated with paintings depicting a
range of populated and other scenes dates from somewhat later, and
enjoys its overwhelming popularity not in Arab culture but in the Per-
sianate world of Iran, the Ottoman lands, and South and Central Asia.

My decision to give less importance to these well-known examples
of representational Islamic art than many readers might expect is
grounded in the premises and methodologies that undergird this
book—specifically, that the religious place of visual and material ob-
jects should be determined primarily by their usage, as well as by the
desire to attempt an investigation of popular attitudes toward reli-
gious visual objects, representation, and resemblance in Muslim soci-
ety. The latter goal is particularly challenging since, as is widely recog-
nized across academic disciplines today, it is problematic to use the
written legacy of elites to reconstruct the lives of the nonelite majority.
There are a number of excellent works that seek to recover the social
lives of specific nonprivileged groups in Islamic history (women and
religious minorities in particular), but few that attempt the practically
impossible task of reconstructing popular life in premodern times;
and those that do tend to focus on a dichotomy between a scholastic
"official" Islam and something else that is polemically condemned by
representatives of the first group.[28] I use a tripartite, imperfect method
of attempting to resurrect the opinions of nonwriting majorities: in
the first place, in my discussion of intellectual trends relevant to issues
of representation, I have focused on writers and thinkers who have
enjoyed broad popularity in Islamic history, on the logic that even if
their ideas reflected elite discourse during the time of their formula-
tion, they permeated societal attitudes and thinking over time to such
a degree that they can rightly be considered aspects of normative so-
cial discourse (to the extent that such a thing exists). In the second, I
rely heavily on existing scholarship on material cultural history from a

range of theoretical backgrounds to hypothesize about the ways in which Muslims might engage with objects and images in their own society, working on the assumption that there are essential continuities to human experience that render Islamic articulations of life similar in pattern to other articulations. And lastly, I use a similar reliance on existing scholarship in a number of related fields to place the visual object and image not in a discourse centered on art, beauty, and aesthetics, but in one where the visual object is judged by its social place, with concepts such as efficacy in intended use, somatic engagement, and economic structures of valuation all playing important parts in the understanding of the image and its life in society.

Judged in this way, the miniature painting stands out as an example of visual art of very restricted circulation, since illustrated books definitionally have a limited distribution: due in large part to their considerable cost, their circulation is limited to those sections of society that can afford them, are guests of those who can afford them, or have access to the sort of library or treasury that might possess them. The specific nature of the audience for which such works were intended might be open to debate, but functionally all who would get to behold the images in illustrated manuscripts would belong to a literate and privileged class, not the wider illiterate or semiliterate population.[29] This is not to say that miniature and album paintings have no social relevance or that the attitudes and dispositions of those who had access to them are unimportant to our discussion, but simply to underline the point that any course of inquiry that places at its center such an exclusive form of visual art necessarily limits its relevance to a discussion of wider social functions. Perhaps unlike any other visual or pictorial category, "miniatures speak to and for the same audiences as do texts."[30] They presuppose the existence of text that almost always accompanies the image and also frames the attitudes and reactions to images of the viewers who belong to one of the very social contexts that comprise the main consumers of texts.

In my treatment of visual objects—as distinct from my discussions of systems of representation and resemblance—I avoid speaking in terms of art practice and appreciation and focus instead on notions of use, not in a purely utilitarian sense or as an object used in ritual practice,

but more as a conscious attempt to position the discussion of visual objects independently of traditional scholarly arguments that focus on aesthetic value. Notions of high culture, "beautiful" art as distinct from popular or folk art—to which the label of kitsch could be applied even in reconstructions of the past—automatically inject the objects with several static categories of valuation based on their relative cost and accessibility. Viewed from the perspective of use in society as opposed to aesthetic valuation, an image or object that is mass produced out of cheap materials has greater societal relevance than an expensive item of limited circulation, even though it is undervalued (even ridiculed) by elites as much for its accessibility as for its expression of sentimentality.[31]

In my approach to religious images, I am going beyond the "methodological philistinism" advocated by Alfred Gell as an antidote to being dazzled by the aesthetic value of artworks,[32] to adopting a position of methodological promiscuity: in essence, I am a historian combing the intellectual history and anthropology of visual and material culture, observing the relationship of visual objects to social and individual agency and relations. As stated succinctly by Rotman, "This means studying 'art as a system of action,' examining the interplay between images, the forces represented and exerted by these images, and the individuals who interact with them. One could call this network of relations 'the power of images,' as David Freedberg does in his book of the same title."[33] Even though this study focuses on visual images, my examination of these images and of the people in whose lives they are imbricated is mediated by texts and textual culture. Just as all people, including the vast majority who do not leave behind textual or material footprints, "live with and by ideas, whether or not their ideas are ever articulated,"[34] visual images from the past are silent. "It is always the scholar alone who speaks in the presence of the work of art, and his entire problem consists in deciding what kind of talking he should do."[35] In so doing, I do not presume that texts are transparent in their meanings or purport to speak for images, or even to suggest that knowledge of some system of signs allows one to understand images as they explain themselves. Instead, I proceed from the belief that visual images "reveal their meaning best by their use."[36]

While accessing a visual world through cultures of text, the historian must use the visual differently than the art historian, recognizing in the first place that the linguistic continuity (or continuity of medium) that exists between a text and its explication does not exist for visual images.[37] Furthermore, for most of the socioreligious contexts discussed in this book, images do not exist without text.

Readers of this book might be justified in objecting to my use of modern examples drawn from discrete sociohistorical contexts to hypothesize about the nature of visual representation across the span of Islamic history. Indeed, there is no easy way to adjudicate the question of unity versus diversity in studying the history of religion. My method is born out of a recognition of the difference between relying on written versus visual and material data in observing the past, and on the cognizance that the latter falls progressively silent the more removed we are from its societal and temporal setting. As I attempt to show throughout this book, there are sophisticated and dense textual treatments of questions of resemblance in many Muslim intellectual contexts, but in none of these do the textual explorations exist in tandem with a rich account that embeds the objects in a theoretical or even historical discussion. As the best option, one is left with the method I employ here, that of recognizing the object as a form of data in its own right, and one that possesses its own systems of understanding that warrant the drawing of broader conclusions from the examination of specific examples. Central to this understanding of the nature of the object is the idea of "corpothetics"—a somatic and intellectual engagement of the viewer with the object of contemplation, a method of enquiry that centers on the relationship of viewer and viewed rather than on theories of viewing.[38]

Such an image-centered method goes together with the recognition of a point I attempt to make repeatedly in this book, and especially in the later chapters: in Muslim contexts, it is wrong to think of images without the presence of visual text. Quite apart from examples of ekphrasis in literary and scholarly works or of other similar forms of text-image relationships, text goes with images in a range of examples analyzed here and must be recognized as part of the practice of images. Text functions visually, but the presence of text—the rhetorical devices

and literary conventions of which are relatively accessible to the educated reader—suggests the possibility that the visual religious object-cum-text might itself, to some extent, be governed by such conventions.

The religious image's primary place is not one defined by beauty or an aesthetic admiration for the skill of its creator, but by its efficacy as a representation, which is to say, the effectiveness with which it allows the observer to access what is perceived through the image. The specific physical nature of the religious image certainly informs the behaviors of the devotees who interact with it, but neither the image's production nor its reception see their genesis in the circles and categories of fine art and its appreciation. Concepts of beauty as concern the visual image can therefore be seen "neither in artistic skill nor in contemplative disinterestedness, but in the reassuring harmony of the believer's disposition toward the sacred with its visualization."[39]

There is a tendency in some scholarly circles to see in the image a "natural sign" that operates on a fixed system of iconographic signification. In Mitchell's words, according to this logic, an idol "must be constituted as an embodiment of the real presence it signifies, and it must certify its own efficacy by contrasting itself with the false idols of other tribes. . . . Most ingenious of all, the Western idolatry of the natural sign disguises its own nature under the cover of a ritual iconoclasm, a claim that *our* images, unlike 'theirs,' are constituted by a critical principle of skepticism and self-correction, a demystified rationalism that does not worship its own projected images but subjects them to correction, verification, and empirical testing against the 'facts' about 'what we see,' 'how things appear,' and 'what they naturally are.'"[40] I proceed from the assumption that no claims to exceptionalism in attitudes toward images can be made either for the modern West or for a supposedly "anti-image" Islamic world, and hold that the concept of practice and its role in society (especially as outlined by Bourdieu but certainly not limited to his writings) helps in understanding the place occupied by the visual in human society, and that the "aesthetic, economic, and pious . . . do not inhabit entirely separate universes."[41]

Rather than possessing a transparent meaning as "natural sign," visual images are somewhat opaque and yield their meaning not through

looking at them directly but through observing those for whom they hold meaning. One could even think of them as metaphors, in the sense that metaphors, like symbol systems as a whole, function through a process of indirection and can only really be made sense of through the observation of their implicative techniques.[42] The images themselves are neither metaphysically nor epistemically static or stable; nor, one might argue, are they purely visual in any essential manner, relying as they do on multisensory processes of apperception. As stated by Mitchell, one must "acknowledge that this whole story could be told another way, from the standpoint of a tradition which sees the *literal* sense of the word 'image' as a resolutely non- or even anti-pictorial notion. This is the tradition which begins, of course, with the account of man's creation 'in the image and likeness of God.' The word we now translate as 'image' (the Hebrew *tselem,* the Greek *eikōn,* and the Latin *imago* [and to which we can add the Arabic *sūra*]) are properly understood . . . not as any material picture, but as an abstract, general, spiritual 'likeness.'"[43]

In making sense of images in the Islamic world one must remember—as an aspect of the focus on their use as opposed to any intrinsic qualities they might possess—that, historically, religious images did not exist purely in a world of religious ritual but that they functioned broadly *through* society which "expresses itself in and through religion. Religion was far too central a reality to be, as in our day, merely a personal matter or an affair of the [mosques]."[44]

Images in the Islamic world can be divided into iconic and narrative ones, a distinction that is heuristically useful if potentially misleading. Narrative images are exemplified by paintings in illustrated manuscripts that depict events in the life of the Prophet or the biographies of saints and other religious heroes. For practical purposes, all others are iconic images. In narrative representational art, the primary subjects within the image are engaged in acts individually or with each other, and the meaning of the representation is contained within its "pictorial context." The image is thus rendered self-contained, and the viewer of the representation is an onlooker as distinct from a participant. In contrast, iconic art is not self-contained in the same manner, and rather than being situated in a pictorial context that gives it

meaning, it relies in important ways on the participation of a viewer
(or worshipper).[45]

The difference between narrative and iconic images has been dis-
cussed with relevance to Buddhist and Hindu art in ways that are illus-
trative of the Islamic societal context. In an examination of the repre-
sentation of *jātaka* tales of the Buddha in South and Southeast Asian
architecture, Brown has pointed to structural, physical aspects of vi-
sual art as the basis of categorizing objects as narrative or iconic. In
particular, he argues that, in cases where monumental art is difficult
to see because of its placement or because there is no obvious linear
narrativity to the images, it is inappropriate to consider such images
as real narrative art.[46] He contends that not only were these images not
meant to be "read" or followed in a narrative manner, but that their
purpose was an entirely non-narrative one: they made the absent Bud-
dha present, bringing into the mind of the viewer or worshipper thoughts
of the Buddha and his teachings.[47] Brown concludes that such Buddha
images historicize and serve as reminders of the Buddha, not through
any narrativity, but simply through their presence. He goes further,
claiming that the images serve an iconic function, where "iconic" means
"a form of the deity that is the focus of reverence and worship."[48]

Rotman argues against Brown that, even though monumental im-
ages of a narrative nature might very well have made the absent Bud-
dha present, they must also necessarily have functioned as "visual
prompts," even if only secondarily. In the first place, he finds it incon-
ceivable that all visitors who viewed the *jātaka* paintings did so in a
purely ritualistic fashion, and contends that it is very likely that a sub-
stantial percentage of the people who visited these images must have
done so (as they do today) with some sort of guide who would contex-
tualize (or narrativize) the paintings. In the second, Rotman does not
see the strength of an argument which claims that images that, due to
their placement, are too difficult to see for narrative content can, never-
theless, be fully perceptible for the purposes of actualizing, or making
present, that which is depicted in them.[49] Rather than actualize the
Buddha's presence, he argues, such monumental examples of narrative
art are brought to life through words, be they the narration of stories
or recitation of panegyrics.[50]

Divine or prophetic images that directly resemble the aforementioned *jātaka* images are lacking in the Islamic context; not only are there no monumental visual representations of episodes in Muhammad's life, but public visual representation of him is itself almost entirely absent. What does exist is the well-known tradition of manuscript illustration with paintings of Muhammad and illustrations of a number of popular religious or romantic stories, as well as illustrated copies of historical works. Paintings in these genres of material production qualify as examples of narrative works of art. There are, at the same time, several examples of visual religious art (discussed in later chapters) that are representational and function iconically in the sense just described, in that they invite the viewer—who is expected to be a devotee—to engage the image. These include devotional images of holy relics such as the Prophet's footprint as well as images of Sufi and Shi'i saints that have gained widespread popularity in certain societies following the proliferation of printing technologies in the last two centuries. In some ways, these images, which are often textually captioned in a manner that guides the viewer in how she or he should engage with the image, can also be seen as narrative images, since the very captioning situates the object within a historical memory involving narratives of holy lives. For example, an image of the mantle of the Prophet might serve as a touchstone causing the viewer to recollect occasions in the Prophet's life in which the mantle features prominently; chromolithographs of saints almost always situate the saint in a context that evokes elements from his or her life, although these are seldom directly described in the accompanying text.[51]

Particularly intriguing in its taxonomic status as iconic versus narrative is the widespread category of Islamic calligraphic art, especially monumental epigraphy. As has been suggested by a number of authors, and is discussed at some length in Chapters 9 and 10, much monumental epigraphy (and Qur'anic inscriptions in particular) does not appear to have been meant to be read. In a manner directly reminiscent of *jātaka* and other Buddhist images, these inscriptions are often placed in locations that render reading difficult if not impossible, while in other examples the script is too ornate to suggest that easy reading was among its intended purposes. It is reasonable to assume,

as some scholars have done, that such inscriptions function iconically, their very presence signifying a range of things to the religious viewer and invoking a variety of memories, emotions, and actions. At the same time, one cannot ignore that textual inscriptions are, in fact, composed of words, which have a narrative component in most of their usages and most certainly in any context where verses (or sections of verses) of the Qur'an appear together. This widespread and characteristic example of Muslim visual religious art, therefore, serves as a synopticon of the ambivalent relationship between iconicity as a characteristic of visual art and other, more pedagogical or informative functions of it.

Over the course of this book, I alternate between treating the image as a material commodity and as a visual representation imbued with power. As material commodity, its religious properties do not simply add value to the object but actually have a transformative impact on its significance. In some sense, once the object gains religious value, it ceases to be a commodity, a point made convincingly by Starrett in his study of religious commodities in modern Egypt where objects of potential religious value such as scripturally inscribed stickers and key chains can be sold together with nonreligious objects in a shop, and even after purchase the potentially religious object does not actually become religiously charged until it is placed in an appropriate context. A good example of this would be a key chain with a religious motif that can be carried around in a pocket with other, ritually unclean objects without concern, but that serves a prophylactic function when the key is inserted in the ignition of an automobile, where it is presumed to protect the vehicle and its occupants from misfortune. Even more importantly, *as commodities*, religious objects are no different than nonreligious ones until they are imbued with intention.

> A [copy of the Qur'an] is comparable to a bouquet of flowers
> or a box of chocolate for some purposes. A papyrus bearing
> the 'Fatiha,' . . . is comparable to a papyrus showing Pharaoh
> on his war chariot. It thus makes little sense for a merchant
> to take special precautions in the placement of religious com-
> modities relative to other commodities. The relevant read-

ing frame for the marketing display is that of the functional differences between commodities rather than of their surface design characteristics. . . . In fact, the same holds for religious commodities in specialized shops. Specialized merchants of religious commodities are hardly likely to feel safer or more fortunate than their colleagues merely by virtue of the volume of sacred writing around them. Swamped with signifiers of blessing, the differences that generate meaning are absent.[52]

In fact, in the microenvironment of the souvenir shop or the warehouse, the visual religious object is stripped of its religious significance and reverts to being a straightforward material commodity.

At the same time as religious practitioners imbue the object with its religious significance, religious objects elicit responses from individual viewers. This is a widely observed fact in a number of religions in which the presence of a religious image is used to evoke religious thoughts and feelings—and consequently moral behavior—in adults as well as children. In a different mode, the dominant form of interaction with the image is through a fear of its power, a phenomenon for which the term *iconoclasm* must suffice despite serious conceptual shortcomings. Mitchell's definition of the term encapsulates the way it is widely understood in modern scholarly circles, and is wholly appropriate to this context:

> Iconoclasm typically proceeds by assuming that the power of the image is felt by somebody *else;* what the iconoclast sees is the emptiness, vanity, and impropriety of the idol. . . . The rhetoric of iconoclasm is thus a rhetoric of exclusion and domination, a caricature of the other as one who is involved in irrational, obscene behavior from which (fortunately) we are exempt. The images of the idolatrous . . . must be declared "dumb," "mute," "empty," or "illusory." *Our* god, by contrast—reason, science, the Logos, the spirit of human language and civilized conversation—is invisible, dynamic, and incapable of being reified in any material, spatial image.[53]

The conceptual iconoclasm of the modern critic resembles that of the premodern religious polemicist, whose iconoclasm cannot be understood separately from its polemical opposites—iconophilia (a term that sounds neutral today), fetishism, and especially idolatry, which still carries a derogatory sharpness in common parlance. But in their affirmation of the need to destroy images, it is the iconoclasts who are the ultimate affirmers of the power of images. As stated by Baudrillard, "One can see that the iconoclasts, whom one often accuses of disdaining and negating images, were those who accorded them their value, in contrast to the iconolaters, who only saw reflections in them and were content to venerate a filigree of God."[54]

The iconoclast and idolater exist across a chasm that does not allow for intermediate positions, where all Muslim, Christian, and Jewish believers (as well as devotees of many other religions) position themselves—irrespective of their own use of religious images—in opposition to an idolatrous other whose images are impure and untrue. This ideological chasm persists in the modern world, where a fictive middle ground is created by erecting the religious image as an aesthetic object. But that very act drains the religious image of its meaning and significance, such that it functions as an empty vessel to be filled with the desires and expectations of the detached, aesthetic viewer. "What distinguishes the iconologist from the art historian, the aesthetician, and the literary critic, however, is the willingness to contemplate the 'impure' image in all its forms—from the figures, analogies, and models that disrupt the purity of philosophical discourse, to the 'ordinary language' of images . . . in mass culture, to the ritual objects the anthropologist might find in 'pre-aesthetic' cultures."[55] In large part, this books attempts to undertake such an iconological quest for Islamic culture.

I

Representation, Resemblance, and Religion

Mad Hatter: "Why is a raven like a writing-desk?"
. . .
"No, I give it up," Alice replied: "What's the answer?"
"I haven't the slightest idea," said the Hatter.
—LEWIS CARROLL, *Alice's Adventures in Wonderland*

The interest in representational images often cloaks an ontological concern with mimesis, where sculpture is seen as more mimetic than two-dimensional representations. Sculpture's very plasticity lets it resemble the living referent more closely than images do, which opens it to attacks for being more deceptive precisely because it is more "real," threatening to destroy the border between the living being (be it divine or human) and the copy, which verges on being a clone, capable of taking the place of its prototype, or at least confusing the viewer as to which is the original and which the copy. Stories of statues coming to life abound in cultures around the world, and in most instances their animation results in tragedy for those near them. The distinction between two- and three-dimensional art, already there in Plato's thought, was well-established by the twelfth and thirteenth century among

Christian writers who distinguished between *similacrum* and *imago,* with the former being applied to sculpture and the second to painting (although the distinction is not always maintained strictly). Of the two, "image" *(imago)* is the one that passes more often into general usage to mean a likeness of a comparative sort, specifically paintings or representations of a deity; *similacrum,* in contrast, implies a replica or copy, sometimes with an archetype and at others the manifestation of an idea, like when the world is seen as a *similacrum* of divine wisdom.[1] A similar difference in implication exists in the Arabic terms for images and representations, where *sūra* and *tamthīl* frequently mean a two- and three-dimensional image, respectively. As I discuss in the context of Islamic attitudes toward idolatry in Chapter 4, a *sūra* is an image or picture, while the word *tamthīl* refers to a similitude or copy.

A "copy"—certainly in the everyday use of the term—is inferior to the original in that it is deficient, characterized by the lack of something that, were it to be present in the copy, would make it indistinguishable from the original. In contrast, a "representation" is superior (or perhaps more powerful) to that which it represents in some important respects. A representation is present when its prototype is absent, or it is accessible while the prototype is inaccessible, with presence and accessibility being better than absence and inaccessibility in all respects but for some philosophical notions of human behavior. God is inaccessible and transcendent out of a complex theological need, but a god that is not present in the world, and accessible and responsive to its worshippers and petitioners, is not a god that warrants their involvement. In that respect, a representation holds a functional superiority over the prototype.

Mimetic representation by the image—by which I mean both sculpture and architecture in addition to two-dimensional art—is dynamic and multifaceted, in that the image does not *copy* the prototype so much as it enters a discursive relationship with it such that they are "ontologically interwoven" or in "ontological communion," as Gadamer put it, wherein the image "shares in what it represents."[2] Mimetic representation of this sort is distinct from the perfect copy exemplified by the photograph. Photographs are, indeed, intimately linked to their causes (by which I mean here the objects represented rather than their

physical processes), but involve a different theory of representation which is causal: we know a photograph to be an analog of an object when we are sure that it is caused by that object; the moment we doubt that causal relationship, the photograph becomes devoid of any real content.[3] Photographs have a tautological nature as representations and can never therefore be removed from their specific referents, nor can they *immediately* or *generally* be distinguished from them. "A pipe [in a photograph] is always and intractably a pipe. It is as if the Photograph always carries its referent with itself. . . ."[4]

This mimetic relationship is exemplified by the so-called voodoo doll, which can never be mistaken for the person with which it is associated, yet it represents the person with whom it has entered into "ontological communion." In semiotic terms, the voodoo doll represents the person iconically, in that it bears a formal resemblance to him or her through association. And through rituals involving the doll as a representational sign, the doll brings the human prototype into spatial and temporal contact with malevolent supernatural forces. To those familiar with the terms of this mimetic system, poking the doll with needles or burning or smashing it are not understood as actually stabbing, burning, or crushing the person, but rather as instigating the successful intervention of these supernatural forces. In the absence of any knowledge of the specific representational relationship established between the doll and the human being, to the outside observer it would simply look as if the doll had been mistaken or imagined as something else (a victim) to whom it bore no close resemblance.[5]

Much of the scholarship on Muslim representational art has missed this important point in the nature of mimesis and representation, focusing instead on an aesthetically constructed notion of resemblance, or else holding to what I consider overly formalistic and ultimately misguided distinctions between representational versus nonrepresentational, iconic versus noniconic, religious versus secular art, and so on.[6] This ultimately teleological system of categorizing Islamic visual and material art misses the point that, from a perspective that emphasizes the place of images and objects in the religious lives of human beings, resemblance is not a matter of "looking like" something (with the photograph of a known person being the most accurately representative),

but rather of perfectly embodying those aspects of the relationship of representation that are valued within the specific context where the object belongs.

Aniconism and Representation

There is a practical, if somewhat outdated, distinction drawn between religious societies and practices that display an *absence* of images as opposed to those that actively *denounce* them, with the latter phenomenon commonly being referred to as "iconophobia" and the former "aniconism." Aniconicism is sometimes defined additionally as a form of religious practice that does not accept the worship or veneration of representational images, especially anthropomorphic ones. Very frequently, aniconic ritual incorporates the use of nonrepresentational items such as found objects, unworked stones, or nonrepresentational manufactured artifacts such as poles or pillars. Following Mettinger, I am using the term *aniconism* in a broader sense to connote the absence of anthropomorphic or theriomorphic representational, mimetic images of deities or other religious personages. In this sense, aniconism can manifest itself in two ways, either through aniconic symbolism or through a notion of sacred emptiness.[7] Such an understanding of aniconism—and consequently its corollary phenomena such as iconism, iconophilia, iconolatry, idolatry, and so on—focuses in the first place upon the presence or absence of religious visual images of any form, without concerning itself with broader questions of representation and mimesis. It also recognizes the intentional absence of images and material objects as a form of presence in and of itself, in that such absences imply an intentional void where the image would be otherwise. This is distinct from a passive or unintentional aniconism, that is, one where human beings simply do not have any concern with, awareness of, or memory of visual or material religious objects. I will not concern myself with such an imagined context since I do not believe that such a purely aniconic human society exists. A broad conception of aniconism (and conversely of iconicity and so on) also allows for the suspension of preconceived notions of the nature of deities in specific reli-

gious contexts, with their inevitable valuation on a spectrum with a singular, transcendent, invisible god at one extreme and a multitude of colorful, immanent, visible gods on the other.

Precisely this tension between notions of a transcendent deity and the mundane materiality of visual and material objects is apparent in the rich visual culture of Christianity, where the Eastern icon and Western images came to signify distinct religious views, though not in the eyes of actual practitioners so much as in the understandings of scholars looking back at the split between the Eastern and Western churches. "Heavenly and earthly were compressed in the [Orthodox] icon's unambiguous stare. Quite the opposite was the case in the West, where Gregory of Tours bluntly stated, 'no joining is possible between earthly and heavenly objects,' and where what Peter Brown calls a 'discontinuous holy' was 'deeply inserted into human society.' The history of medieval art in the West is that of a struggle to transform into meaningful spectacle, the spiritual impoverishment of visible things that had been delegated to a 'second order' of signification."[8]

Christian attitudes toward religious images are dealt with at some length in Chapter 2; here I will address only some important questions concerning notions of visual representation that are illustrative in a comparative religious context and are relevant to the place of religious images in Islamic culture. Even in the case of icons in Orthodox Christianity, widespread belief in the supernatural powers that work through these images is implicit rather than explicit, and is normally presented as such in the stories that describe their miracle-working.[9] The provenance of these supernatural abilities is seldom mentioned, presumably implying—but not stating—that the icon's resemblance to the deity or religious personage (Christ, Mary, or a saint) is the source of its miraculous power.

It is the aforementioned "second order" signification that determines the place of images in much of Protestant Christianity, especially in the modern period, when the ability of images to make the absent present has come to define their religious place. Such images can be narrative or iconic, functioning didactically as illustrations of religious stories or else, through the representational presence of Jesus, by encouraging the believer to think of him and therefore behave in

moral ways. At the same time, the purpose of the image can also be emotional, in that, by making the absent present, it helps ease the viewer's ache of longing for Jesus. Morgan has shown the role played by Warner Sallman's painting entitled *Head of Christ* in constructing the representation of Jesus for millions of Protestants, especially in North America. This painting has been reproduced more than half a billion times in a variety of media since it first appeared in print in 1941, and through its sheer pervasiveness has become inseparable in the public imagination from the appearance of the historical Jesus. Each version of Sallman's Jesus "is an adaptation or variation on the same theme, tailored to the situation of an image maker, the market that manufactures and disseminates the image, and the public that beholds it. The ultimate effect, however, for many believers, if not all, is a corroboration of Christ's 'real' likeness. Countless images form an array of sameness rather than difference."[10]

Among the devout viewers of Sallman's Jesus, the painter's imagined representation of him has taken on a mimetic accuracy such that the image is conceptualized as a "photograph" capturing Jesus's likeness with perfect, mechanical accuracy. It is this belief in its ability to represent Jesus perfectly that led the artist, in response to popular demand, to paint another version of the same representation of Jesus, called *Christ Our Pilot,* in which the subject is simply rotated so that he faces the viewer a bit more, as if looking at her or him. In its many uses, this likeness becomes opulent with the many interests and desires of those who depict Jesus as well as those who are devoted to him. "When devout viewers see what they imagine to be the actual appearance of the divinity that cares for them, the image becomes an icon. The icon is experienced by believers as presenting some aspect of the real thing, shorn of convention, as if standing before the image is to enjoy the very presence of its referent. As an operation of perception that locates in an image the genuine character or personality of Jesus, the icon is the engine of visual piety."[11] Represented in the many variants of Sallman's original conception, the religious viewer has simultaneous access to the historical Jesus, an image of him, as well as the spiritual and divine message inherent in the idea of Christ that is signified

through the formal nature of the artist's rendition of his appearance, expression, and gaze.

Representation in Hinduism and Buddhism

A similar phenomenon whereby a pervasive and popular modern representation of a deity can take the role of a photo-realistic image of a historical figure is encountered in depictions of Hindu gods in chromolithographic posters in modern India, where very standard representations of Bharat Mata (Mother India), Krishna (especially as a baby), and other deities repeat themselves, though none with the pervasiveness of Sallman's Jesus.[12] In the case of many deities, standard forms of representation cover a spectrum from the aniconic to photo-realistic, such that the goddess Durga can be represented by a clay pot or by a number of different anthropomorphic forms with very specific iconographic signifiers *(mudras)*, with all versions representing the deity with equal accuracy from the point of view of the devotee.

In Hindu devotional practice, "seeing" a deity has a very technical meaning; the term *darshan,* meaning "seeing," refers to the central ritual act through which a devotee interacts with the deity. In widespread devotional understanding, it is in the precise moment when the worshipper is engaged in *darshan* as an act of "ritual seeing" that the god inhabits its representation, such that the prototype and its image become one, and representation becomes a misleading conceptual category since the two are ontologically and epistemologically united in that moment. "Seeing," in this context, is a tactile sense wherein the gaze reaches out from the viewer and engages, or touches, the object of vision; the eye becomes a tactile organ and, in touching the representation of the deity, touches the deity itself in the *darshanic* moment.[13] It is their efficacy in the ritual of *darshan,* rather than their mimetic accuracy as visual representations of the gods, that determines the ability of visual images to represent the gods.[14] As such, notions of mimetic realism are not central to Hindu religious art and are likely not to be central to much religious art in other religious traditions, including in

Islam, when viewed from the perspective of the image's efficacy for believers and practitioners as opposed to its aesthetic, artistic value. This situation is hardly new, and holds equally true for Buddhism and Jainism as it does for Hinduism: images do not take a specific form but can change appearance and identity when demanded by the context. As noted by Davis, the lives of Indian images (and to this we could add other Asian religious images as well) "are made and remade through their encounters with differing audiences, who reciprocally bring with them different ways of seeing and acting toward the images they encounter."[15]

Buddhism poses a particularly interesting problem of visual representation that is similar to issues surrounding representation in an Islamic context, despite the seemingly substantial difference in doctrine, practice, and religious culture between the two faith communities. Mahayana Buddhist doctrine (especially in medieval India) holds the absolute emptiness of the Buddha, which not only makes it difficult to represent him visually but also begs the question of why one should try to do so.[16] Furthermore, there is a widespread practice of depicting the Buddha nonfiguratively through images of his footprints, his empty throne, stupas, and other forms. Simultaneously, Buddhism in India and beyond has a rich tradition of representational images, some of which are obviously narrative or discursive, while others seem not to be. The latter category comprises the many representations of the Buddha in various poses that, though perhaps recognizable from stories of the Buddha's life, appear to be iconic in nature.[17] Gombrich and Tambiah have taken diametrically opposed positions in their attitudes toward the notion of Buddhist religious practices in relation to their roles in visual and material culture. Gombrich argues that Buddhist practice comprises two distinct and dissonant modes, the affective and the cognitive. At a cognitive level and in keeping with the Pali Canon, Buddhists are aware that the aniconic relics of the Buddha such as statues and stupas do not actually contain the Buddha's presence. In the affective mode, however, they *act* as if the Buddha were really in those objects despite believing in textual doctrines that state otherwise.[18] Tambiah, on the other hand, insists that there is a large body of Theravada Buddhist texts that reflect the belief that the

REPRESENTATION, RESEMBLANCE, AND RELIGION

35

Buddha could inhere in relics and images, and that such objects were endowed with their miraculous "fiery energy" *(teja)* and "radiance" by the Buddha himself.[19] To Tambiah, this does not imply an ontological presence but rather one that he sees as semiotic, referring to it as an "indexical symbol," which is to say that the images and relics of the Buddha represent him through semantic conventions and simultaneously relate existentially and epistemologically to that which they represent. "The Buddha's words, said long ago, are partially captured and clothed in the *Dhamma* texts and are vehicles of instruction and remembrance; the Buddha's presence...is 'indexically' present...in images and relics and other icons and indices, but they too are vehicles that aid human understanding."[20]

On the face of it, there are substantial differences between Theravada and Mahayana Buddhism in their treatment of visual and material objects, although it is not simple to maintain these differences across historical and cultural contexts. According to the Theravada view, the Buddha was a historical, mortal man who lived in the sixth century BCE and possessed certain superhuman qualities through birth as well as cultivation. As such, it is futile to look for his actual presence in enduring material objects, which can only serve didactic and mnemonic purposes as reminders of the Buddha and his teachings. In contrast, Mahayana Buddhists would maintain that the various Buddhas were semidivine beings, who remain active forces in the world even though their physical bodies might have perished. From this perspective, the Buddha can indeed be present in physical objects and images at an affective level even if, from the perspective of Mahayana philosophy, this presence is purely illusional.[21] In fact, despite the assertions of philosophers that images are "empty," Mayahana Buddhist monasteries created large repositories of Buddha images that served an important function in disseminating Buddhist teachings. Thus, scholarly statements to the contrary notwithstanding, objects such as Buddha images and stupas are integral to the history of Mahayana Buddhist practice, and Mahayana Buddhism (especially the early tradition) is arguably more visual in character than Theravada, which tends to emphasize scripture and concomitant orality and aurality, though by no means to the exclusion of the visual image.[22]

Much in the same way as it holds true for Islamic contexts, it is problematic to divide Buddhist art between the categories of iconic and aniconic, in large part because such a division is not recognized as meaningful by Buddhist faith communities. Furthermore, it is unwise for scholarly observers to take the inaccessibility and lack of an obvious discursive quality in premodern Buddhist monumental imagery as evidence of its non-narrative function, since we are not privy to the rules of representation (as well as of architecture, aesthetics, and so on) that governed its placement and configuration and that would have influenced its perception by contemporary viewers.[23] Among their many functions, Buddhist images can perhaps be seen as fulfilling two related roles at the same time: first, by providing an opportunity for the viewer simultaneously to contemplate the nature of the Buddha's absence and presence, and second, through their form and their use by the viewer, by participating in the process of formulating a system of proper practice in reflection of this very absence and presence.[24] "Such images, really, function as what we might call *metapractical objects:* they provide, at once, an opportunity for practice . . . as well as an opportunity for reflection on such practice."[25]

As I alluded to in the Prologue, an alternative (though related) view holds that the nature and purpose of Buddhist images is to make the absent Buddha present.[26] Rotman has criticized this hypothesis, arguing that, were this notion to be normative in any way, "there must have been a citationality of the narrative tableaus on Buddhist monuments. If the Buddha was to be re-presented, and not just presented to those who had never seen him when he was alive, there must have been a known referent, something to which the viewer could key in. There must have been a known visual tradition of the Buddha image."[27] Rotman argues that it is possible, instead, that the Buddha images were self-referential and therefore looked familiar. In this regard, his argument is similar to that of Morgan, who, as discussed above, demonstrates how the pervasive use of Warner Sallman's *Head of Christ* came to represent the "true" face of Jesus to generations of American Protestants.[28] As the case of Sallman's Jesus makes clear, however, such an identification can occur only as a result of an established tradition of culturally rooted iconic representation, which may also have held true

in the case of the Buddha images, just as it would for Islamic religious art. The Buddha images would have been intended to function by involving as well as invoking "a range of strategies with which Buddhists could work through the incongruities and complexities, and even the contradictions, of precept and practice."[29]

Islam and Representation

Images have fulfilled a number of different functions in Islamic society as well, including working as aides-mémoires at a popular level, as objects of entertainment, and as narrative illustrations. In the last category, images function in a straightforward manner when used as backdrops for storytellers in Iranian coffeehouses, for example, but in more complex ways when they advertise and celebrate participation in the Hajj pilgrimage in rural Egypt.[30] Representational images have a long history in Islamic society, and are found in palace architecture as early as the Umayyad dynasty. The prevailing scholarly view is to make a distinction between secular and religious architecture, pointing out that image use was not found in religious architecture during the Umayyad Era. Much more work needs to be done on the nature of the secular versus the religious in early Islamic society in order to reconstruct these categories, since they are almost meaningless in the context of the Islamic world at a time before there was any real canonization of its doctrine or ritual. It is more likely that the nature and placement of images (and other forms of decoration) in the Umayyad period had more to do with appropriate spatial context than it did with an emergent consensus on the distinction between secular and religious art: what belongs in the bath does not belong in the bedroom, does not belong in the audience hall, does not belong in the mosque.

Ascertaining the emergence of visual representations of religious personages is somewhat easier; the earliest known portrait of Muhammad is found in a thirteenth-century Persian manuscript entitled "The Poem of Warqa and Gulsha," although there is some debate over whether or not one should consider certain earlier images, in particular the paintings of the frontispieces of volumes of Abu'l-Faraj al-Isbahani's *Kitāb*

al-aghānī, dated as early as 1131, as religious images, in which case the first religious representations of Muhammad would be from a century earlier.[31] By the late Ilkhanid period, there was a substantial proliferation in visual representations of the Prophet, especially in Persianate culture. From then on, such images, as well as others with religious themes, became a regular feature of painting in these societies. In many cases, particularly in albums depicting the life of the Prophet or in books with broader biographical themes, there is an obvious religious nature to the images.[32] However, I would stress once again that the production and consumption of miniature and album painting was very much an elite cultural activity and had extremely limited relevance to the behavior or engagement with visual and material objects of the wider community.[33] In many Islamic historical contexts, the rules for the palaces differed from those for the majority of the population in matters of dress, comportment, marriage, and the consumption of alcohol, and it should not be surprising that conventions surrounding art also differed between the two segments of society. At the same time, the major traditions of figural painting in the Islamic world belong almost exclusively to the Persianate world, and it is conceivable that they reflect certain broader social attitudes in visual and material culture. Unfortunately, there is as yet no scholarship that is sufficiently grounded in a study of the historical context to make significant conclusions on this important topic.

Outside of the exclusive circles of miniature painting and album illustration for elite audiences, it is much more difficult to gauge the prevalence of religious images in wider society. There is a proliferation of images of saints in the era after the adoption of the printing press, and there is some evidence to suggest that representations of saints and other religious heroes were in circulation in earlier times, particularly in Turkish society.[34] There has been a very long tradition of representing God, his Prophet, and other important religious personages through iconic objects such as images of the Ka'ba, Muhammad's footprint, and other visual means, which are discussed at length in Chapter 10. Whether such traditions of representation are to be understood as an intentional change from what would be called "realistic" portraiture in a Western context has been a subject of some debate. A widely circu-

lated statement by the sixteenth-century painter ʿAbd al-Samad about his more famous colleague Mir Sayyid ʿAli, in which the latter is said to have turned from an art based on form *(sūra)* to one based on meaning *(maʿnā)*, would suggest that such a distinction between formal resemblance and some other form of representation was there, albeit relatively late in the course of Islamic material history.[35] Regardless of the historical development of visual religious representation in Islamic society, much needs to be done in reexamining the history of such representation in a culture-centered rather than art-centered context. Grabar examined the account give by al-Maqrizi (d. 1442) of a competition between two eleventh-century painters named al-Qusayr and Ibn ʿAziz. One of the painters claimed to be able to represent a person in relief so that the subject appeared three-dimensional (and therefore "real"), while the other boasted that he could do so by embedding the image in a wall. Immediately before this brief anecdote in al-Maqrizi's history is an account of a mosque in Cairo that contained a representation of a fountain with footsteps going up to it; viewed from a particular spot, it looked as if an actual (three-dimensional) staircase led to the fountain. Grabar concludes from these two brief descriptions that medieval Muslims had a naive notion of visual realism: "Both stories suggest an illusionist perfection which hardly accords with the works known from that time. The explanation is that the eye of the medieval viewer in the Muslim world interpreted automatically the simplest outlines of what it saw as an illusion of reality, because there is no way of interpreting something one knows otherwise except as potentially real."[36]

What is more likely than an entire society drawing erroneous and simplistic conclusions concerning the nature of painting as well as of resemblance, is that such statements carry a combination of meanings, none of which is intended consciously to be a proclamation on the nature of representation. In the first place, such descriptions might very well be rhetorical devices that say more about literary conventions than they do about visual illustration. In the second, to say that one thing looks like another does not necessarily convey absolute realism: when I say that my dog looks "just like" Snowy (Milou) in the *Adventures of Tintin* graphic novel series, neither I nor my audience actually

believes that my living, breathing dog is identical in appearance to a cartoon, but rather that it resembles Tintin's dog in certain important respects (white fur, small size, fluffy ears, and so on). Lastly, statements like those of al-Maqrizi concerning medieval Islamic art are designed to elicit wonderment, an important quality of most works of art in medieval Islamic society in which objects of human manufacture, like natural phenomena, can serve the didactic purpose of making the viewer of an object, listener of a song, or visitor to a site contemplate the nature of a divine creator. As such, statements concerning the qualities of an image viewed from a particular angle or of artistic virtuosity in making three-dimensional portraits are not comments on mimetic representation but on a number of other things.

There are, in fact, a broad range of representational visual forms in Islamic culture, both in the present and in the past, some of which are discussed in later chapters, although in the context of this book the analysis of arenas where ideas of visual representation and resemblance are actually expressed holds greater importance than a discussion of the visual forms themselves. Among the many Islamic representational forms, mimetic representation both as mirroring and as resemblance through systems of signification appears in a number of situations. Sufi metaphysics as well as literature rely heavily on the metaphor of a mirror, most commonly seeing the world or the human heart as a mirror that reflects the divine nature. The metaphor is pervasive enough that it has been used by different writers to signify a variety of different metaphysical systems, yet none of them suggests that the reflection actually physically and visually *looks* like the divine nature so much as it perfectly represents certain essential divine qualities. As an important example of visual representation itself, the teachings of the Hurufi movement in western Iran and Anatolia maintained that the human body physically represented God as he is reflected through the letters of the Arabic alphabet. And although Hurufism has ceased to exist as a formal movement, many Hurufi ideas—including the religious importance of letter shapes—continue in a variety of popular as well as esoteric contexts in the Persianate Islamic world.[37]

Conclusion

The broad lesson to be learned from this discussion is twofold—first, that the rules of representation vary by social and historical context; second, that representation and its recognition only exist in the context of human life.

> Representations are not just a matter of mirrors, reflections, key-holes. Somebody is making them, and somebody is looking at them through a complex array of means and conventions. Nor do representations simply exist on canvas, in books, on photographic paper or on screens: they have a continued existence in reality as objects of exchange; they have genesis in material production. They are more "real" than the reality they are said to represent or reflect. All of these factors somehow straddle the commonsense divide between fiction and fact, fantasy and reality.[38]

Images and their resemblance exist in a habitus in which the purposes of those responsible for the images as well as the understandings of their viewers and receivers determine how the images function as representations of prototypes as well as concepts. Religious images might fulfill a multitude of functions including remembrance, honor, instruction, and intercession, where the last is either for protection in a prophylactic or talismanic sense, or is salvific.[39] In light of this spectrum of functions, when considering the representational power of images, we would do well not to overemphasize their formal mimetic qualities and recall Gadamer's statement that a religious image is not a "copy of a copied being, but is in ontological communion with what is copied."[40] It is the affective relationships, rather than any formal mimetic visual qualities, that are the ultimate determinants of the value of a religious image. The substantial methodological problems associated with using modern data to generalize about the past notwithstanding, my research on truck decoration in Pakistan and Pinney's research on Indian chromolithography (in particular, so-called "photos of the gods") makes clear that popular consumers of such religious images are more properly seen within the context of a social

visual culture than in a rarefied world comprised of traditions of artistic production. Popular forms of representation make religious images accessible to a wide range of people who historically do not have access to the high culture art forms of Islamic miniature painting and illustrated albums, such that one could argue that the development of a popular visual culture occurs independently, for the most part, from the very art objects that have been the primary focus of modern scholarship in Islamic art. From contemporary images and their use, we know that consumers of popular religious images display almost no interest in the production of the images or their authorship, such that they are interested in the images as "the sources of future interventions, rather than as embodiments of past intentionalities."[41] In vernacular (as distinct from elite) cultural circles, issues of mimetic representation—of what religious images "look like"—are almost irrelevant in comparison to concerns with what an image can "do," in the sense that efficacy, power, and threat are the primary determinants of the accuracy of an image in representing its prototype. The same valuation is apparent in textual descriptions of images in the formative period of Islam as well as during Muslim encounters with non-Muslim images, when those who characterize images as idolatrous or wondrous, miraculous or demonic, and powerful or impotent, all base their judgment of an image's mimetic accuracy on factors other than those of formal visual resemblance.

2

The Icon and the Idol

Pictures are things that have been marked with all the stigmata of personhood and animation: they exhibit both physical and virtual bodies; they speak to us, sometimes literally, sometimes figuratively; or they look back at us silently. . . . They present not just a surface but a *face* that faces the beholder.

— W. J. T. MITCHELL, *What Do Pictures Want?*

In a narrow sense, the term *icon* refers to any image that serves as the object of organized, ritual, religious veneration by Christians belonging to the Orthodox Church. Although in a contemporary context the term (from the Greek *eikōn,* or "image") brings to mind portable, painted, religious images on wood, canvas, or glass, for the purposes of this historical discussion neither the portability of the image nor its medium is relevant. Therefore the category of "icon" as the word is being employed here also includes frescoes, mosaics, prints on paper, and statuary. The concept of the icon carries relevance for contexts broader than those of Orthodox Christianity, and the relationships of resemblance suggested by iconicity also pertain to Muslim environments, a

subject explored later in this book. Here I will focus my discussion not on theories of iconicity and iconology per se, but on the icon as a heuristic concept that delineates the distinction between supposedly "good" and "bad" images, the latter being referred to derogatorily as "idols."

The notion of idolatry as the antithesis of "good" religiosity in the form of monotheist worship of a transcendent god is so deeply ingrained in many modern minds (and not just Muslim, Christian, or Jewish ones), that the terminology itself becomes a tall hurdle in progress toward any explanation of greater questions concerning the veneration of images and opposition to them. The very concept of idolatry— as distinct from image worship, image veneration, iconophilia, and so on—is inseparable from the specific context of Israelite monotheism as reflected in the Bible and subsequent Christian and Muslim elaborations of it. Both formal, direct condemnations as well as expansions on the idea of idolatry are found in Exodus 20:3–6, Deuteronomy 4:12–19 and 5:6–9, and Leviticus 26:1. The Israelite god forbids the worship of foreign gods and the construction of images of himself and of anthropomorphic and theriomorphic images in general. The matter is emphasized strongly in the episode of the Golden Calf (Exodus 32), which clarifies that idolatry is not simply the worship of "false gods" but also of the "true god" in the form of a visual representation (more specifically in this case, a theriomorphic statue). The categorical rejection of idols continues with the prophets, with Hosea rejecting all representations of God (Hosea 2:17), and on into the New Testament where Paul equates the veneration of idols with demon worship (1 Corinthians 10:20–21), a concept that had already appeared in Deuteronomy 32:17.

The critique of idolatry crosses civilizational and historical lines and follows similar patterns in which both the object of veneration— the idol—and the actor venerating the object—the idolater—are subjects of derision. The idol is denigrated for being base matter as distinct from something supernatural or divine, as well as for its impotence in taking care of itself and affecting the lives of others. The idolaters, in turn, are condemned and ridiculed for being civilizationally primitive as well as intellectually stupid, evidence for which lies in their willingness to worship the worthless idol.

Tropes concerning the fallacious nature of idolatry were well estab-
lished in Mediterranean antiquity; the Ionian philosopher-poet Xeno-
phanes pointed out that human beings always created gods in their
own image, suggesting that if animals had the ability to make objects
they would create theriomorphic idols.[1] Not just philosophical writ-
ings but satirical literature also ridicules the making and use of idols.
In the popular *Battle of the Frogs and the Mice* (or *Batrachomyomachia*), a
parody of the *Iliad* dating from the third century CE, Minerva com-
plains to Saturn that mice have been nibbling away at her mantle and
she cannot afford the cost of a new one.[2] Versions of the story are car-
ried into Christian literature in the early third century CE by the Greek
convert to Christianity Arnobius. In his *Seven Books against the Heathen*,
he speaks of how the pagan gods decay and degenerate because they
are made of base matter, and are eaten from the inside out by vermin:

> I say, do you not see that newts, shrews, mice, and cockroaches,
> which shun the light, build their nests and live under the hol-
> low parts of these statues? [T]hat they gather carefully into
> these all kinds of filth, and other things suited to their wants,
> hard and half-gnawed bread, bones dragged [either] in view
> of [probable] scarcity, rags, down, [and] pieces of paper to
> make their nests soft, and keep their young warm?[3]

Speaking of the gods' inability to prevent themselves from outward
defilement, he says:

> Do you not see, finally, swallows full of filth flying around
> within the very domes of the temples, tossing themselves
> about and bedaubing now the very faces, now the mouths of
> the divinities, the beard, eyes, noses, all the other parts on
> which the outpouring of their emptied fundament falls?
> Blush, then, . . . and take your lesson and norms from the
> dumb animals and let them teach you that there is nothing
> divine in images, on which they do not fear or scruple to cast
> filth.[4]

The imagery of idols of impotent gods being devoured and defiled
by vermin is not limited to the Near East. A similar attitude is found

in the seemingly unrelated Hindu context where, despite the centrality of visual representations of gods in many aspects of ritual, there are strong philosophical and social currents that take an attitude toward the comparative value of iconic and visual versus unembodied divine representation that is remarkably similar to what we find in Judaism, Christianity, and Islam. This is especially true in the period of Hinduism's sustained contact with Islam and European Christianity. For example, Dayananda Saraswati (d. 1883), the founder of the Arya Samaj, a Hindu reform movement that is as opposed to idol worship and ancestor worship as it is to Islam and Christianity, attributed his realization of the false nature of idols to one specific personal experience. As a boy of fourteen he went to a temple to worship an image of the god Shiva. While looking at it, he observed a mouse run over the idol without any intervention from the god, thus making him realize that if the idol was incapable of protecting itself from a mouse, it was certainly incapable of possessing any of the qualities of Shiva himself. He therefore realized that the idol and the god could not be the same.[5]

Pagan Attitudes toward Images

An ambivalence—or perhaps an anxiety—over the propriety of venerating images is found in late antique paganism in forms that both echo and foretell similar concerns among Christians and Muslims. The tension between the philosophical view of the nature of rational belief and the largely artificially constructed alternative of popular practice was often resolved in the direction of condoning devotion to images. Maximus of Tyre raised the hypothetical question of a philosopher who had the opportunity of starting religion afresh among a people who possessed no religious past. In answer to the question of whether or not such a person would introduce images, he posited that, since religion is the common law of all humans, it is better to continue with common practice rather than try to innovate by eliminating the veneration of images.[6] Dion of Prusa went further by condoning the use of images on a variety of grounds, in particular the longing of human beings to be near God, which mimics the desire of children to be near their

parents; in the absence of the object of longing, the image helps make it present.[7]

Similar attitudes are found in several of the apologia of late antique paganism, perhaps most famously in a passage attributed to the Emperor Julian, who abandoned Christianity in favor of paganism:

> Therefore when we look at the images of the gods, let us not indeed think that they are stones or wood, but neither let us think that they are gods themselves; and indeed we do not say that the statues of the Emperors are mere wood and stone and bronze, but still less do we say that they are the Emperors themselves. He who loves the Emperor delights to see the Emperor's statue, and he who loves his father delights to see his father's statue. It follows that he who loves the gods delights to gaze on the images of the gods and their likenesses and he feels reverence and shudders with awe of the gods who look at him from the unseen world.[8]

Julian's defense of images follows a logic that repeats itself in different contexts and times, including in Islamic society: that images serve as reminders, teachers, and comforters by making the absent present, and that they do this without in any way usurping or compromising the dignity of that which they represent. Four points are central to such defenses of images:

1. That the images and statues are not gods themselves but are intended to lead human beings to thought of god(s).
2. Through contemplating a statue, a human being engraves in his or her mind a diminished image of a god.
3. By resembling a god, statues are appropriate receptacles for divine power and can therefore be the actual loci of miracles.
4. Since human beings are fashioned in god's image, it is fitting that god should be fashioned in a human image.[9]

John of Damascus (d. 749), one of the most influential Christian defenders of images and an important figure in the history of Islam's early encounters with Christianity, spoke specifically of the image's function as a reminder: "[The] image is made for the remembrance of

past events, such as miracles or good deeds, in order that glory, honour and eternal memory may be given to those who have struggled valiantly."[10] The mnemonic purpose of the religious image was closely related to its imperial use, and acknowledged as such by John. In defending the belief that religious images function as aids that direct one to an understanding of immaterial concepts, he wrote: "It is impossible for us to think of immaterial things unless we can envision analogous shapes . . . the mind which is determined to ignore corporeal things will find itself weakened and frustrated."[11] Yet another reason for John's support of images was that their contemplation encouraged individuals to do good and desist from evil. In short, images fulfilled a moral didactic function in various ways.

Israelite and Jewish Attitudes to Images

Judaism, like Islam, is often seen as a resolutely aniconic (even iconophobic) religion in which a scriptural ban on images informs all attitudes toward the visual image. In actual fact, Jews as well as ancient Israelites expressed their religious attitudes iconographically using a variety of media in addition to the text, and deployed these various media as dexterously as did Muslims in their attempts to represent God.

Despite a visual aniconism that characterizes Judaism, there is little doubt that early and medieval Jews attributed a variety of significations to images, a fact amply attested to in parables of women fashioning male statues with the intention of copulating with them, the construction of wooden effigies of beautiful women, or the exegeses (especially in the Zohar) of Pharaoh's behavior and image-making, or most famously, the many commentaries on the incident with the Golden Calf, all of which point to a variety of complex understandings of the visual image as something with a power over human beings that can be erotic or political, and only sometimes condemnable.[12]

Early Rabbinic law closely followed biblical prescriptions on the worship of images, but it did not extend the ban on image worship to a blanket condemnation of all forms of visual religious art.[13] In fact, if

medieval Christians are to be believed in this regard, they did not associate Jews and Judaism with a strict aniconism or iconophobia. The dominant Christian view (undoubtedly reflecting a polemical position) appears to have been that Jewish religious culture officially permitted the creation and use of visual art. Bernard of Clairvaux (d. 1153) went so far as to express his criticism of the luxury of the church of his day by likening it to the opulence of Jewish material religion.[14] As late as the sixteenth century, neither Christians nor Jews seem to have regarded Judaism as broadly aniconic or to have thought that Jews were themselves deficient in or devoid of visual religious art. Nor do the Jews of the period appear to have understood the biblical laws concerning images as a complete ban on the production, use, or even delectation of visual images.[15]

The explicit biblical prohibition of images appears to be a late, perhaps Deuteronomistic, development in Israelite religion, and no explicit prohibition can accurately be dated earlier than the fall of the Northern Kingdom. Biblical statements in prohibition of images are mostly directed at images of other gods and probably rest on earlier traditions or conventions of aniconism; as such, they should be seen as extrapolations on the first commandment, although the end result is that they also cause the prohibition of images of the god of Israel.[16] According to Mettinger, so-called Deuteronomist theology explicitly banned certain kinds of religious images because of their association with the paganism of the surrounding cultures of Babylonia and Egypt, because of their status as artifacts of human labor, and because of the anthropomorphic nature of their symbols. This is juxtaposed to an earlier, more permissive, attitude toward images that changed as a result of a greater theological sophistication that came to characterize the Israelite sense of religious difference between themselves and others.[17]

The ambivalence concerning visual images extends to the writings of Jewish philosophical thinkers from the Second Temple period. Josephus, the first-century CE Jewish historian writing in Greek, provides a very detailed description of Solomon's temple and palaces as well as of those built and possessed by Herod. He criticizes Solomon for ordering statues of oxen for the temple and of lions for his throne, and he

also condemns Herod for placing images of living creatures within the temple. However, his denunciations do not constitute a blanket condemnation of visual religious art, nor do the writings of Philo, even though Philo maintains that Moses prohibited his followers from engaging in or possessing sculpture and painting because "their crafts belie the nature of truth and work deception and illusions through the eyes to souls that are ready to be reduced."[18] In fact, it is likely that Philo believed it was not the painting of images that was prohibited but rather the construction and use of polychrome statues.[19] Jewish scholars from the Middle Ages supported the importance of the visual in religious objects. Profiat Duran (Isaac ben Moses Levi) maintained that it was important that one study the Bible from lavish, ornately decorated and illuminated copies because "the contemplation and study of pleasing forms, beautiful images and drawings broaden and stimulate the soul."[20] Even the incident involving the worship of the Golden Calf was not condemned unequivocally. For example, in discussing the sin associated with worshipping the Golden Calf, Judah Halevi (d. 1141) held the Israelites accountable but maintained that of the total population of 600,000, less than 3,000 had committed the sin of engaging in worship using a divinely unauthorized image, and for which they were punished by death.[21]

The ambivalent Jewish position on images is reflected in the varied attitudes expressed by Jews toward image veneration and use in other religious traditions, especially Islam and Christianity. Jewish criticisms of the use of images among Christians first became widespread in the seventh century, when Jews deployed the biblical condemnations in their competition with Christians, wielding the Torah's prohibition against idolatry as the basis of their polemical opposition. In response to the argument that God had, in fact, commanded Moses to make two golden cherubim (Exodus 25:18), the common Jewish rejoinder was that God had permitted images as reminders of him, not as objects to be venerated.[22]

Jewish pilgrims in the Middle Ages seemed to be more explicit in their view of themselves as distinct from the Christians; they expressed this opinion in ways that characterize Christians as only nominally

distinct from idolaters. The twelfth-century traveler Benjamin of Tudela used the biblical term *bamah* ("high place," typically associated with sacrifices to Ba'al) to designate Christian holy places; this was the same word he used for polytheistic or pagan places of worship. The term *kenisah*, in contrast, was the word he used interchangeably for synagogues and mosques. However, he reserved use of the technical term for idolatry (*'avodah zarah*, literally "foreign worship") only to refer to Christian monuments—not places of worship—thus showing either nuance or ambivalence regarding the Christian relationship to idolatry. Similarly, when describing the Holy Land—particularly Ezekiel's tomb, where Jews and Muslims worshipped together—as well as the Temple Mount and Rachel's tomb, another twelfth-century pilgrim, Petahiah of Ratisbon, clearly saw Muslim rituals and sacred spaces to be religiously similar to Jewish ones and therefore unproblematic, but regarded Christian religious spaces as idolatrous.[23] In describing one of the Islamic buildings that had fallen into Christian hands, Petahiah claims that the Christians had attempted to place "idolatrous statues" within it, but they kept toppling over. Eventually, they embedded the statues into the walls, but even that technique did not help the statues that had been placed in the "Holy of Holies" from falling over.[24]

Despite this ambivalence, however, there are clear examples of Jewish condemnation of the practice of idolatry, which is linked in a familiar trope with all forms of licentious and grotesque behavior. A tract that could easily have been written by a Muslim iconophobe is preserved in *The Wisdom of Solomon*, a work probably dating from the first century BCE:

> Afterward it was not enough for them to err about the knowledge of God, but they live in great strife due to ignorance, and they call such great evils peace. For whether they kill children in their initiations, or celebrate secret mysteries, or hold frenzied revels with strange customs, they no longer keep either their lives or their marriages pure, but they either treacherously kill one another, or grieve one another by adultery, and all is a raging riot of blood and murder,

theft and deceit, corruption, faithlessness, tumult, perjury, confusion over what is good, forgetfulness of favors, pollution of souls, sex perversion, disorder in marriage, adultery, and debauchery. For the worship of idols not to be named is the beginning and cause and end of every evil. For their worshippers either rave in exultation, or prophesy lies, or live unrighteously, or readily commit perjury; for because they trust in lifeless idols they swear wicked oaths and expect to suffer no harm. But just penalties will overtake them on two counts: because they thought wickedly of God in devoting themselves to idols, and because in deceit they swore unrighteously through contempt for holiness. (14:22–30)[25]

In brief, it can be said that Israelite and Jewish aniconism is the result of internal developments in the religious tradition; these developments seem to have begun before the theological system that came to justify and sustain the attitude toward images. Most importantly, Jewish aniconism or iconophobia is not comprehensive; it allows for a range of attitudes toward religious images and does not constitute a distinctiveness unique to Judaism.[26] A related attitude, it can be argued, also characterizes Christianity and Islam, although in distinct ways.

Christianity and the Idolatrous "Other"

Philo of Alexandria (d. ca. 50 CE) considered anthropomorphism "an impiety greater than the ocean" and took great pains to differentiate the divine from anything conceivable as a human likeness. In *On the Decalogue* (Book XII, chap. 52–80) and *Of the Contemplative Life* (chap. 3–9), he wrote separate accounts of the extrabiblical, pagan gods, and followed the same five-point critique of idolatry in both; he condemned idolatry, zoolatry, the notion of the pagan gods as true actors in history, and the deification of natural elements and of heavenly bodies (such as the sun, moon, and cosmos).[27] Christian apologists of the early centuries frequently targeted the pagans' uses of images, particu-

larly statues, and referred to their practices as idolatry. For example, Origen made a four-point critique of the use of statues:

1. Through the act of revering them, human beings begin to believe that the statues are themselves gods.
2. Reverence of material objects in the form of statues represents a diversion and debasement of the reverence that belongs solely to God.
3. Demons take up residence in statues and their precincts.
4. The biblical ban on images remains binding on Christians.[28]

Idol veneration as a ritual practice clearly exists in all times, but the *practice* of venerating idols is not the actual concern in most discussions so much as the fact that the *charge* of idolatry or idol worship serves to distinguish one's own group as those who believe in and practice "true" religion from others who practice a false one. For medieval Christians, as for Muslims, the idolatry that characterized the biblical and pagan past did not come to an end with the advent of Christianity. It remained an ongoing threat, both from without, such as from the Muslims whose supposed idolatry will be discussed later, and from within, in the form of the ongoing threat the use of images represented to some Christian thinkers. It is for this reason that idolatry is listed as a key social sin in the didactic program of twelve virtues and twelve vices in the Catholic Church, a program instituted at Notre Dame in Paris and later copied at Chartres and Amiens.[29]

Echoing tales of the introduction of idolatry to the Arabian Peninsula discussed in Chapter 4, the origins of idolatry are understood by Christians to lie no more in ignorance than in tyranny, which uses fear to institute idolatrous worship, as well as in the flattery and conceit of the holders of earthly power. The thirteenth century also witnessed the rising popularity of images of saints as idol-destroyers, which normally appeared in one of two ways—as a saint who refuses to worship idols (an act that frequently leads to his or her martyrdom), or as a saint who initially goes along with idolatry but eventually is responsible for the destruction of idols.[30]

One of the most enduring uses of the concept of idolatry lies in imagining a cultural other as distinct from oneself, a process that is

simultaneously exoticizing in romantic or wondrous senses and a means of arguing for one's own religious and cultural superiority. The importance of idols and idolatry in Muslim conceptualizations of India as a place of wonders is dealt with later in this book. Although never to the same degree as they did in the case of India and Hindus, Muslims also constructed Christianity in terms that involved idolatry, especially during the crusader period when they were engaged in a dialogic relationship with Western Christianity in which mutual charges of paganism and idolatry played no small part. Christian devotion to visual images was juxtaposed to the nonmaterial, pure faith of the Muslims in passages such as the following:

> The Franks said "we will pour forth our soul, spill our blood, give up our lives. This is our church of the Resurrection. . . . We love this place, we are bound to it, our honour lies in honouring it. Here are the pictures of the apostles conversing, Popes with their histories, monks in their cells . . . here are the effigies of the Madonna and the Lord of the temple . . . and what is described and sculpted of his disciples and the Master, of the cradle and the infant. Here are the effigies of the ox and the ass."[31]

Such passages remain rare, and although Muslim apologetics concerning Christians routinely refer to the impropriety of the Christian love for images, they stop short of referring to Christians as idolaters, in all likelihood on account of the explicit Qur'anic recognition that Christians, together with Jews, constitute "People of the Book" and practice a recognized form of monotheism, albeit a distorted and inferior one. Christian apologists, on the other hand, were not subject to any such restrictions, and freely constructed an image of Islam and Judaism in which idolatry played a central role, to the point of reimagining these religions as idolatrous versions of Christianity.

Muslims were the subjects of such reimaginings to the same degree as Jews although, significantly, it is not image veneration itself that was to be condemned by Christians but the worship of "false" images. The poems of Gautier de Coincy, for example, speak of Muslims (Saracens)

and Jews stealing and ritualistically "murdering" Christian images in a manner reminiscent of accounts of the martyring of saints, a parallel that holds strong to the point that the "murderers" sometimes miraculously convert during the act of killing the Christian image.[32] Islam was often represented as a cultural continuation of Greek and Roman paganism, thereby necessitating a demonstration of the Muslims' religion not only as pagan but also idolatrous. As such, Muslims were naturalized as Christianity's "other," constructed as a deviant mirror image of Christianity, complete with a counter-trinity of false gods. As Tolan describes in his comprehensive treatment of representations of Islam and Muslims in the medieval Christian West, medieval Christian texts—be they in Latin, French, or other languages—painted the religion of the Saracens in the same colors as Roman idolatry. In the twelfth century, Muslims were described as worshipping a host of idols made of stone and precious metals, which were inhabited by demons and possessed magical powers, and before which the Saracens prostrated themselves and made sacrifices.[33] Although earlier Christians—particularly those in the East who had a greater familiarity with Islam and its sacred geography—attacked Muslims for perpetuating pre-Islamic Arab litholatry or the Venus cult in their veneration of the Ka'ba, their treatment of Muslims as idolaters was nowhere as vivid as it was in the medieval Latin West.[34] In this latter imagining, Islamic "idolatry" combines cruelty, illicit and licentious sexuality, and destructiveness.

Muslims were said to worship idols of Jupiter or Apollo, although chronicles of the First Crusade refer to them sometimes as *Mahummicolae*, or "Muhammad-worshippers."[35] Accounts of the siege of Jerusalem cast Muslims not only as pagans, but also very clearly as pagans who mirror Christian religious behavior. On seeing the Christians circling the city, the Muslims bring out their idol "Machomet" and beseech him to save the city. The idol is made to confront the crucifix carried aloft by the besieging Christians and, depending on the chronicle, either the crucifix bleeds miraculously or the Saracen idol acts magically, symbolizing in mirrored ways the impending Christian victory. The leader of the Muslims, "the Amiravissus," laments:

O Mathome, Mathome, who worshipped you with greater magnificence, in shrines of gold and silver, with beautifully decorated idols of you, and ceremonies and solemnities and every sacred rite? But here is how the Christians often insult us, because the power of the crucifix is greater than yours: for it is powerful on heaven and earth. Now it appears that those who confide in it are victorious, while those who venerate you are vanquished. But it is not the fault of our lack of care, for your tomb is more adorned than his with gold, gems, and precious things.[36]

The purpose behind such depictions of Islam in writings from the crusades is to demonstrate that the current struggle against a religious opponent is not new, but rather constitutes the ongoing battle between good (as Christianity) and evil (as paganism); this pattern holds true for the epic *chansons de croisade* as much as for the chronicles of the period. The *Chanson d'Antioche* provides a vivid description of Saracen idolatry in terms that are not only reminiscent of Christian accounts of Roman paganism, but also bear close resemblance to Muslim accounts of Hindu idolatry:

The center of the pagan cult . . . is Mahome[t], an idol held in midair by magnets. A defeated Saracen general, Sansadoines, strikes the idol, knocking it down and breaking it after it has shown itself powerless to secure victory for its devotees. Here again, the pagan enemy himself realizes the powerlessness of his idols and destroys them with his own hand. Sansadoines then predicts to the Saracens that they will be defeated by the Christians who will 'break the walls and palisades of Mieque [Mecca], will take Mahomet down from the pedestal where he is placed, [and will take] the two candelabra that sit there' . . . The conquest of Mieque, the Saracens' cultic center, will mark the ultimate defeat of paganism.[37]

The *chansons de geste* go even further in maintaining the alterity of Islam as an inversion of Christianity. In the *Chanson de Roland,* the

Saracens are pagans who worship an unholy trinity of Mahumet, Apollin, and Tervagant, whose images they carry on their banners when they come out to battle the Christian knights. When Roland chops off the hand of Marsile, the Saracen king, the defeated knight rushes home to Saragossa where the idolatrous Saracens blame their idols for the Muslim defeat, hurling Mahumet from the parapets to be defiled by pigs and dogs. Finally, when the Christians conquer Saragossa, they enter the "sinogoges" and "mahumeries" and destroy all the idols.[38]

Tolan, in contradiction of some modern writers, convincingly argues that Saracen idolatry was not simply a literary trope deployed by medieval Christians, but that it became an essential element in Christian understandings of Islam and Muslims, such that both the authors and the audiences of these epics saw the Saracen as synonymous with the pagan.[39] Nevertheless, there are striking ways in which the construction of paganism and idolatry follows patterns regardless of the actual practice of the community accused of being idolatrous or the amount of available information that potentially could disabuse the writer of his or her mistaken ideas concerning the beliefs and practices of the imagined religious other. On the one hand, idolatry is a characteristic of the religious other; on the other, it cannot be a positive religious behavior even, in cases of Muslim descriptions of Indian idolatry, where the author does not make critical statements about the idol or the behavior of the idolaters. The representation of idolatry never escapes a general, underlying critique. Thus, even in the case of the reaction of the Spanish Christians to Mesoamerican populations, the latter had to be constructed in terms of known idolatry for them to fit a pattern of justified subjugation and annihilation. Idols serve as "anti-images" in cultural self-definition, and "otherness" is articulated through notions of idolatry that persist outside the medieval world.[40]

The Iconoclast Controversy

The historical period commonly referred to as the age of iconoclasm has long been presented as a definitive moment in the history of Christianity's relationship with the religious image. It has also been treated

as a critical moment in Islam's encounter with the visual image, both in terms of Byzantine influence on formative Muslim attitudes toward visual imagery and in terms of Islam's putative influence on the rise of iconoclasm among Christians of the time. One needs to bear in mind, first and foremost, that at the end of the century and a quarter formally identified with this period, it was the veneration of images that carried the day; also, not only do very few of the documents produced by the earliest iconoclasts survive, but those that do have been distorted, and sometimes forged, by the iconophile victors who wrote the history of this period. When investigated more thoroughly, notorious events such as the destruction of the icon of Christ at the gates of the imperial palace at Chalcedon by Leo III turn out not to be true, as does the simplistic and brutish nature of the objection to images that is sometimes attributed to the so-called iconoclasts.[41] Furthermore, although the term *iconoclast* was occasionally used pejoratively starting in the early eighth century, its use to name a period in history did not begin until the sixteenth century, and it has only been since the 1950s that the term has been firmly attached to the period of image debates in the eighth and ninth centuries. The Byzantine Christians of the time referred to the phenomenon as *iconomachy*, the "image struggle."[42]

Nevertheless, the iconoclast period and the centuries immediately before it remain critically important to any discussion of the development of attitudes toward the religious image in Christendom and the Islamic world; it is the period roughly from the sixth century until the start of the Iconoclast Era (sometimes referred to as the Byzantine Dark Age) when Byzantium's major transformation from classical antiquity was made. Internal problems, repeated attacks from the northeast, and, importantly, the Arab-Muslim conquests and attacks (including the siege of Constantinople in 717–718) served to destabilize the empire, deprive it of important sources of revenue, and even threaten its existence. At one point, the population of the capital fell to approximately 40,000 and Greek cities, which had continued to be centers of culture and education into the sixth century, shrunk in importance or else were destroyed by invasion. Much of the old educational system— and together with it classical books and the knowledge they contained—was gone, and pre-Christian antiquity ceased to be part of the conscious-

ness of the general populace.[43] It was *after* the Iconoclast Era that the Byzantine Christian world developed an interest in rediscovering its classical past, and it was the iconoclasts and their form of argument that were largely responsible for stimulating this interest.[44]

The iconoclast interlude is seen by most writers on the period to have run from 724 to 843 CE, officially beginning during the reign of Leo III and ending immediately after the death of Theophilus. Its first references are in three letters written by the patriarch Germanos (r. 715–730 CE), in one of which he expresses consternation over certain actions of the emperor Constantine, who is accused of not showing religious images appropriate honor by performing *proskynesis* in front of them.[45] According to the popular view, Leo III (r. 717–741) took steps in 725–726 to severely limit the use of religious images and prohibit image worship, then ordered that all images be destroyed, including the aforementioned icon of Christ on the main gate of the imperial palace of Chalcedon. He declared two edicts against the veneration of icons, in 726 and 729, and forced the patriarch of Constantinople, Germanos, to sign the latter edict and eventually to resign in 730. Leo's reforms were stiffly opposed by the monastic orders as well as major sections of the Byzantine bureaucracy, and he reacted with sustained and systematic persecution, confiscating much land and other property from the monasteries, vilifying and banishing monks and bishops, and appointing loyalists in their place. Anastasios (d. 754), the new patriarch, supported Leo III in his efforts, as did other high-ranking members of the church within the political domains of Byzantium. This was not the case in the Islamic lands, where John of Damascus, who served as a courtier to the caliph Hisham (r. 724–743), famously wrote three apologies in support of icons that collectively came to be known as the "Oration in Defense of the Sacred Images."[46]

Despite the fact that the papacy was politically subject to Byzantium and its emperor, both Gregory II (r. 715–731) and Gregory III (r. 731–741) formally protested Leo III's persecution of icons and iconodules, and he was also condemned by the Council of Rome in 731. After the death of Leo III, his son Constantine V (r. 741–775) continued with a regime of iconoclastic policies. Under his patronage and with his active participation—for he was himself a talented theologian (or at least

pretended to be)—the Byzantine court and its iconoclastic patriarchs elaborated a doctrine opposed to the worship of icons. This doctrine was enforced at the Council of Hieria in 754.[47]

Even though few of the writings from the Council of Hieria survive, and those that do have been shaped and kneaded by the hands of iconophiles opposed to the positions expressed in the documents from the council, it appears that the council in 754 represented a qualitative development in arguments opposing the veneration of images. It is, however, debatable as to whether such formulations are products of that time or represent earlier trends concerning the legitimacy of image veneration within Christian circles. Leo III had justified his iconoclastic policies in sweeping terms that condemned the worship of any material object of human manufacture. In contrast, the Council of Hieria made the christological argument that venerating a physical representation of Christ reified his physical nature. This would imply that iconodules were either limiting him to his human form or separating out his human nature, both of which were doctrinally unacceptable.

The Council of Hieria was followed by several years of sustained persecution of monks who continued to represent the main source of opposition to the new doctrine, with many monasteries either secularized or destroyed, and monks mutilated, killed, sent into exile, or compelled to marry. This repression directly resulted in the anti-iconoclastic Council of Rome of 769, which marked an important step in separating the Eastern and Western churches in Christianity.

Ironically, it appears that it was the christological emphasis of the Council of Hieria that forced the iconodules to develop a theology of their own, since they were forced to defend image worship in arguments that would be manifestly justifiable in Christian terms. In fact, one could argue that Christianity developed complex ideas regarding the nature of the religious image—and subsequent ideas regarding the nature of representation—precisely because Christian iconodules were compelled to justify their own use of images to powerful internal critics. In contrast, Islam (or Judaism, Hinduism, Buddhism, and other religious traditions) lacks such an articulate theology or philosophy of

the visual image because it has never been forced to marshal its defense in a sustained manner.

Following the death of Leo IV the Khazar (r. 775–780), his minor son Constantine VI came to the throne under the regency of Leo IV's widow, Irene. She appointed her secretary, Tarasios, patriarch of Constantinople in 784, and declared herself emperor in 790 after preventing Constantine VI from acceding to the throne. In 787, Irene convened the Second Council of Nicaea, which decreed that the veneration of images was doctrinally permissible so long as it constituted "relative" worship, meaning that the veneration afforded to the image did not constitute an act of idolatry but passed directly to its prototype.

What came to be an influential theological doctrine concerning the status of icons was elaborated by Theodore of Studios (759–826) and Nikephoros, who served as patriarch of Constantinople from 806–815. When Leo V came to the throne in 813 and succeeded in having the Council of St. Sophia in 815 reverse the pro-image worship decrees of 787, thereby reestablishing those of the Council of Hieria, it was Nikephoros and Theodore who wrote in defense of image veneration, although they used different arguments. Nikephoros, for his part, stressed the complete humanity assumed by Christ in his physical form, thereby justifying the representation of him.[48]

In most accounts of the period, iconoclastic policies and the persecution of those opposed to them continued under Leo V's successors, Michael II (r. 820–829) and Theophilus (r. 829–842). Finally, after the death of Theophilus, in 843 the regent-empress Theodora called a council to restore the legitimacy of image worship, bringing the formal period of iconoclast controversy to a close.

Despite the attention given to the period from 724 to 843 as a phase of Christian history, in fact, Byzantine iconoclasm was grounded in antecedents not only in pre-Christian religious understandings but in Christianity itself, a historical observation that situates Christianity more solidly in an attitude toward religious images that is shared across faith communities, including Islam. The period of Christian history prior to the eighth century was characterized more by a widespread distrust of images than by any systematic veneration of them;

at the very least, many early Christians displayed an indifference to religious images. Although it is very possible that veneration of the iconic cross was practiced in places during the first three Christian centuries, it was subsequent to the identification of the cross with the imperial standard of Constantine that its veneration became both widespread and officially sanctioned. By the second quarter of the fourth century, the connection between the icon of Jesus's crucifixion and the symbolism of Byzantine imperial rule was made explicitly in coinage, and by the end of the century *proskynesis* (bowing or kneeling) before the cross was considered appropriate ritual behavior.[49]

State sponsorship of image veneration in early Christendom had clear pre-Christian models, and not only did the practice of venerating the portrait of the emperor continue almost without interruption into the Christian period but it was explicitly condoned by leaders of the early church.[50] Recent scholarship has made it abundantly clear that there was much more to the iconoclast movement than a narrowly religious aversion to images—imperial concerns were inextricably bound up with church issues and power dynamics involving central and peripheral players.[51] Because of this, the tradition of venerating the imperial portrait most likely had some impact on the debate over images: the Christian Byzantine emperors had continued the Roman custom of using portraits of themselves to stand in for them when they were unable to be present. Portraits were dispatched to the provinces and vassal states to receive obeisance on behalf of their prototype—the emperor—and rejection of the image meant rejection of imperial authority. Similarly, such portraits served to represent the person of the emperor in the courts, assemblies, markets, and theaters, and also served to give lawful protection to individual citizens through the legal concept of allowing individuals to seek asylum by reaching the foot of a statue of the emperor *(confugium ad statuas),* a practice that continued in parallel with the new category recognizing the sanctuary of a church *(confugium ad ecclesias).* The church never rejected or even seriously challenged these established usages of visual representations of the emperor—whose sacred status continued into Christian times—which would necessarily have blurred the distinction between the pro-

totype of the emperor and his image. "As is always the case when images are used to make palpable the authority or power of the person portrayed, the role legally assigned to the imperial portrait, particularly in connection with the right to asylum, fell little short of magic."[52]

It was not until the second half of the fourth century that we find anyone writing about Christian representational art in positive terms; and even these examples are passing references rather than any sustained support for images or a defense of them. As Kitzinger has argued, it was Christian practice that preceded both attacks on images and their defense, meaning that popular devotion to images or their propitiation must have already existed in the early centuries of Christianity.[53] In a broad sense, then, this period serves as a model for the iconoclastic episodes of the sixth through ninth centuries, in that the sequence is one of the practice of image veneration preceding its opposition, and the opposition in turn giving rise to the defense of image veneration.

Whatever the trajectory of image veneration in the early Christian centuries might have been, by the second half of the sixth century, literary evidence suggests that it was extensive, particularly in the eastern parts of the empire, and continued as such into the Iconoclast Era. It is in this period that pilgrimage narratives and historical records start to pay attention to the importance of images, with their relevance to belief and practice being summarizable in four categories: (1) devotional practices, (2) belief in the miraculous origin of certain images, (3) belief in the magical properties of images, and (4) the religiously sanctioned use of images to ward off evil and ill health.[54] A century before the beginning of the iconoclast movement, religious images (eikōnes) of Jesus, Mary, and saints were represented in frontal poses now familiar to us (that is, in non-narrative forms or contexts), and were objects of ritual veneration through bowing and kneeling (proskynesis) and kissing (apasmos).[55] Such images appear to have proliferated in private and domestic circles during this time, beyond the direct influence of the church or the palace.[56]

Despite clear evidence of the existence of religious images at the center of veneration practices (though few actual examples predating

the iconoclastic period actually survive), the bulk of official religious writing from this time seems to take a negative view of images and their veneration. For example, the Eighty-Second Canon of the Council in Trullo in 691 forbade the representation of Jesus as a lamb or in any other symbolic form; he could be represented solely in human shape, so that "we may recall to memory his conversation in the flesh, his passion and salutory death and his redemption which was wrought for the world."[57] In this formulation, image making is enjoined by the highest imperial and church authorities for the clear purpose of making the central elements of christological belief somatically comprehensible.

In part, underlying these conflicts are questions of whether or not the visual representation of sacred persons is religiously acceptable at all and of the nature of the relationship between a prototype and its representation. However, these questions do not address directly the issue of the *efficaciousness,* or value, of image veneration, though there can be no doubt that the practice was viewed as both valuable and effective. Throughout the sixth and seventh centuries, there were examples of images exercising influence over human affairs either directly or through intermediaries. One account tells of a woman acquiring an image of the abbot Theodore of a monastery in Cilicia; she lowered the image into a dry well, causing it to fill up with water.[58] More commonly, prayers were answered when accompanied by ritually kneeling or prostrating in front of an image. Examples of the apotropaic function of religious images, as distinct from active change effected by them, are also found in accounts of the siege of Constantinople by the Avars in 626 and by the Muslim Arabs in 717. In the former case, a patriarch ordered images of the Virgin and Child to be painted on the city's western gates, the direction from which the Avars were attacking. At a later date, when Constantinople was threatened by fire, the same patriarch held an image of Jesus in his hands and paraded it along the city walls. Similarly, in the case of the Arab siege, it was an image of the Virgin that was paraded along the walls accompanied by relics of the true cross, which had allegedly been rediscovered during the reign of Constantine.[59]

A Christian Theology of Images

If the writings of Gregory of Nyssa, Nilus of Sinai, and Basil are any indication, there seems to have been no systematic attempt to establish a theory of images in the Christian world before the sixth century.[60] Nonetheless, nonsystematic writings provide some indication of how images were understood by prominent members of the church before the elaboration of any formal doctrine. Gregory of Nyssa, for example, stated that seeing a representation of Abraham's sacrifice of his son was the cause of a deep emotional experience for him.[61]

At approximately the same time (that is, the end of the fifth century), Pseudo-Dionysius had introduced ideas regarding the nature of the physical and intelligible worlds that became central to Christian Neoplatonic notions of the nature of existence. And although there is no direct evidence to the effect, in all likelihood these ideas were influential in the elaboration of Neoplatonic concepts within the Muslim environment. Pseudo-Dionysius viewed the entire sensory world as a reflection of the divine spirit, and contemplation of this sensory world served as a path to the second. Even though he never specifically connected such ideas to questions of the ontological relationship between objects and their representations, the fact that he frequently referred to physical objects in the sensory realm as *eikōnes* serves as a clear indication of the direct connection between the nature of Neoplatonic religious views and issues concerning visual perception. Furthermore, he clearly believed that visible images help in the contemplation of the divine:

> The essences and orders which are above us ... are incorporeal and their hierarchy is of the intellect and transcends our world. Our human hierarchy, on the contrary, we see filled with the multiplicity of visible symbols, through which we are led up hierarchically and according to our capacity to the unified deification, to God and divine virtue.... [We] are led up, as far as possible, through visible images to contemplation of the divine.[62]

Apologists for image veneration in the late sixth and seventh centuries began to focus less on questions of how images affected their beholders and their utility as pedagogic or mnemonic devices, and began to concentrate more on the relationship of the image to its prototype, trying to justify the existence of religious images objectively rather than through appeals to their function. Hearkening back to an argument put forward by Plotinus (and later echoed in Islamic metaphysics), Pseudo-Dionysius argued that, just as there is a cosmic ascent from the lower physical realm and what lies in it to the higher, intellectual realm and on to God, so there is also a descent through which God is reflected in the sequentially lower realms and in the material objects of our physical realm, which are to be called *eikōnes* because of their function in reflecting God. However, none of the known texts dating from before the iconoclast period uses this argument to support image veneration—on the contrary, the earlier texts justify themselves almost purely in biblical terms.[63] In the end, the image of Christ stopped serving its historical didactic role of reminding pious viewers of him, and came to *become* the actual perpetual presence of Jesus among the believers.[64]

At a fundamental level, the iconophiles based the legitimacy of their position on the scriptural evidence that prophets saw an image of divinity as an actual theophanic event rather than something symbolic or mystical, and that the incarnation of Christ extended this opportunity to all human beings. John of Damascus, one of the most important defenders of the veneration of images, quoted Hebrews 11:13: "These all died in faith, not having received what was promised, but having seen it and greeted it from afar," and then posed the question "Shall I not make an image of him who was seen in the nature of flesh for me? Shall I not worship and honour him, through the honour and veneration of his image?"[65]

Thus both the iconoclasts and the iconophiles believed that they were basing their positions on scriptural precedent, and the latter frequently criticized the former for ignoring explicit scriptural dictates. Over time, a much more decisive step was taken in the use of visual images through the assertion that, in addition to rousing emotions and serving the cause of religious education, images serve as a channel

enabling the observer to approach God in order to express love or respect, an argument already encountered in pagan justifications of the use of images.[66]

Christian Iconoclasm and the "Semitic Mentality"

Iconoclastic Christians very clearly accused the iconodules of at least conniving in idolatry, if not being actual idolaters themselves, and drew on the Hebrew Bible (Old Testament) and its prohibition on graven images to justify their position. The Iconoclast Council of 754 equated image veneration with idolatry, and ridiculed the patriarch Germanos as a "wood worshipper."[67] For their part, iconodules accused iconoclasts of being non-Christian, and some modern writers (who hold pro-iconodule sympathies) have tried to explain the rise of iconoclasm in the Byzantine church by explicitly evoking the specter of a "Semitic mentality" that, presumably unlike a Hellenistic or Roman one, has an innate aversion to images. Thus the Armenian and Khazar backgrounds of the iconoclast emperors Leo III and Michael II are mentioned. Furthermore, much is made of the iconoclastic edict of Caliph Yazid II, which is sometimes credited with contributing to, if not actually even causing, the iconoclast movement in Christianity.[68]

Critics of the iconoclasts of the eighth and ninth centuries have suggested that Jewish iconophobic attitudes influenced the moving figures behind Christian iconoclasm. Both the patriarch Germanos and the bishop of Neapolis, Leontius, pointed to Jewish criticism of icon worship as a source of shame for Christians.[69] There is also a famous story—found in several variations—of how Leo III was advised by Jews to destroy Christian images, because this would assure him a long reign. In some versions, it is only by following the advice of a Jew to change his name from Konon to Leo that he becomes emperor, thereby making Jews responsible for all aspects of his opposition to images.[70] Similar accounts are told about later iconoclastic emperors with the express purpose of delegitimizing them as Christians and therefore also delegitimizing any Christian view that criticizes the veneration of images. This purpose is twinned with one that furthers

anti-Jewish polemic: Michael II is described in some sources as having been a heretic from a religious background that combined heterodox Christian beliefs with Jewish ones, and who—like everyone from his background—observed all aspects of Jewish law with the exception of circumcision and had a Jewish teacher to whom he entrusted all his spiritual and worldly affairs.[71]

Among the claims of a Muslim origin to the iconoclastic attitudes in Byzantine Christianity, the most widespread concerns an edict attributed to the Umayyad caliph Yazid II and dated from 721 to 723. Islamic sources for Yazid's edict are few and mostly perfunctory, and include al-Kindi (d. 961), al-Maqrizi (d. 1442), and al-Taghribirdi (d. 1469). It was in Christian circles that the edict gained notoriety as part of a campaign to discredit any anti-image ethos as foreign and of Semitic origin. In his report at the fifth session of the Second Council of Nicaea, John of Jerusalem, representing the Anatolian bishops, made the most influential accusation concerning an Arab and Jewish origin to iconoclasm through the direct impact of Yazid's edict. He accused Yazid, "a man of frivolous and unstable turn of mind," of having been influenced by "a certain man at Tiberias, a ringleader of the lawless Jews, a magician and fortuneteller, an instrument of soul-destroying demons, whose name was Tessarakontapechys, a bitter enemy of the Church of God." This man promised Yazid thirty years of rule if he were to issue an edict throughout his empire commanding that "every representational painting, whether on tablets or in wall-mosaics, on sacred vessels or on altar coverings, and all such objects as are found in Christian churches, be destroyed and thoroughly abolished," and that all representations also be removed from nonreligious spaces such as markets.[72]

The claim that the origins of iconoclasm lie with a weak-minded Muslim king who is under the sway of a conspiring Jew becomes a staple of much writing of Christian iconodules; it is repeated by Theophanes in his *Chronicle* and the patriarch Nikephorus of Constantinople in his three treatises directed against Constantine V in the early part of the ninth century.[73] However, despite these avowals to the contrary, it is almost certain that the rise of Islam had little direct bearing on the course of events during the iconoclast movement, and certainly not

upon the official policies of the Byzantine emperors and their hand-picked church leaders. Nevertheless, some of the best-known Christian apologists for image veneration were in direct conversation with the Muslim environment.[74] In addition to John of Damascus, apologetic tracts on the practice of venerating images of Jesus, Mary, and the saints were written by several scholars, including Theodore Abu Qurra (d. ca. 820), the Edessan monk of Mar Saba who served as the bishop of Harran for a time and traveled widely in the Islamic world engaging in polemical debates.[75]

There is ample evidence to suggest that not only did the early Muslim rulers not follow an anti-image policy such as might be suggested by the edict of Yazid II but, in fact, they viewed Byzantine society as representing a model of imperial high culture worthy of emulation. The use of images on the early Islamic palaces is to be seen in this context, as is the decoration of the Umayyad Mosque in Damascus (discussed further in Chapter 9). At the same time, there is no doubt that the early Muslims developed a new system of visual representation of their own, although one that did not replace Byzantine (and Sassanian) symbols and significations so much as modify them for a new context.[76] In others, the changes seem more directed, such as the decision of the caliph 'Abd al-Malik (r. 685–705) to replace Byzantine and Sassanian symbols on coinage with Islamic ones. It is possible, even likely, that the motivation behind such a decision was almost entirely political, although that does not answer the question of why the new Islamic numismatic symbols were epigraphic rather than figural as they had been for the empires the Muslims were trying to supplant.[77] Even instances of image and object destruction, discussed at length in Chapter 4, are best understood in such a light, as are exhortations to that effect. An example of such an injunction is attributed to the caliph 'Umar ibn 'Abd al-'Aziz: "Let no cross be shown without breaking it and destroying it; let no Jew or Christian use a saddle-horse but instead only a pack animal."[78] It is clear that the destruction of crosses in this context is not attributable to an iconoclastic sentiment so much as a political one, that being to remind Christians and Jews of their inferior position.

Writing in 877, the patriarch Stephen al-Ramli not only demonstrates a clear attempt to place Christianity's relationship to the Hebrew Bible

in terms that correspond to an Islamic view of salvific history (in that the Torah's entire purpose becomes the foretelling and preparation for Jesus's mission), but he also presents the cross as an object of veneration in ways that are justifiable for Muslim sensibilities:

> The cross is a reminder of Christ and what He accomplished for mankind, as well as the marker for the qiblah for Christians. Accordingly, Christians accord the cross a prostration of honor, not of worship. It is a reproach to Satan. Moreover, Muslims pray toward the Ka'bah from all directions, but not on top of it toward heaven. They pray on the top of other mosques.[79]

Stephen al-Ramli's defense of the veneration of objects raises three important points. In the first place, he makes the crucial statement that the signification of an index can vary depending on context as well as intention. In the specific case of *proskynesis,* the ritual act of prostration can mean different things depending on whether the worshipper sees the cross as a heuristic and mnemonic device or simply as a marker for the direction of prayer (a *qibla*), or as a physical representative of Christ *in* which (rather than *through* which) he can be worshipped. In the second place, al-Ramli attempts to draw a clear line between wider categories of veneration, honor, and respect and a narrowly defined category of "worship." Worship—its nature and forms—and the extremely narrow definition of things seen as suitable for veneration were critical questions in the Muslim environment at this time, as they were to remain in later centuries, and by casting the discussion of image veneration in the terms that he did, al-Ramli intentionally framed the question of Christian image veneration in a manner that was relevant to internal debates among Muslims. And lastly, he attempts to put his Muslim audience on the defensive by pointing out that their treatment of the Ka'ba, a material object inasmuch as it is a building, is qualitatively different from their treatment of other similar objects. They must therefore either accept the fact that Christians—like Muslims— are capable of venerating material objects while still distinguishing between the object and the entity or concept it signifies, or else they must concede the doctrinally unacceptable point that Muslims treat

the Ka'ba differently from mosques because they believe that God some-how inheres in its physical materials.

Like that of Stephen al-Ramli, Theodore Abu Qurra's defense of im-age veneration also consciously engages Muslim doctrine and theol-ogy and is of particular interest since this Edessan and one-time bishop of Harran had traveled widely in the Islamic world and had considerable familiarity with Muslim beliefs and attitudes. Perhaps not surprisingly (given the intellectual gulf between Byzantium itself and an iconodule bishop sitting in the relative security of the Sunni caliphate), his writings do not display any knowledge of what trans-pired at the Second Council of Nicaea, which occurred during his lifetime. One of the main arguments he employs in the defense of im-ages is that all scriptural language, be it from the Hebrew Bible, the New Testament, or even the Qur'an, describes God in words that im-pute corporeality to him. This is neither objectionable nor undesirable in his view since, of necessity, human knowledge proceeds from the sensible to the intelligible. And since, in his understanding as in that of many apologists for images before and since, images function as writing for illiterate people, the corporeality of God implied by physi-cal images is in no way more directly connected to God than the cor-poreality implied in scripture.[80]

In a manner reminiscent of Stephen al-Ramli, Theodore Abu Qurra makes a second argument in which he maintains that the Muslim rit-ual of prostration (*sajda* or *sujūd*) is comparable to Christian acts of image veneration such as *proskynesis*: "Everyone who makes prostration to God touches at least either the ground or a carpet with his knees, but his prostration is conducted according to his intention to make a prostration to God. So also with the Christians, their touching of the image in the prostration is in accordance with their intention thereby to honor Christ, their God, or his saints, or the prophets, the apostles, the martyrs and others."[81] The argument made here is somewhat dis-ingenuous since, under normal circumstances, neither Christians nor Muslims attach any sign value to the ground on which they kneel (be-yond it being ritually clean and appropriate), whereas resemblance to the prototype, in some form or the other, is the most important prop-erty of a religious image. In so arguing, Abu Qurra is shifting the focus

from issues of resemblance to those of materiality, questions that have historically been secondary in debates over images, though not entirely absent from them.

Theodore Abu Qurra's belief in the power of images as representations of their prototypes is readily apparent in his account of the miraculous conversion of a Jew and a Muslim following their attempted desecration of a Christian image. The former Muslim, Saint Anthony (who was killed in 799), is alleged to have converted to Christianity after an arrow he shot at an image of St. Theodore ricocheted off the image and came back to injure the shooter himself.[82] Abu Qurra's firm belief in the necessity of image veneration is also clear from his avowal that anyone who rejects prostration before religious images should logically also reject all of the Christian mysteries. For him, it is the very fact of the image's resemblance to that which it represents that makes it deserving of honor, and he takes it as an apparent truth that viewers treat images of those dear to them in ways similar to how they would treat the individual himself or herself.[83]

Protestantism and the Religious Image

The theology of icons may have emerged as a characteristic element of Orthodox Christian thought, but images and their veneration have been no less important in the Western Catholic Church or in the art of Catholic Europe. The distinction drawn by Thomas Aquinas (d. ca. 1274) in his *Summa Theologica* between appropriate veneration of Christ or of the crucifix as *latria* on the one hand, and the inappropriate veneration of the material objects themselves (as *idolatriae*) on the other, becomes a standard theological defense of image use in the medieval Western Christian world and is therefore worth quoting at length:

> As the Philosopher [Aristotle] says, there is a two-fold movement of the mind towards an image: one indeed towards the image itself as a certain thing; another, towards the image in so far as it is the image of something else. And between these movements there is this difference; that the former, by which

one is moved towards an image as a certain thing, is differ-
ent from the movement towards the thing: Thus therefore
we must say that no reverence is shown to Christ's image, as
a thing—for instance, carved or painted wood: because rever-
ence is not due save to a rational creature. It follow therefore
that reverence should be shown to it, in so far only as it is an
image. Consequently the same reverence should be shown to
Christ's image as to Christ Himself. Since, therefore, Christ
is adored with the adoration of "latria," it follows that His
image should be adored with the adoration of "latria."[84]

Like earlier figures such as John of Damascus, Aquinas justifies the
veneration of images on the basis of their ability to direct attention
upward in a system of ascent. And although he explicitly affirms a close
connection between the image and its observer, the embodied, emo-
tional affective response of a believer is still directed at the worship of
the signified thing and is not an end unto itself. The Latin church took
a position opposite, in certain respects, to that of the Orthodox for
which the earthly and the heavenly were brought together in the icon.
Gregory of Tours declared that heavenly and earthly objects could not
possibly be joined. In such a view, religious images must necessarily
remain second-order signifiers, the challenge for the believer and the
church being to avoid making the image itself the object of veneration.
In the words of Camille, "In the earlier Middle Ages the image not only
divided people from one another . . . , it also divided people from God.
The site of the gaze was never, as it was in the Eastern Church, a spiri-
tual meeting place. The image of the enthroned Christ Logos in the
apse fresco or mosaic and on the golden bookcover placed on the altar
symbolized the barrier between God and man."[85]

As I have already alluded to, contestations over the status of reli-
gious images characterize Christian history to much the same degree
as they do other religions including Islam, with the notable exception
of two periods of sustained debate within Christianity in which im-
ages played an important role. In addition to the period of iconomachy,
the sixteenth century saw concerns with icons and iconoclasm as im-
portant aspects of the Protestant Reformation, although in ways that

were markedly different from those that characterized the Byzantine church. In some modern views, the Reformation was to banish images from Christianity in an attempt to completely change the religious landscape:

> If Catholicism had set up images as bridges between God and man, Protestantism burned them all, and there was no going back. Bringing out all the old anti-image authorities from Scripture, the sixteenth-century iconoclasts, like their ninth-century forebears, were directly responding to a crisis of 'overproduction' in the holy. Karlstadt, Zwingli, and Calvin were not only preaching the destruction of works of art— they were attempting to relandscape totally the visual experience of the Christian and empty his or her world of its collective repositories of immanence—to destroy images is to destroy the past.[86]

At first glance, it may seem as if developments within Protestant thought had little relevance for the course of Muslim intellectual and social events until the advent of European colonialism in Islamic lands, and even then that the influence was tangential, confined, for the most part, to Muslim apologetics defending religion and society against political and cultural threats rather than being comprised of specific religious charges that involved the acceptance or rejection of visual images. And indeed, a detailed treatment of Protestant attitudes toward visual religious art is beyond the purview of this book. However, there are direct parallels between Protestant and Muslim attitudes toward images in the distinction between their didactic and liturgical uses, in the active conjuring of images in the imagination, and in the arguments made by some writers to justify image use, if not image veneration.

Not surprisingly, neither iconoclasm nor iconophobia was a defining characteristic of all early Protestant thinking, nor were Protestants uniform in their attitude toward images. Instead, the early Reformers espoused their own, distinctly Protestant, attitude toward both religious and secular arts and displayed a complex view of visual images.[87] For example, Queen Elizabeth I of England (d. 1603), famous for cham-

pioning the Protestant cause, showed a willingness and sophistication in the use of images by appropriating to her own public image signifiers and symbols associated with the Virgin Mary.[88] And in the theological arena, Martin Luther never publicly promulgated a straightforward condemnation of the religious image. His criticism of mystical and allegorical interpretations as non-Christian was based in his belief in the literal clarity of the Bible's meaning and the ability of individuals to read scripture and access this meaning by themselves: "The Holy Spirit is the simplest writer and speaker in heaven and earth. This is why His words can have no more than the one simplest meaning which we call the written one, or the literal meaning of the tongue."[89] But this belief in the primacy of scripture and the importance of literalism did not carry over into his attitude toward visual art.

Martin Luther's ideas on art and the question of the religious image are scattered throughout his writings, further underlining the point that he did not regard the problem of images as a matter of primary importance. Certainly in the early part of his career, he appears to have accepted visual religious art, if sometimes ambivalently.[90] In his *Lectures on the Epistle to the Corinthians* he declares: "to build churches, to adorn them . . . with images and everything that we have in houses of worship . . . all these are shadows of things worthy of children."[91] His 1516–1517 *Lectures on the Decalogue* make clear that his position on religious images was one that opposed a strict iconoclasm, in that his exegesis of the first commandment distinguished between the veneration of objects such as animals, trees, and stones on the one hand and the adoration of God on the other. He also made the theological distinction between the act of idolatry and harboring idols in one's heart, the latter being more dangerous.[92]

Later in his life, Martin Luther appears to have embraced an even more complicated view of images, one in which arguments based on justification (as pedagogical tools, for example) are reconciled in varying ways and at different times with his notion of religious acts and intentions within the wider concept of merit in Lutheran theology. Perhaps his most strident objection to the placement of images in churches and insistence on their removal is based on the view that they were created and donated to the churches for the express purpose of

gaining religious merit, a practice in complete contradiction to the doctrine of the rejection of good works as the means to salvation.[93] More specifically, in 1524 he stated in an address to the iconoclast Andreas Bodenstein von Karlstadt that biblical law only prohibits divine images as objects of worship; it allows religious images of the crucifix, Mary, and the saints as long as they are used as "memorial and witness" rather than as the focus of worship.[94] For Martin Luther, religious images were justified because of an apparent human need for images, both physical and imaginal. With regard to the former category, he declared that he would rather have people paint images of scenes from the Bible on their homes than of "shameless worldly things," so that the images could serve an exemplary pedagogical purpose for the homeowners and passersby. Similarly, he acknowledged that it was impossible to read or hear accounts of Jesus's life without forming a mental image of them, and since it was not a sin to possess a mental image of Jesus, it could not be a sin to see the same images with one's eyes.[95]

Martin Luther did not represent the entire spectrum of attitudes toward the arts among Reformationists, however, and several central figures took a substantially less nuanced attitude toward religious images than he did. Ulrich Zwingli (d. 1531) believed that the Bible forbade both public and private visual religious art. He acknowledged that a strict reading of scripture would permit images depicting stories from the Bible painted on the outside of churches where they would not serve as objects of veneration, but he remained concerned that any form of liturgical art could easily become the object of veneration and therefore of idolatrous worship.[96] For his part, John Calvin (d. 1564) wrote that the second commandment comprises a twofold condemnation of images, first through forbidding the representation of God in a visual form and second through a blanket condemnation of the worship of any image, be it of God or the saints. He maintained that the biblical sanction of images of cherubs was abrogated in Christianity, and that only images that served an explicit didactic purpose could be allowed:

> As sculpture and painting are gifts of God, what I insist for
> is, that both shall be used purely and lawfully. . . . The only
> things, therefore, which ought to be painted or sculptured,

are things which can be presented to the eye; the majesty of God . . . must not be dishonoured by unbecomed representations. Visible representations are of two classes—viz. historical, which give a representation of events, and pictorial, which merely exhibit bodily shapes and figures. The former are of some use for instruction and admonition. The latter . . . are only fitted for amusement.[97]

I have included this brief discussion of Protestant views of images for the purposes of underlining my point that the history of Christianity is exceptional for having had two episodes in which major sections of society were forced to think about the nature of religious images, something that is not shared by other major religions, be they ones such as Islam and Judaism that are considered relatively image-free, or those such as Hinduism and Buddhism that make extensive use of images. In addition, the Protestant attitudes toward images bear some resemblance to Muslim approaches, in that a clear distinction is apparent between images used for liturgical or other formally ritualistic uses and images in general, be they religious or not.

In fact, in North America many Protestants interact with religious images in ways that are often very similar to popular Catholic visual practices. As David Morgan has pointed out in his important study of the famous Sallman painting of Jesus that achieved photograph-like authority as a true likeness of Christ in popular Protestant belief, the majority of North American Protestant traditions have incorporated inexpensive, mass-produced images in some aspect of their religious practice.[98] Morgan concludes that "many American Protestants find a central place for images in their piety when the images invoke the faculty of memory. Pictures, in other words, are safe, even commendable, when they teach by assisting the memory; when they serve to recall scriptural events or dogma; and when they help the individual assemble a personal spiritual narrative."[99]

Modern American Protestants attribute three distinct memory-related functions to visual images: "they satisfy the pedagogical purpose of forming memory; they assist the interpretive recollection of the biblical past; and they inform the constructive representation of

one's life course."[100] It is in this realm of memory and recollection that images function unproblematically for modern Protestants, and even the most iconoclastic of them, for the most part, recognize that images used as memory and pedagogical aids do not run the risk of becoming condemnable objects of religious veneration. In order to re-emphasize this view, many Protestants insist that images serve as reminders and as means of generating mental images that constitute the appropriate form of divine representation.[101] It is through acts of memory and their ability to repeat the somatic, sensory, temporal, and spatial past that such images help to overcome the gulf between the past and the present. Thus visual images (and objects) serve purposes in modern Protestantism similar to the purposes they serve in much of Islam, in the sense that they help concretize multifarious traces of memory and religious imagination, including other images that exist discontinuously in the imagination. In this capacity, some images function as "iconic signs of memory" because they are formed in what can be called the "visual rhetoric of remembrance."[102]

Christian Iconoclasts Reconsidered

Returning to the period of iconomachy, it is important to recall that the victorious iconophiles wrote history so as to make Christian icon-oclasts represent religious deviance, akin in many regards to so-called heretical Christians such as Monophysites, Monothelites, and assorted dualists. They all join Jews and Muslims as well as the pagans of the time (the Hellenes) as models of reprehensible and false religiosity. It should come as no surprise, then, that Constantine V, the emperor who was most instrumental in the elaboration of an iconoclastic the-ology (as distinct from simply promulgating repressive policies), is portrayed in the worst possible way: according to Theophanes, he was "an accursed wretch, God's enemy, impious, arrogant, unholy, jealous, evilly-named, beastlike and savage."[103]

In actuality, the iconoclasts' attitudes toward images and image making were quite complex. Leo III, renowned for his harsh iconoclasm,

had the palms of the painter Lazaros burned (rather than have his hands chopped off, a common punishment), a painful but temporary inconvenience that did not prevent the painter from returning to his craft.[104] The Council of Hieria did not denounce all images of Jesus, but only those that represented his physical appearance through sculpture or painting. In fact, the council formally and specifically endorsed Jesus's image as it appears in the Eucharist (a significant revision, since the opponents of the iconoclasts would have understood the Eucharist not as an image, but as Christ himself). In addition to this iconic representation of Christ, the iconoclasts also formally endorsed the concept of the saints as living images deserving of imitation. "According to this definition of images, one should put reliance, not upon pictorial representation, but upon the scriptures and the biographies of the saints."[105] The iconophiles repeatedly made the argument, first attributed to the patriarch Germanos, that the fact of Christ's incarnation had brought idolatry to an end. This statement, arguing that the image of Christ was not divine and therefore did not participate in the divine essence, was intended to defend the iconophiles against charges of idolatry, and it appears to have been successful in this regard, since the council reinstating iconoclasm in 815 no longer included the accusation of idolatry.[106]

Among those documents of the period that relate directly to the question of image veneration, a *florilegium* dating from 754 CE is comprised of eight excerpts from church fathers of which six are concerned primarily with ethical theories of images. Of the remaining two, the first (attributed to Athanasius) argues that it is ridiculous for sentient beings to be praying to insensate objects, since salvation cannot be attained by petitioning a created thing. The second excerpt (written by Eusebius of Caesarea for the empress Constantia) maintains the impossibility of producing an image of Christ, since it is inconceivable for a mortal or physical image to capture the divine presence that was within Jesus throughout his earthly life. The underlying principle common to these *florilegia* is stated clearly in the first of the eight, by Epiphanius of Cyprus, who exhorted Christians not to place physical images in their homes, churches, and cemeteries, but rather to remember God

in their hearts.[107] In keeping with this belief (and reminiscent of the event in the life of Muhammad and 'A'isha that was discussed in the Prologue), Epiphanius is supposed to have torn down a curtain because it bore a representation of Jesus or a saint; he replaced it with a plain one and demanded that decorations of that sort not be used in churches.[108]

Invoking other figures from the early church, the iconoclasts maintained "there is no point in painting the physical faces of the saints with colors on tablets, since we do not need such things but rather to imitate their way of life, by virtuous deeds of our own." The sentiment appears again as "we have been taught, not to fashion images of the saints by means of material colors, but rather to imitate their virtues, which are really living images, with the aid of what has been recorded about them in books, so that we may be stimulated in this way to a zeal like theirs."[109] The same idea is expressed indirectly in the eighth anathema of the council, which condemns anyone who contemplates the divine word made flesh (that is, the Logos) "through the medium of material colors, and does not worship him with the whole heart, with the eyes of the mind, as he sits *in excelsis,* more dazzling than the sun, at the right hand of God, on the throne of glory."[110]

In broad strokes, the iconophiles of the eighth and ninth centuries justified the veneration of images on the basis of established Christian tradition, and they condemned iconoclasts as innovators. Specifically, they cast themselves as representing the ideal religious life (celibate and ascetic) and the iconoclasts as personifying profane existence (gluttonous, intemperate, and committing "unnatural acts"). They viewed themselves as the steadfast protectors of tradition, passively resisting persecution at the hands of the iconoclasts who were seen as aggressors and destroyers of the past, and whom they accused of mixing church and state authority. Finally, the iconodules viewed images as physical objects mediating between God and human beings; iconoclasts, in contrast, defined images either as the Eucharist or as the imagined saint who is a source of imitation.[111] In their defense of images, the iconodules held positions that were reminiscent of earlier Hellenic pagan justifications. They maintained that images were the "books" of the illiterate and therefore served a pedagogical and didactic function, encouraging

human beings to think about the holy thing the images represented. Even the notion that statues were vessels for God's power found a place in the thinking of the iconodules since, in so doing, the image-vessel would do nothing more than resemble Christian saints whose bodies, while alive, were filled with the Holy Spirit.

Iconophilia and Emotional Response

Iconophilic texts concentrate on four main issues: the definition of images and their justification, their functions, the purpose of tradition, and the relationships among image, text, and speech.[112] During the period immediately after the end of the so-called Iconoclast Era, not only was the theology of image veneration reinforced, but there also was a new emphasis on the impact images had on their beholders. These shifts in Byzantine ideas concerning visuality occurred in tandem with other developments in Byzantine Christian thought. Among the most significant works in this regard is the *Life of Tarasios* written by Ignatios the Deacon between 843 and 847. Ignatios departed from conventional attitudes toward images and attributed emotional effects to them. He was not alone in emphasizing the emotional response of images, however; many conversion narratives and stories of miracles and healing demonstrate how such an emotional response was increasingly being presented as the correct one to be experienced upon encountering a religious image, at least as such encounters were represented in the written literature.[113]

In an important article on visual perception in ninth-century Byzantium, Brubaker argues that the increasingly emotional response to art during this period was based not on what is seen, but on what is imagined, though one must be clear that "imagination" meant something quite different to ninth-century Byzantines than it does to us (a point that one also needs to bear in mind when talking about Muslim responses to images, as discussed in Chapter 3). According to Theodore the Studite, "Imagination *(phantasia)* is one of the five powers of the soul [the others are sense, opinion, reason and intelligence]. However, imagination [is considered] a receptacle of an image, because the

two have in common [the transmission] of resemblances."[114] Imagina-
tion, for the Byzantines, serves as the capacity to transmit resemblance
as distinct from a creative innovation. For Brubaker it becomes "the
ability to transmit a resemblance, to comprehend the prototype be-
hind the image, to see more than is present," something that is ex-
pressed clearly by John of Damascus: "If we sometimes understand
forms by using our minds, but other times from what we see, then it is
through these two ways [imagination and sight] that we are brought to
understanding." The visual image is a sign signifying more than we
actually see.[115]

Among the appropriate responses to Christian images, as far as the
iconophile was concerned, was to cry in front of them; in fact, the Acts
of the Ecumenical Council of 787 stated that the tears resulting from
the contemplation of an image constitute proof of its sanctity, and a
spurious letter from Pope Gregory II to Leo III refers repeatedly to the
tears and sense of guilt and shame aroused by religious images.[116]

The Second Council of Nicaea in 787 CE attempted to put a final
definition on the image as it related to its prototype, relying in this ef-
fort on earlier definitions put forth by a number of writers, including
John of Damascus: "the image [icon] resembles the prototype, not with
regard to the essence, but only with regard to the name and to the po-
sition of the members which can be characterized."[117] The essence re-
ferred to in this declaration is divinity, the omission of which is the
one critical factor that saves iconodules from becoming idolaters. Ear-
lier, John of Damascus had stated: "An image is of like character with
its prototype, but with a certain difference. It is not like its archetype
in every way."[118] And somewhat after the reinstatement of iconoclasm in
815, the bishop Nikephoros offered three more definitions of religious
images: (1) "an image is a likeness of an archetype which reproduces in
itself by way of resemblance the entire form of what is impressed upon
it, and which differs from it merely by the difference of substance with
respect to matter"; (2) "an imitation and similitude of a pattern differ-
ing in essence and substratum"; and (3) "an artifact shaped in imita-
tion of a pattern but differing in substance and subject; for if it does
not differ in some respect, it is not an image nor an object differing
from the model."[119]

Christian written sources concerning icons were heavily revised after the Council of Nicaea in 787, with stories of miracles rewritten to include icons as well as relics. The Council of 787 accused earlier iconoclastic councils of corrupting the intention (if not the words) of the church fathers by using those intentions out of context. Similar accusations of misuse of the place of images, therefore, could also be made, in the sense that an image could be good or bad depending on its purpose and use. Speaking specifically to this question of intentionality, John of Damascus states: "But concerning this business of images, we must search for the truth, and the intention of those who make them. If it is really and truly for the glory of God . . . then accept them with due honour."[120]

3

Iconoclasm, Iconophobia, and Islam

Our God is in the heavens; he does whatever he pleases.
Their idols are silver and gold, the work of men's hands.
They have mouths, but do not speak; eyes, but do not see.
They have ears, but do not hear; noses, but do not smell.
They have hands, but do not feel; feet, but do not walk;
 and they do not make a sound in their throat.
Those who make them are like them; so are all who trust
 in them.

—PSALM 115:3–8

There is, of course, no basis to make any historical argument suggesting that the nascent Muslim community of the seventh and eighth centuries adopted its attitudes toward images and their veneration directly from the Byzantine church. On the other hand, it is obvious that early Muslims situated themselves quite squarely within a Christian and Jewish historical context. Several factors, including that the Qur'an was seen as a definitive scripture abrogating the Hebrew Bible and the New Testament, demonstrate that Christianity and its mate-

rial and intellectual environment were living concerns for early Muslims. Among the many other relevant issues demonstrating this fact are the real or imagined but extensively documented interactions and conflicts of Muhammad with Jews and Christians both within the Arabian Peninsula and beyond its borders; the demographic dominance of Christians in important provinces of the early Muslim empire (Egypt, Palestine, and Syria); and the material tastes of the early Umayyad elites as displayed in the architecture and decoration of their palaces. Also, the Muslims, who were threatening Constantinople itself within a century of Muhammad's death and whose early conquest of Jerusalem had implications for the relationship between Christianity and Islam that go far beyond the purview of this book, were very much on the minds of the church and imperial leadership of the Byzantine Empire. However, mutual awareness, influence, and interaction do not prove, or even necessarily imply, that the different religions directly influenced each other's attitudes toward images.

As already noted, some scholars have argued that the rise of iconoclasm in the Byzantine Christian world was directly related to the influence either of Semites or of Islam.[1] Observing that some of the emperors who supported iconoclastic policies were of Semitic descent, they have made an outdated and thoroughly discredited argument for what amounts to a Semitic genetic aversion to idolatry. Others have made a much more historically rigorous claim for influence based on the rapidly ascending fortunes of Islam and the correspondingly diminished ones of Byzantium that placed the Christians on the defensive in their interactions with Muslims. The main historical argument in favor of seeing Byzantine iconoclasm as a response to the rise of Islam lies in the chronological sequence of three things: the caliph Yazid II's decree for the destruction of Christian images, the condemnation of images by Bishop Constantine of Nacoleia in 724, and the beginning of the active iconoclastic movement under Leo III in 726. Perhaps coincidentally, Jewish polemic against Christian image veneration appears to arise only after the coming of Islam. The apologias in support of image veneration also blame the origins of Christian iconoclasm on the purported conniving of Jews and Muslims, though this cannot be

taken seriously as an accurate view of history. There is a difference between misplaced notions of innate iconophilic or iconophobic mentalities and the historical argument that the rise of Muslim Arabs as a regional power made the Byzantines more sensitive to questions of image veneration. As stated by Brubaker:

> Icons took on new significance at the end of the seventh century because they addressed the spiritual crisis and insecurities brought about by the Islamic conquests. The ramifications were almost immediate. Changes in practice by around the year 680 were countered by the institution of canonical legislation regulating the proper use of Christian imagery at the Quinisext Council of 691/2. Conversely, the following generation of churchmen, active in the 720s . . . represent the backlash against the new role of icons and provide our earliest documented iconoclasts.[2]

As I have demonstrated, Christian hostility to images and their veneration was already well established long before the birth of Islam and the life of Muhammad.[3] And though individuals such as John of Damascus and Theodore Abu Qurra were deeply aware of their Muslim surroundings, the train of their arguments concerning image veneration is wholly comprehensible as one of internal Christian debate. The as-yet-unformed Muslim attitude toward image veneration allowed John of Damascus considerable freedom in his formulation of apologias for image veneration, such that he was arguably much better off for being at a Muslim court than he would have been were he to have lived under Byzantine territorial control.

Of course, there are other occasions in history in which Muslims did engage in iconoclastic acts against Christians, just as they did against Hindus, Buddhists, and others in separate contexts. The first anti-Christian iconoclastic act that we know of occurred in 723 when, as has already been discussed, Yazid II ordered that all icons and images be removed from churches in the lands under Muslim rule. This order was reversed by his successor, Hisham, and a prickly tolerance of the Christian veneration of images turned out to be the norm for most of subsequent Islamic history.

Between Tolerance and Reverence

Applying modern notions of tolerance and coexistence to eighth- and ninth-century Damascus would be utterly misleading; quite obviously, Christians as well as Jews living under Muslim rule at that time (as at other periods) were subject to discriminatory laws, and surely faced overt derogatory and humiliating treatment. There are also sources that accuse Christians of idolatry, although they are fewer in number than one might expect, given the long history of competition between Muslims and Christians. Anti-Christian Muslim polemic frequently points to the doctrine of the Trinity as a form of polytheism and to the use of icons and the crucifix as idolatrous practices, although the rhetoric seems to refrain in most cases from referring to Christians as "infidels" *(kuffār)* or "polytheists" *(mushrikīn):*

> You revere the cross and the icon, you kiss and prostrate be-
> fore them, but they are man made things which cannot hear
> or see, can do neither good nor ill; you think that the greatest
> of them are those made of gold and silver, just as the people of
> Abraham did with their images and idols *(bi-suwarihim
> wa-awthānihim)* . . . [The Prophet] commanded us to worship
> God alone, not to associate anything with Him *(allā nushrika
> bihi shay'an)*, not to make any god with Him, not to worship
> the sun, the moon, idols, a cross or an icon, and not to adopt
> one another as lords apart from God.[4]

For their part, Jews are less often accused of associating compan-ions to God *(shirk)*, although they are criticized for being overly cor-poreal in their conception of God and for thinking of him anthropo-morphically (in other words, of being guilty of *tajsīm*).[5] Despite such criticisms, the Jewish and Christian rights to worship continued more or less unimpeded through the Umayyad period, and this included the practice of venerating images as an integral part of Christian ritual. Muslim rulers and scholars were well aware of the Christian use of images; more importantly, some of them appear to have had a relatively sophisticated understanding of the nature of icons as understood by Christian iconophiles. In his important biographical dictionary of

physicians, *al-Tabaqāt al-atibba,* Ibn Abi Usaybi'a (d. 1270) provides a detailed account of how a rival physician and fellow Christian of the famous doctor and translator Hunayn ibn Ishaq (d. 873) used a ruse in an attempt to make his rival fall out of favor with the caliph al-Mutawakkil (d. 861). The rival, Bukhtishu' ibn Jibra'il, acquired a beautiful and ornate icon of the Virgin Mary with Jesus in her lap and surrounded by angels, and carried it into the presence of the caliph, who admired it greatly. Bukhtishu' then held the icon in his arms and kissed it repeatedly. Al-Mutawakkil asked him the purpose of this behavior, to which Bukhtishu' replied: "My lord! If I do not kiss the image *(sūra)* of the Mistress of the Worlds *(sayyidat al-ʿālamīn),* then who should I kiss?"[6] The caliph then inquired if all Christians acted in this way, to which he replied: "Yes, Commander of the Faithful! In fact, even more than me, since I am restrained because I am in front of you."

Bukhtishu' then informed al-Mutawakkil that there was a heretic *(zindīq)* claiming to be a Christian in the caliph's service who was contemptuous of icons and spat on them, and when asked his identity, said it was Hunayn ibn Ishaq. The caliph demanded that Hunayn be brought in front of him to be questioned, but Bukhtishu' pleaded for the caliph to let him leave and to then wait an hour before summoning Hunayn. The caliph granted his wish, whereupon he rushed to Hunayn and deceived him, saying that the caliph had questioned Bukhtishu' about the image of Mary and Jesus and, fearing that the caliph would either take it away or use it to humiliate Christians, Bukhtishu' had replied that the image meant nothing to him, and that there were many like it in the baths and markets of Syria. He went on to claim that al-Mutawakkil had challenged the physician to prove his claim of the image's unimportance by spitting on it, which he had done in an act of dissimulation. Bukhtishu' told Hunayn that this had pleased the caliph greatly, and that Hunayn should do the same because it would ensure that al-Mutawakkil would look on Christians with favor.

When Hunayn appeared in court, the icon was sitting in front of al-Mutawakkil, who said: "Hunayn! Look at how beautiful and amazing this picture is!" Hunayn replied: "It is as the Commander of the Faithful says." The caliph asked him what he really thought of it, and the physician replied: "There are many paintings like it in baths, churches

and other places." The caliph said: "But isn't this the picture of your lord and his mother?" Hunayn replies: "God forbid, O Commander of the Faithful! Only God has form and creates form!"

The caliph replied that if the image could neither benefit nor cause harm, then Hunayn should prove it by spitting on the painting, which he did, soon after which another Christian physician referred to by his title "al-Jathliq (Catholicus)," who was probably conniving with Bukhti-shu‘, came in and saw the icon. He cried out and snatched it up, kissed it profusely, and began weeping. The caliph told him to sit down, which he did, still keeping the icon in his lap. The caliph asked al-Jathliq why he had taken an object that had been in front of the ruler and placed it in his own lap without the caliph's permission, to which al-Jathliq re-plied by saying that the caliph had rights over all things except the re-ligiosity of his subjects, and that he could not command al-Jathliq to leave an image of Mary on the ground. He went on to say that it was her due to be treated with respect and to have the finest incense burnt in front of her. He then offered to pay whatever al-Mutawakkil wanted for it, just to prove how much he valued the icon.

Al-Mutawakkil was impressed with his devotion and asked what should be done to someone who had spat on the icon. Al-Jathliq re-plied that, if the offender were a Muslim, then nothing, because the Muslim would not know the image's value, but that its value should be explained to him so that he would not behave so inappropriately again. And if he were a Christian, but ignorant or lacking in sense, then he should be rebuked in public, made to fear on account of having com-mitted a grave sin, and censured until he repented. "But if he is [a Christian and] of sound mind and has spat on it, then he has spat on Mary, the mother of our Lord, and on our Lord, the Messiah."

Al-Mutawakkil was pleased and amazed with al-Jathliq's devotion to his god and gave him the icon as well as some money before allow-ing him to leave. Then he summoned Hunayn and had him whipped one hundred times, then bound and imprisoned, following that with the seizure of his property including his books, and the destruction of his dwellings. Hunayn remained in prison for six months, during which time he was whipped and tortured.[7] The gist of the story is that, through a complicated deception, Hunayn was tricked into showing

disrespect to an icon of the Virgin Mary in the presence of the caliph al-Mutawakkil, who punished him on the grounds that to disrespect the icon of Mary was *equal* to (not *similar* to) disrespecting Mary.

There are several other accounts in which Hunayn ibn Ishaq displays a lack of respect for visual images, to the point that, in all likelihood, he served either as a trope for the defective Christian believer whose behavior helps illustrate the Christian attitude toward images for a Muslim audience, or, in a more complicated way, as a stand-in for a Muslim (or "Muslim-like") interlocutor in a scene where only Christians can be present. In one such report, Hunayn takes out a book containing an image depicting Jesus on the cross with a group of people standing around him. Zakariyya al-Tayfuri (or perhaps Isra'il ibn Zakariyya al-Tayfuri), another famous Christian physician, asks if these are the people who crucified Jesus, to which Hunayn replies in the affirmative. Al-Tayfuri says "Spit on them," but Hunayn refuses. When al-Tayfuri asks him why not, Hunayn replies: "They are not the ones who crucified the messiah, because this is a picture." Al-Tayfuri calls Bukhtishu' and the other physicians and they all curse Hunayn and bring the matter to al-Mutawakkil's attention; he strips Hunayn of his position at court, after which Hunayn retreats to his home and dies shortly thereafter.[8] In another account, al-Tayfuri brings together a group of Baghdad's Christians in his house where there is an image of Jesus together with the apostles, and al-Tayfuri has a lamp burning in front of it. Hunayn asks al-Tayfuri: "Why are you wasting oil? This is not the messiah and they are not the apostles—they are only images!" Al-Tayfuri says: "If they do not deserve respect, then spit on them!" Al-Tayfuri then drags Hunayn to al-Mutawakkil, who punishes him in a manner already recounted.[9]

In many respects, such accounts are reminiscent of earlier Christian reports of icon desecration and its significance for understanding the place of religious images. For example, St. Stephen the Younger is said to have thrown coins bearing the image of the emperor Constantine V on the ground while at court. It took some effort on the part of Constantine to prevent his courtiers from attacking Stephen, which the emperor only did because he understood that Stephen was trying to trick him

into exposing the inconsistencies in the iconoclastic position that argued against any relationship between an image and its referent.[10]

The accounts involving Hunayn, Bukhtishuʿ, and the caliph have significance at several different registers. It is clear that the author of the narrative is aware that sanctioned icon veneration among Christians does not consist of veneration of the image in and of itself, nor are images venerated as perfect stand-ins or metaphors for the true object of worship; rather, when an image is worshipped, the act of veneration passes to the image's prototype. If there is any truth to the details of this anecdote, it implies that the caliph and, presumably, other patricians of the early Muslim community who surrounded him at court, would have understood Christian image veneration in iconological terms. But implicit within the tone and structure of this story is the message of Christian inferiority, both religiously and politically. The conditional manner in which al-Mutawakkil coerces Hunayn ibn Ishaq to spit on the icon—in fact, the long-running emphasis on spitting on it that runs through the entire story and through similar anecdotes—emphasizes the caliph's awareness that the object is *not* deserving of respect. This fact is also suggested by his demand that the icon be given to him, since his handling of it—however respectful he may be—without actually believing in the icon, would constitute his treating it as a curio or other artifact, which would definitionally be dismissive of the status it enjoyed among the Christian iconophiles in the narrative. Perhaps more importantly, the behavior of the Christians emphasizes the weak-mindedness of image veneration as it would be regarded by Muslims. Hunayn ibn Ishaq, the protagonist and narrator of the anecdotes, is tricked by Christian rivals into showing disrespect to the icon. Neither he, nor any of the other Christians, appears to be particularly concerned about the religious fallout from his behavior, which smacks both of impiety and of a lack of true belief in the power of icons. After all, in these stories, Christians at the caliphal court are manipulating icons and their veneration for the purpose of power plays amongst themselves, thus displaying themselves as deceitful, impious in their own faith, and hypocritical in their belief in material objects that neither defend themselves nor cause ill to befall others.

Icons of Prophets

Perhaps the most intriguing set of historical accounts showing a familiarity on the part of Muslims with the nature, if not the theory, of icons concerns the description of portraits of the prophet Muhammad that were held in the possession of non-Muslims. Variations of this story are found as early as the ninth century CE, and they continue into the early modern period, as has been discussed at some length by Grabar and Natif. The earliest known version was completed around 895 CE by al-Dinawari and is found in his *Al-akhbār al-tiwāl*.[11] In this version, a companion of the Prophet named 'Ubada ibn al-Samit was sent by Abu Bakr to the Byzantine emperor to give him the choice of converting to Islam or facing attack. When he got to Constantinople, the Muslim envoy and his companion were given an audience with the emperor, who quizzed them on the details of Islam. In their second audience, the emperor had an attendant bring an object (*'atīda*) with multiple compartments, each with its own little lid. He opened one of the compartments and took out a black piece of cloth containing a white image, "the likeness (*ha'ya*) of a man as beautiful as could be, like the full moon." The emperor asked if they recognized the face, to which they replied in the negative, and then they were informed that it was Adam. The emperor returned the image to its compartment and took out another one, wrapped in a white cloth this time and containing a white image of a handsome older man with a stern face, whom they also did not recognize. The emperor informed them that this was Noah, returned the image to its compartment, and extracted a third image, white and wrapped in a black cloth. The Meccan immediately recognized it as the image (*sūra*) of Muhammad. "When we saw it, we cried. [The emperor] said, 'What is the matter with you?' We said, 'This is the image (*sūra*) of our prophet Muhammad, may peace be upon him.' Then he said, 'By your religion! Is this truly the image of your prophet?' We replied, 'Yes, this is the image of our prophet, as though we are seeing him alive [before us]!'" The Byzantine emperor then folded up the piece of cloth and put it back in its compartment, saying that this was the last of the images but he had wanted to show it to them early to understand more about them. He then proceeded to

show them the contents of the other compartments, which contained images of prophets (specifically, Abraham, Moses, David, Solomon, and Jesus), and explained that the pictures (or perhaps only the image of Jesus) had come into the possession of Alexander and eventually were passed down to him.[12]

In al-Dinawari's narrative, Muhammad's image is treated differently from those of the other prophets, who are described with physical characteristics, such as Adam's moon-like face or Noah's handsome but stern and frowning one. Variants of this tale are also found in the collections of prophetic stories by al-Tha'labi (d. 1035) and al-Kisa'i (d. ca. 1100). Al-Tha'labi writes about a wooden ark, covered in gold and measuring three by two cubits, that God sends down to Adam. It contained pictures (suwar) of the prophets descending from Adam, all housed in their own compartments (buyūt). The last of them was made of red sapphire and contained a picture of Muhammad standing in prayer and with men—identified as his companions Abu Bakr, 'Umar, 'Uthman, and 'Ali—standing around him.[13] In al-Kisa'i's work, Adam receives a white fabric from God bearing images (suwar) of the pharaohs and the prophets, including Muhammad.[14]

The most interesting redactions of this story are in the Dalā'il al-nubuwwa of Abu Nu'aym al-Isfahani (d. 1012) and the book of the same title by Abu Bakr Ahmad ibn al-Husayn al-Bayhaqi (d. 1403).[15] In the fullest version of this account, which repeats many of the elements of al-Dinawari's telling, a member of a prominent Meccan family named Hisham ibn al-'As al-Umawi travels with a companion to Constantinople to meet Heraclius to deliver a letter from the Prophet and to attempt to convert him to Islam. In his second audience with Heraclius, the emperor calls for a wondrous gilded artifact in the shape of a cube and containing compartments (buyūt) with lids (abwāb). Heraclius opens one compartment, removes a black silk packet, and unwraps it to reveal a red image of a man with big eyes, large buttocks, and an unusually long neck; though beardless, he wears his hair in two braids.[16]

When Heraclius asks the Meccans if they recognize the man in the image, they say that they do not, and Heraclius explains: "This is Adam, peace be upon him, and he is the most hirsute of all men." The next compartment he opens contains, wrapped in the same black silk, the

white image of a man with long curly hair "like that of a Copt," red eyes, a large head, and a beautiful beard, who is said to be Noah. The next compartment similarly holds the image of a man with an extremely white complexion, white beard, beautiful eyes, a smooth forehead, and long cheeks, who appears as if he were smiling, and he is declared to be Abraham. Neither al-Bayhaqi nor al-Isfahani provide a physical description of the white image in the next compartment, but when Heraclius asks the two Meccans if they recognize the person in the image, both immediately begin to weep and cry out: "Yes, this is Muhammad, the Prophet of God!" Heraclius stands up in amazement and asks them if it is indeed Muhammad, to which the Meccans reply: "This is who it is, as though we were looking at him!" Heraclius then contemplates the image for an hour, and finally says: "This is the last of the compartments, but I hastened to it because of you, to see what concerns you."[17]

When the Meccans ask Heraclius about the provenance of the portraits, he replies that Adam had wished to see the prophets who would come from among his descendants, so God had revealed them to him on pieces of heavenly silk (according to al-Isfahani), and Adam had kept them in his treasury (khizāna). Subsequently they were taken by Alexander and given to the prophet Daniel, eventually coming into the possession of Heraclius. When the travelers return to Mecca, they relate their adventure to Abu Bakr, who weeps and tells them that, indeed, Muhammad had told him that the Christians and the Jews possessed physical descriptions (na't) of him.[18]

Both al-Bayhaqi and al-Isfahani relate two additional stories referring to images of Muhammad. One concerns a Meccan merchant and contemporary of Muhammad who went to Syria on business. Some Christians, who had heard of a new prophet in Arabia, took him to a monastery that housed a number of paintings (suwar) and sculptures (tamāthīl). When they asked him if he saw his prophet among the figures represented in the images, he said no, so they took him to another, bigger monastery with a greater number of paintings and sculptures; here the Meccan was faced with a depiction (sifa) of Muhammad as well as with his image, with a depiction and image of Abu Bakr standing next to him.[19]

Al-Maqrizi's history includes a version of the story of an image of Muhammad made for and in the possession of a non-Muslim king. In this case it is the Christian ruler of Egypt, entitled al-Muqawqis, to whom Muhammad sends an envoy inviting him to embrace Islam. Upon reading the letter, the ruler meets with Muhammad's ambassador in private and pulls a piece of fabric (samat) out of a basket, the cloth bearing images of the prophets. A second piece of fabric bears a portrait of Muhammad that the Meccan does not see. He is queried on the Prophet's appearance and the muqawqis compares the verbal description with the image on the cloth, which he confirms to be an accurate representation of Muhammad, although he never shows the image to the envoy.[20]

The story also appears in different redactions in the Persianate world. In one eleventh-century source, Shiroye, the last Sassanian king, sends a painter to Muhammad to make a portrait of the Prophet, which he brings back to the ruler, who places it on his pillow. And in the fifteenth century, the Timurid historian Mirkhwand writes of a miraculous box (tābūt sakīna) in the possession of Heraclius and containing images of the prophets. Mirkhwand's account is then picked up by the sixteenth-century writer Dost Muhammad to justify the painting of images; he referred to the container as a "box of witnessing" (sandūq al-shahāda).[21]

Another early version, found in the Murūj al-dhahab of al-Mas'udi (d. 957), locates the story in China. Al-Mas'udi acknowledges that his information is derived from a text from 916 by Abu Zayd al-Hasan al-Sirafi, who had embellished an account of a voyage to China undertaken in 851 by a merchant named Sulayman. In this instance, the Chinese king asks the Meccan traveler: "Would you recognize your master (sāhib), that is to say your Prophet, if you saw him?" The Meccan replies: "How could I since he is with God?" to which the king says: "I do not mean his [person], I am talking of his portrait (sūra)." The Meccan responds in the affirmative and weeps, and the king orders his attendants to bring a box from which he removes a scroll of paper (darj). The king has the images on the scroll shown to the visitor, who immediately recognizes them as portraits of the prophets and begins

whispering blessings on them. The Chinese king asks him on what basis he can identify departed prophets, and the man replies: "By what was depicted of their things: Noah shown entering the Ark, Moses with his rod and the children of Israel, Jesus on a donkey and accompanied by apostles." Each individual portrait had a textual description of that particular prophet's genealogy, age, land, and the details of his prophethood inscribed above it. "The prophet Muhammad was on camelback, surrounded by his companions wearing [bedouin] shoes made of camel skin and toothpicks made of the bark of palm trees hanging from their belts."[22] The Meccan traveler reports that some of the prophets either had their thumbs and forefingers touching in the shape of a circle (signifying the unity of creation) or else were holding up their forefingers (reminding viewers to fear God).

As noted by Grabar and Natif, these narratives fulfill the important function within Islamic religious culture of proving the truth of Muhammad's prophetic mission by demonstrating how non-Muslims have known about his coming long before either the Muslims or their pre-Islamic Arab forebearers have, thereby squarely situating Muhammad's mission in the larger world of Christianity as a global religion.[23] But situating the story outside an Islamic orbit is also significant for its message concerning the nature and use of images: that the image is in the possession of a Christian king or monastery and is housed in a way already used for the storing of icons makes clear that some Muslims at an early period in the development of the religion were familiar with Christian icons and the nature of Christian icon veneration. Although it appears unlikely that any such attitude toward visual images passed directly into Muslim religious practice, the immense popularity of the works in which these accounts appear—especially the collections of prophetic tales—ensures that a broad cross-section of Muslims have not only been exposed to the concept of the visual representation of Muhammad, but they have also tacitly accepted the role of visual signification in their prophetology. The signifiers mentioned in all these accounts, and especially the one located in China, are similar to those encountered in Byzantine iconography, although in the Chinese case they also bear some resemblance to divine visual signifiers, or *mudras*, found in South and Central Asian Buddhist and Hindu

art. Given the pairing of China with India in much of medieval Islamic literature on geography and marvels of the world, as well as the Muslim fascination with Indian idolatry, it is not impossible that the referent here is Buddhist or Hindu, rather than Christian, iconography.

The situating of the images entirely within a non-Muslim environment, with the Muslim actors limited to the role of visitors, has the additional function of keeping image veneration outside of the realm of Muslim society and ritual while simultaneously utilizing it to Muslim religious ends. Significantly, neither do the Muslim travelers ever ask for the image of the Prophet, nor is it offered to them, and there is no mention of the practice being copied in the Muslim world after the return of the travelers. In all cases, the image vanishes from history after it is seen by the Meccans, and in one version it actually erases itself. The end of the image's life as a rhetorical device makes sense, since it is not needed after it has demonstrated that Muhammad's mission was foreordained. At the same time, however, it is important that the image ceases to exist in order to eliminate the possibility of prophetic images becoming objects of veneration. This point is made explicitly in a related Chinese story dating at the earliest from the seventeenth century, which describes a Chinese emperor sending an ambassador to invite Muhammad to visit China. The Prophet responds by sending a painting of himself, which is designed to miraculously self-erase after a certain amount of time as a precaution against it becoming an object of worship.[24]

Even though the images are located and remain outside of the Muslim domain, never to become part of Muslim religious life, it remains significant that the Muslims who see the images react by weeping, thereby displaying an emotional response appropriate to viewing a representation of a deeply venerated religious figure. Weeping would be the correct response for many Christians as well.[25] In this aspect especially, the story in its various forms emphasizes that Muslims are not constitutionally aniconic or immune to the power of images; faced with an image with a powerful referent, their reaction is the same as that of non-Muslims, a point also made by al-Biruni when speaking of Indian idolatry.[26]

The emotional reaction of the Muslim characters in these accounts and the formal resemblance to Byzantine icons notwithstanding, there

is no sign that the Muslim writers or audience of these stories understood the nature of resemblance inherent in the Byzantine icon. There is, however, another medieval context that makes clear a familiarity with Christian icons, this one coming from thirteenth-century Anatolia, a context in which Muslims lived and interacted closely with Christians.

Two anecdotes found in the biography of the famous poet Mawlana Jalal al-din Rumi (d. 1273) give us some indication of how Muslims might have understood visual art, portraiture, and the nature of the religious image in Anatolia at the time. In the second story, Gurji Khatun, wife of the ruler of Anatolia, is leaving Konya for her ancestral home of Kayseri because she has fallen out of the Sultan's favor. Being a disciple of Rumi, she cannot stand the thought of being away from him, so she commissions a Christian painter named 'Ayn al-dawla, who is also a disciple of Rumi, to make a painting of her master on paper so she can have him with her at all times. 'Ayn al-dawla was famous for his incomparable talent at making portraits, and he completes a portrait of his master, but when he compares it to Rumi, the latter's appearance seems to have changed and the picture does not resemble Rumi at all. 'Ayn al-dawla makes another portrait with the same result. Finally, after making twenty sketches, he gives up on trying to make an accurate likeness of Rumi, breaks his pens, and falls prostrate on the floor, having learned that an image can never accurately represent its prototype.[27]

The second account concerns a Byzantine icon, and also has 'Ayn al-dawla as the principal character. In this story, another Christian painter and disciple of Rumi named Kaluyan (or Kalwiyan) tells 'Ayn al-dawla about an image of Mary and Jesus drawn on a tablet or plaque *(lawh)* in a monastery in Constantinople, saying that it is without compare in its resemblance to Jesus and Mary and that painters come from around the world to copy it but fail in their attempts. 'Ayn al-dawla is driven by desire for that image and goes to the monastery to become an attendant there, serving the monks for a year. One day he spies his opportunity and steals the image, taking it back to Konya with him. He is then summoned to Rumi, who wants to know where he has been for all this time. He relates the whole story to Rumi and shows him the image, whereupon the master admires it but declares that the two personages

in the image are complaining bitterly against ʿAyn al-dawla, saying that he is not true in his love for them. When ʿAyn al-dawla asks how this could be so, Rumi replies that they are saying that they never get to eat or sleep, staying up all night and fasting all day, while ʿAyn al-dawla leaves them both in order to eat and sleep. The artist protests that the images can neither eat nor sleep, nor can they speak since they are life-less paintings *(naqsh-i bī jān)*, at which Rumi scolds him, saying that it is he who is a lifeless image since, because of his obsession with an inani-mate object, ʿAyn al-dawla fails to see the design of God's world and of all the creatures God has animated within it.[28]

These anecdotes provide conflicting messages, the second clearly re-flecting the idea that an icon is inseparable from its prototype in some essential way, while the former illustrates that an image cannot capture the essence of that which it represents. However, taken together, they display a familiarity with the nature and function of icons in Orthodox Christianity, a religion that was very much part of the environment of Rumi's central Anatolia.[29]

4

Idols, Icons, and Images in Islam

If a believer finds a golden idol
Does he leave it for others to worship?
Or does he seize it and hurl it in the fire,
Destroying its stolen shape
So the idol's face is erased from the gold.
The form is but a hindrance and a false guide —
Its golden essence is the true essence of its value,
The idol form stamped on the gold is borrowed.
—MAWLANA JALAL AL-DIN RUMI

The belief that Islam represents a revolutionary break from the earlier history of Arab society is central to the religion. Pre-Islamic Arabia is referred to in historical, religious, and literary sources as an age of "ignorance" *(jāhiliyya)* that was eradicated by the arrival of Islam, the religion of surrender to the will of the one, true God. In the opinion of some Muslim scholars, and certainly in the view of wider Muslim society, *jāhiliyya* characterizes not just pre-Islamic Arabia but also any contemporary society that does not correspond to an Islamic notion of acceptable religious practice, in particular, to a

scripturally based form of monotheism in which active piety through adherence to ritual and dogma is seen as a reflection of inner morals and ethics as well as belief in the only true religion. To exist in a state of *jāhiliyya* implies being sunk in a variety of forms of moral turpitude, in which sexual misconduct, infanticide, drunkenness, violence, cruelty, and oppression form the social and moral evidence of a systemic impropriety of which idolatry constitutes an essential element of religious ignorance.[1] There is nothing uniquely Muslim about the association of idolatry with immorality; as has already been demonstrated, this association is a trope that figures prominently in other contexts, including that of late antiquity as well as Christian polemics against Jews, Muslims, and even other Christians. Nevertheless, the worship of idols forms a central identifying characteristic of the state of *jāhiliyya,* and the descriptions of pre-Islamic religious images in Islamic writings have a relevance similar to that possessed by the images and idols of non-Muslims such as Hindus and Christians in later times.

Early Islam and Idolatry

Although idols and idolatry figure prominently in many Muslims' self-understanding of their religious origins, past and present, there is no word that can be translated readily as "idol worshipper" or "idolater" that occurs frequently in the Qur'an or in early Muslim literature. The reprehensible religious practices of the Arabs of the pre-Islamic *jāhiliyya*—as well as those of non-monotheists, real and imagined, in other lands—are referred to most frequently as *shirk* and *kufr,* with the practitioners themselves being called *mushrikūn* and *kuffār.* The latter term refers to disbelief, such that *kuffār* (sing. *kāfir*) is translated satisfactorily as "disbelievers" or "infidels." *Shirk* is sometimes translated as "idolatry," although it actually refers to associating something or someone with the true god. Consequently, *mushrikūn* is better translated as "associationists," "associators," or even "polytheists," rather than "idolaters," since any interrelation with idols and idolatry is simply not part of the word's etymology.[2] The Qur'anic terms that are more accurately

translated as "idol"—*sanam* (pl. *asnām*) and *wathan* (pl. *awthān*)—are normally not used to refer to the idols of the Meccan environment of Muhammad's time, but to those of a bygone era, such as the time of Abraham and the story of Moses delivering the Israelites from Egypt. The Qur'an refers to idols as loathsome and filthy (*al-rijs min al-awthān*, Qur'an 22:30), and encourages believers to avoid them. The Qur'anic terms are frequently used interchangeably, although they are also said to be distinct, with a *sanam* being an idol in human form made out of wood, gold, or silver, and a *wathan* being an idol made of stone.[3] The word *tāghūt* refers to idols as well, although it is used also to refer to idol temples and sanctuaries associated with idolatry.[4] One thing that seems apparent from seeing how Qur'anic exegetical and other works use these terms is that Muslims did not feel the need to establish clear distinctions between their significations; this indicates that idols and idolatry were not seen as distinct in category from other types of worship foreign (and unacceptable) to Islam, such as various forms of animism and fetishism, litholatry, the petitioning of supernatural entities not considered deities, and so on, and that they all fell into a broad category of *shirk*. Nevertheless, *shirk* has come to mean polytheism not just in common Muslim understandings but also in Islamic law, and idolatry is seen as one of the essential components of polytheistic belief. The identification of *shirk* with idolatry is partly a result of a Qur'anic association of the two (although not an unequivocal one), but it is mostly due to their explicit twinning in religious literature, where the Meccans who opposed Muhammad are viewed uncomplicatedly as idolaters and the derogatory term of *mushrikūn* is applied to them categorically. As will be discussed later in this chapter, Islamic sources do not distinguish among a god, a supernatural being appealed to as an intercessor, an idol hewn by human hands, or an unworked found object (such as a stone) that serves as the focus of religious ritual. Thus the name Allat is sometimes used to refer to one of the best known of the pre-Islamic deities, but the name is also used for an idol representing the god, for stones representing the god, and for the god's sanctuary.[5]

The most famous written work describing religious images in pre-Islamic Arabia is *The Book of Idols (Kitāb al-asnām)* attributed to Ibn al-

Kalbi (d. ca. 822), although this text is probably a composite work comprising material from several sources. The book was highly regarded by the influential geographers and historians al-Mas'udi (d. 957) and Yaqut (d. 1229). *The Book of Idols* did not see a wide circulation in the Islamic world; in fact, it was virtually unknown until the early twentieth century when it was published in Egypt on the basis of a unique manuscript. Fortunately, however, its content had not languished in obscurity, because almost all of it was reproduced by Yaqut in his popular and influential geographical work, the *Mu'jam al-buldān*.[6]

Most of the descriptions provided by Ibn al-Kalbi are quite short and do not appear to follow a clear organizational pattern, except that the interpolation of descriptions of idols and their sanctuaries with accounts of how human beings (and Arabs in particular) went from being monotheists to believers in idols—as well as musings on turning away from the worship of the true God—suggests an underlying moralistic tone to the book not dissimilar from that found in works that treat wonders of the world as sources of warning (*'ibra*). The *Kitāb al-asnām* is not consistent in its descriptions and contains some contradictory information: it gives different locations for the same idols, conflicting definitions of the terms *sanam* and *wathan*, and provides two divergent explanations for the origins of idolatry.[7] Nevertheless, Ibn al-Kalbi's *Book of Idols* is invaluable for the information it provides concerning how pre-Islamic Arab idolatry was viewed within the early Muslim community, and how such imagined idolatrous practice was connected to an equally imagined wider form of idolatrous religiosity that contrasted sharply with the ideals of Muslim religious life. He describes the pre-Islamic Meccans as particularly prone to idolatry, with each household having an idol *(sanam)* that they worshipped; when a household member intended to make a journey, the last thing he would do at home was to prostrate himself before the idol, which was also the first thing he did on his return.[8]

Ibn al-Kalbi lays the birth of idolatry in the cradle of monotheism— the family of Abraham (Ibrahim). According to Ibn al-Kalbi, Isma'il, the son of Ibrahim, settled in Mecca, where he had many children who themselves multiplied fruitfully to the point that Mecca became

overcrowded, necessitating the migration of many of the descendents of Isma'il to other lands. Before leaving Mecca, each of them took a stone from the Ka'ba, the building constructed by Ibrahim as a divine sanctuary. When they settled in their new home, Isma'il's descendents set up this stone and circumambulated it in imitation of the ritual associated with the Ka'ba. Over time, the focus shifted from reenactment of the original, religiously sanctioned ritual, to worship of the stone itself, and the practice subsequently degenerated into the worship of a variety of other things.[9] Versions of this narrative claim that idolatry was introduced to Arabia by one 'Amr ibn Luhayy, who had visited Syria and seen people worshipping idols there. He inquired about the practice, and the Syrians told him that these gods sustained them and bestowed upon them whatever they appealed for, so he asked them to give him an idol. They gave him one of Hubal, which he brought to Mecca and set up together with the idols Isaf and Na'ila. In this way, he distorted the religion of Abraham and compelled the Arabs to engage in idolatry, much to the distress of the Hanifs (the anachronistic, proto-monotheistic group identified with Abrahamic monotheism). According to al-Mas'udi, 'Amr ibn Luhayy lived 345 years, which seems long enough to establish idolatry in a place it had not been before. The situation continued until "God revealed Islam and sent Muhammad, on him be peace, and purified the land and delivered the worshippers."[10]

Ibn al-Kalbi is clear in his condemnation of the practice of idolatry, which he associates with other sins in a familiar pattern according to which *shirk* represents a constellation of moral failings. Thus the first idols associated with the Ka'ba, Isaf and Na'ila, were originally a man and woman from the Jurhum tribe who had come from Yemen to perform a pilgrimage at the Ka'ba. Finding the sanctuary empty, they committed adultery in it and were immediately turned to stone. When the Meccans came and found them, they set up the petrified Isaf and Na'ila in the sanctuary of the Ka'ba, where they became objects of worship among pilgrims and the Quraysh.[11] According to one account reproduced by al-Azraqi, they were placed in the interior of the Ka'ba, and were worshipped by the Arabs, who prostrated themselves in front of them and performed animal sacrifices to them.[12]

Ibn al-Kalbi also refers to the worship (through the ritual of cir-cumambulation) of stone relics, called *ansāb,* although it is unclear whether he is referring to found objects or worked stones.[13] He provides other examples connecting the worship of idols with vile behavior. The Syrians and the tribes of Quda'a, Lakhm, and Judham shared an idol called al-Uqaysir to which they made pilgrimages. As part of the associated ritual, the men would shave their heads, mixing the hair with wheat to the ratio of one handful of wheat for every hair. People would make a dough, bake it, and eat the bread made of "wheat, hair, and lice."[14]

The condemnation of idolatry found in Ibn al-Kalbi's work is less of the worship of *false* gods than of *wrong* gods. He does not bother to criticize the idols themselves, which he does not differentiate from the gods they personify; for Ibn al-Kalbi, idols are not representations of the gods he describes but rather are those very gods.

> The so-called gods are nothing but stones: a man once brought his camels to a god named Sa'd who was in the form of a long rock. He planned to make his camels stand on the rock in order to obtain blessing, but they ended up shying away and scattering at the sight of the blood from sacrifices that covered the rock. The man threw a stone at the rock and cursed it for causing his camels to shy. He then gathered them up and returned home saying, "Is he not but a rock in a barren land, deaf to both evil and to good?"[15]

In a somewhat similar example demonstrating the arbitrary nature of idol worship, and therefore its significance as evidence of weak-mindedness, Ibn al-Kalbi states that when Arabs on a journey would stop for the night, they would collect four stones; three of these would be used to support the cooking pot and the fourth would be used as an object of worship in imitation of the Ka'ba.[16] The denunciation of idols as little more than rocks and clay stands in contrast to other accounts in which the gods are real enough, but are false, in that they are distinct from the "true" god of the new religion. The Qur'anic reference to the "daughters of Allah" (53:19–20) is well known, as is the

incident of the so-called Satanic verses in which an attitude of toler-
ance toward secondary deities was discarded in favor of their absolute
rejection. Ibn al-Kalbi lists the female deities at the center of this inci-
dent, Manat, Allat, and al-'Uzza, as three of the four gods most fa-
vored by the Meccans in the period immediately before the advent of
Islam. (The fourth was the male god, Hubal, who was the greatest of
them according to Ibn al-Kalbi.) Of the three, al-'Uzza was the most
recent and the most honored, and the Quraysh would sacrifice ani-
mals to her.[17]

Early Islamic histories and traditions of Muhammad (hadith) record
the destruction of al-'Uzza by the Muslim military champion, Khalid
ibn al-Walid, at Muhammad's command. Among the different versions
of this event documented by Ibn al-Kalbi, one deserves special atten-
tion. According to this account, Muhammad commanded Khalid ibn
al-Walid to the valley of Nakhla where there were three trees inhabited
by al-'Uzza, and ordered him to cut down the first one. When he re-
turned, Muhammad asked him if he had seen anything unusual there,
to which Khalid ibn al-Walid replied that he had not. Muhammad
commanded him to go back to Nakhla, cut down the second tree, and
report back, which he did, saying again that he had not seen anything
out of the ordinary. Muhammad then ordered him to go and cut the
final tree. When Khalid ibn al-Walid arrived in Nakhla, he saw an Abys-
sinian woman with wild hair, gnashing and grating her teeth, and ac-
companied by Dubayya al-Sulami, the custodian of al-'Uzza. Dubayya
addressed the woman, calling her al-'Uzza, beseeching her to kill Kha-
lid, "because unless you kill Khalid today you will be condemned to
humiliation and shame." Khalid ibn al-Walid struck her with his sword,
cutting off her head, at which she fell to the ground in a pile of ashes.
He then killed Dubayya, her custodian, felled the tree, and returned to
Muhammad with his report. Muhammad allegedly commented: "That
was al-'Uzza, and there will be no goddess for the Arabs after her. In-
deed she will never be worshipped after today!"[18]

This version of the destruction of al-'Uzza is not found in the collec-
tions of hadith considered canonical by the majority of Muslims, but
notions of canonicity are primarily relevant only in the legal uses of
hadith. There is a much larger corpus of prophetic traditions that

serves as the wisdom literature of Muslims and guides attitudes and ethics in all walks of life. The implications of Ibn al-Kalbi's account of the killing of al-'Uzza are clear: Muhammad did not deny that al-'Uzza was *real*. She was not a mere tree that the deluded Arabs, in their ignorance, insisted on worshipping. Dubayya, her custodian, did not try to stop Khalid ibn al-Walid himself but rather he beseeched the goddess to defend herself (and, by extension, those who worshipped her). It took one of the greatest champions of Islam to kill al-'Uzza, a feat that presumably could only be accomplished because it was the will of the superior deity of Muhammad and Khalid ibn al-Walid. Clearly, Ibn al-Kalbi did not deny the existence of other gods, or that idols and icons possessed supernatural powers. He simply believed that Allah was superior to them all; part of the proof of this was that his worshippers could vanquish all other gods as well as their devotees.

Ibn Sa'd relates an account reminiscent of al-'Uzza and her inability to defend herself and her worshippers: "Rashid was given Ruhat, in which there is a well called 'the well of the Messenger.' Rashid had been the custodian of an idol of the Banu Sulaym. One day he saw two foxes pissing on it, and he said, 'Can a god [literally "lord"] have two foxes pissing on his head? He is debased whoever has foxes pissing on him!' Then he assaulted it, and shattered it."[19] The theme of idols that are unable to defend themselves is a common one in early Islamic literature, as is that of religious heroes ridiculing idols and idol worship, and of idolaters turning against their gods when the latter prove impotent in the face of attack or misfortune. During the capitulation of Ta'if, the worshippers of the idol al-Rabba (identified with Allat) expected their god to defend itself from the attack of the Muslim champion Mughira ibn Shu'ba. During the course of the struggle, Mughira pretended to be struck down by the idol, but then stood up again, laughing, and ridiculed the locals for their belief, calling the idol a "contemptible thing of clay and stone."[20] The obvious reading of such disavowals is the dismissal of other gods, but underlying the statements is the explicit acknowledgment of the power of idols and icons, and even the existence of other deities as "false" gods, which remains a pervasive theme in early Islam as well as in descriptions of foreign lands and cultures.

Idols and the Religion of Abraham

One critical point that is often overlooked in discussions of Islam and its relationship to the imagined history of pre-Islamic Arabia and its time of *jāhiliyya* is that polytheism and idolatry are perceived as introductions—even imports—to the Arabian Peninsula and its religious culture. Muslim prophetology situates Islam squarely within a prophetic tradition beginning with Adam and culminating with Muhammad. In this scheme, all prophets were themselves monotheists and preached monotheism, so that polytheism and idolatry can be seen only as corrupt deviations from a primordial monotheism. Idolatry is often regarded as a sign of intellectual weakness and immaturity by Muslims as well as others; but according to the Islamic view of prophetic history, this weakness is not evolutionary, leading to the "maturity" of monotheism and a lack of reliance on images, even though image-independent monotheists are certainly seen as more spiritually advanced than image-using polytheists. Rather, idolatry and polytheism represent religious regression, a falling away from the evolutionary path of monotheism that begins with Adam, and on which figures such as Noah and especially Abraham represent key turning points.

The majority of Muslims believe that Islam, as professed and promulgated by Muhammad, is identical to the religion preached by Abraham, such that Abraham, more than any other prophet, functions as the spiritual ancestor of the religion. It is a central doctrine that the Ka'ba in Mecca was built by Abraham as a "house" *(bayt)* for the one true god that he worshipped, and not only does the commemoration of events in his life (in imitation of Muhammad's reenactment thereof) constitute a central component of Muslim ritual in the pilgrimages of Hajj and 'Umra, but also in wider constructions of religious history. This is particularly so in questions pertaining to pre-Islamic Arab monotheism and idolatry. In such an understanding, a form of Abrahamic monotheism persisted with people called Hanifs who rejected the polytheism that had infected Arabia and had displaced (or corrupted) the divinely sanctioned religion of Abraham. The Hanifs persisted as an anachronistic monotheistic group within the larger context of an idol-worshipping majority, and their practice was

connected directly to Muhammad's family. His grandfather, 'Abd al-Muttalib, is described as having known that the well near the Ka'ba was the Zamzam of Abraham's son, Isma'il, and as having prayed to Allah inside the Ka'ba, which housed an idol at that time that had been placed there originally by 'Amr ibn Luhayy according to at least one account.[21]

According to early Muslim sources, monotheism had been brought to the Arabian Peninsula by Abraham himself when he was commanded to go to Mecca and restore the Ka'ba, which had been built for Adam but had fallen under disrepair, neglect, and abuse. He accomplished this with the help of his son Isma'il, and the two of them established the rites of the Hajj at that time. Isma'il remained in Mecca, and his descendents practiced the religion of Abraham, especially the rituals centered around the Ka'ba, for several generations. It was their aforementioned spread due to population pressure, use of Meccan stones as symbolic reminders of the Ka'ba, and subsequent forgetting of the significance of their litholatric rituals, which, combined with corrupted Abrahamic rituals, gave rise to the *jāhiliyya* religion of the Arabs.[22] Certain early Islamic works are explicit in identifying the proto-monotheistic Hanifs with followers of the "religion of Abraham" *(dīn Ibrāhīm)*.[23] Throughout this period, the Hanifs kept Abrahamic religion alive in the midst of idolatrous and polytheistic Arabia:

> But [in spite of the idolatry and polytheism which had spread among the Arabs] there were survivals of the time of Abraham and Ishmael which they followed in their rituals— revering the sanctuary, circumambulating it, hajj, 'umra, standing upon 'Arafa and Muzdalifa, offering beasts for sacrifice, and [reciting the *tahlīl*] in the hajj and 'umra—together with the introduction of things which did not belong to it.[24]

In his own stand on idols and their worship, Muhammad is clearly understood as following squarely in the footsteps of Abraham. The Mecca of his time is presented as being steeped in idolatrous practice, such that there was not one man in the Quraysh who did not have an idol in his house.[25] Conversion to Islam is frequently presented as having been premised on a zealous iconoclasm. When 'Ikrama ibn Abi

Jahl converted to Islam, he could not hear of an idol in any of the houses of the Quraysh except that he would go there in order to smash it.

According to early sources such as Ibn al-Kalbi and al-Azraqi, when the Prophet entered Mecca on its conquest in 630 CE, there were 360 idols in the city, many of them arrayed in the sanctuary of the Ka'ba, with some actually inside it, and its interior walls and pillars were decorated with images. Muhammad struck these idols in their eyes and faces with his bow and said: "Truth has come and has destroyed falsehood! Indeed, falsehood has come to nothing!" Then he commanded that they be turned over onto their faces and taken out of the sanctuary and burned.[26] Abraham's break with the religion of his ancestors is also echoed in traditions of Muhammad's life that outline the replacement of the idolatry of the Quraysh with the religion of Islam. In one such account, when Abu Uhayha of the Quraysh was ill with the sickness that eventually took his life, he was visited by Abu Lahab, Muhammad's paternal uncle who is remembered as one of the most vociferous opponents of the spread of Islam. When Abu Lahab found the sick man crying, he asked him: "Why are you crying, O Abu Uhayha? Do you cry on account of death, for there is no escape from it?" Abu Uhayha replied: "No, but I fear that al-'Uzza will not be worshipped after me." Abu Lahab vowed that he would continue in the worship of al-'Uzza, to which the dying man responded: "Now I know I have a *khalīfa!*"[27] The pre-Islamic gods themselves are shown to lament their end. Al-Waqidi and al-Azraqi relate an account reminiscent of the destruction of al-'Uzza by Khalid ibn al-Walid: "[When the Prophet destroyed the idols of Mecca] there came out of one of these two stones a grey haired black woman who was tearing at her face with her nails, naked, pulling at her hair and crying in her woe. Asked about that, the Prophet said, 'This is Na'ila who has abandoned hope that she will ever be worshipped in your land again.'"[28]

There is a tendency in early Islamic commentaries on the Qur'an, as well as in religious writings and teachings more generally, to draw a clear distinction among disbelievers in Islam, and neither the accusation of disbelief *(kufr)* nor the sobriquet of "associater/idolater" *(mushrik)* normally gets applied to Jews or Christians, despite the fact that on several occasions throughout history Jews and Christians have been

accused of being less than perfect monotheists in interreligious po-
lemics. Muslim accusations of *shirk* follow earlier polemical stances in
which allegations of idolatry are leveled against opponents who would
consider themselves monotheistic and, in fact, would level similar ac-
cusations against others.

Shirk is understood both as idolatry and as believing in deities be-
side Allah, with the two being conflated on occasion. The *Sīra* of Ibn
Hisham describes a tribe called Khawlan that used to make an offer-
ing of a portion of their crops and livestock to Allah and to another
god called 'Umyanis.[29] Ibn Hisham includes this account as part of
the explanation for the concept of divine associates *(shurakā')* men-
tioned in Qur'an 6:136: "They assign to Allah a share of the crops and
cattle He created, saying: 'This is for God'—as they declare—'and this is
for our associates [gods] *(shurakā')*.' And what is for their associates
does not reach Allah, but what is for Allah would reach their associ-
ates. How evilly do they judge!"

On the face of it, there is no reason to assume that the "associates"
mentioned in this verse are divinities rather than human associates to
whom a portion of the harvest is given. However, Ibn Hisham inter-
prets the verse as a reference to *shirk,* claiming that if a portion of
'Umyanis's share went to Allah, it was given back to 'Umyanis, but if a
part of Allah's share went to the other god, it was kept in that allot-
ment, suggesting that the Khawlan not only associated another deity
with Allah, but also preferred it.

Although the accusation of *shirk* does not traditionally seem to have
been made against Christians, this would certainly seem to be the case
with some of the major signifiers of the Dome of the Rock in Jerusalem,
which was undoubtedly built in no small measure with a Christian au-
dience in mind, or at the very least with an eye toward projecting for a
Muslim audience a message concerning the relative status of Christian-
ity and Islam. The inscriptions on the inside of the dome as well as on
the north and east portals use verses from the Qur'an that refer to *shirk*
(Qur'an 17:111 and 9:33, possibly also 61:9), since both *mushrikūn* and
sharīk ("associate" or "partner") appear in these earliest inscriptions.[30]

Muslim Writers on Other Religions

Several Muslim authors wrote extensively describing other religions, most often in the context of composing regional or global historical geographies. In many cases, such works are concerned primarily with describing wonders and mirabilia, and it is therefore not surprising that their accounts of foreign religious beliefs and practices tend to emphasize the bizarre over mundane ethnographic details. Nevertheless, such descriptive accounts found an enthusiastic readership in Islamic lands and went a long way toward constructing Muslim notions of non-Muslims—both in the pre-Islamic past and in foreign lands they perceived to be exotic, such as India and China.

Such authors' treatments of pre-Islamic Arabia rely on the skeletal data from the Qur'an that was reworked by early Muslim writers such as Ibn Hisham, al-Azraqi, and al-Tabari, and subsequently reformulated in ways that constructed Muslim understandings of their own religious past and the historical relationship of Islam and Muslims to other religions. Two such scholars, al-Mas'udi (d. 956) and al-Shahrastani (d. 1153), whose writings on Indian religions are discussed in some detail in this chapter, represent excellent examples of such a practice. For al-Mas'udi, Qur'an 39:3 ("Those who took other protectors, apart from Him, say: 'We only worship them so as to bring us closer to Allah'") refers to pre-Islamic Arabs who believed in Allah and Muslim-Abrahamic eschatological details concerning creation, death, resurrection, judgment, and an afterlife, but who simultaneously worshipped idols, made pilgrimages to their sanctuaries, and sacrificed offerings to those deities.[31] Elsewhere, he sees evidence of the worship of angels in Qur'an 53:19–20 ("Have you, then, seen Allat, and al-'Uzza, and Manat, the third one, the other?") and Qur'an 16:57 ("And they ascribe to Allah daughters, glory be to Him, and to themselves what they desire").[32]

Muslim sources differ greatly on identifying the precise nature of well-known deities as well as in locating them within the geography of pre-Islamic Arabia. Allat is most commonly placed in Ta'if (as is stated by Ibn al-Kalbi), but also in Mecca, Nakhla, and 'Ukaz.[33] She is also mentioned as being a worked stone, cubic in shape (sakhra murabba'a), or a stele (bayt), and also as a sanctuary or building. There are also ref-

erences to her "head," which suggests that she existed as an anthropo-morphic or perhaps zoomorphic idol.[34] Similar contradictions exist in descriptions of Manat and al-'Uzza, although, not surprisingly, all three of them become located in Mecca as the primary false gods of pre-Islamic idolatry, in direct consequence of prevalent understand-ings of the relevant Qur'anic passages and their context.

Islam, Images, and India

The gods of Arabia and of the late antique Mediterranean world not-withstanding, it is the gods of India that occupy a central place in Islamic accounts of idolatry. India has long held status as a land of wonder and fascination among the residents of Islamic lands to its west. Travel literature and geographical writings give prominence to descriptions of India; furthermore, there is a long history of works de-voted to the description of India and its wonders, such as the *Kitāb 'ajā'ib al-Hind* (Book of the Wonders of India, ca. 955 CE) and *Akhbār al-Sīn wa'l-Hind* (Accounts of China and India, compiled 851 CE).

As Friedmann points out, India was viewed as the original home of idolatry by the majority of early Muslim writers, and Arab idols were often seen as of Indian origin. Idolatry began in India when Adam descended from Paradise and landed on the mountain named Budh in Sarandip (identified with Sri Lanka). Adam became the object of wor-ship among the children of Seth after his death, and one of the descen-dents of Cain carved idols for his people to use as objects of worship. Eventually, Noah's flood washed the idols off the mountain and spread them around the world, some of them washing ashore near Jidda in the Arabian Peninsula. Al-Tabari claimed that it was from here that they were retrieved by 'Amr ibn Luhayy, who was guided to the location by the jinn. The tradition of associating India with the home of idola-try and specifically with the idolatry of pre-Islamic Arabia continues long after Muslims become an established part of the Indian cultural landscape: the historian Firishta (d. ca. 1620) asserts that the Hindu idol of Somnath was originally at the Ka'ba and was brought to India by idolaters.[35]

It is widely believed that the Islamic conquests in South Asia resulted in an orgy of idol destruction and temple desecration that was motivated by a rabid religious intolerance masquerading as monotheistic piety. This view persists despite some excellent scholarship (by Richard Davis, Michael Meister, Barry Flood, and others) proving that, on the whole, Muslim iconoclasm and temple looting represented a continuation not only of Islamic attitudes toward power and the symbolic treatment of defeated people (including other Muslims), but that they also were participating in an established South Asian Buddhist and Hindu social discourse of religion, power, and material economy. In the words of Davis: "Alive to the identities and mythic backgrounds of the figures, royal looters dislodged select images from their customary positions and employed them to articulate political claims in a rhetoric of objects whose principal themes were victory and defeat, autonomy and subjugation, dominance and subordination."[36]

Davis and Flood have described the complex issues of symbolism as well as economic and political redistribution associated not just with the destruction of idols, temples, and their precious goods, but also with their relocation and reuse as spoils of war. Very frequently, idols were included in the spoils and were taken all the way to Baghdad, sometimes even to Mecca. In some cases, they were destroyed in a public spectacle reminiscent of executions and book burnings, suggesting that there was a ritual element to this. In other cases, idols were mirabilia, objects of wonder that circulated in the Islamic world before being placed in a royal treasury or regifted to someone else.

Chroniclers, Geographers, and Travelers

Beginning in the ninth century, a number of Muslim authors wrote about India, its religious practices and objects as part of a period of wider interest in global geography and history that carried into the twelfth century and beyond, although writings on India change significantly after the establishment of Muslim states in northern India. Of these authors, Ibn Khurdadhbih (ca. 912), al-Masʿudi (d. ca. 947), al-

Muqaddasi (d. ca. 990), al-Biruni (d. ca. 1048), Gardizi (d. before 1041), Faqih-i Balkhi (d. 1106), al-Shahrastani (d. ca. 1142), and al-Idrisi (d. ca. 1166) are especially important, although to this list one could add several others such as Ibn al-Nadim (d. 998), Ibn Hauqal (d. 977), and Marwazi (d. ca. 1120).[37] Idols and idolatry figure prominently in early Islamic descriptions of India, and over time they become one of the defining factors differentiating a constructed "Hindu" from a Muslim culture, even in contexts were Islam has been naturalized in a South Asian environment. At the same time, descriptions of idols and idolatry written by Muslims are by no means simplistic: they display a variety of nuanced attitudes and motivations toward alien societies as well as toward the relationship of religion to material and visual culture. Some eschew any discussion of idols even when they are listing the strange and wondrous things of India, suggesting that idols and idolatry did not necessarily arouse loathing and fear in early Muslims. An example of such a work is the "Book of Wonders of India" attributed to a sea captain named Buzurg ibn Shahriyar al-Ramhurmuzi and which dates from around 955 CE.[38] Al-Ramhurmuzi's work promotes the exotic with stories of giant lobsters and ants, snakes that eat elephants, and monkeys that seduce sailors. There are many anecdotal descriptions of strange Indian customs and events in this collection of tales—including of Indian festivals and the conversion of a Hindu king—but idols and idolatry are not among the things considered noteworthy by the compiler.

Other accounts are much more detailed in their descriptions of religious practices. According to al-Mas'udi, many of the people of India and China (as well as from neighboring regions) believe that God has a body as do the angels, and that they are all hidden in the heavens. They make for themselves images (tamāthīl) and idols (asnām) in the forms of God and the angels in various shapes, some human; they then worship these idols and images and make offerings to them, believing that they draw closer to God in this way. Others of their idols represent the stars and other celestial bodies that they believe resemble God, with different groups worshipping different stars, for which they have specific idols. They make temples and statues for these stars and call them by their names.[39]

Al-Mas'udi goes on to list the major idol temples of the world, with their locations stretching all the way to China. He also describes noted temples of the past, including a famous one of the Sabeans in Harran that contained a statue of Azar, Abraham's father.[40] He provides us with a full account of items sent by 'Amr ibn al-Layth, the Saffarid ruler of Afghanistan and the Indus Valley, to the Caliph al-Mu'tadid in 898. 'Amr's gifts comprised one hundred camels, chests filled with treasure, and four million dirhams. In the treasure he sent was an idol in the shape of a woman with four arms and a double-belted necklace (*wishāhān*) of silver adorned with red and white gemstones. Between the arms of this idol were smaller figures with arms and faces decorated with jewels and ornaments. 'Amr ibn al-Layth had taken this idol from somewhere in eastern Afghanistan, most probably from the temple of Lakshmi or Sukhavati at Sukavand, between Kabul and Ghazni.[41] The object was taken to Basra, where it was put on public display, and then on to Baghdad, where it was exhibited for three days. Al-Mas'udi emphasizes the attraction the image held as a spectacle, and crowds gathered to gawk at it when it was on show, to the point that the crowds referred to it as a *shughl* ("distraction," but also "work" and "entertainment") because they were distracted from their labors and entertained by it for those days. The idol—renamed *shughl*—remained an important anecdotal detail of Indian mirabilia in writings after al-Mas'udi.[42]

In his description of the Indus valley (al-Sind), the renowned tenth-century geographer al-Muqaddasi pays special attention to his description of the idols. Like the relocated *shughl*, there are idols that acquired fame *as idols* in idolatrous contexts. Among these are several from the Indus valley, particularly those of Multan, one of which is famous for having been animated. Al-Muqaddasi has the following to say about them:

> As for the idols in this region, there are two in Harawa made of stone: no one approaches them. They have a power such that should a man try to lay his hand on one, it will be held back and will not reach the idol. They both appear as though made of gold and silver. It is said that if one expresses a wish in their presence, the request will be granted. . . . The two

statues are quite enchanting. I saw a Muslim man who said
he had forsaken Islam to return to the worship of the idols,
having been captivated by them; when he returned to Naysa-
bur [in Iran] he became Muslim again. The two idols really
are miraculous![43]

Implicit in this statement, and in others like it, is the acknowledg-
ment of the power of idols and icons. Such accounts are less about de-
nying the existence of deities other than Allah than they are about the
affirmation of monolatry (rather than monotheism) and a condemna-
tion of hylotheism (confusion of God with matter). These issues de-
serve much more discussion in an Islamic context than I can present
here.[44] Instead, I turn to the famous al-Biruni, whose book on India,
Kitāb tahqīq mā li'l-Hind min manqūla maqbūla fī'l-'aql aw mardhūla (bet-
ter known as *Tā'rīkh al-Hind,* ca. 1030), is perhaps the most detailed
treatment of Indian society in early medieval Islamic writing. A re-
nowned polymath from Central Asia, al-Biruni stands out not only for
the amount of detail he provides in his discussion of the religions,
peoples, and places of India, but also for his nuanced understanding
of the nature of images and their need in religious ritual and doctrine.
He is unusual among Muslim writers in this regard, as well as for not
placing Muslims—or even monotheists—in a category separate from
other religious groups in the context of his discussion of image venera-
tion. His distinctions among human religious groups is not based on
religion, but on intellectual class:

It is well known that the popular mind leans towards the
sensible world, and has an aversion to the world of abstract
thought which is only understood by highly educated peo-
ple, of whom in every time and every place there are only few.
And as common people will only acquiesce in pictorial repre-
sentations, many of the leaders of religious communities
have so far deviated from the right path as to give such im-
agery in their books and houses of worship, like the Jews and
Christians, and more than all, the Manicheans. These words
of mine would at once receive a sufficient illustration if, for
example, a picture of the Prophet were made, or of Mekka

and the Ka'ba, and were shown to an uneducated [Muslim] man or woman. Their joy in looking at the thing would bring them to kiss the picture, to rub their cheeks against it, and to roll themselves in the dust before it, as if they were seeing not the picture, but the original, and were in this way, as if they were present in the holy places, performing the rites of pilgrimage, the great and the small ones.[45]

Al-Biruni states unequivocally that this need of "common people" for sensory, tangible religious objects is "the cause which leads to the manufacture of idols"[46] as well as the veneration of the dead and angels. He then goes on to discuss the origins of idolatry, recognizing that some sources claim that before the emergence of monotheism, all human beings were idolatrous (in contradiction to the common Muslim view that sees idolatry as a deviation from a proto-monotheism). He lists the origins of idolatry according to the Torah as dating from the time of Abraham's great-grandfather, and the Roman version of the practice as resulting from Romulus having erected a gold image of his brother Remus as a way of ridding himself of intestinal troubles he suffered following his crime of fratricide.[47] He then goes on with accounts of many Indian idols, their manufacture, their *mudras,* symbols, vehicles and so on. He also provides a detailed description of the idol of Multan, called Aditya, and several others in Thanesar, Ghazni, Kashmir, and elsewhere, and details of the rules of representation of individual gods.

In describing Hindu practices of idol worship, al-Biruni stresses that these "ridiculous views" are only held by "the common uneducated people": "For those who march on the path to liberation, or those who study philosophy and theology, and who desire abstract truth which they call *sâra,* are entirely free from worshipping anything but God alone, and would never dream of worshipping an image manufactured to represent him."[48] He states that the Hindu practice of idol worship arises from the same universal human need for concrete *(mahsūs)* rather than abstract or conceptual *(ma'qūl)* things that would be demonstrated by image and relic veneration among Muslims.[49] Clearly, for al-Biruni, formal confessional identity does not by itself constitute a sufficient

line to separate idolaters from monotheists; rather, idolatry is a phe-
nomenon that transgresses religious boundaries, and the elite believ-
ers of supposedly idolatrous religions are themselves monolatric.

Al-Biruni states that when Muhammad ibn al-Qasim (d. 715) con-
quered Multan, he inquired about the source of its wealth, since he
found it a flourishing town with a great deal of treasure. He was in-
formed that the local idol of Aditya was the cause, and so he decided
to leave the idol in place to profit from the pilgrimage trade, but he
had a piece of cow's flesh hung around its neck as an act of mockery
and humiliation, which he symbolically emphasized by building a
mosque on the site. Al-Biruni's discussion of the treatment of the idol,
or of its fate under the Isma'ilis and Mahmud of Ghazna, neither ex-
presses approval (or disapproval) of iconoclastic acts, nor belief in the
veracity of the details he is giving. In fact, the author points out that if
one takes the accounts of the idol of Multan at face value, it would
have been 216,000 years old, and al-Biruni finds it difficult to believe
that an idol said to be made of wood and leather could have lasted that
long in a humid environment.[50]

He notes that idols are esteemed based on who erects them, not on
what they are made of, and idols such as the wooden Aditya at Multan
were valued more than many others made of gold. He lists a number of
idols erected by important figures, which goes to contradict his state-
ment that "idols are erected only for uneducated low-class people of
little understanding; that the Hindus never made an idol of any super-
natural being, much less of God; and, lastly, [that] the crowd is kept in
thralldom by all kinds of priestly tricks and deceits."[51] To support his
claim that it is only the uneducated among the Hindus who engage in
idolatry and that the educated never confound images and idols with
God, who is the true object of worship, al-Biruni quotes the *Bhagavad
Gita* in a way that sounds very much like a Muslim discussion of *shirk*:

> Do you not see that most of those who wish for something
> address themselves in offering and worshipping to the sev-
> eral classes of *spiritual beings*, and to the sun, moon and other
> celestial bodies? If now God does not disappoint their hopes,
> though he in no way stands in need of their worship, if he

even gives them more than they asked for, and if he gives
them their wishes in such a way as though they were receiving
them from that to which they had addressed their prayers—
viz. the idol—they will proceed to worship those who they ad-
dress, because they have not learned to know him, whilst *he*,
by admitting this kind of intermediation, carries their affairs
to the desired end. But that which is obtained by desires and
intermediation is not lasting, since it is only as much as is
deserved for any particular merit. Only that is lasting which
is obtained from God alone.[52]

Al-Biruni claims that idols held the same intermediary function for
the ancient Greeks as they did for the pre-Islamic Arabs who imported
them from Syria. In this status, they frequently represent corruptions
of statues or buildings erected as memorials. It is this belief that they
are memorials first and foremost that allowed the Caliph Muʿawiya to
send statues taken from Sicily in AH 53 (763 CE) to India to be sold
to the local rulers intact as idols rather than to be melted down.
The most notable aspect of this incident of trading in images for the
modern reader is perhaps that, in the eyes of Muʿawiya (and probably
also al-Biruni and his readers), all idolaters were alike, so that there
was nothing remarkable about an idol from Sicily finding a ready mar-
ket of worshippers in Sindh. But for al-Biruni, the noteworthy point
is that the Caliph was not at all troubled by the possibility that
he was engaging in the sinful and abhorrent act of trading in idols,
since such objects were—in essence and in origin—memorials and aides-
mémoires.[53]

Al-Biruni's work represents a landmark on account of its nuanced
and detailed treatment of religious practices in India, and other writ-
ers following him do not focus on the subject with the same care.
Gardizi, who may have been a student of al-Biruni, provides an ac-
count that is much shorter than that of al-Biruni, but he displays a
similarly noncondemnatory tone in his *Zayn al-akhbār*.[54] Gardizi men-
tions the worship of a number of different idols as the ritual focus of
various sects, but he does not make condemnatory statements as part
of his remarks, nor does he pass moral judgment on them, although

an overarching disapproval of such practices is probably to be assumed since they are presented together with descriptions of nakedness in ritual and phallocentric religious practices, both of which would be considered highly inappropriate by the author. Nevertheless, the majority of Gardizi's discussion is positive. He speaks about the Indians' wonders, telepathic powers, and their medical knowledge that is unrivaled in the Islamic world: "The people of India are skilful, clever, and shrewd. They make good and subtle things. From their midst come many sages, especially in the province *(wilāyat)* of Kashmir." He goes on in his praise, saying: "(Among) the wonders (are their) mathematics, geodesy, geometry, and astronomy, in which their science and authority *(sangī)* have reached a degree which it is impossible to explain for it is superhuman. (Similarly they excel in) the art of singing and dancing and in the construction of implements of merriment."[55]

A related sense of appreciation of Hindu intellectualism as contrasted with an expression of the absurdity of idolatry is also displayed in the *Bayān al-adyān* of Abu'l-Ma'ali Muhammad ibn Ni'mat-i 'Alawi, also known as Faqih-i Balkhi. Written in 1106 CE, the chapter on Hinduism is barely one page in a substantial book. Faqih-i Balkhi declares that the Hindus are second to none in their command of astrology, medicine and pharmacology, mathematics, and so on. But he expresses amazement that people this sophisticated could be idol worshippers *(but-parast)* and kill themselves through immolation for the sake of these idols. He then goes into a discussion of the variety of beliefs and rituals that fall under the rubric of Hinduism, like al-Biruni (but in much attenuated form), expressing no condemnation of Indian religious ideas as they are understood in Islamic writings of the time.[56]

A generation after Faqih-i Balkhi, the Khurasani theologian Abu'l-Fath Muhammad al-Shahrastani (d. 1153) stands out among medieval Islamic writers—and especially among heresiographers—for his detailed treatment of Indian religious ideas, which he lays out in the section entitled *Ārā' al-hind* in his monumental book on religious sects and groups named the *Kitāb al-milal wa'l-nihal,* the most commonly cited Muslim heresiographical work of the period. As has been discussed by Lawrence in his study and translation of the sections devoted to

Indian religions, al-Shahrastani's *Ārā' al-hind* is not based on any first-hand experience with India that the author had, but is drawn in its entirety from received information, much of which dates from a century or more before the time of its writing.[57] Al-Shahrastani begins by outlining the beliefs of what he regards as the subcategories of the *Barāhima* (the Brahmin caste); these subcategories include the followers of the Buddha, the "proponents of Meditation and Imagination," and the "proponents of Metempsychosis or Transference." After this comes an account of the followers of "Spiritual Beings" and the worshippers of stars, the sun, and the moon. Until the section on moon worshippers ("Jandrīkanīya") there is no specific description of idols, yet al-Shahrastani is explicit in considering all of the preceding religious categories as idolatrous:

> Know that those sects whose doctrines we have just cited revert in the last analysis to idolatry, since there is no other way for them to worship except in the presence of a person to whom they look up and to whom they devote themselves. Hence the followers of spiritual beings and star-worshippers erect idols which they claim represent the beings actually worshiped. In short, the relation of the idols—wherever it is determined—is to a hidden object of worship. The constructed idol consequently assumes the form, shape and figure of the other being, becomes its representative and takes its place.
>
> At the same time, however, we are absolutely certain that a rational person cannot put his hand to a piece of wood and chisel it into a form and then believe that it is both his God and his Creator and the God of all; for its existence was preceded by the existence of its maker, and its form created by the craft of its chiseler.
>
> But when people are intent upon orienting themselves to idols and link their needs with idols, without permission or authority or proof or power from Almighty God, then their devotion to idols and their request (for the fulfillment) of needs from them is tantamount to asserting the divinity of

such idols. Concerning this practice, they used to say, 'We serve them only that they may bring us closer to Allah' (Qur'an 39:3). But if they did restrict themselves to the forms of idols in ascribing lordship and divinity, then they would not go beyond them to the Lord of lords.[58]

I have quoted al-Shahrastani's pronouncement in its entirety because of its importance as one of the most sophisticated, if still critical, descriptions of the nature and practice of image veneration in Islamic scholarship. Al-Shahrastani clearly understands the mimetic and representational uses of images and appears to be affording them an iconological status as stand-ins for a hidden divine referent. Yet he claims that the very act of worshipping a representation necessarily causes it—not the hidden referent itself—to become the object of worship. His critique of the rationality of worshipping something that has been fashioned by human hands is familiar from many other contexts, Muslim and otherwise. However, the precise opprobrium he levels against using image veneration as a means to draw closer unto God does not have a known precedent in Muslim religious literature, in that it is not simply the mistaking of the representation for the object of worship that he finds objectionable. Rather, he also objects to the idea that the lack of divine sanction for religious images renders them autonomous objects of worship, distinct from representations of a divine referent, since without sanction from God the adoration does not pass to him, leaving the idol as the actual (final) object of worship.

Al-Shahrastani describes one idol in great detail, relying on Gardizi for most of his details:

They have an idol known as Mahākāla, who has four hands and a great head of hair, which he lets hang down. In one of his hands he has a huge snake with its mouth wide open; in another a staff; in the third a human skull; and with the fourth he pushes it back. In both his ears like two earrings are snakes, and on his body are two large snakes, which have twisted around him. On his head he wears a crown of skull-bones. They believe that Mahākāla is a malicious being who

yet merits adoration due both to the greatness of his power and to the praise-worthy and lovable, as well as the objectionable qualities, he possesses. . . . The people who worship him come to [his temples] three times a day. They prostrate themselves before him and circumambulate him. At a place called Akhtar there is a large idol in the form of this deity. . . . Continuously they beseech it and ask it for what they need, until perhaps it happens.[59]

Al-Shahrastani and al-Biruni stand out for their detailed treatments of Indian religiosity, the description of Mahākāla-worship demonstrating a nuanced understanding of the ambivalent powers venerated in a deity of what is most likely a north Indian Shaivite group. But even in such accounts, the quality of idols and idolatry as an exotic, alien, and often grotesque practice remains connected with what are seen as more laudable religious practices, as is evident from the detailed treatment of serpents as well as human skulls and bones. Nevertheless, al-Shahrastani's arguments, in particular, could form the kernel of a Muslim theory of religious images; however, they have not been influential in that regard and have been lost within the much longer descriptive elements of his work that speak about the various categories of natural and man-made phenomena and objects that are worshipped in India. Similar claims could be made about the statements concerning religious practice made by other writers whose sophisticated treatments of the subject get buried in the details of their thick geographical and anthropological accounts.

Al-Shahrastani and al-Biruni's nuanced treatment of the place of idolatry in Indian religious practice can be explained in part by a cultural familiarity with elements of the South Asian environment. The same cannot be said of the geographer and cartographer al-Idrisi (d. ca. 1166), an Andalusian from Ceuta who lived in Sicily, who must have been much less conversant with Hinduism than these two influential writers as well as the Central Asian Faqih-i Balkhi. However, al-Idrisi displays a somewhat nuanced understanding of the *use* of idols, and his status as one of the most important medieval Islamic geographers makes his description of Indian religiosity and idols important. Al-

Idrisi's account of India is somewhat disorganized and is limited largely to the Indus valley and the western coast of India. None of it is drawn from firsthand experience and he appears to have been unfamiliar with the important writings of al-Biruni and al-Mas'udi.[60]

Like his contemporary al-Shahrastani, al-Idrisi understands the use of idols as a means of mediation *(tawassut)* between the worshipper and God, stating that Brahmins "worship idols, believing in them as mediators between themselves and Almighty God."[61] Despite his antipathy toward idolatry and all forms of hylotheism, he accords a fundamental religious and moral acceptability to the Indian (as well as Chinese) idolaters: "None of the people of India and China deny the Creator. They believe in Him because [they recognize] His wisdom and eternal craftsmanship. They do not believe in the Prophets or the Books. Nevertheless, they do not in any circumstances depart from justice and equity."[62]

Al-Idrisi provides a detailed description of the famous idol of Multan mentioned earlier by al-Mas'udi. Al-Idrisi states that the temple of the idol is situated in the most crowded marketplace in the center of the city with a large, vaulted, and richly decorated main building surrounded by rooms for the attendants of the idol. The idol is itself in the shape of a human being, sitting cross-legged, with its arms resting on its knees, placed on a dais made of baked bricks and plaster. "The whole of its body is dressed in a skin resembling red Morocco leather. Nothing is visible of its body except its two eyes. Hence, there are some people who assert that its body is made of wood; and there are others who reject this statement of theirs and deny it. However, its body is never left uncovered. It has two precious stones for its eyes, and its head is covered with a crown of gold inlaid with gems."[63]

Al-Idrisi claims that the idol is widely venerated and that people from the remotest parts of India undertake pilgrimages to see it, making rich offerings of "ornaments, perfumes, and other things beyond description, in order to exalt and glorify it." However, it is not venerated by the people of Multan itself because, aside from the temple attendants, the population is entirely Muslim (an implausible and erroneous view). Nevertheless, the idol is important enough to the kings of neighboring kingdoms that the threat of destroying the idol made by

the idol's attendants (not simply by the Muslims of Multan) is enough for the potential invaders to retreat. "Had it not been so, Multān would have been destroyed [long ago]. Hence the glorifiers of this idol believe its presence there to be a divine assistance to them."[64]

Al-Idrisi's account of Indian religiosity and its religious landscape is apologetic in that it acknowledges that the Indians are idolaters yet, simultaneously, claims that they worship one God. He does this without distinguishing between a monotheistic elite that condemns idols and a polytheistic lower class that is idolatrous. Instead, he seems to be demonstrating a nuanced iconological understanding of the religious use of images in a manner reminiscent of al-Shahrastani, although with a lesser degree of condemnation for idols and their veneration, as well as without demonstrating much theological nuance. This is partially explained by the differences in the two men's scholarly training, in that al-Idrisi was a mapmaker and geographer and al-Shahrastani a theologian and heresiographer. It is also tempting to contemplate how the difference was a result of their backgrounds—al-Idrisi, born in Ceuta, spent the most productive years of his life at the court of the Norman King of Sicily Roger II (d. 1154). Therefore, al-Idrisi was likely to have been familiar with image veneration in Christianity—both in the Catholic environment of Sicily and in the Eastern church, on account of the Byzantine artisans who worked on the Cappella Palatina—and so conceivably could have applied his understanding of Christianity to his treatment of Indian images. One of the most notable characteristics of al-Idrisi's writing on Indian religions, including his treatment of idolatry, is that he naturalizes Indian practices within an Islamic vocabulary, using specifically Qur'anic terms for universal religious categories, and also covering among his classifications of Indian sects those who believe in Allah as well as the prophets *(al-rusul)*. His statement regarding the meditational nature of image veneration in India, including his reference to the actual object of worship as "Allah *ta'ālā*," is clearly reminiscent of Christian notions of the purpose of images, and may indeed by explainable by his close familiarity with Christianity.

The twelfth century saw a substantial growth in the Muslim presence in India, a result of both an increase in military campaigns and

the settlement of merchants and religious missionaries. Thus, the status of India as a place of marvels began to diminish as more and more Muslims had direct exposure to the subcontinent. Nevertheless, because this region's imagined past included idolatry as a central characteristic, India did not shed its connection with the most wondrous (as well as odious) forms of idol veneration in the memories of Muslim writers and their audiences.

Perhaps the last of the important writers in what amounts to the scholarly tradition of classical Islamic indology is the Persian geographer Zakariya ibn M. al-Qazwini (d. 1283), whose influential and immensely popular works on cosmography and geography, entitled *'Ajā'ib al-makhlūqāt wa-gharā'ib al-mawjūdāt* (The Wonders of Creation and Marvels of Existence) and *Āthār al-bilād wa-akhbār al-'ibād* (Monuments of the Lands and News of the Worshippers) contain important details on the idols of India. Al-Qazwini echoes earlier writers such as al-Biruni and al-Azraqi (who are themselves relying on earlier precedents) in categorizing Indian religious groups into a number of sects, including idol worshippers, fire worshippers, and moon worshippers, tying their religious beliefs with the practice of illicit sex. Quoting al-Mas'udi, he states that the biggest idol in India is one named Baladhari (the correct pronunciation cannot be ascertained), and when pilgrims come to see it they worship it by prostrating themselves *(sajda)*.[65]

In his section on Sindh, al-Qazwini writes that, among the wonders of the city of Somnath, there is a temple *(haykal)* in which there is an idol *(sanam)* called Sumnat (Somnath). The idol floats in the middle of the air in this temple without a pedestal beneath it and without being suspended from anything. The idol enjoys a great reputation throughout India, and whoever sees it suspended in the air is amazed, be he a Muslim or a nonbeliever. The Indians do a pilgrimage *(hajj)* to it every night and they believe that when the spirits leave their bodies they collect around this idol. They bring valuables to this temple as gifts, and it has in excess of 10,000 villages endowed to its financial support. One thousand Brahmin men serve the idol and five hundred women sing and dance at its door, all of them (both the men and the women) receiving their livelihood from the endowment income.[66]

Al-Qazwini describes the destruction of the Somnath temple in 1024 CE by Sultan Mahmud in some detail, saying that more than 50,000 Hindus were killed in the campaign against the city. When the sultan saw this idol he was amazed, and ordered that all the treasures associated with the temple be confiscated and the temple destroyed. The contents of the temples in Somnath were worth more than 20,000 dinars, and included many idols of gold and silver encrusted with jewels. Finally, Mahmud said to his companions: "What do you say concerning this idol and its suspension in the air without a support or rope?" Some of his advisers offered the opinion that it must be suspended by an invisible wire, so the Sultan commanded a soldier to take a lance and walk around the idol, passing the blade above and below it; but the lance failed to encounter any resistance. Then others among those present suggested that the dome must be made of magnetic stone and the idol of iron in just the right amount for a perfect balance of magnetism to keep it suspended in the air. Mahmud then ordered that two stones from the top of the dome be removed, which caused the idol to lean over to one side. After that, they kept removing stones until the idol lay on the floor.[67]

Images between Destruction and Fascination

An element of icon destruction certainly pervades Muslim approaches toward Indian images, although these attitudes and actions are more complicated than some straightforward urge to destroy idols for the sake of piety. Through all historical accounts of image and temple destruction, one cannot help but detect a level of indifference on the part of the Muslims—their reaction to idols is situational, rather than the product of an articulate and sustained religious doctrine.[68]

The biography of Zahir al-din Muhammad Babur, the Timurid prince who conquered northern India and established the Mughal Empire, provides an illustrative anecdote concerning the attitude toward Indian idols. While traveling in India in September 1528, Babur visited the fortress of Urwa (Urwahi) near Gwalior. In Babur's words as recorded in his biography:

Urwahi is surrounded on three sides by a single mountain, the stone of which is not so red as that of Bayana but somewhat paler. The solid rock outcroppings around Urwahi have been hewn into idols, large and small. On the southern side is a large idol, approximately 20 yards tall. They are shown stark naked with all their private parts exposed. Around the two large reservoirs inside Urwahi have been dug twenty to twenty-five wells, from which water is drawn to irrigate the vegetation, flowers, and trees planted there. Urwahi is not a bad place. In fact, it is rather nice. Its one drawback was the idols, so I ordered them destroyed.[69]

The Chaghatay Turkish text in which the biography was composed uses the word *but* for the statues, a term that is very satisfactorily translated as "idol." The far more widely circulated Persian translation by 'Abd al-Rahim Khankhanan uses the same word, and goes further in specifically identifying them as bodily or embodied idols *(buthā-yi mujassam)*. Despite his clear identification of the statues as "idols," however, it is not their religious status that offends Babur but rather their nakedness. Their "private parts" are exposed *(bī-satr-i 'awrat)*, offending Babur's sense of propriety, and it is for this reason that the statues are destroyed.[70]

Conclusion

It appears that certain individuals within the writing and reading sections of the Muslim population had a nuanced understanding of how images and idols were used by Christian and Indian worshippers. At the same time, a report in al-Baladhuri—claiming that the caliph Mu'awiya sent gold idols captured in Sicily to India for sale—suggests a lack of concern with the particulars of image veneration, since the underlying assumption would be that all images (even Roman or Christian ones) would find an audience in India, the ultimate home of idolatry in the Muslim imagination. That such a transaction had economic implications cannot be ignored, especially since profiting from

images became an ethically charged subject in later times; at this stage, however, it seemed to be of little consequence since the only source to show disapproval of the transfer of images from West to East appears to be al-Shaybani's *Kitāb al-siyar al-kabīr*.[71]

The association of Sindh and Hind with idolatry goes to the very beginnings of Arab Islamic writing. Early Arabic sources report that Indian merchants had brought idol veneration as far as the Iraqi port cities of Uballa and Basra, where they had set up an idol of Zhun, a sun god whose worship was centered at Zamindawar in southern Afghanistan but who was possibly closely related to the more famous Aditya of Multan.[72] The latter temple, whose importance as recorded by al-Muqaddisi has already been mentioned, was one of the most important pilgrimage sites in Sindh and all of northern India until its destruction in 965 by the Isma'ilis, and it seems to have been part of a network of temples that continued to operate well into the period of Islamic rule in the Indus valley. For example, the town of Ramayan (or Ramiyan) near Multan held a temple, at the entrance to which there was a copper idol inlaid in gold that was the focus of rituals similar to those described for the temple in Multan, and other temples are reported at the nearby market town of Biruda (or Biruza).[73] Furthermore, their reputation for captivating Muslims was not limited to the one individual described by al-Muqaddisi: the Fatimid caliph al-Mu'izz (r. 953–975) chastised the Isma'ili *dā'ī* in charge of Multan for tolerating Muslims' pilgrimages to the famous temple in that city and engaging in heterodox religious practices.[74]

One of the distinguishing characteristics of Muslim polemics concerning idolatry as compared to the polemics of their Christian equivalents, as well as of Muslim iconoclastic acts, is their partial justification in economic terms, with specific reference being made to the need for gold and silver to circulate in society as instruments for regulating economic value. In this view, converting precious metals into objects constitutes a form of hoarding that indicates a misplacement of the significance of the metal from an economic instrument to an object that possesses value in and of itself, and therefore constitutes a form of idolatry. It is perhaps for this reason that Muslim rulers who were keen on displaying their religious credentials would destroy silver and

gold vessels—sometimes together with images.[75] This point is made explicitly by the fourteenth-century historian al-ʿUmari, who stated that India had been taking in gold for 3,000 years without putting any of it back in circulation.[76] This contrasts with al-ʿUmari's famous description of the lavish spending of the Malinese king Musa I (d. ca. 1337) when he went on Hajj (even though Musa I apparently poured so much gold into the Egyptian economy that he caused a financial crisis through gold's devaluation).

In the context of the Abbasid political economy, the religious object functioned as a rhetorical and social sign whose value derived from its circulation within the Islamic ecumenae as well as from its materiality and previous usages. In Flood's words, "At the end of their peregrination, looted icons could be sent to Mecca . . . for ritual display and/or destruction and redistribution as alms or coin in a kind of potlatch that accrued further symbolic capital for the donor. Within a loosely but consistently articulated theory of value that valorized circulation over accumulation, such gestures exploited the material instability of the icon to enact practical critiques of idolatry."[77]

Tying up precious metals in the making of idols therefore constitutes a blameworthy act for which Indians in particular were guilty, and therefore were doubly idolatrous for their act of hoarding: "In the first place, it commits the sin of hylotheism, the confusion of a transcendental God with matter. In the second, it fetishizes materiality through accumulation, which displaces value from the mediating function of precious metals onto the materials themselves."[78] The negative view of lavish spending on religious artifacts as impious and even idolatrous was even found in attitudes toward the use of gold in the ornamentation of mosques. Al-ʿUtbi specifically contrasts the use of gold to build idols with its pious disposal in mosque construction, exemplified by the work of Mahmud of Ghazni:

> As for the gilding . . . it was not just a matter of gold plate, but also of doorbolts of red gold, cast from the golden images of idols [asnām] that had been broken up and cult statues [bidada "buddhas"] that had been taken [from India]; thus did they find themselves subjected to the fire, after

having been worshiped with submissively lowered cheeks and chins. Is not he who spends gold on the walls of the mosques of God, as a lesson for the monotheists and a provocation for the heathen, nobler and more bounteous than he who casts it into an object of worship, which he then sets up as something intended to dole out benefit and harm? We take refuge in God from a lord whose private parts are shamelessly exposed, lacking even a loincloth! And we pray to God that He reward, in the name of Islam, a king who performs such deeds and acts as these, and whose constant habit is to extend his spirit and his gifts for the sake of God![79]

Sultan Mahmud, the destroyer of the temple at Somnath, emerges as the exemplary Muslim iconoclast who separates the twin significations of the veneration of golden idols not only by looting the temple but also by refusing to return the idol for a vast amount of gold offered in ransom by the Brahmins. His pious decision to crush idolatry and, simultaneously, not to recognize the idol as an object of value is rewarded when, in the process of destroying the idol, it is found to contain a treasure of precious stones far richer than the gold that was offered for its return.[80] The example of Mahmud has been evoked on several occasions by Muslim rulers and others as the model of pious comportment toward idols and idolatry. In actual fact, however, the Muslim treatment of Hindu idols has not been one of a straightforward iconoclasm, but rather reflects local political and religious concerns as well as the interaction of centers and peripheries, and involves well-established systems of monarchic behavior that are not limited to Islamic society.

The financial dimension to the appropriation and destruction of idols competed with the potential economic benefit of leaving temples and their cultures of pilgrimage intact, and in many cases Muslim rulers preferred to keep the idols as a source of revenue. In his *Talbis Iblis*, Ibn al-Jawzi (d. 1200) reports that, when the Muslims first conquered Multan in Umayyad times, many of them wanted to destroy the city, but the local residents promised them a tribute of one-third of the temple's income if they let the temple remain. This offer was conveyed to the caliph 'Abd al-Malik, who ordered that the temple should remain

as a place of pilgrimage for Hindus who would bring large sums of money as offerings (reportedly from one hundred to a thousand dirhams each, with the ritual being invalid unless the offering was made).[81] Earlier, during the conquest of Samarqand in 705, religious images were first abused and burned, after which they were melted down, yielding fifty thousand *mithqāls* (equivalent to approximately 2.5 kg).[82]

The gifting of idols as spoils of war appears to have been common in the early Islamic period, as was discussed briefly earlier in this chapter. Among other examples, one learns of how, in 884, the ruler of Mansura, Musa ibn ʿAbd al-ʿAziz of the Habbarid dynasty that had only recently seized power from the Abbasid governor, sent the caliph al-Muʿtamid three silver idols, together with gifts of exotic animals, a throne made of aloe wood, and textiles and spices.[83] As objects of wonderment, reuse, or even in their destruction, idols figured prominently in the symbolism of Muslim religious power and piety in the eastern territories of India and Central Asia as well as in the centers of Baghdad and even Mecca, where some objects were taken to be destroyed or to be displayed, including, by some accounts, pieces of the idol taken from the Somnath temple.[84] In fact, it was not just religious images (be they manufactured or found objects) that were treated as the signifiers of idolatry, since the religious signs of other Muslims could also be subjected to rituals of destruction, as could nonritual objects of other religious groups. Mahmud is said to have sent on to Baghdad gifts, including a robe of honor, given by the Ismaʿili counter-caliph to the Ghaznavid general Hasanak. The Abbasid caliph had the robe, a symbol of the Ismaʿili counter-caliph's authority, burned at one of the palace gates that was normally used for the ceremonial destruction of idols as well as for displaying the heads of religious and political criminals.[85] This act had an explicit symbolism in a contest for Muslim legitimacy in which the Ismaʿili leaders were equal participants. Indeed, following their conquest of Multan, al-Muʿizz is alleged to have included the following request in his congratulatory letter: "We would be very much pleased if you could send us the head of that idol *(sanam)*; it would accrue to your lasting glory and would inspire your brethren at our end to increase their zeal and their desire to unite with you in a common effort in the cause of God."[86]

The varied fates of the temples in the Indus valley are symptomatic of the diverse motivations underlying Muslim iconoclastic acts, as is clear from al-Baladhuri's detailed description of the conquest of Sindh. When Daybul was conquered by Muhammad ibn al-Qasim in the early eighth century, the substantial portion of the population that was killed in a three-day massacre included the two custodians of the city temple. Furthermore, as part of the conquest, the lower tower of the temple was razed and a mosque constructed in the city, and similar policies were followed in the case of Brahmanabad. Similarly, when Kandahar was captured under the reign of al-Mansur, its temple was destroyed and a mosque built in its place. Yet no such destruction took place during the conquest of other cities with idol-venerating populations such as Nirun, Sadusan, and al-Rur, and there are reports of cities under Muslim rule with functioning idol-temples during the period of conquest.[87] In the case of Muhammad ibn al-Qasim's seizure of Multan, the sources do not mention the destruction of any temples, nor the killing of their custodians, only the imprisonment of fighting men. The significant differences in al-Biruni's account of this conquest as compared with that of al-Baladhuri are that al-Biruni states that the conqueror ordered a piece of cow's meat hung from the neck of the idol as a gesture of humiliation and that he had a mosque built in the city, suggesting that idolatry was allowed to continue along with the practice of Islam.[88] This status quo appears to have persisted until the conquest of Sindh by the Isma'ilis at the end of the tenth century.

One of the commonest practices combining gestures of victory and humiliation with the economic value of reuse of looted artifacts was the incorporation of religious objects in the architecture of new buildings in a way that required them to be stepped upon, most frequently in thresholds and doorways. This practice is not limited to the treatment of Indian religious objects, since early Islamic accounts mention that an image of the god Hubal was reused in the threshold of the Banu Shayba gate at the sanctuary of the Ka'ba, and that an idol named Dhu'l-khalasa was laid across the threshold of a mosque.[89] This practice was also carried out in India, most famously in the case of the linga from the Somnath temple. However, Muslim rulers were not the only ones to exploit the symbolic value of religious objects and buildings for

political effect in South Asia; temple looting and destruction were used regularly by Hindu and Buddhist rulers as well. For example, in the eighth or ninth century, Theravada Buddhist monks destroyed the silver image of a god housed in the temple of Vajrasana at Bodh Gaya and melted it into coinage on much the same logic as that employed by Muslim rulers.[90] Looting and the gifting of spoils of conquest functioned as an important part of the language of politics and religion in South Asia before the arrival of Muslims, and it continued in this role independent of them, such that Muslim rulers can be understood as participating in a well-established system of manipulating images in their capacity as contestants in the culture of local politics.

The use of such symbolism included not only humiliation (such as the hanging of beef on Hindu idols) or the act of trampling venerated objects underfoot, but also other gestures that indicate how Muslims held sophisticated understandings of the role of the image and icon in the ritual lives of other communities. In one version of the destruction of the Somnath temple, Mahmud ordered the idol ground into a paste and then wrapped in betel leaves to be fed to the temple Brahmins. When the Brahmins asked him for the idol's return, he said: "You misdirected people! The idol which you are demanding of me and for which you are raising such a clamour has been already consumed by you along with your betel-leaf. Give up the vain hope now, for henceforth your temple is your own stomachs which you worship instead of the idol."[91] This account resonates in three registers: first, Mahmud gets to live up to his promise of returning the idol without having to become a "seller of idols"; second, he accomplishes the humiliation of the god and its devotees while simultaneously proving their collective impotence and lack of insight; and third, it evokes the Hindu ritual of *prasād* food offerings as linked to the temple Brahmins' reputation for gluttony.

Removed from their original context, religious as well as political objects are brought into what Flood has termed a "system of second-order signification" in which they function—sometimes concurrently—as objects of monetization, negotiation, fascination, and repudiation. An example of this is provided by the treatment of regalia sent by the Kabul Shah to the caliph sometime around 813. The Kabul Shah

renounced idols, converted to Islam, and delivered his jewel encrusted throne and crown to the (future) caliph al-Ma'mun, who was serving as the governor of Khurasan at the time. The crown was conveyed personally to the Ka'ba by al-Ma'mun's vizier, but the throne was first deposited in al-Ma'mun's treasury in Marv and only subsequently forwarded to Mecca. In a letter to his vizier dated 817, al-Ma'mun praised him for "curbing polytheists, breaking idols, killing the refractory."[92]

At the same time as they participated in a political and cultural theater in which the use of material symbols, including religious images, played an important part, medieval Muslims appear to have been largely indifferent to the nature of idol worship. There is ample evidence to suggest that Muslim social elites did not see statues of Hindu gods as threatening or taboo in ways that always necessitated their destruction. On the contrary, statues that in their previous context would have had religious significance are mentioned as part of booty taken on campaigns or as noteworthy gifts exchanged between vassals and their superiors. In other cases, such statues are brought up in chronicles as an expected part of the Indian cultural landscape and accorded no special qualities.

This is not to say that there are no instances of Muslims destroying Hindu idols for the express, stated purpose of eliminating idolatry or marking the victory of Islam, as has already been discussed, since there are many examples of precisely this sort of behavior and of rulers who proudly bore the title of "idol destroyer" *(but-shikan)*. What deserves emphasizing in the context of this book is that there is no identifiable, sustained Muslim attitude toward Hindu idols or images. If anything, they were seen as curios or "wonders" (mirabilia), and are remembered as such. In his *Tadhkirat al-mulūk,* a Persian history of Bijapur, the historian and courtier Rafi' al-din Shirazi provides a detailed description of the Ellora cave temples and of the temple at Lakmir. Not only does he see them as wonders of skill and ingenuity, but he goes so far as to criticize his former patron, 'Ali 'Adil Shah (d. 1580), for destroying idols after he had conquered Vijayanagar in 1565:

> Imagine how much work has been done on the inside and
> outside of all the idol temples, and how many days and how

much time it took to complete them. May God the exalted and transcendent forgive the World-Protector with the light of his compassion, for after the conquest of Vijayanagar, he with his own blessed hand destroyed five or six thousand adored idols of unbelief, and ruined most of the idol temples. But the limited (number of buildings) on which the welfare of the time and the kingdom depended, which we know as the art of Ellora in Daulatabad, this kind of idol temple and art we have forgotten.[93]

Shirazi's description of the Ellora caves and Lakmir treats these artifacts as objects of wonder, or as mirabilia, an important category throughout Islamic history. Mirabilia stand distinct from objects of the sort mentioned as items of curiosity on account of their freakishness, though the two categories sometimes overlap when the item is of voyeuristic appeal, particularly on account of monetary value. For example, the eleventh-century *Book of Gifts and Rarities (Kitāb al-hadāya wa'l-tuhaf)*, which was revised in later centuries, lists a number of items seized as booty that were of monetary value as well as having visual appeal. These include two gold trays with figures *(tamāthīl)* modeled of ambergris, sent by the caliph al-Radi bi'llah (r. 934–940) to one Abu'l-Husayn Bajkam in 939.[94] In a battle in 637, a certain Kharija ibn al-Salt chanced upon a statue of a she-camel made out of gold with stripes of pearl and corundum. There was a figure of a man, made out of gold, on its back. Kharijah delivered this object to the overseer of booty.[95] A later campaign on the eastern front led to the acquisition of a golden peacock "studded with precious gemstones, whose eyes were of ruby, its feathers of glass enamel inlaid with gold, emulating the colors of peacock feathers; and a gazelle that looked, in color and shape, like a real gazelle. It was similar [to the peacock] in being studded with large pearls and precious stones . . . the gazelle's belly was the only white on its body—just like the color of [real] gazelles, and it was closely set with magnificent large pearls."[96]

Other objects mentioned in this work were very likely of religious value in the contexts from which they were seized but, after their appropriation by the Muslim Arabs, were transformed into mirabilia,

though it is quite likely that many such items had already been looted from their original locations by the very people from whom the Muslims acquired them as loot or tribute. Such could be the case for a gem-studded statue *(timthāl)* of a man found in Ctesiphon, "so valuable that it could not be priced." It was almost certainly the case with a silver idol *(sanam)* "in the shape of the most huge man possible," sent in 708 by the governor of Iraq, al-Hajjaj ibn Yusuf, to the Umayyad caliph al-Walid ibn 'Abd al-Malik.[97]

5

Beauty, Goodness, and Wonder

That idol has covered her woman's tresses, but not abandoned
 her pagan ways
She has cut the belt around her delicate waist, but not yet
 become a Muslim
I have wept so much blood longing for your ruby lips
Every door and wall of your town are made coral from my
 tears.

—AHMET PASHA

The majority of scholarship on Islamic art has conceptualized its subject using patterns that are familiar from writings about Western art. In such a system, the value of true "art" lies in pure aesthetic experience—an exclusively emotional response unblemished by utilitarian or other concerns. By such a reckoning, art that is religious in subject and retains valence as a religious signifier cannot provide the viewer with an aesthetic experience but only a purely religious one that is to be seen as categorically distinct. As has also been the case with scholarship about European art, Islamic art gets related to beauty, pleasure,

and aesthetics, despite the apparent absence of any systematic theory of the arts in the medieval Islamic world.[1]

It is not my purpose in this chapter to mount an assault on the academic discipline that goes by the name of art history, but in the process of exploring a visual-culture-based understanding of the place of material objects and their perception in Islamic society, I need to highlight aspects predominating in art historical approaches to visual and material objects and their uses that run counter to the arguments put forward in this book. Some of the proposed shortcomings are more factors of time, in that Islamic art history (like much scholarship on the Islamic world) has been relatively late in coming to grips with structural and poststructural theory. The key issues concern what constitutes the nature of art; it must be understood not only that what defines "art" is determined by local standards, but also that the economy of beauty versus utility in art varies in different contexts.[2] Viewed from a cultural historical perspective, one of the failings of much work on the nature of art is in how its treatment of so-called "popular" art traditions not only focuses on the perceived inability of the producers of art to view themselves as artists according to some supposedly normative notion of the artist as a conscious creative agent, but also the inability (or unwillingness) of the consumers of such art to speak about form and aesthetics in recognizable "art-speak." Writing in defense of the production of art at one extreme of a divide whose other pole is the world of "high-culture" art, Gell has pointed out that, in so-called popular, folk, or primitive culture, the producers of art are not learning the technology of production or of the designs, motifs, and forms they use for whimsical or arbitrary reasons. In all societies, those locally regarded as artists self-consciously work to satisfy the needs of an audience of consumers who must be regarded as sophisticated as well as educated in their ability to assess the quality of the object and its adherence to traditions of artistic production, and to determine if the object meets their requirements. Notions of beauty certainly play a role in such assessments, and it is just as misleading to assume that "folk" or "popular" arts are assessed solely on the basis of their utilitarian (or even magical) value as it is to claim that aesthetic concerns trump utilitarian ones in the case of so-called "high" art.[3]

This observation bears directly on questions of definitions of art versus artifact, of aesthetics, and of broader issues concerning museumship (not just the question of whether an object belongs in a museum of fine art or one of natural history but also whether or not displaying an object in a museum modifies or even obliterates its original purpose, and so on); the aesthetic valuation of art objects also derives in no small part from the way in which linguistic semiotics and philosophical aesthetics have found their way into the study of art. Art historians have been very interested in the use of language since the late nineteenth century when they tried to associate their discipline with that of philology, which enjoyed prestige as a positivist "science" (and continues to do so in certain academic circles). Under this influence, issues of legibility, signification, and meaning have been employed unproblematically, reducing the status of images to that of orderly signs that only await decoding by a trained interpreter.[4] Much of the problem, from the perspective of visual and culture studies, lies in the treatment and interpretation of iconography (a topic dealt with at length elsewhere in this book). Even though it would be impossible to study images and iconography without relying on texts for clarification of meanings or establishing contexts, an excessive reliance on texts runs the risk of treating images as nothing more than illustrations accompanying the text, as "verbal statements made by non-verbal means." The visual image is "more intractable, offering only ambiguous answers to many of the questions that the text-bound historian is inclined to ask."[5] This problem is probably a consequence of the overly enthusiastic application of a method employed by Panofsky in the study of painting across time and culture. Many students of iconography focused on the discovery of a textual source that would help explain the meaning of an image, as if finding a contemporary text referring to images would unlock the mysteries of the visual world. In the process, such scholarship ignores the fact that consumers of images do not necessarily inhabit the same universe as the bookish scholars who write about issues of resemblance or representation. The artists are likely to have lived at an even greater remove, since they would rarely be scholars, having earned their reputations for their ability to create visually rather than to textually explain the nature and purpose of visual representation.[6]

Following the material turn across a number of historical and anthropological disciplines, this book takes a more guarded view of the value of linguistic models for the understanding of visual art. At one level, one must remember (following Freedberg) that art is about *doing* in addition to communicating meaning or affecting emotion. "'Doing' is theorized as agency, as a process involving indexes and effects; the anthropology of art is constructed as a theory of agency, or of the mediation of agency by indexes, understood simply as material entities which motivate inferences, responses or interpretations. Indexes stand in a variety of relations to prototypes, artists, and recipients. Prototypes and the things that indices may represent or stand for, such as the person depicted in a portrait—though things may be 'represented' non-mimetically, and non-visually."[7] Art is not meant only to be displayed, viewed, and enjoyed, but in every cultural and social context it serves a broader role in helping people think about and be connected to their world.[8]

Muslim societies are no different from others in this regard, yet some scholars have taken theoretical stances on the nature of Islamic art that run counter to the wider view prevalent in visual and material cultural studies. To take the (already debatable) hypothesis that Islamic art is never a "form of religious worship or of communicating with the divine" does not automatically mean that it can only be "an aesthetic medium used for displaying pleasing things, artfully produced, either for pleasure or for donation as a pious act."[9]

The distinction between aesthetics and utility (or function) looms large in discussions of Islamic art; whatever is defined as "Islamic" is labeled as purely aesthetic, since according to the very narrow definition of what constitutes religion that is being applied, such an object cannot have a religious function. This problem is illustrated by claims about Islamic art such as "The creation of the visual arts was guided by aesthetic criteria alone; as an expression of beauty, the art object could serve as a religious or a status symbol, or to embellish everyday life,"[10] or by:

> The arts of the Arabs are not metaphoric, not to be understood as revelations of universal wisdom. . . . It is the context

and the user who bestow moral significance upon the work of art. As a profane discipline it obeys only the criteria of the specialists and technicians of each genre and the patron's judgment.

By adopting Aristotle's distinction between the beauty of form and that of content, the Arabs opted for the aesthetic approach. The lack of a systematic visual symbolism, the rarity of human depictions, and a preference for schematic and abstract representations led Islamic art toward a pronounced visuality and aestheticity.[11]

Such extreme connections made between Islamic art and aesthetics are misguided, though partly understandable based on the legacy of much of Islamic scholarly literature. Late antique thought influenced the Islamic world not just in the realms of philosophy and the sciences, but also in matters of aesthetics. Plato's thought regarding beauty and goodness therefore forms an important foundation for the subsequent development of Islamic ideas. As in Christendom, writers in the medieval Islamic world maintained a close relationship between concepts of transcendent beauty and aesthetics, and held that beautiful visual objects had the capacity of evoking love and of providing a preview of metaphysical or heavenly beauty. Similarly, the medieval Islamic theory concerning the attraction of the soul to harmonious proportion and bright colors in the composition of visual images reflected a belief in objective standards of beauty as well as subjective systems of aesthetic perception and appreciation, assuming the existence of a relationship between an object and its viewer that took under consideration the emotional response of the latter.[12]

Islamic philosophical attitudes toward aesthetics and the arts are often traced to late antique precedents, and are especially similar to positions on the arts expressed by Plato, which deserve to be outlined briefly here.[13] A major part of Plato's critique of art centers around a condemnation of artists, whom he sees as doubly blameworthy for being mimetic or imitative. In the first place, a painter (or even a writer) accepts and replicates appearances without understanding what underlies them, and in the second, when they imitate (and replicate) the

bad, they are contributing to the totality of badness in the world.[14] In a concrete example of a painting of a bed, God (or some other form of intellect) generates the idea of a bed, after which a carpenter makes it. The artist, for his or her part, only copies the bed and is therefore at three removes from its original form, neither understanding it, nor being able to manufacture it. Plato makes the same point in Book X of the *Republic* with reference to philosophy where "the artist begins indeed to look like a special sort of sophist, and not the least of his crimes is that he directs our attention to particulars which he presents as intuitively knowable, whereas concerning their knowability philosophy has grave and weighty doubts. Art undoes the work of philosophy by deliberately fusing knowledge by acquaintance and knowledge by description."[15]

For Plato, as for most writers of Muslim ethical works, beauty is moral rather than purely aesthetic in nature, and is therefore linked to goodness. One understands the beauty of the world by studying the work of its divine creator.[16] In places, Plato wants to divorce beauty from any connection to art, since beauty and virtue are too weighty as concerns to be muddled with something as frivolous as art.[17] In other contexts, he states that the arts can and must be employed in an intelligent manner to bring about harmony rather than induce irrational, emotional pleasure. This point is made clearly in the *Timaeus* where Plato argues that the role of a true artist is to identify and amplify the harmonious elements of creation through the (re)production of good design as distinct from the creation of objects that pretend to rival God's creative prerogatives. To accomplish this, such artists (like all craftsmen) should study the world very carefully in order to differentiate between its reality and its appearances.[18]

Plato's attitude toward art is functional and moralistic at a minimum, and religious in nature when viewed from a broader perspective; many of his attitudes on the subject bear striking similarities to Islamic attitudes toward past-times, trades, and cultural products, if not explicitly the arts. Murdoch takes a degree of literary license, yet retains clarity and value in summarizing Plato's objections to art:

> Art is dangerous chiefly because it apes the spiritual and subtly disguises and trivializes it. Artists play irresponsibly

with religious imagery which, if it must exist, should be critically controlled by the internal, or external, authority of reason. Artists obscure the enlightening power of thought and skill by aiming at plausibility rather than truth.... Art is playful in a sinister sense, full of a spiteful amused acceptance of evil, and through buffoonery and mockery weakens moral determination. The artist cannot represent or celebrate the good, but only what is daemonic and fantastic and extreme; whereas truth is quiet and sober and confined. Art is sophistry, at best an ironic *mimesis* whose fake "truthfulness" is a subtle enemy of virtue. Indirectness and irony prevent the immediate relationship with truth which occurs in live discourse; art is thus the enemy of dialectic.[19]

At the same time, however, in the *Laws* Plato speaks of the positive didactic purposes of art in education and the promotion of good qualities.[20]

Aesthetic Theory and the Nature of Art

The Platonic concern with the uses of art notwithstanding, for the most part, modern Western aesthetics is concerned with questions of beauty in art. Lessing, the towering figure in the development of modern aesthetics, was explicit in his view that the real purpose of painting and related visual arts was to represent beautiful bodies in space, detached from any practical context. Religion, in his view, is the enemy of real art, since it wrenches art from its proper purpose and subordinates it to an alien agenda, that of functioning as symbols and signifiers for narrative and discourse. Art that lends itself naturally to such pedestrian purposes is not to be considered art at all:

> Among the antiques that have been unburied we should discriminate and call only those works of art which are the handiwork of the artist purely as artist.... All the rest, all that show an evident religious tendency, are unworthy to be called works of art. In them art was not working for her own

sake, but was simply the tool of Religion, having symbolic representations forced upon her with more regard to their significance than their beauty.[21]

The true purpose of art, in this view, would be to inspire a form of detached contemplation completely free from any concern with didactic, ritual, or other purposes. Not surprisingly, such a stance is not without its critics, who see the field of modern aesthetics as having anesthetized human cognition by eliminating the concept of function or relevance by removing the visual object from a context of engagement or relevance and changing it to one of disinterested contemplation. As put by Geertz, "the aesthetic involves a different sort of suspension of naive realism and practical interest, in that instead of questioning the credentials of everyday experience, one merely ignores that experience in favour of an eager dwelling upon appearances, an engrossment in surfaces, an absorption in things, as we say, 'in themselves.'"[22] The echoes of Lessing persist in viewpoints that draw distinctions between religious modes of perception and understanding that attempt to make sense of human experience through symbolic and ritual systems, and the aesthetic view that decontextualizes objects yet simultaneously gives them a superficial stability through the very act of decontextualization. It is the tearing of an object from its context that allows for objects of historical significance to be neutered and seen purely as "art." This process can be described as one of anaesthetization, and the aesthetics of detached contemplation as "anathetics" to distinguish them from the Greek field of aesthetics known as *aisthētikos* that connoted a broad sphere of sensory reality.[23]

The dichotomy between the purposes of religion and the nature of aesthetics is complicated somewhat by the notion of disinterested belief found in American Protestantism and shared in many ways by modalities of Muslim belief and practice. In the American case, the association of religion with disinterestedness can be traced to Jonathan Edwards (d. 1758) and his followers, for whom real belief was characterized by a disinterested and selfless appeal to God's beauty; this beauty was pondered without any concern for personal gain, with the divine qualities contemplated out of appreciation for their intrin-

sic value.[24] However, such religious disinterestedness applies to the contemplation of God and to the human relationship with the divine, not to the production and use of objects that represent the divine and that would still be subject to questions of contextual use.

In contrast to an aesthetic theory of disinterestedness, visual and material culture-centered views of the arts argue that artistic production and appreciation always occur in social environments, and that social communities value specific forms, styles, and ornamentation in objects, which they also encode with meanings that they collectively regard as intelligible.[25] In this regard, a distinction can be drawn in much of the relevant scholarship between Western and supposedly non-Western systems of aesthetics, the latter only existing as a construct because of what Gell has called our "quasi-religious veneration of art objects as aesthetic talismans."[26] The desire to identify and work within systems of so-called "indigenous aesthetics" represents nothing more than an attempt to make non-Western arts (as well as Western popular and folk arts) meaningful to Western consumers of art.

The case for a more experientially grounded system of aesthetic appreciation is compelling; in such a system, both beauty and goodness (to which beauty is linked) would be perceived in visual objects that constitute imperfect representations in some manner, and would thus provoke contemplation on the part of the observer. In religious terms, this imperfect mimesis is essential; were it not there, the claim that one possessed a perfect representation of God or his varied manifestations would inevitably lead to charges of idolatry.[27] Aesthetic contemplation need not be completely distinct from the religious, nor does it necessarily transform the nature of perception. In fact, the religious reaction to visual objects is itself aesthetic, constituting what Morgan has called the "apocalyptic glance" that—although it does not rest contemplatively in the present—anticipates meanings to be revealed in the future.[28]

The religious (or apocalyptic) aesthetic is distinct not only from that of disinterested contemplation imagined by Lessing, but also from that at the center of Kantian aesthetics, which sees the contemplation of beauty as a kind of noninstrumental enjoyment. Objects are beautiful precisely because they possess within themselves their reason for

being, and do not elicit any emotion or suggest a use for themselves beyond their enjoyment. Freed from the danger of utilitarian or even erotic desire on the part of the beholder, the beautiful object does nothing other than exist as an object of pure contemplation. For Kant, it is only the representation of the object in the imagination that lends itself to aesthetic contemplation, not the physical object itself.

Such distinctions between physical existence, representation, and contemplation in the imagination arguably cannot be applied to most material objects, and especially not to religious art since representation, imagination, and experience necessarily merge in many aspects of religious visual culture. Put differently, popular aesthetics—which include the sorts of religious aesthetics studied here—depend on viewing the imagined object as real, in contrast to a Kantian aesthetic of disinterestedness that joins understanding and imagination in a harmonious mental state.[29]

Equally important as a critique of an aesthetic of disinterestedness in the context of religious visual culture is the danger of overlooking a major portion of religious experience and behavior. This is likely to happen if we accept the conclusion put forward by proponents of so-called "high" art aesthetics who argue for an opposition between apophatic (ineffable and transcendent) and cataphatic (experiential and immanent) religious experience, with the former as superior to the latter, and hold that aesthetic contemplation can only brook religion in a timeless and decontextualized form, as an essence.[30]

If one holds to an aesthetic theory in which the only acceptable use of a beautiful image is one of detached and disinterested contemplation, then, when faced with the fact that human beings actually *do* use images in various arenas of their lives in myriad and visceral ways, one is likely to find the "nonartistic" image threatening. This is precisely the case with Lessing (as well as Burke and others), who treats images as markers of the social, religious, and sexual "other" and deserving of fear and contempt. The contempt might derive from the belief that images (as distinct from art) are an inferior order of signs, powerless and mute; the fear springs from the knowledge that these signs, together with the individuals and societies that believe in them, gain a voice and, through it, power.[31] As we shall see in the discussion of iconology

BEAUTY, GOODNESS, AND WONDER

149

and representation, such a fear of the not-purely-artistic image is based
in the realization that no comprehensive system of understanding im-
ages can avoid confronting the vitality that imaged form holds for both
iconophiles and iconoclasts (as well as for fetishists, idolaters, and a
host of other individuals for whom images hold meaning). The exis-
tence of such images and their audiences makes it very difficult to posit
that there are unmediated, transcendent objects of aesthetic contem-
plation that are neither true or false nor worshipped or despised.[32] In
the study of visual religious art, one must confront these very images
in their myriad forms, be they figures and imaginal constructions,
ritual objects, or the wide variety of visual and material objects found
in society at large.

Bourdieu's ideas concerning the social place and relational nature of
artistic production and reception are relevant in this regard. He argues
(against Foucault) for the necessity to look beyond a "field of discourse"
in order to understand specific elements of discourse within it, and
consequently to relate artistic objects to the specific social conditions
of their cultural production. He simultaneously argues against the
Kantian aesthetic of a pure, disinterested gaze and the related notion
that art objects hold some innate, independent qualities, underlining
the fallacy of a valuation in which "a homologous opposition" is drawn
between bourgeois art that is valued as true art and other forms of
artistic production that are suspect because they are popular as well as
mercantile.[33]

Islamic Aesthetics

Such a concern with a socially determined contextual notion of aes-
thetics has not penetrated deeply into discussions of Islamic visual
culture and art, and most works on the subject are still concerned with
highly abstract, philosophical aesthetic theories linking beauty to vir-
tue rather than to embodied or somatic aspects of human experience.
At one level, it has been argued that aesthetic experience in the pre-
modern Islamic world is relative—deriving from subjective awareness
that results jointly from the quality of the object and the observer's

perspective, and contrasting therefore with aesthetic theories that argue for fixed and universally discernible standards of beauty.[34] On another level, there is an attempt to find precisely such a universal notion of beauty in an ultimately futile search for a singular Muslim aesthetic that runs through all times and places. Thus even in contending with the variety of aesthetic approaches in Islamic culture, important works on the subject assert the continuity of a highly intellectual and rarified scholarly world that is to be seen as the arbiter of how beauty is to be qualified:

> Classical Arabic thought invested beauty with various significations, from the sublimely beautiful in the human person and yoked with ethics in Ibn Hazm's theory, to the phenomenologically modulated and classified beauty of Ibn al-Haytham to both opposed visions of the luminescent and intellectual beauty from the divine source of Ibn Sina and the beautiful structural order of the material world of Ibn Rushd. In a sense all kinds of beauty—logical, metaphysical, physical and ethical—are to be found in medieval Islam. An analogous remark can be made about the opposite concept, ugliness which equally presents many faces and various aspects associated with immorality, imperfection, disproportion, ignorance and disorder.[35]

There is no doubt—nor is it at all surprising—that notions of beauty play an important role in many aspects of Islamic thought and culture. The Qur'an speaks frequently of beauty, and Qur'anic notions of beauty are relevant to all discussions of aesthetics in the Muslim world because not only is Qur'anic speech seen as the model of rhetorical excellence on which all later Arabic writing ostensibly is based, but the Qur'an itself is the epitome of beauty. Both concepts have far-reaching consequences in elevating writing and somewhat abstract notions of aesthetics and perception in Muslim society. Similarly, the centrality of beauty is affirmed in a famous noncanonical hadith that continues to be popular to this day: "God is beautiful and He loves beauty."

The common Arabic words for beauty, *husn* and *jamāl*, appear in the Qur'an, although both refer primarily to either moral goodness or else

to divine beauty, which is definitionally inimicable. *Husn,* etymologically related to the word for "good," is commonly used in the Qur'an and in classical Islamic ethical literature as referring to beauty of character or moral beauty and, as such, carries a moral rather than aesthetic connotation. *Jamāl* is an epithet for God and is not used in the Qur'an to refer to physical beauty. Over time, Muslim theologians—particularly Sufi ones—began to categorize divine epithets mentioned in the Qur'an into two groups, the "Attributes of Beauty" (*sifāt al-jamāl* or *al-sifāt al-jamāliyya*) and the "Attributes of Majesty" *(al-sifāt al-jalāliyya),* that were paired with each other. Beauty as *"jamāl"* therefore does not refer to a visually perceptible form of beauty, nor necessarily to beauty at all, but is a typological complement of majesty. The two categories represent God's nurturing and authoritative aspects, and are frequently understood—if not explicitly described—as feminine and masculine.[36] The word most commonly used in the Qur'an to describe a visible form of beauty is *zīna,* the verb *zayyana* meaning to adorn, ornament, or make beautiful. The Qur'an uses this word both for the beauty of the world and the adornment of women. Although both the Qur'an and commentary literature certainly see contemplation of the physical beauty of the world as serving didactic, exhortative, and cautionary purposes, *zīna* is fundamentally a reference to visible forms of beauty or ornament of an aesthetic variety.[37] *Zīna* and *tazyīn* continue to be used in religious works of the classical period as words connoting physical adornment, both in the sense of the adornment of human beings and of the earth, although good moral character is also described as a form of human adornment. As such, even the most physical notions of beauty in the Qur'an remain inseparable from the concept of moral goodness, maintaining a connection between aesthetics and ethics.

Moral beauty relies on notions of human virtue that emphasize harmony above all else, in the sense that no part of an individual's character runs to an extreme, and similar notions of harmony characterize certain aesthetic notions of beauty as well, such that physical beauty constitutes outward evidence of inner virtue. Precisely this link between inner and outer beauty is made in a hadith that claims the beautiful believer is the most beloved of God and the ugly disbeliever

the most hated of him, and a widespread belief in the physical beauty of prophets and saints reinforces such an idea.[38]

Ibn Khaldun (d. 1406) is explicit in twinning beauty to harmony of physical and moral sorts, and he claims that the somatic perception of beauty "harmonizes with the cognitive soul, which enjoys perceiving that which is in harmony with itself" in much the same way that the souls of lovers meet and blend together. He goes on to declare that the "perfection of proportion and setting are the quintessence of beauty in everything."[39] He makes this point clearly in the following passage:

> Agreeable sensations of vision and hearing are caused by harmonious arrangement in the forms and qualities of [the things seen or heard]. This impresses the soul as harmonious and is more agreeable to it.
>
> If an object of vision is harmonious in the forms and lines given to it in accordance with the matter from which it is made, so that the requirements of its particular matter as to perfect harmony and arrangement are not discarded—that being the meaning of beauty and loveliness whenever these terms are used for any object of sensual perception—that [object of vision] is then in harmony with the soul that perceives [it], and the soul thus feels pleasure as the result of perceiving something that is agreeable to it. . . . Thus every man desires beauty in the objects of vision and hearing, as a requirement of his nature.[40]

As Behrens-Abouseif has noted in her discussion of Arab aesthetics, Ibn Khaldun's concept of aesthetic harmony includes not just the composition of the object but also the affinity that results between the object and its observer. Criteria of harmony and proportion remain subjective and flexible in such a system, and do not refer to some external aesthetic standard. The same holds true for aesthetic statements made by other scholars, such as when the twelfth-century writer 'Abd al-Latif al-Baghdadi praises the Sphinx for its harmonious proportions or when al-Jahiz (d. 869) talks about the beauty of women—they do not refer to standard criteria or canons of beauty to rate the object of their discussion. Instead, their emphasis is on subjective criteria such as the pleas-

ing effect of the objects, which help them judge the object of apprecia-
tion as beautiful.[41] Similarly, the idea that human beings derive pleasure
from beautiful things because their souls are drawn to beauty is made
by many writers, including the sixteenth-century Taşköprüzade, who
states: "Man's soul adores and is in love with beautiful things. When-
ever the soul sees a beautiful image or hears a beautiful sound it re-
members the realm of intelligible entities and for that reason it is de-
lighted and exalted."[42]

Philosophy, Science, and Aesthetics

Islamic philosophical writings address questions of beauty and virtue
with some frequency, although aesthetic beauty is not itself central to
the discussion for many authors, their emphasis remaining primarily
on how to live a virtuous life and thereby to maximize happiness in
this world and an afterlife. Al-Farabi and Ibn Sina both address issues
of beauty, as do other philosophical and scientific thinkers including
the Ikhwan al-Safa', Ibn Hazm, Ibn al-Haytham, and others. However,
as I've already mentioned, one must not forget that much philosophi-
cal thinking remained arcane, esoteric, and disconnected from larger
intellectual currents in Islamic society, especially after the thirteenth
century, to the point that it would be misleading to argue that philo-
sophical aesthetics had much direct impact on the way material and
visual religious art was understood by a wider society. This is likely
true of the Ikhwan al-Safa', an esoteric group of scholars whose popu-
larity in modern Western scholarship outstrips its direct influence in
its own environment. If anything, through the assumptions that un-
derlie their arguments, philosophical thinkers might be seen more
appropriately as indices of the beliefs of their times rather than as in-
tellectual vanguards influencing the wider society with the finer points
of their ideas.

In his *The Principles of the Views of the Citizens of the Virtuous City (Mabādi'
ārā' ahl al-madīna al-fāḍila)*, al-Farabi (d. 950) describes the First Cause as
dazzlingly beautiful: "It is difficult and hard for us to apprehend (the
First Cause) because of the weakness of our intellectual faculties, mixed

as they are with matter and non-being.... The overwhelming perfection (of the First Cause) dazzles us.... The more perfect and the more powerful a visible is, the weaker is our visual apprehension of it ... the perfection of its splendor dazzles our sight so that our eyes are bewildered. Thus are our minds in relation to the First Cause, the First Intellect and the First Living."[43] He goes on to define beauty as synonymous with anything that is in a state of "ultimate perfection," concluding that "since the First is in the most excellent state of existence, its beauty surpasses the beauty of every other beautiful existent" through the nature of its essence and on account of its self-intellection. Whereas in the case of all other existents—including human beings—in which beauty is an accident, in the case of the First Cause, beauty *(jamāl)* and the beautiful *(jamīl)* are one essence.

Ibn Sina (d. 1037) also addresses the question of beauty and believes that God (the Necessary Being) not only possesses beauty and pure splendor *(al-jamāl wa'l-bahā' al-mahd),* but that he is also the origin of all harmony, "given that every harmony occurs within the multiplicity of one composition or mixture and in this way creates unity in multiplicity."[44] For all other existents, beauty and splendor comprise the fact that they are the way they have to be.[45] Speaking of divine beauty, Ibn Sina declares:

> Let none, then, be so bold as to compare Him to anything whatsoever. He has no members that divide Him: He is all a face by His beauty, and His beauty obliterates the vestiges of all other beauty. When one of those who surround His immensity undertakes to meditate on Him, his eye blinks with stupor and he comes away dazzled. Indeed, his eyes are almost ravished from him.... It would seem that His beauty is the veil of his beauty.... Even so it is by veiling itself a little that the sun can be better contemplated.... Whoever perceives a trace of His beauty fixes his contemplation upon it forever.[46]

Human beings attain happiness only insofar as they are able to discipline their speculative faculties and think abstractly, through which they apprehend more exalted things.[47] This includes not just exalted intellectual thought but also artistic forms such as poetry, which Ibn

Sina characterizes as imaginative speech and claims that assent to poetry "is a kind of compliance due to the wonder *(ta'ajjub)* and plea-sure *(ladhdha)* that are caused by the utterance itself."[48]

A related attitude toward beauty is displayed in the work of Ibn Hazm (d. 1064) who, like Ibn Sina, considered beauty to be an object of love: "As for what causes love in most cases to choose a beautiful form to light upon, it is evident that the soul itself being beautiful, it is af-fected by all beautiful things, and has a yearning for perfect symmetri-cal images; whenever it sees any such images, it fixes itself upon it; then, if it discerns behind that image something of its own kind, it becomes united and true love is established."[49] In the fifth and sixth chapters of his *Kitāb al-akhlāq wa'l-siyar,* Ibn Hazm classifies the attri-butes of perceptible beauty into a threefold hierarchy in which he de-fines both splendor or awe-inspiring beauty *(raw'a)* and the highest or-der of physical beauty *(husn):*

> Splendor is the beauty *(bahā')* of the visible parts; it is also elegance and nobility [perhaps "lightness" and "swiftness," *al-farāha wa'l-'itq*]. Beauty is something that no other name designates in speech, but is sensed *(mahsūs)* in the soul simi-larly by all who see it. It is like a fine fabric draped over the face, a radiance that attracts hearts toward it. Opinions agree on its comeliness *(istihsān)* even though there are no beautiful attributes *(sifāt jamīla)* in it; everyone that sees it admires it, considers it beautiful *(istahsanahu)* and accepts it, even though when its attributes are contemplated individu-ally it does not look impressive. It is as if something in the soul of that which is seen is found by the soul of the viewer. This is the most exalted level of beauty *(sabāha).* Beyond that, tastes differ: some prefer splendor *(raw'a),* some prefer femi-nine beauty [perhaps "sweetness," *halāwa*], but we do not find anyone who prefers symmetry of proportion *(qawām)* in and of itself.[50]

Ibn Hazm, the Ikhwan al-Safa', and Ibn Sina all appear to situate beauty in an abstract, conceptual realm, and they differ in this from other thinkers such as Ibn Rushd and Ibn al-Haytham, both of whom

accord material specificity to beauty.[51] Ibn al-Haytham is rightly noted for his writings on optics, but his thoughts on the psychology of perception are just as important, and perhaps more revolutionary, than those on physics. He was no doubt following in late antique intellectual footsteps in his belief that proportion is the primary determinant of beauty, to which he added the aesthetics of light as a factor, and his treatment of the psychology of visual perception might well be the most sustained premodern discussion on the aesthetics of beauty in Arabic.[52]

Ibn al-Haytham discusses in detail the factors that go into the production and perception of beauty, which I will reproduce here at length because of their value to understanding an important hypothesis concerning visual perception in medieval Islam, the technical aspects of which are addressed in Chapter 6. Some of these factors are physical and belong more appropriately in a discussion of optics, but the majority bear directly on visual aesthetics:

> It is these particular properties that separately produce beauty—and by "producing beauty" I mean that they produce in the soul an effect such that the form appears beautiful—[which] will be evident from a brief consideration. For light produces beauty, and thus the sun, the moon, and the stars look beautiful, without there being in them a cause on account of which their form looks beautiful and appealing other than their radiant light. Therefore, light by itself produces beauty.
>
> Colour also produces beauty. For every bright colour ... appeal[s] to the beholder and please[s] the eye. Similarly, dyed clothes and covers and utensils, also flowers, blossoms and meadows, are felt to be beautiful. Therefore colour by itself produces beauty.
>
> Distance, too, may produce beauty by accident. For some apparently beautiful forms may have marks, wrinkles, or pores that mar and perturb their beauty. But when moved farther away from the eye, these minute marring features disappear, and the beauty of the form stands out. Similarly, many beautiful-looking forms possess certain refinements,

such as minute designs or outlines or ordering [of parts] which account for the beauty of the form. Many of these features may not appear to the eye from moderate distances, but when brought closer to it they become visible and the beauty of the form becomes manifest. Thus, increasing or diminishing the distance [from the eye] may cause beauty to appear, and, therefore, distance by itself produces beauty.

Position produces beauty, and many things that look beautiful do so only because of order and position. Beautiful writing also is regarded as such because of order alone. For the beauty of writing is due only to the soundness of the shapes of letters and their composition among themselves, so that when the composition and order of the letters is not regular and proportionate the writing will not be beautiful, even though the shapes of individual letters may be correct and sound. Indeed, writing is considered beautiful when of regular composition, even though the letters in it are not quite sound. Similarly, many forms of visible objects are felt to be beautiful and appealing only because of the composition and order of their parts among themselves.

Solidity produces beauty, and thus the full-grown bodies of individual human beings and of many animals are considered beautiful.

Shape produces beauty, and thus a crescent moon looks beautiful. The beautiful forms of individual human beings and of many individual animals, trees and plants look beautiful only on account of their shapes and the shapes of the parts of [their] form.

Size produces beauty, and that is why the moon is more beautiful than any one of the stars, and the larger stars are more beautiful than the smaller.

Separateness produces beauty. Thus dispersed stars are more beautiful than nebulae and the Milky Way. And that is also why separated lamps and candles are more beautiful than a continuously collected fire. For this reason, too,

blossoms and flowers dispersed in meadows look more beautiful than when they are gathered and crowded together.

Continuity produces beauty. Thus meadows with contiguous and dense vegetation are more beautiful than those in which the vegetation is interrupted and discontinuous. And of the meadows that look beautiful because of their colours, those which are continuous are more beautiful than the others. The additional beauty in these is produced by continuity alone.

Number produces beauty, and so portions of the sky with many stars are more beautiful than those with few stars. And for this reason, too, lamps and candles look beautiful when many of them are gathered in one place.

Motion produces beauty; hence the beauty of dancing, and of the movements of the dancer, and of many of the gestures and movements of man in speech and in action.

Rest produces beauty, and therefore gravity and staidness appear beautiful.

Roughness produces beauty. Thus many rough clothes and covers look beautiful; and for this reason many of the goldsmith's artifacts become beautiful by having their surfaces roughened and textured.

Smoothness produces beauty, and therefore it is beautiful in cloth and utensils.

Transparency produces beauty, and therefore transparent precious stones and transparent utensils are felt to be beautiful.

Opacity produces beauty, for colours, lights, shapes, outlines, and all beautiful-looking features that are seen in the forms of visible objects are perceptible to sight only on account of opacity.

Shadow causes beauty to appear, for many of the forms of visible objects have in them minute marks . . . which mar them and eclipse their beauty. . . . But when placed in shadow or in faint lights their beautiful features become manifest as a result of the disappearance of those marring marks. . . .

Darkness causes beauty to appear. For the stars are visible only in darkness. And, similarly, the beauty of lamps, candles and fires only appears in the darkness of night or in darkened places, but not in daylight or in strong lights. And the stars are more beautiful in dark nights than in moonlit nights.

Similarity produces beauty. For paired organs of an animal are beautiful only when they are similar. Thus if eyes are of different shapes ... they will be extremely ugly. They will also be found ugly if one is black and the other blue, and likewise if one is larger than the other. ... Again, designs and the letters of a script are beautiful only when identical letters or parts are similar.

Dissimilarity produces beauty. For the shapes of animals' organs are of dissimilar parts, and without this dissimilarity they would cease to be beautiful ... eyebrows are beautiful only when they are narrower at the ends than elsewhere. ... And, similarly, designs and the letters of a script will not look beautiful if their parts are of equal thickness. For the extremities of letters and the ends of their deep curves are beautiful only when they are narrow, that is, narrower than the remaining parts of the letters. A script would be very ugly if its letters were of equal thickness and of the same shape at their ends, middles, beginnings, junctions and joints. Dissimilarity therefore produces beauty in many of the forms of visible objects.[53]

According to Ibn al-Haytham, these properties *(ma'nā)* do not result in beauty in all situations, but they can produce beauty in combination with each other, and often an item can be more beautiful when it joins together more than one of these properties (for example, writing when it possesses beautiful shape as well as position). What is most striking about Ibn al-Haytham's aesthetic theory is that beauty is presented as an objective, externally determined visual quality. It is the presence of one or more of his twenty-two listed beauty-producing properties that determines whether something is beautiful or not, yet his penchant for meadow flowers and almond-shaped eyes suggests

that Ibn al-Haytham was unaware of the culturally determined nature of his objective standard of beauty. Unsurprisingly, these factors are not seen as determining beauty in exactly the same way in the art and literature of the wider Islamic world across time, nor are similar lists of criteria found in other sources, although Ibn al-Haytham does have certain notions of perception (discussed in Chapter 6) that provide a novel theory of recognition and evaluation in visual perception. What is clear with relevance to aesthetics is that he sees proportionality and harmony as key to beauty, such that the properties that are capable of resulting in beauty do so when combined with another appropriate factor or placed in an appropriate location (for example, almond-shaped eyes look best with a narrow nose of the right size).[54]

Among the other examples of medieval Islamic thinkers who have been seen as bearing on discussions of visual aesthetics are the Ikhwan al-Safa' (Brethren of Purity), whose relevance to the study of art and perception has been discussed at length by Necipoğlu. Unlike proponents of the aesthetic theories mentioned above that are based on scientific (or rational) principles, the Ikhwan al-Safa' approached beauty metaphysically, arguing that aesthetic pleasure results when the soul discovers its own inner harmony reproduced in the object of contemplation. Love for beauty is a natural emotion that causes one's sensory organs to long for harmonious visual and auditory input.[55] For this group of philosophers (as for many other Muslim metaphysical thinkers), the love of beauty is innate, and exposure to beautiful things arouses emotions of love, longing, delight, and wonderment.[56] Like other writers addressing questions of beauty, the Ikhwan al-Safa' regarded visual objects as beautiful based on their ability to capture and reflect proportionality and symmetry, which in the case of this group of thinkers amounted to representing the corresponding qualities of the universe.[57]

Literary Aesthetics and the Visually Beautiful

Recent scholarship on the aesthetics of Islamic art has tried to look at classical and medieval writings on Arabic poetics and literary theory

to understand aesthetic standards in the visual arts. Some of the most important contributions to these questions occur in works exploring the relationship of texts to images. Although visual imagery abounds in Arabic (and other) Islamic literature, and theorists talk about issues of imagination and imagery, there is no real reason to think that textual imagery in Arabic belles-lettres had much influence over the development of visual aesthetics, especially in the non-Arabic-speaking parts of the Muslim world. Equally importantly, literary aesthetics constitute an elite discourse and are not likely to be an accurate reflection of the popular aesthetics—even literary ones—of their societies. Nevertheless, it is worth noting that questions of beauty as they are developed in classical and medieval Arabic literary theory strongly reflect ideas concerning the nature of the imagination and of beauty, wonderment, and pleasure seen in the Islamic philosophical tradition as developed by Ibn Sina. Two Arab writers, 'Abd al-Qahir al-Jurjani (d. 1078) and al-Qartajanni (d. 1285), have been of particular interest to Islamic art historians trying to find a link between literary aesthetics and the world of visual culture.

Al-Jurjani stresses the importance of harmony as a universal criterion of beauty and its appreciation as manifested in the construction of structural relationships. "[Beauty] is manifest in all crafts and artistic activities which are associated with subtlety, fineness, and skill. In the images produced in such crafts it is always the case that the more widely different the shape and appearance of their parts are and then the more perfect the harmony achieved between these parts is, the more fascination the images will possess and the more deserving of praise for their skill their creators will be."[58] Al-Jurjani uses a piece of jewelry as an example of an object that is beautiful on account of the harmonious composition of its elements. Significantly, his notion of harmony does not imply similitude, since al-Jurjani maintains that beauty lies in contrasts or "the affinity of contraries" *(shiddat i'tilāf fī shiddat ikhtilāf).*[59]

Perhaps al-Jurjani's major contribution relevant to aesthetic attitudes toward the visual image is in the strong connection he creates between imagery, meaning, and syntax in the composition of poetry. For him, imagery became an integral part of the structure of language,

inseparable from its meaning.[60] Al-Qartajanni, in a similar vein and like most other literary critics of his day, valued novelty and strangeness for their ability to induce wonderment and pleasure. Novelty is best generated through artifice, meaning that any use of imagery—visual or otherwise—in poetry valued by al-Qartajanni and those like him would not even attempt to be a faithful representation of an object, person, or feeling. Accurate reproduction was not the goal of the aesthetically desirable literary image, impressing the audience with novel turns of phrase and metaphors was.[61] Arabic literature (and by extension most poetry written in Islamic languages) can hardly be seen as mimetically faithful or even attempting something representing visual mimesis. Examples from Arabic literary theory do, however, illustrate the central role played by the desire to generate wonderment for aesthetic as well as ethical purposes in medieval Muslim society.

Beauty and Religious Amazement

The most important medieval Islamic thinker to address issues of beauty and aesthetics is the philosopher, theologian, and Sufi, Abu Hamid al-Ghazali (d. 1111). Unlike other philosophical and literary thinkers mentioned in this chapter, al-Ghazali's influence is truly pervasive in large part because he intentionally set out to formulate a Sunni orthodoxy by synthesizing a variety of intellectual currents existing in Muslim thought. His direct influence extends far beyond the narrow circles of an educated elite: for several centuries, he has been one of the most popular religious thinkers across the entire Muslim world, with the majority of his works widely translated and extensively read by a broad cross section of Muslims. Al-Ghazali is famous for having started his scholarly life as a theologian with strong philosophical inclinations, only to have grown disillusioned with philosophy and to have turned to Sufi piety and mysticism in his quest for truth and happiness. However, recent scholarship suggests that his famous break with philosophy is somewhat exaggerated and that he continued to write philosophical treatises even after the notorious "conversion" to mysticism he himself mentions.[62]

Al-Ghazali discusses questions of beauty, allegory, and illusion in a number of his works, including his book on the interpretation of the Qur'an, the *Tafriqa*, which directly addresses questions of allegorical meaning. It is his *Alchemy of Happiness (Kīmiyā-yi saʿādat)*, a Persian work encapsulating the most important aspects of his religious thought, that contains the most valuable statements concerning notions of beauty and aesthetics and their relationship to virtue, and the value of this book has been recognized by scholars of Islamic art as early as Ettinghausen.[63] Overall, the *Alchemy of Happiness* displays a familiar Sufi attitude toward the material world, with the physical body being given ancillary importance relative to the metaphysical body and the realm of the imagination (a topic discussed in Chapter 8). The significance of beauty rests on a recognition of perfection, which lies on the inside—or at an esoteric level—and for which outer, physical appearances can easily be a deceptive indicator. Physical senses can only perceive outer appearances, whereas the heart—the seat of inner senses—has the capacity to perceive the true nature of things. Viewed in this light, perception and contemplation of beautiful physical objects encourages the viewer to focus on the misleading outward dimension of things and to believe mistakenly that the physical world represents reality.

Al-Ghazali speaks about several categories of beauty and the nature of their perception, arranging them in a hierarchical pattern, familiar from Islamic metaphysics, in which there is a progression from physical human beauty, through that of the created universe, to its culmination in divine beauty. It is in the context of physical perception that vision and visual imagination serve an important role: in the section on love in his magisterial *Revivification of the Religious Sciences (Ihyā' ʿulūm al-dīn)*, al-Ghazali states that the eye is attracted to beauty and takes pleasure in perceiving beautiful things.[64] Therefore, it is a sign of limited understanding to get caught up entirely in the delights of external, physical beauty, since the essential beauty of human beings lies in their inner qualities. Similarly, one could argue, the beauty of objects of human manufacture such as painting, architecture, and poetry is but an image of the inner beauty of their makers.

Visual contemplation of an object arouses love for the object in proportion to its beauty, so that the more beautiful a face, the greater the

pleasure in gazing at it. For al-Ghazali, pleasure *(ladhdha)* is itself a form of perception *(idrāk)*, such that to enjoy (or "taste," *dhāqa)* something is to know it. According to this scheme, physical beauty and the pleasure derived from its contemplation are not ends unto themselves but rather serve to give human beings a sense of the pleasures of the afterlife and thus attract them to a more contemplative, virtuous life.[65]

In his *Alchemy of Happiness (Kīmiyā-yi saʿādat)*, al-Ghazali reiterates his position concerning the superiority of inner beauty to outer forms, using strong words emphasizing the emptiness of outward human beauty: "If you look into the beauty of his appearance, it is a skin drawn over a pile of dung *(mazbala)*. If he doesn't wash himself for two days he becomes disgraceful, such that he begins to stink and filth arises on him."[66] At the same time, he acknowledges the importance of images and their greater visceral appeal as compared to intellectual knowledge or nonvisual imagining, since when we imagine those we love, the pleasure of seeing them in person *(dar dīdār-i sūratī)* is better than the pleasure *(ladhdhat)* one feels in imagining them.[67]

An important point running through much of al-Ghazali's intellectual position on questions of appearance and beauty is that the true value of an object (or person) lies in its essence rather than its outward form, since the physical characteristics of a thing are accidents that hide its true nature. He prescribes the love of beauty in general because, ideally, it leads to love of divine beauty, which is the highest object of love as well as its cause. "Know that there is none other than God, most high, who is deserving of love *(dūstī)* in actuality; whosoever loves another does so out of ignorance, in the sense that it is actually connected to God. As such, loving the Prophet is the same as loving him."[68] Thus, for al-Ghazali love is distinct from sensual desire:

> The meaning of loving *(dūstī)* is a natural inclination to a thing that is pleasing *(khush)*. If that inclination is strong it is called love *(ʿishq)*. . . . You do not find anything pleasing or displeasing unless you have a prior awareness of it. Awareness of a thing can be through the senses or the intellect. Of senses there are five, each of which has its own delight *(ladhdhat)*, and

due to that delight it likes a thing, that is, its nature inclines to it. The delight of the sense of seeing is in pleasing forms and appearances (*surathā-yi nīkū*), greenery, flowing water, and the like, as a consequence of which it likes the thing. . . . [All five of these senses] are possessed by animals.

The sixth sense is a thing in the heart that is called the intellect (*'aql*), insight (*basīrat*) or light (*nūr*), or any other interpretation one wants to give it such that human beings are distinguished from the beasts through it. It, too, has perceptions which are pleasing to it and which are beloved of it (*mahbūb*), such that these other delights correspond to the senses and are beloved of the senses. It is for this reason that the Messenger said: 'Three things of this world have been made beloved to me: women and perfume, and the light of my eyes lies in prayer." He placed prayer at a higher level; but someone who, like the beasts, is ignorant of the heart and knows nothing but the senses, cannot believe that prayer is pleasing and that one could love it. But one who is governed by the intellect and far from beastly qualities, loves the spectacle (*nazzāra*)—seen through the inner eye (*chashm-i bātin*)—of the beauty of the divine presence, the wonders of his creation and the perfection and majesty of his essence and attributes more than the spectacles seen through the outer eye, such as pleasant forms . . . in fact, all these [latter ones] grow wretched in his eyes when the beauty of the divine presence is revealed to him.[69]

Al-Ghazali clearly believes that true beauty is of the inner kind, and that it is weak-minded to focus exclusively on outward forms. If true beauty did not lie within, it would be nonsensical to love the Prophet and his companions since they were buried centuries earlier. Furthermore, he argues that even a child, when asked to describe someone whom she loves, focuses on that person's inner qualities rather than his physical ones.[70] At the same time, al-Ghazali maintains that there is actual value to aesthetic contemplation of beautiful people and objects,

since the degree of pleasure one attains from contemplating beauty is proportional to the amount of love aroused in the viewer. In other words, the more beautiful a face one looks at, the higher one's pleasure and the greater the amount of love. Physical beauty is a blessing from God for al-Ghazali and—following Greek ethical and aesthetic models that were already established in Islamic thought—he believes that beauty and virtue are integrally connected, and the ability to appreciate beauty is a sign of the viewer's inner goodness.[71] At the same time, he never loses sight of the primacy of the nonphysical, with God—the ultimate nonphysical entity—representing the pinnacle of beauty and virtue.

Even in the case of the contemplation of human beings, inner beauty, apprehended through esoteric perception *(al-basīra al-bātina)*, constitutes beauty in its real form. Thus the true beauty of religious luminaries such as important scholars or companions of the Prophet cannot only be perceived by this inner sense, since either their physical appearance was not indicative of their inner beauty, or the very fact that they are dead and no longer physically present makes clear that their beauty cannot be contemplated physically.[72] The ultimate example is contemplation of prophetic beauty, and al-Ghazali draws a stark comparison between someone who loves an image painted *(naqshan musawwaran)* on a wall because of the beauty of its outward appearance and someone who loves one of the prophets because of the beauty of his inner attributes.[73] Al-Ghazali's statements regarding the irrelevance of the physical beauty of prophets is at some remove from popular Islamic attitudes since, following the logic of the direct connection between beauty and virtue, prophetic figures and religious heroes such as 'Ali (Muhammad's cousin, son-in-law, and the first imam of the Shi'as) are believed to have been beautiful. There are hadith traditions that describe Muhammad's physical appearance together with his moral character, and the overarching message of them is to underscore his physical harmony and proportionality, a key component of beauty as has already been outlined. Furthermore, contemplation of the Prophet's physicality gained great popularity in the Ottoman Empire as well as elsewhere, giving rise to important traditions of textual portraiture and iconography that are discussed at length later in this book.

Despite his discussion of physical beauty and its visual contempla-
tion, it is clear that al-Ghazali is not concerned with aesthetics as
much as with ethics and piety. In his discussion of the different forms
of perception, he locates outward perception toward the bottom of a
hierarchy, and includes emotional perception and inner perception *(al-
basīra al-bātina)* as the means to get beyond outward forms.[74] His dis-
cussion of the beauty of art as a moral reflection of the artist makes
clear that his concern is with the ethical or moral stature of the artist
as human being rather than with the quality of the work of art.[75] Never-
theless, his discussion of physical beauty and perception is significant
for a variety of reasons. Al-Ghazali connects the visual perception of
art with the perception of the created universe. His argument that
there is a parallel between the contemplation of beautiful painting or
calligraphy leading us to contemplate the talent of the artist on the
one hand, and the contemplation of the physical world encouraging us
to contemplate its divine designer on the other, shows that he was
aware of the important role visual perception plays in fostering won-
derment, an exercise of some importance in premodern Islamic cul-
ture not just for fostering admiration and respect for God but also as
an admonition *('ibra)*, a reminder of personal insignificance and tran-
sitoriness, and an exhortation to a moral life.

More important in this context are two other implications of his
discussion of beauty, these being the recognition that visual percep-
tion has a predictable emotive response, and the idea of a visual object
as being representative, however imperfectly, of an ideal beyond itself.
Explicit acknowledgment of the power of beautiful images to generate
pleasure and love constitutes a clear recognition of the power of the
image, its use in society (and religion) being limited by questions of
propriety rather than by any lack of appreciation for the value of the
visual. The representational quality of the visual is more complicated,
since it involves an element of mimetic dissonance wherein outward
appearance is simultaneously recognized as representational yet ac-
knowledged as being imperfect in its representation. Al-Ghazali's
discussion of the flawed relationship between the outward appearance
(or lack thereof) of religious personages brings to mind the literary
critic Kilito's analysis of discussions of the physical likeness of the

early Muslim encyclopedic scholar al-Jahiz (d. 869). His erudition and talent notwithstanding, al-Jahiz was notorious for having been the very picture of ugliness, with people supposedly having declared that he was "as ugly as the devil. Paint the devil and you will have painted al-Jahiz." However, since there are no portraits of the devil, in order to depict the devil (depicting al-Jahiz) one would be obligated to depict al-Jahiz himself.[76] Thus not only is the physical depiction of the person in question not an accurate representation of his inner beauty, but it is mimetically dissonant, in that for al-Jahiz to look "like" the devil, he must necessarily look "like" himself.

Wonder and Wonderment

The common thread connecting philosophy, theology, and literary aesthetics here is not a preoccupation with similar concepts of virtue as much as it is a concern with the importance of wonderment and its generation. The connection between the imagination, wonder, and pleasure is present in the poetics of al-Farabi and Ibn Sina. In writing about poetry as imaginative speech, Ibn Sina described imaginative assent to the form and content of poetry as "a kind of compliance due to the wonder *(ta'ajjub)* and pleasure *(ladhdha)* that are caused by the utterance itself."[77] Similarly, al-Qartajanni wrote about the centrality of wonder and imagination in poetic mimetic representation, saying: "Poetry is metrical, imaginatively-creative discourse, characterized in the Arabic language also by the inclusion of rhyme. The imaginatively-creative premises it combines, whether objectively truthful or false, have as their only conditions, insofar as they are poetry, imaginative creativity." A few pages later he states:

> All this must be [realized] by a mimetic representation of the usual by the usual, the strange by the strange, or the strange by the usual. And the closer the object is to that by which it has been mimetically represented, the clearer will be the similarity; on the other hand, the more strangeness and wonder

are added to the imaginative creation, the more original it will be.[78]

Al-Qartajanni clearly values the strange and wondrous over the ordinary, and artifice over faithful representation. He is joined in this aesthetic standard by al-Jurjani, who declared his preference for artifice by stating that "the best poetry is that which lies most."[79] A similar concern with imaginative representation as a tool for the generation of wonderment is shared by painters and calligraphers in the Islamic world, as well as philosophers such as al-Farabi and Ibn Sina who defined wonder as the first step toward attaining wisdom.[80] Like al-Farabi, Ibn Sina emphasized the intrinsic aesthetic worth of the pleasurable sense of awe while simultaneously recognizing its importance for generating future knowledge, not simply as a means for furthering knowledge.[81] His concern in this regard is reminiscent of Plato's claim in the *Theaetetus* as well as Aristotle's in the *Metaphysics* that wonder is the starting point of philosophy.

Medieval philosophers and theologians in Christian Europe, as in the Islamic world, emphasized wonder as the first step in acquiring knowledge, and Christian devotional and hagiographical works stressed wonderment as the opposite of imitation. Though they did not generate psychological or aesthetic theories of wonder, they certainly engaged in theoretical discussions on the subject. In a medieval Christian religious context, the audience of stories and visual representations of saints' lives was encouraged to wonder at the powers and ascetic practices of the saints, not to try and imitate them.[82]

Just as it is impossible for us to establish the reality of medieval aesthetics in the sense of knowing the precise nature of what was considered beautiful by the living people of a time long since past, we cannot engage in a simple study of emotion to know exactly what writers meant by notions of "wonder." As Bynum has argued for medieval Europe, we do not have the right to assume a "Darwinian universal emotion" readable each time we see "depictions of people with open mouths and raised eyebrows or to think that emotion-behavior is so culturally constructed as to exist only where we find words for it."[83]

Emotional reactions such as wonder (or delight and pleasure) do not occur of themselves but are evoked. As such, textual sources give us information not about the nature of wonderment but about phenomena—acts, objects, and language—that are known to or intended to provoke wonderment. "Finding wonder-words is easy; finding wonder is far more complicated."[84]

An imaginative instinct is widely acknowledged in Islamic writings. It is this faculty that makes bees make perfect honeycombs and spiders weave webs. The same faculty is also the source of prophetic visions and artistic creativity.[85] As already alluded to, al-Ghazali likened the human perception of divine creation to the perception of art, in that contemplating visual art moves the viewer to reflect on the artist's skills in the same way as contemplating the wonders of the created world causes one to think about and draw closer to God.[86] Wonderment is not just a desired reaction in Islamic aesthetics—it is the starting point of knowledge and therefore to be sought out and stimulated, and is recognized as one of the important aesthetic qualities of excellent calligraphy. Ibn Sina made a distinction between "true seekers" and "fools" when discussing wonders and mysteries, stating that while fools treat the mysterious as a laughing matter, the wise recognize it as a divine portent or sign.[87] The word he uses is 'ibra (pl. 'ibar), which has multiple meanings related to passing through or beyond something. One important sense in which the word is used in classical Arabic is to refer to death, in the sense of passing from this life to the next. Perhaps as a consequence, it can also mean an object of wonder or contemplation that serves to provide insight into God's purpose in the entire enterprise of creation; it is in this meaning that wonder is widely used in historical, philosophical, mystical, and literary works.[88] Thus practically anything can serve as a divine portent to be contemplated by the wise: the text of the Qur'an, natural phenomena, plants, and animals.

Natural phenomena—some mythical—constitute the main subject matter of the geographer Zakariyya al-Qazwini (d. 1283) in his 'Ajā'ib al-makhlūqāt wa-gharā'ib al-mawjūdāt (Wonders among Things Created and Marvels among Things Existent), a very popular work that has been frequently published with illustrations and also translated into Persian, Turkish, and Urdu. Echoing Ibn Sina, al-Qazwini states as a human

condition that the young understand the concept of the marvelous but quickly become bored with seeing it; in contrast, the wise and accomplished continue to marvel at what they see. Al-Qazwini opens his book with a discussion of natural wonders *('ajā'ib)* and wonderment *('ajab)* such as the bee's ability to make honeycombs and honey. According to al-Qazwini, amazement at seeing a wondrous thing causes the human being to ponder its underlying cause and thereby get closer to and develop a better understanding of God.[89]

Natural phenomena, including flora and fauna, are not necessarily visual marvels of the sort that concerns my analysis here, except very tangentially in the sense that they are visually represented in books such as al-Qazwini's *'Ajā'ib al-makhlūqāt*. However, wonderful objects of human creation, or mirabilia, are frequently mentioned in historical and other works. Indeed, describing or at least listing mirabilia was an important aspect of documenting the spoils of war or lists of gifts exchanged between dignitaries, some of which, like the idol nicknamed *"shughl,"* have already been mentioned. Such mirabilia were the subject of entire books such as the *Kitāb al-hadāya wa'l-tuhaf* (Book of Gifts), which was probably first written by al-Qadi ibn al-Zubayr in the eleventh century and later recast into its existing form in the fifteenth century. Most of the items listed in this work are nonfigural precious objects, although a few statues or figurines *(tamāthīl)* are also mentioned, most of which were sent to the royal treasury. As mentioned earlier, the author lists a gold peacock studded with precious stones, its eyes of ruby, feathers of enameled glass inlaid with gold imitating the natural iridescence of a peacock, accompanied by a crested rooster covered with large pearls and gemstones. These were found together with a gazelle, also studded with pearls and gemstones. The author remarks on the realism of the gazelle, to the degree that it even had a white belly like the real animal, being set with large pearls.[90] On another occasion, a certain Mihfan is said to have found at Ctesiphon (al-Mada'in) a figurine covered in precious stones that was too valuable to be priced.[91]

Some of the statues appear to be of human beings (or anthropomorphic gods), either by themselves or accompanied by animals. One of the items found following a battle in 637 was a statue of a she-camel made of gold and striped with large pearls and rubies, ridden by the

figure of a man made of the same material.[92] A large statue found near Fars in 708 by al-Hajjaj ibn Yusuf is recognized as an icon *(sanam)*, made of silver.[93]

Such mirabilia are objects of wonder because technology is wondrous in and of itself, in that the end product is the result of a process that is barely comprehensible to the viewer in terms of both the expertise and the virtuosity implicit in its creation.[94] Beyond functioning as objects of awe and wonder, they serve as a warning concerning the transitory nature of human life. This understanding of wonders of the past is explicit in the description of the Ellora cave temples and the temple of Lakmir by the historian and courtier Rafi' al-din Shirazi quoted in the previous chapter, and it is encountered frequently in Islamic historical and geographical writings.

The mirabilia par excellence in the medieval Islamic world were the pyramids of Egypt, dealt with most famously by the thirteenth-century historian, grammarian, traditionist, and court genealogist Abu Ja'far al-Idrisi (d. 1251) in a monograph on the subject entitled *Anwar 'ulwiyy al-ajram fi kashf 'an asrar al-ahram*. Al-Idrisi interweaves two related issues in his discussion: first, that it is incumbent upon all pious Muslims to visit the mirabilia *('aja'ib)* of the earth—be they wondrous natural phenomena or human (or demonic) masterpieces of art and architecture; second, that learned scholars are in consensus concerning the primacy of the pyramids among all mirabilia. According to him, human beings have a natural instinct urging them to see and marvel at mirabilia: "The capacity of marveling at the miraculous attests to the normal human disposition *(sihhat mizaj al-fitra al-zakiyya)* as well as intellectual sanity *(salamat bunyat al-fitra al-dhakiyya).*"[95] Al-Idrisi believed that nothing compared to the admonitory power of an individual contemplating an object deserving of cognition *(mushahada)* and observation *(mu'ayana)*, and he devoted a chapter of his book on the pyramids to the topic of contemplating the wholly fantastic.[96] He appears to have seen the occasion to deal with the miraculous not as an opportunity to provide entertaining and sensational stories as much as a serious obligation to encourage individuals "to visualize those powerful and wealthy rulers of days long gone by who had commissioned the building of these awesome monuments as a symbol of

their might. Yet their hubris was punished by their demise. Only stones are left as witnesses to their vanished former glory."[97]

Al-Idrisi considered it a religious obligation to heed the admonitions of *'ibra,* and the related terms *i'tibār* and *isti'bār* appear repeatedly in his book. He is similar in this regard to al-Qazwini, who composed the *'Ajā'ib al-makhlūqāt* both as an act of piety and as a reminder to himself and others to ponder the wonders of creation as a way to get closer to God. For al-Idrisi (and perhaps al-Qazwini as well, although that is not the subject of his book), marvelous objects manufactured by humans are themselves reminders of God, and gazing at them is a pious act.

Yet it was not only mirabilia that inspired awe and wonder. Many historical sources mention the quality of the material arts in parts of the Christian world conquered by the Muslims, and speak of them with awe and admiration.[98] At the same time as they make the world comprehensible, books in the Islamic as well as Christian worlds that are concerned with the miraculous and wondrous are fundamentally antiphilosophical since they elevate the specific above the general, the exception above the rule. Aside from their pious function to encourage human beings to draw closer to God, the central purpose behind the fascination with mirabilia is to provide a system by which to categorize and intellectualize the known world, making it comprehensible and understandable. Wondrous creations are the visible signs of a divine intelligence, which assure the viewer that there is an order and wisdom behind an otherwise confusing world.

Conclusion

Wonderment, its cultivation and encouragement, all rely on notions not just of beauty but also of awe, as well as on the embedding of the wondrous object in a symbolic framework wherein it functions as the object of wonder. Beauty, as a purely aesthetic category, is not wholly relevant to such a project. In fact, one might argue that beauty primarily matters in Muslim religious visual culture when it fills a purpose beyond a purely aesthetic contemplation of the beautiful, because even

such contemplation is praised only because it serves a pious didactic purpose. In an argument that echoes both Plato and Martin Luther, al-Ghazali sees the artist's role as important because the creation of beautiful objects arouses wonderment and, as such, reflects the inner beauty of the artist. Yet, as Necipoğlu has noted, despite their acknowledgment of the importance of artists and their overall positive qualities, al-Ghazali's writings do not provide any examples of visual objects serving as symbolic representations of religious ideas.[99]

That aesthetics, in the sense of a purely contemplative form of viewing, is distinct from the kinds of visual piety that characterize the use of images in religious situations does not mean that visual piety is noncontemplative.[100] In discussing religious visual culture, we might do better to adopt Pinney's term "corpothetics" to connote sensory, corporeal aesthetics. Pinney deploys the term "corpothetics" in opposition to "aesthetics" in order to underline the importance of focusing on the practices that relate to religious images rather than fixating on the images themselves. "If 'aesthetics' is about the separation between the image and the beholder, and a 'disinterested' evaluation of images, 'corpothetics' entails a desire to fuse image and beholder, and the elevation of efficacy ... as the central criterion of value."[101] Corpothetics lies in opposition to the ideal of a disinterested gaze and instead favors an intellectual as well as somatic engagement of the viewer with the object of contemplation. Of course, the reorientation of "aesthetics" into "corpothetics" is a fraught matter because "if there is no 'meaning' capable of easy linguistic extraction, the evocation of significance becomes a matter of subtle observation."[102] The best solution lies in situating the religious image in a framework of inquiry that combines the study of visual symbolism as "iconology" with an awareness of the shifting nature of practice and meaning in human society—in other words, one that combines a visual turn in anthropology and semiotics.

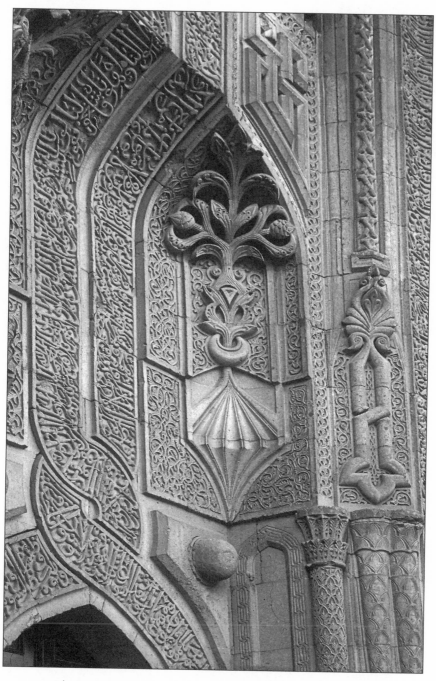

PLATE I: İnce Minareli Medrese, Konya, Turkey.

Photograph by the author.

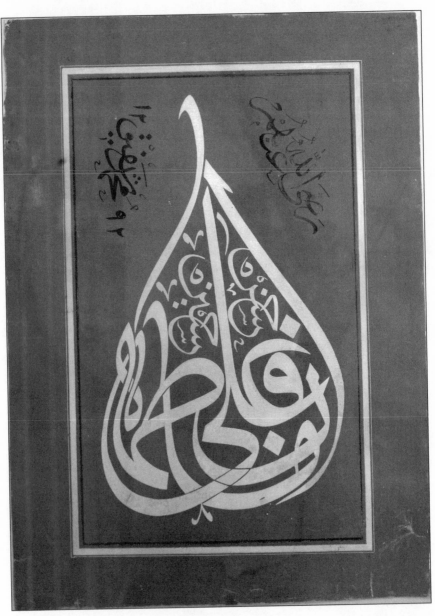

PLATE II: Calligraphic panel dated AH 1292 (1875 CE) by the Ottoman calligrapher Mehmed Şefik Bey. The text reads "Mercy 'Ali, Fatima, Hasan, Husayn."

Private collection of İrvin C. Schick, Newton, Massachusetts.

PLATE III: Calligraphic panel dated AH 1309 (1891–1892 CE) by the Ottoman calligrapher Elhac Mehmed Fehmi Efendi. It is entitled "Form of the Seal of Prophethood of Muhammad the Chosen One."

Private collection of İrvin C. Schick, Newton, Massachusetts.

PLATE IV: Footprint of the Prophet. Chromolithograph from Pakistan.

Munich State Museum of Ethnology, 99–320.394.

PLATE V: Sandal of the Prophet. Chromolithograph from Pakistan.

Munich State Museum of Ethnology, 99–320.394.

PLATE VI: Qalandar Shrine in Sehwan. Chromolithograph from Pakistan.

Munich State Museum of Ethnology, 02–323.596.

PLATE VII: Sandal of the Prophet *(na'lin sharif)*, from an *An'am-i Sharif*, ca.
1790, artist unknown.

Harvard Art Museums / Arthur M. Sackler Museum, The Edward Binney, 3rd Collection of
Turkish Art at the Harvard Art Museums, 1985.260.

PLATE VIII: Calligraphic Roundel of 'Umar (recto), Calligraphic Roundel of Abu Bakr (verso), folios 75–76 from an *An'am-i Sharif*, ca. 1790, artist unknown.

Harvard Art Museums / Arthur M. Sackler Museum, The Edward Binney, 3rd Collection of Turkish Art at the Harvard Art Museums, 1985.260.76.

6

Alchemy, Appearance, and Essence

How do you show the art of medicine without a sick man?
How do you see the power of alchemy without base copper?
The defective mirrors the perfect; the lowly mirrors the
sublime.
Everything is revealed by its opposite—honey by vinegar.

—MAWLANA JALAL AL-DIN RUMI

The role played by the sciences in the construction of premodern visual and material culture is difficult to quantify. On the one hand, there was an extensive and rich tradition of research in the experimental and theoretical sciences in the early modern and medieval Islamic world. On the other, such learning was definitionally restricted to an educated elite and probably played a limited role in shaping the majority of the population's conception of the visual and material world. At the same time, however, the priorities in exploring new knowledge displayed in such scientific works reflected the living concerns—in terms of their assumptions and wider goals—within the societies of their times, and therefore deserve to be examined for their bearing on issues of materiality, visuality, and systems of perception. This is particularly

true of optics and alchemy, both of which address questions of the relationship between the appearance of an object and its true nature. Alchemy, especially, enjoyed wide popularity both as a scientific system and as a metaphorical one, and was imbricated in the way wide sections of premodern Islamic society understood not just natural processes but also the relationship of the spiritual world to the physical world.

Alchemy was much more than a forerunner of chemistry: in many ways, it was a comprehensive system of knowledge for investigating the nature of inorganic matter and the transmutation of metals, at the same time as it sought to explain the interconnected nature of the entire created world. It accomplished this goal by relying on the metaphysical and philosophical background of its intellectual context as well as on astrology, magic, and theories concerning visionary and allegorical experience. Very importantly, as in the case with European, Chinese, and Indian alchemical theories, in Islamic alchemy connections between alchemical methods and religious ideas were more than theoretical: an absolute correspondence was believed to hold between the external physical chemistry of alchemical practices and inner spiritual dispositions.[1] In the specific context of this book, alchemy is important for its relevance to visual iconology, since the dominant tradition of Islamic alchemy hypothesizes that the difference in metals is one of appearance rather than substance. As such, it bears directly on questions of perception, appearance, and resemblance between the nature of an object and its physical representation.

Despite its relevance to a broad range of subjects in premodern Islamic scholarship, few scholars have bothered to recognize the place alchemy held as a legitimate science; its impact is rarely taken seriously. Given the unfortunate degree to which alchemy has been consigned to the margins of Islamic intellectual history, it is necessary here to provide a quick overview of the history of alchemy in order to demonstrate how mainstream a phenomenon it actually was, and to show the number of figures with otherwise legitimate scholarly credentials who either engaged in alchemical experimentation or wrote about it theoretically.

A History of Islamic Alchemy

Islamic alchemy relied heavily on translations from Greek works. In this regard, its trajectory closely resembles that of the reception and early development of Islamic medicine and philosophy, although it differs from them in that the paths by which alchemy entered Islamic culture are largely unknown and it remains woefully understudied as a subject. Yet the Greek influence is undeniable, since not only is the very word *al-kīmiyā'* derived from the Greek term *chymeia* or *chēmeia*, but much of its terminology comprises direct translations.[2]

The earliest surviving Arabic alchemical writings appear to be the ninth- through tenth-century collection attributed to Jabir ibn Hayyan, although there are examples of translations from earlier Greek and Middle Persian works. The tradition traces its roots and continuing legitimacy to Greek scholarship on the subject, claiming a Greek eponymous founder in Chymes (or Chimes), who is referred to by Ibn al-Nadim as both Kimas and Shimas, and is mentioned frequently by writers on Islamic alchemy. However, much greater importance in the development of the tradition is accorded to Pythagoras, who is referred to by al-Jildaki (d. 1342, probably the most important figure in the history of Islamic alchemy) as "the first teacher" *(al-muʿallim al-awwal)*, and whose book with the Arabic title *Kitāb fī'l-aʿdād al-tabʿiyya* (Book on the Natural Numbers) is quoted several times by another famous alchemist, al-Tughra'i (d. 1121). In addition, al-Masʿudi, al-Muqaddisi, and al-Shahrastani—all of whose importance to Muslim understandings of foreign societies has already been discussed—mention both Socrates and Archelaos as alchemists, with the latter having at least two important alchemical treatises to his credit. Almost all Islamic writers on alchemy mention Hermes as the founder of the science.[3] Plato, too, was recognized as an alchemist and four works on the subject attributed to him circulated in Islamic circles; Aristotle also was described as an alchemist, though with less justification. A less famous name is that of Qaydarus (probably Phaidros, the hero of the Platonic dialogue), whose *Risāla* carried authority in Islamic alchemical circles such that it was believed to have been translated into Arabic

(from Persian) for the Umayyad prince Khalid ibn Yazid (d. 704), who is himself important to Islamic alchemy.[4]

A number of figures throughout the premodern history of Islamic society were famous as alchemists, some legitimately so and others mythically. Khalid ibn Yazid is celebrated as a patron of sciences such as medicine and astrology, but especially of chemistry. He is said to have had in his employ a Christian monk named Istafan (Stephanos) who served as a translator of Greek texts, and to have either learned alchemy from another monk named Maryanus or to have inferred it directly from a book that the Chinese emperor had sent to his grandfather Mu'awiya as a gift. And although Ibn Khaldun recognized that Khalid could not have had anything to do with the development of alchemy in Islamic society, the tradition itself continued to credit this Umayyad prince with at least four books related to alchemy as well as a collection of esoteric poems.[5]

The most important figure of the early period of Islamic alchemy is Jabir ibn Hayyan, the purported author of a substantial corpus, much of which enjoyed greater circulation in Latin than it did in Arabic.[6] As for the identity of their author, the dominance of elements of Isma'ili thought in the works would suggest that they could not date from earlier than the ninth century. In all likelihood, the corpus attributed to Jabir is the work of a number of writers over roughly two centuries.

Following Jabir, the tenth-century Shi'i writer Ibn Umayl al-Tamimi is one of the most important representatives of the allegorizing trend in Islamic alchemy. In the introduction to his famous *Kitab al-ma' al-waraqi wa'l-ard al-najmiyya* (The Book of Silvery Water and Starry Earth) he describes how he entered the temple of Busir—believed to be the prison of Joseph—with his friend Abu'l-Husayn al-'Adawi. There he saw figural representations on the walls and ceilings and hieroglyphic inscriptions that put forward alchemical wisdom as laid out by Hermes. According to Ibn Umayl, it was this learning that he had reproduced in "The Book of Silvery Water" as well as in some of his poetry.[7] "The Book of Silvery Water" attained the status of a classic of alchemical writing in the Islamic world and was still being copied well into the nineteenth century.

Among theologians who are also known as alchemists, the important Mu'tazili thinker al-Qadi 'Abd al-Jabbar (d. 1025) is also said to have written a long alchemical treatise (although its authenticity is doubtful). His contemporary, the polymath Miskawayh (d. 1030), is regarded as an avid alchemist by al-Jildaki and by Abu Hayyan al-Tawhidi.[8]

In the next century, Mu'ayyad al-din al-Tughra'i, a high-ranking civil servant and author under the Seljuks until his execution in 1121, was to leave a lasting impact on the course of Islamic alchemy. In the opinion of al-Jildaki and others, he was the greatest chemist after Jabir as evidenced by his *Kitāb al-masābīh wa'l-mafātīh* and *Kitāb haqā'iq al-istishhād*. However, his knowledge appears to have been more theoretical than empirical.[9] The same holds true for Fakhr al-din al-Razi (d. 1210), the famous philosopher and theologian, who had a deep interest in alchemy and especially in the transmutation of metals. His writing on the subject eschews any allegorical or mystical connections to alchemy that were popular among many of the early Islamic writers, especially Jabir and Ibn Umayl. Al-Razi is credited with writing thirteen works related to the subject, culminating in his masterpiece, the *Kitāb al-asrār* (Book of Secrets), an extensive work in three parts dealing with materials, devices, and procedures, and characterized by a strictly systematic structure.[10]

Little is known about the highly influential thirteenth-century alchemist Abu'l-Qasim al-Simawi, whose *Kitāb al-'ilm al-muktasab fi zirā'at al-dhahab* (*Book of Knowledge Acquired concerning the Cultivation of Gold*) is one of the most influential works in the history of Islamic alchemy. 'Izz al-din al-Jildaki (d. 1342) is also largely unstudied, despite being the most important figure in the history of the subject. He was one of the most insightful and encyclopedic scholars of Mamluk times, and the fact that he is relatively unknown today is a testament to the way any association with alchemy and magic appears to discredit otherwise reputable scholars and scientists in the eyes of posterity. In addition to contributing ideas of his own, al-Jildaki's writings on alchemy are valuable for bringing together the theories of earlier scholars including pseudepigraphical ones. His *Kitāb nihāyat al-talab fi sharh al-muktasab* comprises an extensive commentary on the *Kitāb al-'ilm*

of al-Simawi and also contains sayings attributed to Greek authors such as Pythagoras, Hermes, Democritus, and others.[11] A thorough analysis of his magisterial *Kitāb al-burhān fī asrār ʿilm al-mīzān* is likely to yield a great deal of information on the relationship between science, religion, and magic in the medieval Islamic world, seeing as how it attempts an integrated discussion of a variety of philosophical, physical, astrological, cosmological, theological, magical, and alchemical topics. Al-Jildaki's *Kitāb anwār al-durar fī īdāh al-hajar* (The Lights of Pearls for the Explanation of the Stone) contains ten chapters on the nature of the alchemical elixir. Throughout his discussion, al-Jildaki repeatedly draws explicit analogies between the representation of the elixir and the physiology of human beings, and includes direct quotations from medical scientists.[12]

Al-Jildaki has had a lasting impact on Islamic alchemy, and later works are often commentaries on his writing. An important example of this is the *Kitāb kashf al-asrār fī hatk al-astār* (The Revelation of the Secrets in Tearing Off the Veils) by the fifteenth-century Anatolian author ʿAli Beg al-Izniqi, also known as *al-muʾallif al-jadīd* ("the new author"). Al-Izniqi argues that the knowledge of alchemy is identical to revealed knowledge (*wahy*), and that the goal of the science is the transformation of imperfect metals into perfect ones. He writes that the world of chemistry exists in nine levels, paralleling the cosmological realms of the spheres, and that progress from one level to the next (for example, from the level of the basic elixir, which is gained from natural elements, to the level of the elixir achieved from chemically treated elements) parallels cosmological ascent as a process of perfection.[13]

Alchemy remained extremely popular in the later middle period of Islamic history down to the early modern period. Among other writers from the time, Bel-Maghush al-Maghribi has a short treatise dedicated to the Ottoman ruler Suleyman (r. 1520–1566), in which he explains the process of producing gold. Bel-Maghush creates a genealogy of alchemical knowledge that begins with Adam and combines Muslim prophetic figures with important Greek thinkers, attributing the spread of alchemical knowledge in the Islamic world after the Prophet's death to a chain comprised of ʿAli ibn Abi Talib, Khalid ibn Yazid,

Ja'far al-Sadiq, Jabir, al-Razi, Ibn Wahshiyya, al-Tughra'i, Ibn Arfa' Ra's, al-Simawi (whom he refers to as Abu'l-Qasim al-'Iraqi), and al-Jildaki, among others.[14] Two centuries later, in the second half of the seventeenth century, Hasan Agha Sirdar from Upper Egypt wrote fifteen alchemical treatises combining new material with commentaries on earlier writings, and arguing for the agreement of alchemy with Qur'anic knowledge.[15]

By the seventeenth century, a new epoch can be seen dawning in Islamic alchemy with the works of Ibn Sallum. His thought on the subject is contained in the fourth part of his large medical work entitled *Ghāyat al-itqān*, in which he changes the role of alchemy from a science of the perfection of natural materials to one of chemistry in the service of medicine.[16] Despite the eventual move of alchemy into chemistry in the service of medicine outlined by Ibn Sallum and the subsequent adoption of science curricula based in a modern European tradition across the Islamic world, alchemy continued to enjoy some degree of legitimacy into the eighteenth century, when it still played a part in the education of Ottoman elites.[17]

The Teachings of Alchemy

The culturally pervasive reputation of alchemy as a legitimate science in the medieval Islamic world is illustrated by a thirteenth-century painting from the Ilkhanid Era that, it has been argued, represents a visual defense of alchemy by referencing the famous "Book of Silvery Water" of Ibn Umayl. Discussing the parallelisms between the painting and the text of Ibn Umayl, Berlekamp has argued for an important place for this image in the history of Islamic painting: most modern scholarship on the subject maintains that the role of images in Islamic scientific works is ultimately didactic, with the images designed to help teach the information contained in the text. In the case of the "Silvery Water" painting, however, the text accompanying the image, which includes Ibn Umayl's description of an alchemical tablet, helps explain the content of the painting, which only unfolds through a close contemplation of it in conjunction with the accompanying alchemical text.[18]

It bears reiterating that in the medieval Islamic world, alchemy represented the state of knowledge in metal arts and enjoyed great prestige as a field of knowledge. The parallel between material alchemy and spiritual alchemy was seen as a real one in that both reflected laws of the universe. At the same time, however, religious circles appropriated alchemical terminology and concepts to a degree—both as a process and as a metaphorical language—as simply the adoption of scientific method and terminology in an attempt to have the prestige of science rub off onto religion, in much the same way that modern religious writers might attempt to "prove" how scientific discoveries are prefigured in scripture.[19]

Alchemical processes and practices involved the use of elaborate devices that were used to heat metals in order to actually *change* the form of the metal. In this regard, alchemy relates to visual iconology, a point already noted in the study of late antique alchemy: "The key to the rituals is the iconic status of the metals and, even more important, the iconic status of the changes made to them. These changes have a formal resemblance to the changes the world must undergo on its way to perfection."[20] The primary goal of the alchemical process was to make the color of the metals go through a series of changes—blackening, whitening, yellowing, and so on—which demonstrated the process of the metal transforming to a higher level of progressively more precious metals. In this way, color functioned as the sign that signified the true nature of the metal for the observer.

According to most Islamic alchemists, minerals belong to three main classes: "bodies," "souls," and "spirits." All metals, with the exception of mercury, constitute "bodies," as do the "magnesia" (for example, magnetite) and minerals similar to it. Sulfur, marcasite, realgar, orpiment, and substances like them are "souls," while mercury and ammonium chloride (sal ammoniac) are "spirits." The alchemical elixir requires a combination of substances in all three categories, normally in a ratio of one part "spirit," two parts "soul," and one part "body."[21] One of the most representative descriptions of alchemy is found in the *Kitāb al-ʿilm al-muktasab fī zirāʿat al-dhahab* of al-Simawi; this work is divided into five parts, which together comprise nineteen chapters, the first of which begins with the following words:

The subject of the art of chemistry is a uniform, actual type (*nawʿ wāhid haqīqī*) which is called the hammerable mineral. This type is divided gradually into six individual natural species (*ashkhās*) which are not fixed like the species of animals and plants, namely the gold, silver, copper, iron, lead and tin. Each form of it differs from another by differences of formative accidents, after whose evanescence the permanence of the kind must be possible. Thus we state that each of the two natural, different kinds ... cannot be merged nor transformed through the Art [of alchemy]. With these six forms, however, each can be transformed by the Art into another, for example lead into silver.[22]

The second chapter deals with the attainment (or reattainment) of natural perfection by means of the removal of accidents, which is accomplished through the science of chemistry and the use of elixirs that must be fusible and mixable, while at the same time being self-persisting and pure in themselves, and possessing the ability to color materials. The fifth section of al-Simawi's book compares the elixir's function in metal alchemy to the nature of the seed in vegetative life as well as with gestation and birth in animal life. The main argument in the *Kitāb al-ʿilm al-muktasab* is that all metals are the same in reality; they differ from each other only in some nonessential properties that can be removed by chemical means, and each act of alchemical purification results in the next purest metal, eventually culminating in gold, which is free of nonessential properties. A basic idea in Islamic alchemy (and one that was shared with other alchemical traditions) was that metals gestated inside the earth in a manner paralleling the gestation of a fetus in an animal or human womb. Perfect metallurgical "gestation" would result in the "birth" of gold, but if a metal were removed from the earth prematurely, it would be in the imperfect state of a baser metal. In the words of al-Simawi: "Have you not considered the sperm and its change into blood, then into a tiny piece of flesh, then into an embryo, and then into form after form until it becomes a complete man? Yet that which would explain its growth and properties is not seen until it has attained its final stages."[23]

The difference between the metals is one of appearance, not of substance, in that the essential metal is one but its outward appearance differs depending on perspective, where "perspective" can be understood as the place along the continuum toward perfection where the metal is seen, as well as the viewpoint of the observer who either understands the underlying truth of this essential unity or does not. For the alchemist, it is never the true nature of a metal that is transformed, since transmutation across species is considered an impossibility. As al-Simawi states:

> We say and maintain that two species of natural things which differ radically and essentially cannot be changed and converted one into the other by the Art [of alchemy] as, for example, man and horse. But these six bodies [i.e., gold, silver, copper, iron, lead, and tin] can be mutually converted: thus lead may be converted into silver, for if you place a pound of lead in the fire, it rectifies and matures it, and most of it is burnt away, leaving a small part as silver. . . . Now since it is possible for a part of the lead to be changed into silver, there is nothing to hinder the conversion of the whole. In the same way silver may be converted into gold, by the refinement of the smelting fire only. For it is tinctured by the fire and strengthened and transmuted and behaves like gold with the touchstone. Thus it is possible to effect a certain transmutation since the specific nature is constant; but if silver differed from gold in species it would not be possible to convert it into it, just as it is impossible to convert a horse into the human species by the Art, because they differ radically and essentially.[24]

Al-Simawi draws an analogy with cotton to explain the related concepts of the unity of essence of things that are visually distinct as well as the important alchemical idea that the movement to perfection has to occur in its appropriate stages: a cotton seed cannot be made into a garment directly. Rather, it needs to germinate and change its seed form into a plant, then raw cotton, then thread, then cloth, and finally a garment. "In the same way, these bodies change at first only into the form of silver, and then into gold; and this follows uniformity of spe-

cific nature, for what is right for any one of all these forms is right for the others, since they are all varieties of the 'metallic mineral.' "25

Al-Simawi draws a similar allegory elsewhere to make much the same point, but also to emphasize that the truths of alchemy are not accessible to the majority of the populace:

> Sergius the Monk said: "Consider the tailor, how he takes one piece of cloth and cuts it up part by part and makes from it a body and sleeves and gores and hems, then combines them after that and reconverts them into one thing. In the same way, this, our Art, is from one thing, hidden and treasured with the Sages, who deliberately keep it secret from the ignorant. And they have named it with the best of names and it is placed in the most noble of places. It is both hidden and displayed: the wise know it and honour it, while the ignorant fools despise it and treat it with contempt."26

The semiological questions inherent in understanding alchemy were not lost on medieval Muslim authors, who wrote very specifically on notions of the relationship between words and meanings as well as on allegory, allusion, and the nature of speech in its abilities to convey meaning. In the *Kitāb al-ʿilm al-muktasab*, al-Simawi provides a succinct explanation of the power of language as a signifier of a separate truth:

> Know, that *words* indicate *meanings*. The meanings are the things named, while the words are the names. The commonest word is our phrase "a thing." Now the thing may be either one or more than one, while the word *one* may be used in two ways, (a) literally, and (b) metaphorically. *One* in the true sense is that which has no parts, while *one* metaphorically may be the whole of a collection, which is called *one*. Thus you speak of *one* decade or *one* hundred or *one* thousand. And *one* is *one* by definition, just as *black* is the description of blackness by definition.27

Al-Simawi underscores his message concerning the ability of a multitude of signs to point to a single underlying truth by quoting sayings attributed to the earliest authorities of Islamic alchemy. Pythagoras

states through al-Simawi: "Just as all things originate from the One, so this Art is from one thing and one essence only. And just as in the body of man there are four natures (which Allah created) gathered together in one body, each of them performing a function different from that of the others, and each having definite equilibrium and colour and power, so is this thing." Marianus the Monk advises Khalid ibn Yazid in a similar vein: "As for thy question concerning the Root, 'Is it from one thing or from diverse things?', verily it is one thing and one root and one essence and one species; to it there is nothing added and from it there is nothing removed."[28]

A critical element of the use of language to signify meaning is in the exploitation of allusion and allegory, which al-Simawi claims is central to the way in which alchemists communicate:

> Know ... that complete phrases are divided into three classes, (1) a phrase of exact agreement which perfectly describes the allusion; this is the plainest form of speech and is not used in an allegorical sense at all: it is, rather, straightforward; (2) a phrase of inclusion; this indicates a part only of the meaning and is more obscure than the first, in contrast to which it may be used in an allegorical sense; (3) a phrase of necessary association; this is more obscure than the first two and is simple allegory.[29]

The third category is the one employed most often by alchemists; an example of it would be to describe a man as a lion, conveying the idea of bravery through simile and metaphor. Alchemists, according to al-Simawi, describe things by mentioning their necessary characteristics rather than referring to their essences.[30] He states that allegory must either be absolute, in that it indicates its referent through a system of "necessary association," or it may be relative, which can be of four kinds: (1) indicating the referent by "necessary association" coupled with something he refers to as "inclusion," (2) by "inclusion" joined with "exact agreement," (3) referred to using "inclusion" by itself, or (4) through "necessary association" joined with "exact agreement."[31]

Al-Simawi's discussion of the nature of these systems of allusion and signification is knotty and an exploration of it is unnecessary in

this context. What is clear, however, is that questions of the nature and perception of material things and the ability for them to signify an underlying true referent were important ideas not just for this one author, but within an extremely popular intellectual tradition that also explored questions of signification in language. Alchemy's importance for understanding signification was not lost on writers in other spheres, especially with reference to alchemy's function as an analogy for the process of creating art. Al-Jurjani wrote of the catalytic quality of the artistic imagination in transforming the raw materials of art into a nobler object:

> Poetry creates out of ignoble material inventions of transcen-
> dental value; and acts in such a manner as to make you be-
> lieve that alchemy is truthfully capable of performing what is
> claimed for it, and that the philosopher's stone is true and
> credible—save that these operations are in the case of poetry
> operations which involve man's imagination and understand-
> ing rather than the body or senses.[32]

The concept of a spiritual alchemy is pervasive in Islamic society, and spiritual self-perfection is frequently referred to as an alchemical process, as evidenced by the title and subject matter of al-Ghazali's celebrated book, the *Kīmiyā-yi saʿādat* (*The Alchemy of Happiness*), to which I referred in Chapter 5. However, it is misguided to view the concept of spiritual alchemy as only metaphorically related to its physical counterpart with the distinction between striving for the purification and perfection of the soul being understood as completely separate from that of inanimate matter. In fact, the relationship between the two is very strongly held both in Shiʿi and in Sufi thought. The Ismaʿilis from the ninth and tenth centuries onward were active in producing alchemical works, and Ibn Abi'l-ʿAzaqir and Abu Yaʿqub al-Sijistani (d. ca. 975) are known to have produced alchemical texts.[33]

A large body of alchemical sayings is attributed to the first imam, ʿAli ibn Abi Talib, and Jaʿfar al-Sadiq, the sixth imam, is claimed to have been one of Jabir's teachers.[34] The importance of alchemy in early Shiʿi thought, especially among what came to be known as the "extreme" Shiʿa (*Ghulāt* groups), is apparent by looking at the figure of

Abu Ja'far ibn 'Ali al-Shalmaghani, better known as Ibn Abi'l-'Azaqir, who was executed for heterodox views in 934. He is believed to have regarded the prophet Muhammad as a traitor to 'Ali's cause (the latter being a divine incarnation), and predicted a victory of 'Ali's religion and the end of Islam. Ibn Abi'l-'Azaqir denied the existence of an afterlife in other realms and preached a bodily resurrection of human beings. Ibn al-Nadim credits him with four alchemical books, one of them being an important commentary on the *Kitāb al-rahma* of Jabir.[35]

The ascetic al-Hasan al-Basri (d. 728), who figures prominently as one of the founding figures in what came to be called Sufism, is supposed to have composed an alchemical treatise, as did another proto-Sufi figure, Sufyan al-Thawri (d. 778). Among other towering figures of early Sufism, both Dhu'l-Nun al-Misri (d. 861) and al-Junayd are also brought within the lineage of the masters of Islamic alchemy.[36]

Critiques of Alchemy

Alchemy was not accepted by some conservative religious scholars as a legitimate form of learning, and was viewed as one of an array of esoteric pseudosciences that were even more suspect than the natural sciences of which these scholars also disapproved. For example, Ibn Taymiyya (d. 1328) made alchemy a target of his attacks, and his student Ibn Qayyim al-Jawziyya's *Kitāb miftāh dār al-sa'āda* comprises a sustained polemic against the so-called occult sciences, and gives a great deal of attention to alchemy.[37] There can be little doubt that a degree of charlatanism and fraud found their way into the world of alchemists, seeing as how a major purpose of the enterprise, especially as it was popularly understood, was the production of gold. Nevertheless, as a serious undertaking, alchemy was not an attempt at visual deception but a catalytic technique that hastened a refining process that was inevitable, since ultimately all metals become gold. The progress of metals corresponds to and iconically represents the refinement that all things experience. Each metal embodies a specific aspect of the natural world, such that the metals are located at "the center of a web of associations and analogies that permit their manipulation to have far-reaching religious significance."[38]

In addition to the doctrinally motivated criticisms of individuals like Ibn Qayyim al-Jawziyya, there was also philosophical opposition to alchemy based in the charge that the alchemical process does not change the substance of an object but only its appearance. This point was made with much clarity by Ibn Sina, who condemned the alchemists as charlatans because they "were only able to make something that externally resembles the precious metals, but the senses do not perceive specific differences *(fuṣūl)* in the metals after the alchemistic operation, but only attributes and accidents *(lawāzim, shawārid)*; the substances *(jawhar)* of the base metal remained untouched."[39]

Optics

Alchemy's history is that of a science which, despite its enormous popularity over many centuries, fell off the main shelf of the experimental sciences onto a dusty pile of discredited esoteric past-times and pseudosciences. In contrast, optics—which would have been viewed with similar distrust as a physical science by many religious scholars of the Islamic middle ages—successfully made the transition into a modern experimental science, such that its major medieval figures are celebrated today as founders of an important scientific field.

Ibn al-Haytham's optical theories of perception have already been outlined in the context of Islamic aesthetic theory as it relates to notions of beauty and proportion. However, medieval optical writings are also important for the information they provide on how their proponents viewed the relationship between objects and their images in the eye, theories that argued for both epistemological and ontological relationships among object, observer, and image.

Medieval Optics

Kepler may have opened the door that allowed for the development of modern optical theory, but his work represented an evolutionary rather than revolutionary transition from medieval optics, and the basic aims and premises of visual theory remained more or less the same from Ibn

al-Haytham in the eleventh century to Kepler and his successors in the seventeenth. What separated Kepler and his medieval Arab and Latin predecessors was a conceptual chasm, with medieval scholars of optics primarily concerned with understanding the process of vision and Kepler mainly interested in the nature of light.[40] The main goal of medieval optics was to make sense of the manner in which objective reality was manifested subjectively in a system of visual perception and through the mediation of color and light. In contrast, for Kepler, optics was about light and its function independent of any sensory or perceptual element.[41]

Medieval authors on optics relied heavily on the work of Greek thinkers who explained vision by a theory in which a visual ray emitted rectilinearly from the eye and struck the object of vision. Combined with an understanding of reflection and refraction, optics came to be seen as a theory of vision made possible by direct, reflected, and refracted visual rays. Such a complex theory took time to be formulated: although it is visible in Ptolemy's writing (ca. 170 CE), it was not until three hundred years later that Proclus put forth a theory of vision that combined the study of rectilinear vision with that of the appearance of specular images (reflection) and the representation of three-dimensional objects on a flat surface (refraction).[42] Elements of this theory appear in the writings of al-Farabi, even though Ptolemy's *Optics* had probably only been available to Muslim scholars for fifty years before al-Farabi's time.[43]

The visual ray theory, commonly referred to as the extramission theory of vision, was not without its problems, and was contrasted with an alternative theory of intromission in which simulacra of the object of vision struck the observer's eye. Even within each theoretical framework there was considerable change over time in the views of authors. For example, although Euclid postulated that visual rays emitted *from* the eyes of the observer rather than from some other location, it was al-Kindi some centuries later who believed this hypothesis could be demonstrated empirically.[44] It was al-Kindi's claim "that the strength of the visual power varies with its position in the visual cone" that introduced geometry into scientific comprehensions of the process of vision. However, al-Kindi did not understand vision as a composite impression

produced in the eye by a large number of rays (as in the modern under-standing of vision). Instead, for him, each ray constitutes a complete likeness of the object of vision that is impressed upon the eye of the observer very much like simulacra or things like films that are believed to strike the eye in other theories of vision. This would have been self-evident to al-Kindi and his predecessors, since he would think it only possible for a coherent visual impression of an object to enter the eye as a consequence of a coherent process of radiation, which would require the image to depart from the object of vision as a singular unit.[45]

In contrast to al-Kindi, the majority of medieval Islamic writers on optics have favored an intromission theory of vision, including Ibn Sina, who deals with visual theory in various works including the *Kitāb al-shifā', Kitāb al-najāt, Kitāb al-qānūn fī'l-tibb, Dānishnāma,* and *Maqāla fī'l-nafs.* Ibn Sina's emphasis is on disproving the extramission theory, not on defending the theory he favors. His main concern is with the criteria by which one is to evaluate theories of vision. In contrast to the mathematicians who argued that—because of the use of a visual cone in modeling—it was only the extramission theory that could explain visual perception, Ibn Sina argued that the mathematics of visual cone modeling were rendered inapplicable and irrelevant by dint of the fact that "the visual power is not, according to the version of the extra-mission theory under consideration, fixed in the eye, where it can per-ceive the angle between rays touching the extremes of the object, but in the base of the visual cone, where it is able to acquire immediate knowledge of the object's true size; thus a *physical* or *psychological* un-derstanding of the extramission theory reveals its inability to explain such facts of perception as the diminution of objects with distance from the observer."[46] Elsewhere, Ibn Sina argues that any extramission theory is redundant on the grounds that, "since the air itself is in con-tact with the eye, it goes without saying that it transmits [the image] to the eye, and there is no need for a ray to issue [from the eye]."[47]

For Ibn Sina, the only acceptable theory of vision is an essentially Ar-istotelian one and which he outlines in his *Shifā':* "Just as other sensibles [than color and sight] are not perceived because something extends from the senses to them and encounters them or is joined to them or sends a messenger to them, so vision does not occur because a ray

issues forth in some way to encounter the visible object, but because the form of the thing seen comes to sight, transmitted by a transparent medium."[48]

An essential difference between the extramission and intromission theories of vision is that, in contrast to the essentially mathematical nature of the former, intromission is primarily concerned with explaining how the visual properties of the object of vision were communicated to the organ of sight, not with explaining theories of perspective. In fact, both the extramission and intromission theories can allow for a perception-centered theory of optics in which *seeing*—with all it entails in terms of the relationships among the visual object, the viewer, and the image of the object—takes center stage. Such a stance on the process of vision is apparent in Augustine; though his ideas are not direct precursors to any Islamic theories of vision, he highlights the ways in which optical theories impact conceptualizations of the nature of objects and their perception. In extramission theory, the visual ray emanating from the viewer's eye "touches" the object of vision and, simultaneously, the ray theory allows for the object to impress itself on the body of the viewer. As a consequence, the process of vision links the object and the viewer, with the image of the object forming a bridge of continuity between the two.[49]

Ibn al-Haytham and Perception

The most significant development in the medieval Islamic study of optics came with Ibn al-Haytham, who tried to undertake a systematic, fresh examination of the entire science of vision. Ibn al-Haytham distinguished between the two main explanations for the process of vision at his time (discussed in the previous section)—the extramission theory favored by mathematicians *(ashāb al-taʿlīm)*, according to which a visual ray exits the eye and hits the object, and an intromission hypothesis preferred by physicists or natural philosophers *(ashāb al-tabīʿa)*, in which the eye receives "forms." He did not find either of these theories sufficient to explain the nature of vision, and argued that a sound hypothesis would synthesize both of them.

Ibn al-Haytham's theory of the nature of visual perception is a major focus of his seven-part *Optics:* five of the eight chapters of the first book concern his theory of vision and include discussions of the effect of light on sight, the manner of vision, accounts of the conditions of vision, as well as a detailed exposition of the structure of the eye. The second book comprises the substance of his visual theory and deals with objects of vision and the nature of their perception. The later volumes also address aspects of the subject, including questions of errors in vision, the nature of "pure sensation," and recognition. This work represents the most elaborate and systematic treatment of the subject until his time.[50]

Ibn al-Haytham's theory involved a total rejection of all variants of the extramission or visual-ray theory put forward by Galenic theorists and mathematicians. He countered an important—but previously unstudied—flaw of the intromission theory: if vision is achieved by way of an impression made by an object *inside* the eye, then why is the object seen outside the body rather than in the visual organ? Ibn al-Haytham hypothesized that vision occurred through the necessary intervention of a "faculty of judgment" that drew an "inference" from the visual impression produced by the object in the eye and conveyed this to the brain. Thus, he argued, the intromission theory could not provide a complete explanation of the process of vision unless it was combined with a psychological theory that postulated that modes of inference were necessary for vision in addition to the basic ones involving light and color. For this reason, his writings place significant emphasis on the psychological processes of seeing, and it is in this regard that he represents the most significant advance over his predecessors, providing not just a new theory but also a new methodology for the study of vision.[51]

Ibn al-Haytham argued that empirical evidence supporting his hypothesis of intromission came from the effect of light in the eye: a sensation of pain is felt when one gazes at an intensely bright light. He even appears to argue that the visual sensation itself as experienced in the crystalline part of the eye is the same as the sensation of pain (even though the latter sensation is absent).[52] The vision of the object inside the eye does not manifest itself as a complete image in the eye (like

a pinhole camera); rather, "as a representation of the object, it is perceptible only after it has been singled out from a multitude of confused rays on the crystalline-surface and transmitted to the brain: and it is perceptible only to the faculty of sense."[53] He distinguishes between two modes of perception—one immediate *(idrāk bi'l-badīha)*, the other contemplative *(idrāk bi'l-ta'ammul)*—and points to the distinction between the "ascertained form" of an object *(sūra muhaqqaqa)* and its true form, the latter being one that manifests all its visible properties. The only way to ascertain that the true form has been perceived is through contemplation, since it is only through this process that we apprehend an object's finer features. Thus, even though a true form may actually be perceived in immediate perception, it is only through the process of contemplative perception that this authenticity is ascertained.[54]

Ibn al-Haytham's interest in the nature of recognition as a part of visual perception is especially interesting, in that it involves a process of both memory and comparison using the faculty of judgment. It is as a consequence of memory that the observer's mind stores a databank of images both of entire objects and of their constitutive properties. New visual perceptions are compared with those seen previously, and a process of judgment in examining them and their constitutive parts allows the viewer to make sense of the new visual input. Sabra summarizes the process of vision well:

> A form is an optical array disengaged by the crystalline humor and presented through the optic nerve to the faculty of sense. The visual material of which this form is composed, the light and color in it, are registered as light and color sensations. But the perception of the received configuration as an ordered disposition of light and color is the work of a mental faculty over and above mere sensation. There is a process that turns the disentangled visual material into a perception of form and, ultimately, into a perception of an object lying out there with all its visible properties—shape, size, position, and so on. Seeing an object is not the result of a

mere imprinting on the mind (brain) of a form emanating from the object. It is an inference from the material received from the object as sensation.[55]

For Ibn al-Haytham, sight does not perceive the *qualities* of a visible object but only its form, which is itself composed of a permutation of individual properties that sight perceives and then conveys to the imagination and faculty of judgment.[56] It is this last place—a faculty of the mind or the imagination—that can appreciate the beauty of the visible object. Perceived forms of visible objects are then fixed in the imagination, and the more repeatedly they are perceived by sight the more firmly they become fixed, their presence allowing the viewer to make judgments about a visual object (composed of similar forms) that is seen later. Recognition and appreciation are based on a process of comparison to a likeness that already exists in the imagination.[57]

The most important aspects of Ibn al-Haytham's theory as they relate to the subject of this book are his ideas concerning recognition as a factor of perception, and his extensive details on how visual properties of an object are apprehended. What makes recognition important is that it does not require an examination of all properties of the recognized object and can therefore take place immediately. The faculty of judgment immediately goes through its memory to find a similar form stored in the imagination, and if no such form is found, recognition cannot take place (Ibn al-Haytham does not appear to subscribe to the belief in the existence of universal forms). The properties that aid in recognition are "signs" *(amārāt)* that allow for rapid inference, recognition, and comprehension of visual objects without the individual being aware of their process on account of the repetition of visual observance.[58]

For Ibn al-Haytham and those who followed him, the act of seeing was a complex affair that occurred in stages, from physical radiation, to physical sensation, to perception and, finally, to understanding. Each of these stages is characterized by a specific intentional form of representation that, as a "virtual likeness," resembles the way paintings are virtual likenesses of what they purport to represent. "The luminous

color-forms transmitted through air are intentional representations, or virtual likenesses, of the actual colors on the object's surface. Physically radiated to the eye, these color-forms generate a visual representation, or image, in the optic complex. This image is a virtual likeness of the object at the level of pure sensation. Transmitted through the spirit pervading the optic complex, the visual representation gives rise to a more abstract perceptual representation. This intentional representation is realized in the animal spirit of the brain. So too is the conceptual representation arising from it."[59]

Ibn al-Haytham believes that under perfect optical conditions and with a sound mind, the object as perceived in the mind is identical to the object viewed. The implications such a theory holds for the nature of the visual image, resemblance, and recognition are immense: if the image in the mind is perfect, then reflections as well as representations can be identical to, or at the very least indistinguishable from, their prototypes. The same idea appears in Sufi metaphysics, as discussed in Chapter 8. If an image is identical to the object it represents, then it has to share in the prototype's qualities, which lends an ontological authenticity and value to the image that would not hold were it simply a representation.

Ibn al-Haytham's importance to the history of optics is unquestioned, especially in the influence he wielded over later writers in the Latin West. However, it appears as if his optical theories were not similarly influential in the Islamic world. No mention of the *Kitāb al-manāzir* has been found in the writings of Islamic mathematicians and philosophers of the eleventh and twelfth centuries, nor is there evidence of the impact of his teachings during this period. In all likelihood, Ibn al-Haytham's magisterial work remained unknown in the Islamic world in the centuries immediately following his death, and he remained famous primarily as a mathematician and theoretical astronomer.[60] It was left to one Kamal al-din Abu'l-Hasan al-Farisi (d. ca. 1320) not only to recover his writings on optics from oblivion, but also to bring together various aspects of Ibn al-Haytham's thought concerning the physics and psychology of vision that existed separately in a number of different treatises in his own *Tanqīh al-manāzir li-dhawī al-absār wa'l-basā'ir*. The accounts surrounding al-Farisi's un-

dertaking of this work suggest that Ibn al-Haytham's optical theories did not enjoy any popularity in the medieval Islamic world: al-Farisi was interested in optics, and was told by his teacher, the astronomer and philosopher Qutb al-din al-Shirazi (d. 1311), that he recalled seeing a book in an obscure library in his youth that dealt with the subject of optics. Al-Shirazi procured a copy of Ibn al-Haytham's *Optics* for his disciple, who then chose to write his famous commentary on it. However, al-Farisi's writings on optics before he composed his own commentary on the *Kitāb al-manāzir* make clear that he knew of neither Ibn al-Haytham's work nor of Ptolemy's *Optics*.[61] In other words, it is highly unlikely that scientific theories concerning optics had much direct impact on the formation of Islamic attitudes toward visual objects and their perception during this important period.

At the same time, however, one should remember that, despite the relatively small immediate audiences for advanced research in the experimental sciences or natural philosophy in premodern (or even modern) Islamic societies, the existence of such influential scholars indicates a committed interest in exploring issues of sight and perception in a broader educated community.[62] Importantly, neither the scholarly debates of theologians, jurists, and Sufi metaphysicians, nor the literary allusions of poets and other writers, represent a perspective on vision that stands in opposition to the hypotheses forwarded by scholars such as Ibn al-Haytham and al-Farisi, suggesting that scientific notions of optics informed or—at the very least—were in harmony with other theories concerning perception and the notion of the imagination in premodern Islamic society.

7

Dreams, Visions, and the Imagination

Night was not yet over when
The moon leaned over my pillow
and said, "Wake up! Dawn is here!
The cup is empty of the wine of dreams
That was yours this night."
Saying farewell to the image of my lover,
I raised my eyes to the dark, still waters of the night
As silver eddies danced across its surface . . .
The bright faces of my fellow prisoners
Bubbled up from the darkness——
Sleep and dreams had washed their faces clean of
The longing for home and the pain of separation.

—FAIZ AHMED FAIZ, "ONE PRISON MORNING"

Imagination, prophecy, visions, and dreams are integrally linked in much of Islamic thought, which almost universally posits that beyond the physical, quotidian world discernible by sense perception lies another, larger realm. Whether through scripture and theology or through scientific, philosophical, or metaphysical writings, Muslim scholars have

maintained that the suprasensible world has an ontological status that is more real and more perfect than the one we perceive through our senses. Prophecy represents a divinely ordained status through which chosen individuals see the "real" world in what is understood to be its "true" relationship to the suprasensible one. Similarly, for philosophers and Sufi metaphysicians, a refined intellect also enables gifted individuals to see truths and patterns of resemblance and representation that lie beyond the powers of the external senses.

Although it has not been seen as such in any systematic way, writing on dreams and dreaming represents one of the most important areas for analyzing Muslim understandings of the relationship between the physical realm and what lies beyond. As such, dream literature (oneirocritical works) are an important set of sources to consider when looking for patterns of resemblance, even though virtually none of the substantial scholarship on dreaming approaches the subject from this perspective.[1] Vision and sight are primary features of all dreams, therefore visual representation and mimesis are central to the understanding of dreams and their interpretation. Furthermore, the signifiers and symbols as well as their relationship to the imagination play a fundamental role in the understanding of dreams since the imagination transforms spiritual or metaphysical truths into symbols. This idea also serves as one of the cornerstones of Muslim philosophical understandings concerning the nature of prophecy because, according to the most influential philosophical traditions, the revelations received from God by a prophet get dressed in images and figures in order to be communicated to the populace at large.[2]

There is a large amount of writing dealing with dreams and dream interpretation across all Islamic cultures and historical periods. Dreams and dream visions served a variety of functions in premodern Islamic society, just as they did in late antiquity, with the dream functioning as "the site where apparently unquestioned, and unquestionable, realities, life and death meet, qualify each other, even change places."[3] Whether as an individual's own dreams with easily understood messages that serve as moral lessons or cautionary communications, or as complex dreams that beg for interpretation and became part of the rich registry of dreams in manuals of oneirocriticism, the dream remained

an important means for learning and communicating truth. Dreaming in Islamic societies continues to retain many of the important conceptual features that characterized the medieval literature on dreaming, including the connection to religious revelation, notions of true and false dreams, visual correspondence between the dream vision and its counterparts in the physical world, and the importance of imagination as a place of real visions.[4]

Dreaming in Islamic History

Two important questions concerning dreams necessitate their inclusion in a book dealing with issues of art perception. First, how do we actually know the systems of representation linking the dream and waking states—in other words, what is the mimetic system of dreaming? And second, what kind of truth do dreams convey, and what is the truth value of the dream?

In sweeping terms, dreams and dream interpretation in Islamic society can be divided into two main categories—dreams as they appear in dream manuals, where they function as sources of divination or moral lessons, and a broader, less easily defined variety of literature in which dreams serve a variety of functions including conferring status, providing evidence, and symbolizing interpersonal relationships. Most classical dream manuals belong in the first category, but this does not preclude their relevance for other kinds of uses. Although practically all dream manuals have some sort of introduction, virtually none of them directly addresses the theoretical nature of the relationship between what is seen in a dream and its equivalent in waking life. Such theoretical discussions that do exist distinguish between two kinds, or levels, of seeing: "the dreamer's visionary experience itself, which occurs in a liminal state during which the activities of the external senses are suspended, and the insight required to interpret such visual manifestations."[5]

Dream manuals were extremely popular from the very beginning of Islamic society, such that in the earliest centuries there were as many dream manuals written as there were commentaries on the Qur'an.

The acceptance of dreams as a legitimate source of knowledge is attested to by numerous accounts in various contexts. For example, Sahnun (d. 854), one of the greatest scholars in the history of the Maliki school of Sunni law, appeared in a dream to declare that reading the Qur'an with a written text in front of oneself was preferable to reciting it entirely by heart, thereby settling an important controversy in Islamic legal thinking.[6] Similarly, the diary of the Baghdadi Hanbalite scholar Ibn al-Banna' (d. 1079) narrates at least twenty-three dreams over a one-year period, some of them at length. They cover personal concerns and political events, as well as doctrinal issues, and are not only reports of his own dreams, but also those of others that were described to him because of his reputation as a dream interpreter.[7]

As a rule, classical Islamic dream manuals are not theoretical works on dreaming or psychology but are how-to's of divination. They function as diagnostics or symptomatological aids of a very straightforward sort, stating quite clearly that if one sees a specific thing, it means another specific thing. The earliest extant manual is that of Ibn Qutayba (d. 889), and although it enjoyed great popularity over several centuries, today it survives in only one complete copy.[8] The Islamic tradition of dream interpretation is popularly traced back to Ibn Sirin (d. 728) and a number of dream manuals are attributed to him, although it appears that he never actually composed one. Both Ibn Sirin and Ibn Qutayba were actually important figures in the transmission and use of hadith, Ibn Sirin as a formal transmitter in canonical collections, and Ibn Qutayba as a collector and scholar of hadith. This fact points to the close relationship between dream interpretation and religion in early Islam. In actuality, the importance of dreaming is attested to in hadith, which draws direct explicit links between the phenomenon of dreaming and the characteristics of prophecy.

The Dreaming Process

The dream visions encountered by the dreamer are transformed into a verbal narrative of the experience, which goes through another stage

of transformation in the process of being interpreted. These transformations (or translations) raise issues concerning the relationship not just of images to words, but also of the dreamer to the dream interpreter as well as of the connection between author and audience.[9]

It is important to draw a distinction between two ways of seeing in the context of dreams: the dream vision *(ru'yā)* of the dreamer and the interpretative seeing *(nazar)* of the interpreter. In discussing the phenomenon of dreaming, Ibn Khaldun described these two forms of seeing as necessary for understanding the content of a dream. According to him, when the dreamer awakens, he is not aware of the true nature of what has transpired, only that he saw *(ra'ā)* something. It is, in fact, the interpreter who *sees (yanzuru)* the underlying meaning of the dreamer's visions through the help of "the faculty perceiving likeness" *(bi-quwwat al-tashbīh)* as well as his familiarity with the nature and circumstances of the dreamer. In many ways, therefore, the process of dream interpretation is analogous with that of scriptural interpretation *(tā'wīl)*, a point noted in several dream manuals.[10]

In addition to the distinction between dream visions and their interpretation, another necessary distinction can be drawn between two kinds of dreams as represented in works on dreaming, these being symbolic and literal dreams. Symbolic dreams are the content of dream visions and require interpretation *(ta'bīr)*, and therefore form the subject of the bulk of oneirocritical works. In contrast, literal dreams are self-explanatory by definition. They are almost always verbal rather than visual and carry a clear message, such that they do not fit in the categories of dreams that are found in the dream manuals that focus on issues of interpretation. Literal dreams possess neither an oneirocritical purpose, nor do they function as signifiers; instead, they constitute an explicit form of verbal moral counsel.[11] The *Kitāb al-manām* of Ibn Abi Dunya (d. 894) constitutes an example of the latter category of writings, which has never been as popular as the works dealing with the interpretation of dream visions that gathered together symbolic dreams with the purpose of demonstrating a range of methods of dream interpretation. Under the encouragement of the Abbassid caliphs, such oneirocritical works took the shape of a distinct genre of dictionary-like catalogs, following in the tradition of Greek works on dream interpretation

such as that of Artemidorus, which was translated into Arabic by Hunayn ibn Ishaq. The very popular early-modern *Tafsīr al-anām fī taʿbīr al-aḥlām* by ʿAbd al-Ghani al-Nabulsi (d. 1731) is an example of such a work: organized alphabetically by items seen in dreams, it can function as a reference book even for amateur dream interpreters, although the fact that al-Nabulsi frequently ascribes multiple meanings to the same object encountered in the dream suggests that he presumes the existence of an authoritative interpreter who is capable of identifying the correct symbolism of a specific vision. In this encyclopedic guide to dream interpretation, al-Nabulsi never questions the objective validity of the content of a dream, reflecting the pervasive acceptance of the truth of dream visions as established by hadith and also of their function as sources of revelation. He is aware of the possibility that some individuals might approach an interpreter with fake, invented dreams, but does not consider it the responsibility of the interpreter to judge their genuineness. "If the answer is auspicious, the merit is the interpreter's; if bad, it is at the cost of the willful questioner."[12]

The link between dreaming, revelation, and religious authority is clearly stated in a widely circulated hadith that declares that having a vision of the Prophet in a dream is equal to seeing him physically. In many versions, this statement is combined with a declaration that the devil cannot disguise himself to look like the Prophet. Taken together, these two authoritative statements denote that the appearance of Muhammad in a dream holds the same legitimacy and authority as seeing him physically. The popularity of this hadith—and the fact that the canonical hadith collections include it in the section dealing with dreaming as evidence of the reliability of dreams—makes it clear that not only was the veracity of dreaming a widely sanctioned Muslim religious idea, but the correspondence between what is seen in a dream and its "waking life" referent is a perfect one.[13]

This hadith tradition allows the institution as well as the living guidance afforded by prophethood to continue after Muhammad's death despite the almost universal Muslim doctrine that denies the existence of prophets subsequent to him. Muhammad continues to oversee the Muslim community through his appearance in dream visions much as he did while he was alive, and individual Muslims retain the

ability to seek his guidance and follow his ongoing advice. This point is underscored by a famous hadith that states that Muhammad said: "Mission and prophecy have come to an end; there is no messenger after me and no prophet." According to the hadith, his companions were upset at the prospect of being without guidance, and Muhammad reassured them by saying: "But the tidings *(mubashshirāt)* remain" (echoing Qur'an 10:63–64). When people asked him to clarify the meaning of this statement and the nature of the "tidings," he replied: "[They are] the Muslim's dream *(ru'yā)*."[14]

It is not only the Prophet whose appearance in dreams constitutes a legitimate form of guidance or authority: Ibn Sirin is credited with stating that "Whatever the deceased tells you in sleep is true [or the truth] *(haqq)*, for he resides in the world of truth *(dār al-haqq)*." The declaration makes clear that it is the dream—not the appearance of Muhammad specifically—that invests the visionary appearance with religious authority, and that any dead person can appear with reliability in a dream. "This statement is not focused on the Prophet's appearance, but rather recognizes the reliability of any dead person who appears in dreams. It is the dream itself, not the Prophet, that creates legitimate authority."[15] Ibn Qutayba is even more direct in affirming the religious legitimacy of dreams, saying: "Among the types of knowledge and the varieties of wisdom with which humans occupy themselves, there is none more obscure, none more refined, exalted, and noble, none more difficult ... than the dream, for it is one of the parts of revelation *(wahy)* and one of the modes of prophecy *(nubuwwa)*."[16]

The category of literal dreams and the amateur practice of dream interpretation notwithstanding, part of the complexity inherent in interpreting the visions encountered in dreams rests on the varying methodologies necessary for any such interpretation, since dreams not only differ according to the personality of the dreamer, but also by his or her circumstances, and even by the seasons. Furthermore, according to Ibn Qutayba, sometimes dream visions do not apply to the person who dreamed them but to someone else; other times dreams represent the opposite of what they appear to mean; other times they are false; and sometimes they are even devoid of meaning. The complexity of the discipline of dream interpretation necessitates a highly qualified dream interpreter. In the words of Ibn Qutayba:

It is incumbent on him to be learned in the Book of God and in the traditions of the Prophet . . . in the proverbs of the Bedouin and in well-known verses of poetry, and in etymological and dialectical studies. He must moreover be refined in his character, a quick study, equipped with a thorough practical understanding of men and their characters, knowledgeable in the use of analogy and able to memorize lots of material.[17]

Dream Resemblance

The process of interpreting dream visions occurs, in a fundamental sense, by positing links between dream-vision symbols and their meanings. As analyzed by Lamoreaux, such links can be propositional, conditional, indicative, or anecdotal. In the case of a propositional link, "an interpreter posits a relation of equivalence between the symbol and its meaning, predicating the meaning of the symbol. 'Venus is the king's wife.'" A conditional link would be one such as "if he sees a frog speaking to him, he will obtain dominion" (and sometimes the conditional clause has its apodosis linked to an indefinite relative clause, as in "whoever sees that the resurrection has happened in a place, justice will be spread in that place"). Indicative links are ones in which the symbol in the dream vision is understood to indicate (*dalla*) its meaning directly, as in: "a turtle covered with mud indicates a woman who is perfumed and adorned, who presents herself lewdly to men." Finally, an anecdotal link is one in which the dreamer narrates the details of his or her dream to a dream interpreter and receives an interpretation of it. "Regardless of the literary form in which the interpretation of the dream is presented, in each instance it is possible to discern two logical elements, a description of the dream symbol and a statement of its meaning."[18]

Dreams are understood, first and foremost, to contain symbolic messages; thus, it is the visual elements of the dream that are the keys to its interpretation, viewed within the context of environmental and situational factors. The appearance of a camel in the dream vision of an Arab, for example, means something completely different from its

appearance in the dream of a Greek person.[19] This point is based in an acknowledgment that the entire phenomenology of dreaming is grounded in specific cultural contexts, in terms of both the visual qualities of the dream itself and the contextualization and interpretation of the dream. The contextual specificity of the symbolic system of Islamic dream interpretation relies on a stable—if complex—system of interpreting signs, which can be deciphered in fixed and reliable ways by a qualified dream interpreter. In fact, like constructed visual symbols in the waking world, dreams can be cultivated or, at the very least, one can live one's life in ways that increases one's chances of receiving dream visions.

In many ways, the dream, as a signifier, is composed of three main parts. The first is the "cultural template" on which the dream is situated; the second is the metaphorical (or perhaps representational) relationship between the dream and the dreamer's individual psychosocial position. The third is the belief of the dreamer and others in the reliability of the relationships of signification between the dreamer and the object or person encountered in the dream vision; in other words, the belief in the direct semiotic relationship between the dream vision as a signifier and the social world of the dreamer as that which is signified.[20]

Some dreams appear understandable on the grounds of their symbolism, such as ones that comprise visions of urinating into a vessel with a hole (which signifies that the dreamer's wife is infertile), or urinating on the Qur'an (signifying that the dreamer's offspring will memorize the Qur'an), the constant in both being the symbolic relationship between urine and semen. In other cases, the symbolic relationship is based on perceptions in waking life; for example, frogs are believed to glorify god through their croaking, therefore seeing a frog in a dream signifies a holy person or good fortune. Other symbolic relationships are very direct, such as a vision of resurrection implying either death or justice. Yet others seem completely arbitrary and call for the services of a trained interpreter who understands, for example, why a turtle signifies a wise man, but a muddy turtle a lewd woman.

In actual fact, the stability of such symbolic correspondences is overstated by dream manuals and their amateur users since, in prac-

tice, no visual symbol encountered in a dream occupies a stable rela-
tionship with its referent such that its context becomes irrelevant.
This holds true for traditional oneirocritical works, but especially so
for other genres of literature that include accounts of dreams and
dream visions as an integral part of their purpose. Sufi hagiographical
works comprise the most important of these genres, but other works,
including political histories and royal writings, rely on dream visions
for a variety of purposes.[21] In Sufi literature, dream narratives primar-
ily serve prescriptive or exemplary functions, with virtually no distinc-
tion between dream experience and waking experience, in the sense
that what is encountered in a dream could also be encountered in a
waking state. Therefore, in many types of Sufi writing, dream visions
constitute a means of seeing that is not distinct from other types (such
as regular seeing, or waking visions), such that dream narratives con-
stitute one of several modes of utilizing vision in the instructional and
descriptive elaborations of Sufism.[22]

Resemblance between the object seen in a dream and its waking-life
counterpart is an accepted fact in the nature of dreams as they are
understood in Islamic society. Similar to semiotic relationships of
other sorts, symbolic resemblance and signification in dreams relies
on the interpretations of an informed observer. The absence of such an
observer—either as the dreamer him or herself or as the dream
interpreter—might prevent the explanation of a symbolic relationship
between the object of the dream vision and its physical counterpart, but
in no way does it bring into question the truth value of visual dreaming.

Dreaming in the Philosophical Tradition

Discussions of the truth value of dreams as well as of the imagination
are primarily found in the philosophical and Sufi traditions of Islamic
thought. Writings on the nature of dreaming in these contexts owe a
great deal to the philosophical tradition of late antiquity, a topic which
is beyond the scope of this chapter and is part of the wider process of
adoption and translation of Greek learning in Islamic society. More
than any other single work, the Arabic version (for it is more than a

straightforward translation) of Aristotle's *De divinatione per somnum* (which forms part of his *Parva naturalia* dealing with psychological topics) proved extremely popular with Muslim as well as Jewish philosophical thinkers, and they believed this work accurately represented Aristotle's ideas on matters of dream interpretation. It exerted a significant impact on the thinking of philosophers such as al-Farabi, Ibn Sina, Ibn Bajja (d. 1138), and Ibn Rushd (d. 1198). Outside of the philosophical tradition, it was also relied on by al-Dinawari (flourished ca. 1040) in the writing of his *Kitāb al-taʿbīr fiʾl-ruʾyā aw al-qādirī fiʾl-taʿbīr (The Book of Dream Interpretation)*, one of the most important works in the Muslim oneirocritical tradition.[23]

Though these thinkers took the Arabic version of *De divinatione* to reflect the thought and writings of Aristotle accurately, in actual fact the Arabic version differs from Aristotle's work in several important ways. The Arabic text forms part of the *Kitāb al-hiss waʾl-mahsūs*, which is a translation of the *Parva naturalia*. According to Hansberger, who has engaged in a close reading of the most reliable manuscript of this work, the Arabic *De divinatione* "never even questions the assumption that the ultimate source of veridical dreams is God; divination in dreams is not only possible, but a fact of life."[24]

The Arabic *De divinatione* focuses on two primary points in its discussion of true dreams—their divine provenance and the psychologico-metaphysical circumstances of the individual at the time that he or she is experiencing such a dream. Its explanations are provided within a context that draws on both Muslim scriptural material and the philosophical legacy of late antiquity. According to this text, all true dreams are created by God as part of the process of creation rather than at the moment that an individual dreamer experiences the dream or in the moments prior to the dreamer's experience. The conveying of the dream to the dreamer is an act of the Active Intellect. Through this process, God provides individuals knowledge of what awaits them in their earthly future and in the afterlife.[25]

The Arabic version of *De divinatione* describes a set of "spiritual faculties" (*al-quwā al-rūhāniyya*) through which visionary dreams are perceived, entirely bypassing the physical organs of perception. These are comprised of the imagination or "formative faculty" (*musawwir*),

memory *(dhikr)*, thought *(fikr)*, as well as a shared spiritual faculty *(sensus communis,* or *al-hiss al-mushtarak* in Arabic).[26] According to this work, all things have three different forms, a corporeal one that can be sensed physically *(sūra jismāniyya);* a spiritual one *(sūra rūhāniyya),* and an intellectual one *(sūra 'aqliyya).* These three distinct forms are concentrically arranged, with the corporeal form on the outside, enclosing the spiritual form, which in turn encloses the intellectual form. The arrangement of three distinct forms of the same entity provides a satisfactory explanation of how an entity seen in a dream does not appear the same as one seen in a wakeful state, even though its essence (or true identity) is the same. "When having a veridical dream, the dreamer perceives the spiritual form, which is, though similar, not identical with the corporeal form."[27] The concept of different forms also helps explain how even true dreams do not always provide an accurate prediction for future events, since the form of the future event as seen in the dream might not be correctly identified as resembling the event in the future that it is depicting.

The way in which pure intelligibles are communicated from the Active Intellect to a human being who perceives them without the participation of the external senses is explained in the Arabic *De divinatione* in the following manner:

> The Intellect expresses the intellectual form (which is not perceptible) in "spiritual words" *(kalimāt rūhāniyya).* These are somehow conveyed to the dreamer's *sensus communis;* that is, they arrive at the "clearing house" of sense perception without any interference of the external senses, directly from the Intellect. The *sensus communis* passes them on to the formative faculty, which represents these "spiritual words" as "spiritual forms"; the latter are what the dreamer "sees" in his dream. The other spiritual faculties also play their role: memory will store those forms; and when the dreamer awakes he may be able to discover the *significatum (ma'nā)* of the dream with the help of the faculty of thought.[28]

Veridical dreams are therefore entirely true and free of error. Because they arise independently of the dreamer in the Active Intellect,

they are untouched by previous experiences of the dreamer and are perceived by his or her spiritual faculties as completely new experiences or perceptions. In the event that the meaning of a veridical dream is not readily apparent to the dreamer such that he or she requires the assistance of a dream interpreter, the same holds true for the veridical, error-free nature of the dream vision; even though the interpreter does not experience the actual dream in the way the dreamer does, the interpreter shares the same act of "revelation" from the Active Intellect:

> The Intellect conveys the same spiritual words to the interpreter which it conveys to the dreamer; only in his case they are not converted into "spiritual forms", that is, a dream-vision; the interpreter is able to understand their meaning directly. His ability to receive this kind of "inspiration" from the Intellect is either due to his spirituality, or due to his ability to read "signs that have become manifest in the world." It is his task to convert the spiritual words into "corporeal words," into normal speech which the dreamer can understand.[29]

Al-Farabi and the Imagination

The Arabic version of the *De divinatione* undoubtedly had broad influence on works concerning dreaming and the imagination in the Islamic world. Al-Farabi's theories on dreams and dreaming appear to have been heavily influenced by this work, even though he never mentions it by name. The most influential Islamic political philosopher and arguably the greatest Neoplatonist since Proclus, he lists all the treatises comprising the *Kitāb al-hiss wa'l-mahsūs* in his own *Falsafat Aristūtālīs* (The Philosophy of Aristotle), and his description of the section on the nature of sleep and wakefulness *(bāb al-nawm wa'l-yaqaza)* closely follows the text of the important manuscript of the Arabic *De divinatione* discussed briefly here.[30] Furthermore, al-Farabi's ideas on divinatory dreams, which are spelled out in his *Mabādi' ārā' ahl al-madīna al-fādila*, seem to build directly upon the Arabic *De divinatione*. For example, al-Farabi maintains that dream visions occur during the

state of sleep because it is at that time that the imaginative faculty is free to act on its own without the burden of processing sensory inputs. Furthermore, his concept of the imitative activity *(muhākāh)* of the imaginative faculty echoes the Arabic *De divinatione* in that the imaginative faculty can imitate not just sensibles but also intelligibles, and imitation can occur independently of any input either from memory or from the external senses.[31]

Al-Farabi's concept of human psychology and perception posits an imaginative or representational faculty *(al-quwwa al-mutakhayyila)* between the intellect and the external senses. During wakeful states, the imaginative faculty is occupied processing sensibles perceived by the external senses and working for the rational and appetitive faculties, but during sleep, it is free to create its own images through what might be understood as a process of mimetic reproduction—the creation of images based on earlier sensory or intellectual inputs:

> When all the auxiliaries of the faculty of sense actually sense and perform their actions, the faculty of representation is acted upon by them and kept busy by those sensibles which the senses bring to it and imprint on it; it is also kept busy in serving the rational faculty and supplying the appetitive faculty.
>
> But when the faculties of sense and representation and reason are in the state of their first perfection and thus do not perform their actions—as happens during sleep—the faculty of representation is on its own, free from the fresh imprints of sensibles which are provided again and again by the senses, and is relieved of the service of the rational and appetitive faculties. Thus it will turn to those imprints of sensibles which are preserved in it and have remained, and will act upon them by associating them with one another and dissociating them from one another.[32]

The capacity of the imaginative or representational faculty to imitate sensibles is critical to my discussion of mimetic representation. However, this faculty can also imitate input from the intellect (intelligibles). In the words of al-Farabi: "The faculty of representation also

imitates the rational faculty by imitating those intelligibles which are present in it with things suitable for imitating them. It thus imitates the intelligibles of utmost perfection, like the First Cause, the immaterial things and the heavens, with the most excellent and most perfect sensibles, like things beautiful to look at."[33]

It is the Active Intellect that brings intelligibles from potentiality to actuality in the human mind. If the Active Intellect bypasses the human intellect and sends the intelligibles to the imaginative faculty instead, the results are true visions, which are given by the Active Intellect in dreams. In actual fact, these true visions are imparted by the Active Intellect to the imaginative faculty at all times—both during sleep and wakefulness—but the input from the senses and through the human intellect are so strong while the person is awake that he or she does not notice them. Furthermore, very few individuals possess a representational or imaginative faculty powerful enough to successfully receive and process true visions while awake.[34]

The representational faculty holds the unique role of uniting what it apprehends with the most beautiful of sensible objects, such that:

> When it happens that the faculty of representation imitates those things with sensibles of extreme beauty and perfection, the man who has that sight comes to enjoy overwhelming and wonderful pleasure, and he sees wonderful things which can in no way whatever be found among the other existents. It is not impossible, then, that when a man's faculty of representation reaches its utmost perfection he will receive in his waking life from the Active Intellect present and future particulars of their imitations in the form of sensibles, and receive the imitations of the transcendent intelligibles and the other glorious existents and see them. This man will obtain through the particulars which he receives 'prophecy' (al-nubuwwa, supernatural awareness) of present and future events, and through the intelligibles which he receives prophecy of things divine (al-ashyā' al-ilāhiyya). This is the highest rank of perfection which the faculty of representation can reach.[35]

Below this gifted category of human beings are those who see things only partially while they are asleep as well as when they are awake, and below them are those who only see these things while asleep.[36] In all cases, however, the visual things apprehended are real, so that the imagination remains a place where visual apprehensions are real and true.

Ibn Sina and the Imaginative Vision

The importance of the imagination as a location of visions holds true for other influential Islamic philosophers in addition to al-Farabi, although not always in the same way. For Ibn Sina, imagination plays a very important role, but he does not afford it any explicitly ontological status independent of the individual doing the imagining. However, in his *al-Risāla al-adhawiyya* he appears to grant imagination some degree of ontological autonomy:

> Some scholars say that when the soul leaves the body and carries the imaginative faculty along with it (i.e., in the case of the intellectually undeveloped souls) . . . it is impossible for it to be absolutely free from the body. It then imagines that it is experiencing pains by way of the usual physical chastisements, and all that it used to believe during its earthly life [i.e., about the afterlife] would happen to it after death. . . . These scholars say that it is not impossible that the soul should imagine an agreeable state of affairs and that it should experience, in afterlife, all that is mentioned in the prophet's revelations.[37]

In Ibn Sina's view, revelation is in need of its own symbolic interpretation (*tā'wīl*, literally "carrying back to the source or the initial point") in exactly the same way as dreams require their interpretation (*ta'bīr*, literally "carrying across to the other side of a river"). Rahman argues that al-Farabi and Ibn Sina use this device to provide a psychological explanation of positive or technical revelations such as the Qur'an or the Bible.[38]

As outlined by Rahman in his discussion of another very influential Muslim metaphysician, Shihab al-din al-Suhrawardi (d. 1191), even though the Realm of the Imagination or of Similitudes ('ālam al-mithāl), which I translate here as the Realm of Images, exists primarily to serve as a place where "the incredible is rendered credible and where the miraculous is somehow made 'normal,'" this realm also encroaches on the physical world: the intellects of the celestial bodies project angels into the physical world, the angel of revelation belonging to precisely this system of projection. Put differently, the realm of figures functions as a kind of "unconscious of the universe" where things like love, hate, and fear are created as concrete symbols and make the miraculous (or supernatural) into the physical, allowing things from the nonphysical realm to intrude into the physical world.[39]

The concept of the Realm of Images or of Similitudes ('ālam al-mithāl) gained in importance in metaphysical thought in subsequent centuries. For example, Ahmad Sirhindi (d. 1625), a pivotal figure in the development of the Naqshbandiyya (one of the largest and most influential Sufi orders), embraced the concept of the 'ālam al-mithāl, although he treated it as experiential, lacking any ontological status of its own. Even so, for Sirhindi the Realm of Images does not cease to be a visual realm, and its content bears a representational relationship with things in the physical world:

> That world [i.e., the 'ālam al-mithāl] in itself does not possess any forms or figures; these appear in it as mere reflections from the other two worlds—just like a mirror which in itself does not contain any form and whatever forms come to exist in it, come [as reflections] from outside. . . . 'ālam al-mithāl is for seeing, not for being; the place of being is either the spiritual world or the physical world.[40]

The ontological status of the Realm of Images is defined very clearly by Mulla Sadra (Sadr al-din Shirazi, d. 1640), who described the physical, spiritual, and imaginal worlds as sharing an ontological relationship. Developing a philosophical principle of "higher possibility" formulated by Suhrawardi, Mulla Sadra maintained that "nothing can exist at the lowest level unless it has passed through the upper grades

of 'existence,'" and conversely that "nothing moves to a higher grade of 'existence' without having passed through the intermediary grades."[41] If this is the case, everything that exists in the physical world has a tripartite existence: from the realm of the pure intellect, it descends into the realm of images and downward to the physical realm. Conversely, when things ascend in their path toward return—both in the sense of perfection discussed in the context of alchemy and in the sense of the return of the spirit to its origin—they pass through the realm of images on their way to the spiritual world.[42]

One of the most remarkable points made by prominent Muslim metaphysical thinkers is that things created in the Realm of Images (ʿālam al-mithāl) can be projected into the physical realm. In fact, this is the arrangement through which saints and prophets perform miracles. The real correspondence between the objects in the physical and imaginal realms outlined by Islamic philosophers is also affirmed in Sufi metaphysics, which is arguably the most pervasive intellectual system addressing issues of representation and resemblance in Islamic intellectual history.

8

Sufism and the Metaphysics of Resemblance

Were my body to become one large eye, I would not see enough
 of my guide.
In every cell a million eyes, I'd close one and open another.
Even seeing this much wouldn't calm me, what else can I do?
Bahu, one vision of my guide is as a million billion
 pilgrimages.

 —SULTAN BAHU

Well-meaning scholars and practitioners who see in Sufism an artis-
tic muse that explains the underlying motivation and message behind
the entirety of Islamic visual art have done significant damage to the
rigorous intellectual use of Sufi writings in the study of perception (and
visual perception in particular) within the wider field of Islamic his-
tory. The problem is especially severe in discussions of abstract forms
such as the arabesque, which are often seen as representing some
inner meaningful system of spiritual signification that can be decoded
through a form of mystical insight.

 Earlier scholars have bemoaned the anti-intellectual implications of
this trend, in particular Terry Allen, Oleg Grabar, and Gülrü Necipo-

ğlu, the last of whom provides a short list of examples of such works in her important book *The Topkapı Scroll*. Such bad examples of scholarship bear repeating in this context because they underscore the difference between a widespread, mistaken notion of the tenuous place of Sufi thought in Islamic intellectual history and its actual status as the arena in which the bulk of philosophical thinking was carried on after the twelfth century.

Particularly egregious in its treatment of the relationship between Sufism and the arts is a work published by Ardalan and Bakhtiar following the World of Islam festival in 1973. The preface by S. H. Nasr, which sets the tone for the entire book, describes the architectural traditions of Islamic Iran as "composed of timeless 'forms that echo transcendent archetypes' intimately related to cosmology and [identifying] its most fundamental principle as the concept of God's unity *(tawhid)*."[1]

Nasr has claimed elsewhere that there is a direct connection between the Islamic doctrine of divine unity and a Muslim "love" for geometry.[2] And in a similarly anti-intellectual way, R. Al-Faruqi claimed that the Islamic notion of divine unity somehow imbues the practice and appreciation of the arts with "an intuition of unimaginableness and inexpressibility—in short, of infinity."[3] He described the arabesque as the quintessential "religious work of art in Islam":

> It is the semitic religious work of art par excellence since it produces an aesthetic—not logical—intuition of "not-nature," of "not-finitude," and of "inexpressibility," the only intuitable categories of transcendent reality. Every work of art in Islam is a more or less successful exemplification of it.[4]

Even otherwise outstanding scholars of Sufism have fallen victim to the temptation to see Sufism as a font of universal explanations. Much of this writing—though by no means all of it—is directly linked to the thought of the so-called Perennialist School, which has sought to reinvigorate modern secular life with a spiritual meaning that is attained by realizing the nature of perennial religious truths. From the time of its early proponents such as René Guénon (1886–1951), Ananda K. Coomaraswamy (1877–1947), and Frithjof Schuon (1907–1998), such thinkers have seen Sufism not only as a source of much perennialist

knowledge but also as proof of the existence of what they regard as timeless truths. Guénon in particular drew a direct connection between metaphysics and symbolism that was to have a heavy influence on later followers of the school such as Titus Burckhardt and S. H. Nasr. I have already mentioned examples of Nasr's position concerning the relationship between visual representation and a concept of eternal religious knowledge. Burckhardt, for his part, has been extremely influential in linking Sufi metaphysics to the message of Islamic art through a number of works including *Sacred Art in East and West,* influencing a broad audience into believing that so-called Sufi "mysticism" constitutes a changeless muse underlying all of Islamic religious art across the ages and reflects "the timeless spiritual unity of the Islamic visual tradition in all periods and regions."[5]

These examples are not, in and of themselves, devoid of all value. Many of them, particularly some of the perennialist writings, represent a genuine attempt to find a sense of order in comparative metaphysics, aesthetics, and art, and they are legitimized in a fashion by attracting a substantial audience. Where they fail is in providing a historically grounded reading of Sufi material; they do not place these metaphysical writings within the context of the intellectual tradition within which their authors were operating. It is of some significance that the authors of Sufi metaphysical works, like writers in most other Islamic intellectual traditions, clearly did not have the visual arts in mind when they were composing their works. In fact, the overwhelming majority of important Sufi writings relevant to the topic do not refer to visual arts at all, but rather to issues of resemblance between two or more categories of objects or beings.

Dreaming and Epistemology in Sufism

As is the case of Islamic philosophical writings, in Sufi thought dreaming and the imagination occupy a central role in widely accepted notions of the relationship between the physical world and some other ideal realm, as well as between visible, physical objects and their prototypes. Dream visions are an extremely common feature of several genres

of Sufi literature, especially hagiographical works and collections of sayings. Prophets, saintly mothers, and Sufi masters—living as well as dead—appear in such visions and provide the same range of functions as individuals do in accounts of dreams in other traditions. But visions are undoubtedly more common in so-called Sufi literature than they are in other categories of Islamic scholarly writing, with the exception of formal oneirocritical literature. In the majority of cases, the person encountered in the dream vision is real, his or her dream appearance constituting an alternative form of existence that is equally "real" as his or her physical one, if not even more so. Although there are no guarantees of success, Sufi teachings include techniques for facilitating visions, both in waking and sleeping states. There are numerous examples of these varied categories of visions in Sufi literature across the Islamic world from the earliest times to the present. Al-Hakim al-Tirmidhi (d. ca. 936–8) recounts many of his own dream visions as well as those of his wife, who repeatedly saw and conversed with an angel.[6] Ibn al-'Arabi (d. 1240), whose importance to Sufism is discussed below, received spiritual instruction from teachers who were not present and, famously, had trouble distinguishing between a woman who approached him in the night in Mecca and a vision of Sophia, the goddess of knowledge. In the Persianate world from the thirteenth century onward, the cultivation of visionary visitations of Sufi masters functions as a complex, yet completely normal, part of Sufi religious life.[7]

Despite the pervasiveness of such visions of people (and also objects) that have both a physical and imaginary experience, most descriptions of such phenomena do not include any theorizing concerning the nature of visionary forms or of their relationship to their physical counterparts. In part, this is due to the pervasiveness of such phenomena, such that there is little reason to justify belief in visions or realms of the imagination. It is also because Sufi metaphysics has laid out some theories concerning the nature of the imagination and the role of the Realm of Images or the Imagination in connecting the physical and spiritual worlds in ways that have had a pervasive impact on Islamic society. Epochal figures such as al-Ghazali and (especially) Ibn al-'Arabi may have written for highly learned audiences in the main, but their ideas have percolated through much of Islamic society

and are found in the religious, literary, and material culture at myriad levels.

Al-Ghazali on Dreaming

Al-Ghazali, in particular, makes the link between imagination, dreaming, and prophecy, seeing in the universal experience of dreaming proof that prophecy is capable of understanding things that lie beyond the domain of the intellect.[8] His famous pseudoconfessional work completed approximately three years before his death in 1111, *al-Munqidh min al-dalāl* (translated as *Deliverance from Error*) contains a brief but sustained look at dreaming framed within a broader discussion of the challenges encountered in determining the accuracy of knowledge gained both through the intellect and through the senses. Al-Ghazali distinguishes between a priori knowledge and knowledge acquired through the senses, stating that these two forms of knowing sometimes conflict with each other, and that it is the responsibility of the intellect to ascertain the veracity of the input of the senses, which he deems to be unreliable. However, he also acknowledges that the intellect itself is not above error, which poses epistemological problems of its own.[9] In his magisterial *Ihyā' 'ulūm al-dīn*, al-Ghazali warns of the dangers of trusting in external appearances and the consequent need to search for the inner truth of things. This view underlies an overall hermeneutical attitude that relies on the interrelationship of the Qur'an and its explanation *(tā'wīl)* with dreams and their interpretation *(ta'bīr),* and in which the signification of a sensible form *(sūra)* can be observed from its meaning but not from the visible form itself.[10] In his view, the close correlation between seeing (through the senses) and knowing necessitates a careful use of different Arabic words for "seeing." Distinct from *nazara* used in this context, al-Ghazali uses *absara* for seeing with a kind of inner sight of reason, which he describes as "one moment of human beings in which there is an eye *('ayn)* with which it sees *(yubsiru)* all kinds of rational knowledge *(ma'qūlāt).*"[11] However, all things that exist in realms hidden from the physical senses can be perceived with the light of this inner vision *(nūr al-basīra).* The verb *basara,*

and the noun *basīra* that derives from it, therefore indicate an inner vision that is distinct from what is implied by the verb *nazara* (noun *nazar*), which means seeing sensible things visually or optically, although this verb is also sometimes used to indicate intuitive apprehension. The distinction drawn by al-Ghazali between the two forms of seeing closely parallels distinctions between *seeing* of the dream vision on the part of the dreamer versus the *seeing* of the interpreter, between *ru'yā* as a vision that is seen and an interpretation that is "seen" in a theoretical sense.[12]

In *al-Munqidh min al-dalāl* and *Mishkāt al-anwār (The Niche of Lights)*, al-Ghazali discusses the relationship between dreaming, prophecy, and sensory perception in the context of the nature of what he calls true light *(al-nūr al-haqīqī)*, the relationship of the visible to the invisible, and the phenomenon of lifting the veil on the unseen *(inkishāf)*. In this context, he characterizes dreaming as seeing with "the other" eye designed for seeing things in the inner or spiritual dimension.[13] This inner eye is opened at the highest level of human spiritual development; after a process of refinement in which an individual gains the power of discernment *(tamyīz)* and reason *('aql)*, one reaches a stage where "another eye is opened, by which [one] beholds the unseen, what is to be in the future, and other things, which are beyond the ken of intellect in the same way as the objects of intellect are beyond the ken of the faculty of discernment and the objects of discernment are beyond the ken of sense."[14] This prophetic discernment is not shared by all human beings, and those who do not possess it are compensated by God by being given the prophetic faculty of dreaming.[15] For al-Ghazali, the faculty of dream vision, a sister to the inner eye of prophecy, provides an important and necessary corrective to physical visual perception, which is the most easily deceived (and therefore unreliable) of all the senses: "Do you not see [sense perception said], how, when you are asleep, you believe things and imagine circumstances, holding them to be stable and enduring, and, so long as you are in that dream-condition, have no doubts about them? And is it not the case that when you awake you know that all you have imagined and believed is unfounded and ineffectual? Why then are you confident that all your waking beliefs, whether from the sense or intellect, are genuine?"[16]

Al-Ghazali posits an intimate relationship between dreaming and the imagination *(khayāl)*, writing that when an individual has a vision *(ru'yā)* of a thing, the ability to close his or her eyes and still perceive the image *(sūra)* of it is a result of the imagination.[17] Elsewhere, he states that in the physical or sensory world *('ālam al-shahāda)*, the body is actually a simulacrum or image *(mithāl)* of the spiritual heart, a non-physical organ that cannot be apprehended through the senses.[18] Perceived through the physical sense of vision, the body—as the outward form—does not resemble it completely. Using the case of Satan who appears in many forms in dreams, al-Ghazali argues that the meaning of a form supersedes its "sensible form," such that a thing can appear in a multitude of forms. But seen through a superior and true visual faculty of the imagination in dream visions or prophecy, the resemblance between a "sensible form" and the actual form is clear.[19] Al-Ghazali defines an image *(mithāl)* as something in the physical realm that accurately conveys the meaning or signification *(ma'nā)* of what it represents. In the semiotic relationship of a metaphysical entity and its physical image, it is the process of dream interpretation *(ta'bīr)* that connects a visual image to its referent. In claiming that "Prophets only speak to the people by striking images *(bi-darb al-amthāl,* what is normally translated as "in allegories")," al-Ghazali is arguing that physical images serve as essential signifiers of divine truths.[20]

The subject of dreaming is addressed directly in a work entitled "Treatise on the Realization of the Vision of God in Dreams and the Vision of the Prophet *(Risāla fī tahqīq ru'yat Allah fī'l-manām wa-ru'yat al-nabī)*," although the authenticity of this work is open to some question since it normally forms part of a larger work, entitled *al-Madnūn*, of which the widely circulated version is probably not by al-Ghazali.[21] Regardless of whether or not it constitutes a pseudo-Ghazalian work, however, the fact that it has been accepted and circulated as authentic merits its inclusion among the sources that inform posterity about al-Ghazali's position on dreams and the imagination.

In this treatise, al-Ghazali berates ordinary people for believing that when one sees a vision of the Prophet in a dream, one actually sees *him,* and simultaneously critiques the philosophical position on the nature of dreams. According to this treatise, it is the imagination

(khayāl) that gives all images *(naqsh)* existing in the soul a visual form *(sūra).*[22] In the case of a dream of the Prophet, the author argues that a dreamer actually sees an "image" *(mithāl)* that is an intermediary *(wā-sita)* between the Prophet and the dreamer, serving as a means of communication between Muhammad and his follower in ways strongly reminiscent of the Christian doctrine of icons. The dreamer is not viewing the actual essence of the Prophet, but rather an "embodied image" that serves an intermediary role. In al-Ghazali's words: "The dreamer says, 'I saw God in a dream,' not in the sense that I saw His essence *(dhāt).* Therefore, when he says, 'I saw the Prophet' this is not in the sense that he saw the essence *(dhāt)* of the Prophet, or his spirit *(rūh),* or the essence of his personality *(dhāt shakhsihi)* but in the sense that he saw his image *(mithāl)."*[23]

In this treatise, al-Ghazali distinguishes between an image *(mithāl)* and similitude *(mithl),* saying that the latter is an inappropriate conceptual category for religious mimesis since, unlike the "image," the concept of "similitude" implies an equivalence *(musāwī)* in all qualities between the prototype and its resemblance, something that simply cannot be conceived of in the case of God.[24] He provides an explanation of this idea through speech: one can describe a vizier as analogous to the moon, in the sense that, like the moon serves as an intermediary between the Sun and the Earth, a vizier is an intermediary between the sultan and his subjects. But saying this in no way implies that the vizier looks like the moon or is equivalent to it.[25] He gives another example dealing with the Prophet:

> In many dreams the Prophet was given a vision of milk and rope. He said, "The milk is Islam and the rope is the Qur'an."...The similarity...between the milk and Islam and the rope and the Qur'an is nothing but an analogy....One clutches a rope for safety, just as one does the Qur'an; milk nourishes the outer life, just as Islam nourishes the inner life. These are images and not [similitudes] because these things do not have [similitudes].[26]

Al-Ghazali underscores the importance of the relationship between an object and its sign, arguing that it is vital to know the content of a

dream, since to misunderstand a dream vision is to make the ontologi-
cal and epistemological mistake of confusing an image for a simula-
crum.[27] He declares in his *Ihyā' 'ulūm al-dīn* that all dreams are divine
in origin,[28] and his idea that dreams function as the epistemological
guarantors both of the senses and of prophecy has a precedent in Is-
lamic philosophical writings, in particular in al-Farabi's aforemen-
tioned *Mabādi' ārā' ahl al-madīna al-fādila* (Principles of the Views of the
Citizens of the Virtuous City, translated as *On the Perfect State*).[29] For
al-Ghazali, a prophet is someone whose inner eye is completely opened,
enabling him or her to see what others cannot. Despite lacking this
faculty, in those brief moments of sleep when other normal human be-
ings dream, they become like prophets, seeing in ways that are more ac-
curate than our sense perceptions as well as our intellects.[30] The distinc-
tion between al-Ghazali's understanding of the nature and place of
dreaming and that of al-Farabi centers around the relative importance
of the rational and imaginative faculties in their thinking. Al-Farabi
raises the rational faculty to a status such that all other faculties are
subsumed beneath it. In contrast, al-Ghazali argues that ultimate
truths are communicated through various forms of vision that lie be-
yond reason, these being either prophetic forms of seeing or dream vi-
sions.[31] Both thinkers consider dream visions a source of knowledge
not only of supernatural truths but also of the realities of the physical
world; the implication of al-Ghazali's thought, and arguably that of
many other Sufi thinkers, is that such a nonphysical form of seeing is
also the most accurate way of visually perceiving the physical world.

 Al-Ghazali provides a clear account of the importance the image
(*sūra*) holds in his thought:

> *Sūrat* (image or form) is a common noun. Some things are
> sometimes expressed through metaphor or allegory so that its
> impression on the heart of the listener may be deep. Its value
> is that it leaves a greater impression on the heart. This kind
> of metaphor belongs to the principle of expressing a certain
> meaning through a picture which contains the same mean-
> ing or a similar meaning. The knowledge that in such cases
> there are inner meanings which differ from the outward sig-

nifications can be determined only either by rational or legal evidence. The feeble-minded will regard the literal exoteric meaning sensible and will not go beyond it, but the man who has an insight for realities will comprehend the secret it contains. On the authority of this tradition, a meaning other than the outward is intended. *Sūrat* or image means here an intellectual and not a physical image. In it those attributes of the human soul are mentioned which have been derived from the personality of God and His attributes and actions.[32]

The World as God's Mirror

The distinction between a physical image and its suprasensible prototype pervades Sufi metaphysical thinking from the twelfth century onward to such a degree that it is difficult to imagine that any educated person in the premodern Islamic world was unaware of its various implications, even if only in rudimentary form or through its tropic appearance in poetry or allegorical romances. Metaphors in which the world and its contents resemble their archetypes through various forms of mirroring, the concept of an outward *(zāhir)* form bearing a mimetic relationship to a more real inward *(bātin)* one, and other theories in which the same essence manifests itself differently in two (or more) realms circulated widely at the center of the most widespread systems of theological and metaphysical teaching.

The list of figures whose ideas concern such mimetic correspondence is very long and cannot be discussed comprehensively here, although that very fact should be seen as evidence of the pervasiveness of conceptual systems in which the physical world bears a symbolic relationship to a realm of archetypes. Among the many medieval scholars to put forward such theories, the Iranian writer and teacher Simnani (d. 1336) had a wide influence on Sufism in Iran and South Asia, particularly on the Mujaddidi branch of the Naqshbandi order, which represents one of the most important Sufi orders in modern times.

Simnani laid out a complex system of metaphysical physiology that comprised organs bearing an exact correspondence with the organs of

the physical world. Referred to as "subtle substances" *(latā'if)*, they suffer predictable change through actions (particularly, rituals and other practices) undertaken in the physical world. At the culmination of human spiritual development, when the "subtle substance of I-ness" *(al-latīfa al-anā'iyya)* first takes its place opposite the divine face, it is passive, functioning as an inanimate mirror that simply reflects God and allows him to observe himself. The concept of the universe or human being reflecting God is common in Sufi writing, based as it is on a famous hadith that states that God created the world in order to be known. However, in Simnani's understanding, the divine reflection transforms the passive mirror, such that it becomes an animated and active witness to God, making God the object that is witnessed. In this transformative moment, it becomes impossible to differentiate God as he witnesses himself in the mirror from the mirror as it bears witness to God. They are like two bright lights reflecting back at each other. The beauty of God is reflected and witnessed by the mirror, which then reflects this beauty back to God, who witnesses the perfect reflection of his own beauty as identical to his beauty.[33]

In his discussion of such metaphysical transformations, Simnani is not directly concerned with the relationship between the nature of objects and their appearance. Nonetheless, the implications of his writings on the subject are twofold: in the first place, they suggest that vision can have a transformative impact on an object, in that the passive act of reflecting causes a transformation into the active act of seeing, a process that can bring the seer to life in the most literal sense. In the second, an image (in this case a divine reflection) can represent its referent so perfectly as to be truly indistinguishable even to an omniscient god, meaning that even in the absence of ontological identity, apparent and epistemological identity between the visual signifier and the visually signified is a real possibility.

The question of the relationship between objects and their symbols as well as of the phenomenon of things that share an essence yet exist in two or more realms is taken up most famously by the towering figure of medieval Sufi metaphysics Muhyi al-din Ibn al-'Arabi.

Ibn al-ʿArabi's Metaphysics

No Sufi author has influenced the development of Islamic philosophi-
cal thinking more than Ibn al-ʿArabi (1165–1240) who, from his birth in
Andalucia to his death in Syria, left a staggering written legacy that
transformed thinking in much of the Muslim world. Even though Ibn
al-ʿArabi's writings tend to be dense, both conceptually and linguisti-
cally, his impact on the wider society cannot be overestimated. In ad-
dition to the development and promotion of his theories in intellec-
tual circles, his influence is readily apparent in the works of writers
who enjoyed immense popularity in the Persian speaking world, such
as Jamali-yi Dihlawi (d. 1542), the court poet of the Indian sultan Sikan-
dar Ludi (r. 1489–1517), whose *Mirʾāt al-maʿānī* (Mirror of Meanings) was
one of the most widely read works on Sufi symbolism and philosophi-
cal terminology as it appears in Persian poetry. Among the important
individuals in the dissemination of his ideas was ʿAbd al-Rahman
Jami (d. 1492), an encyclopedic thinker and writer whose commentary
on Ibn al-ʿArabi's *Fusūs al-hikam*, entitled *Naqd al-nusūs fī sharh naqsh al-
fusūs* (Selected Texts Commenting on the Imprint of the *Fusūs*) is the
most widely read commentary on Ibn al-ʿArabi's most popular work,
and which was read, copied, taught, and printed in Iran, Central Asia,
and South Asia. The *Fusūs al-hikam* (often translated as "The Bezels of
Wisdom") itself was widely influential directly as well as through the
more than one hundred commentaries written upon it. Presented as
the quintessence of Ibn al-ʿArabi's writings, it is simultaneously a fasci-
nating apocalyptic text and one that provides information distinct
from what is put forth in his voluminous *al-Futūhāt al-makkiyya* as well
as his many shorter treatises.[34]

Ibn al-ʿArabi has not been without his detractors, some of whom have
seen him as a threat to their own notions of normative Muslim belief
and practice. For the most part, critiques of Ibn al-ʿArabi are often simply
manifestations of a general condemnation of Sufism in which he be-
comes targeted on account of his celebrity and influence rather than for
specific ideas he espoused. Until the embracing by many modern Sunni
Muslims of a narrow group of so-called traditionalists such as Ibn
Taymiyya, Ibn al-Qayyim al-Jawziyya, and Ibn Kathir as representatives

of an imagined normative Islam, their viewpoints (including their denunciations of Ibn al-'Arabi) were somewhat peripheral to the course of religious life in the Muslim world. In fact, from Ibn al-'Arabi's time down to the early modern period, Sufi beliefs and practices were more pervasive in the majority of Muslim societies than the positions held by their critics. In some very large, well-populated, and culturally productive regions, such as most of the Ottoman Empire, Iran, and Central and South Asia, Sufi organizations became a major part of the structure of society such that it was virtually impossible to function outside their orbit. Similarly, Sufi metaphysics was learned in a variety of formal and informal settings, and its pervasive influence is obvious in the written legacy of these regions.

Ibn al-'Arabi is most famous for having promoted a theory, called "Oneness of Being" *(wahdat al-wujūd)*, according to which God is inseparable—in an ontological sense—from the world he created. Ibn al-'Arabi believed in a correspondence between the physical world we perceive through our senses and a suprasensible realm. In his writings, everything in the cosmos can be traced back to divine attributes (which are the names of God) that he often refers to individually as a "root" *(asl)* or "support" *(mustanad)* of things that exist in the physical world. "No property becomes manifest within existence without a root in the Divine Presence *(al-janāb al-ilāhī)* by which it is supported."[35] As part of this theory, Ibn al-'Arabi lays out in great detail his ideas about a correspondence between archetypal entities that exist in the celestial realm, the Realm of Similitudes *('ālam al-mithāl)*, which can also be referred to as the Realm of Images or of the Imagination, and particular entities that exist in the physical world *('ālam al-wujūd)*. For our purposes, the important aspects of this theory deal with how an object in this physical world can be understood to relate to God, or to the archetypal entities in a nonphysical realm.

According to Ibn al-'Arabi, creation is a process of unending divine self-manifestations in innumerable, sequential levels, the highest being an interior, nonvisible manifestation of God's essence and the lowest being of physical matter, visibly and somatically (or sensorially) manifested in the physical world. Everything that exists in the physical world is "real," but in a limited sense, in that its existence is contin-

gent upon the existence of divine qualities or names with which it shares being, but in some sort of ontologically distinct sense.

The process of divine manifestation takes place in three distinct levels, of which the Realm of the Similitudes or of Images *('ālam al-mithāl)*, is located interstitially between the physical realm of material forms *('ālam al-ajsām)* and a nonmaterial, spiritual realm *('ālam al-arwāh)*, and it plays a critical role in questions of epistemological and ontological resemblance.[36] This is a place that is not imaginary in the sense of not being real, but rather is "imaginary real"—existing as a space that is imaginal (that is, of images and imagination), but its contents possess an existence that is no less real than that of the physical world and its contents.

Rahman, despite his overall critical attitude toward Sufi metaphysics, noticed the importance of the concept of Ibn al-'Arabi's Realm of Images for an understanding of art and artistic production:

> Once the world of figures is affirmed as a reality, it is impossible in the nature of things to set limits to it. For this realm is no smaller or bigger than imagination itself.... Once the flood of imagination is let loose, the world of figures goes beyond the specifically religious motivation that historically brought it into existence in the first place, and develops into the poetic, the mythical, and the grotesque: it seeks to satisfy the relatively suppressed and starved artistic urge. Much of the contents of the *'ālam al-mithāl,* as it develops later, has, therefore, nothing to do with religion but indirectly with the theater.[37]

In Ibn al-'Arabi's thought, the *'ālam al-mithāl* not only delineates the boundary but also mediates between the divine, mysterious level above it *('ālam al-ghayb)* and the physical, visible realm below *('ālam al-shāhada)*. Its function as both an ontological and an epistemological interstice between a realm that is entirely invisible and unknowable on one hand, and a realm that is visible and occupied by physical objects and beings on another, depends on complex aspects of Ibn al-'Arabi's metaphysics concerning the nature of God, his names, their relationship to the cosmos, and the concept of the Perfect Human Being *(al-insān al-*

kāmil), all of which are topics tangential to the overall project of this book.[38] I will therefore attempt to outline relevant aspects of his thought in a highly simplified form.

Ibn al-ʿArabi and the Imagination

In Ibn al-ʿArabi's thought, the imagination functions both as a catalyst and a liminal or interstitial space—which he (along with other Sufi metaphysicians) refers to using the Qurʾanic term *barzakh*—between the physical realm and its contents, and the realm of ideals. He uses two terms, *mithāl* and *khayāl,* more or less interchangeably to refer to the imagination, even though the two are not really synonymous, since the latter can refer to both the world of the imagination and the mental faculty of the same name, while *mithāl* means a likeness, similitude, resemblance, or even an image.[39]

For Ibn al-ʿArabi, imagination functions as both the location and the faculty (or agent) for defining the ontological and epistemological relationship of existence to knowledge, a relationship that is central to his metaphysics since, for him, it is divine self-knowledge that is the very cause of all existence. The Realm of the Imagination (or of Images) serves as the interior epistemological center of human awareness and is sometimes identified with the soul *(nafs),* while in other contexts it is regarded as a faculty of the soul. The soul is described as the interstitial space between the spirit and the body that parallels in important ways the dichotomy between visible and invisible characteristics of the divine and physical worlds.[40] As imagination, the soul serves as the connection between the appearance *(sūra)* of a thing and its actual meaning *(maʿnā),* between the signifier and the signified. This soul-as-imagination is where metaphysical things (or meanings) assume visible form in dreams or visions of other kinds. Ibn al-ʿArabi asserts that dream visions demand interpretation, where interpretation consists of progressing from one visible form to another.[41]

In its alternative function as a faculty of the soul, the imagination possesses the power to bring visible objects as representations together

with the meanings they represent. This is accomplished through a form of existentiation of ideas into forms, accomplished through an extraordinary, spiritual power called *himma,* which is a human version of God's creative faculty, and refers both to the faculty of bringing imaginal things into physical, perceptible existence and to the method of accomplishing this.[42]

The relevance of the imagination to the process of visual representation is underlined by Ibn al-'Arabi in his *al-Futūhāt al-makkiyya* when he speaks about the nature of reflection and its relationship to the object it represents:

> Imagination is neither existent *(mawjūd)* nor nonexistent *(ma'dūm),* neither known or unknown, neither affirmed nor negated. A person who sees his image in the mirror knows decisively that he has perceived his form in some respect and that he has not perceived his form in some other respect. Since he has perceived minuteness in the image, which is due to the small size of the mirror, he realizes that his form is bigger than the one he has seen, which rules out any possibility of identifying between the two forms. . . . Then if he says: "I saw my form, I did not see my form," he will be neither a truth-teller nor a liar.[43]

In its interstitial role, the imagination gives physical shape to spiritual things and renders physical those things that are spiritual. As a consequence of this process of two-way conversion, the "storehouse" of the soul-as-imagination *(khizānat al-khayāl)* contains images from both the physical and spiritual realms.[44] Despite this capacity to generate images, the imagination can only existentiate things in forms that can be perceived by the senses, and is thus both narrow and wide (restricted and unfettered) in its nature and capabilities:

> As for its narrowness, that is because imagination does not have the capacity to accept any affair, whether sensory, suprasensory *(ma'nawī),* relations, attributions, the majesty of God, or His Essence, except through form. . . . Hence sense

perception is the nearest thing to imagination, since imagi-
nation takes forms from sense perception, then it discloses
meanings through those sensory forms. . . .

. . . Imagination is the widest known thing . . . it is inca-
pable of receiving meanings disengaged from substrata as
they are in themselves. That is why it sees knowledge in the
form of milk, honey, wine and pearls. It sees Islam in the
form of a dome or pillar. It sees the Koran in the form of
butter and honey. It sees religion in the form of a cord. It sees
the Real in the form of a human being or a light. Hence it is
the wide/narrow.[45]

The inability of the imagination to construct a representation that
lies beyond that which is perceived necessarily implies that the appear-
ance of an object must have an epistemological as well as an ontological
relationship to its essence. Were that not the case, the constraining
would only occur in one direction, limiting the *representation* to what
can be perceived, but in no way preventing the *signified meaning* from be-
ing constrained within any limits. The correspondence between what
appears in the Realm of Images or the Imagination and the visible world
also implies that imaginal events have the ability to affect experiences in
the visible world, particularly through the process of dreaming:

You see someone sleeping next to you, but he sees himself in
chastisement or bliss, as a merchant, a king, a traveler. In his
sleep, fear overtakes him in his imagination, and he cries
out. But the one next to him has no knowledge of that or of
what he is in. Sometimes, when the affair intensifies, a change
occurs in his constitution, and in his manifest, sleeping
form, this leaves a trace of a movement, a shout, words, or
nocturnal emission. All this derives from the faculty of imag-
ination's overcoming the animal spirit such that the body
changes in its form.[46]

The clearest statements addressing the relationship between the
nature of an object and its appearance are found in Ibn al-'Arabi's
Fuṣūs al-ḥikam, a fascinatingly constructed text of an apocalyptic na-

ture that purportedly synthesizes the entirety of the author's meta-physical theories into a concise twenty-seven chapters, each of which is framed as a discussion of the qualities of a specific prophet.[47] The chapter on Jesus (chapter 15) provides much food for thought on how one might comprehend the relationship between physical existence and something beyond the physical world to which it relates. Ibn al-'Arabi's reading of the conception of Jesus echoes many of the ideas concerning this event as they are commonly presented in Islamic texts: Jesus had no earthly father; rather, he was conceived by Gabriel infus-ing Mary with a divine breath *(nafakh)* that he brought from God. Cru-cially, in the context of this discussion, Ibn al-'Arabi maintains that human beings cannot be created except in the normal biological way, therefore Gabriel had to appear to Mary in human form and Jesus had to be conceived biologically (in Ibn al-'Arabi's understanding of biol-ogy), with both parents contributing fluid to his generation. In the case of Jesus, he was formed from "actual fluid" *(mā' muhaqqaq)* from Mary and "notional fluid" *(mā' mutawahham)* from Gabriel.[48]

The reason it was imperative that Gabriel appear in a fully human form to Mary, Ibn al-'Arabi argues, is because of the fact that being part human and part divine was essential to Jesus's nature. When Jesus dem-onstrated human qualities such as humility, it was on account of the part of him inherited from his mother, while when he demonstrated di-vine qualities such as raising the dead, it was through the part of him inherited from Gabriel. Had Gabriel not appeared in human form, but had infused the breath of God in Mary while remaining in his natural luminescent state, Jesus would have been forced to transform into a lu-minescent form in order to act out his divine qualities. It is the fact that physical appearance and actual substance (or essence) are linked that required Gabriel to appear as human in order to enable Jesus to keep a human form when he acted in both his natures.[49]

Of course, Jesus is a unique case in light of his dual nature, but it is clear from Ibn al-'Arabi's writings that the relationship between physi-cal entities and the archetypal concepts or entities they represent is a real one, and examples of this conception appear several times in the *Fusūs al-hikam*. Gabriel also appeared to Joseph in human form, an ap-pearance that he took from the so-called Plane of the Imagination

(hadrat al-khayāl). Joseph, as beholder, immediately recognized Gabriel and transposed him to his true form only because of his prophetic abilities and knowledge. However, both the human form of the imagination and the angelic form represent Gabriel's true forms:

> He said, "That was Gabriel who had come to teach you your religion." He also said, "Bring that man back to me", calling him "man" on account of the form *(sūra)* he understood in which he appeared to them. Then he said, "This is Gabriel" [thereby] acknowledging [or taking into account] the form *(sūra)* he understood this imaginal man *(al-rajul al-mutakhayyal)* to be. He was truthful in both statements— true in vision *('ayn)* in his visual senses, and true in it being Gabriel, for it was Gabriel, without a doubt.[50]

These prophetic visions occur in the Realm of Images *('ālam al-mithāl)*—or alternatively in the Plane of the Imagination *(hadrat al-khayāl)*—and are treated by Ibn al-'Arabi as part of the liminal, intermediating function of the Realm of Images. This interstitial space is populated by imaginal forms (sing. *sūra mithāliyya* or *sūra khayāliyya*) that are different manifestations or appearances of things that populate the physical and divine realms, but with which they are ontologically identical, to be recognized as such through dream visions or their siblings, prophetic or Sufi modes of understanding. Ontological oneness is a pervasive and rather complex aspect of Ibn al-'Arabi's thought, and one that has been treated by him, his commentators, and modern scholars primarily as the subject of metaphysics and epistemology. Yet both the underlying assumptions and the conclusions of Ibn al-'Arabi's writings on the imagination and the nature of the realms of the imagination or of images and their contexts point inescapably toward a visually constructed system of resemblance in which two objects in different realms might "look" different but be epistemologically and ontologically identical. And furthermore, their identity is apparent to anyone who possesses the correct form of cognition. At the same time, however, the theory argues that there is a relationship between the appearance of a thing and its properties, such that, despite ontological and epistemological unity across three realms, the

thing possesses different properties in each realm, and needs to *hold the visual appearance* that accompanies the characteristics of a particular realm. When discussing the well-known story of Moses climbing Sinai to converse with God, Ibn al-ʿArabi describes how the Samaritan priest fashioned a bull out of gold, snatched some of the breath of Gabriel, and infused it in the bull calf, causing it to bellow (or moo). Had he fashioned another animal, the statue would have made the sound of that animal. In other words, not only is physical appearance directly related to the archetypal nature of the thing it resembles, but the qualities characteristic of that archetypal thing are inseparable from the physical form itself as we perceive it in our quotidian world: an image of a bull, once animated, can only bellow. It cannot bleat like a sheep, or bray like a donkey, or speak like a human being.[51]

Ibn al-ʿArabi's arguments in favor of a substantive connection between a visual object and its intrinsic nature are relevant to wider discussions of visual representation, as are other, broader, Sufi theories on the relationship between visible, physical entities and their archetypes. As mentioned earlier in this chapter, Sufi metaphysical theories concerning the correspondence between images and prototypes, ontological and epistemological links between two or more entities, and the role of the imagination and of specialized education in developing particular ways of seeing and apprehending, are all pervasive in the majority of Islamic societies. Their popularity is amply demonstrated in literary and religious works across languages and genres, including in so-called "popular" and belletristic poetry, the signature artistic form in much of the Islamic world. That topics of such relevance to visual representation occur in literary works says less about the place of the visual arts than it does about the centrality of texts and of writing in Islamic society. The visual is not only mediated by the textual but, in fact, the textual serves as the visual, as discussed in Chapters 9 and 10.

9

Words, Pictures, and Signs

Picture for a moment our modern cities stripped of all signs,
their walls blank as an empty consciousness. And imagine
that all of a sudden the single word GARAP appears every-
where, written on every wall. A pure signifier, having no ref-
erent, signifying only itself, it is read, discussed, interpreted
in a vacuum, signified despite itself—in short, consumed *qua*
sign. What indeed can it signify except for the society itself
that is capable of generating such a sign? By virtue of its very
lack of signification it mobilizes an entire imaginary collec-
tivity. It comes to stand for a whole society. In a way people
end up "believing" in GARAP.

—J. BAUDRILLARD, *The System of Objects*

Writing, words, and cultures of text have been important since the
earliest recorded periods of Islamic history, and a direct link between
the scriptural word and cultures of writing and text was made almost
immediately after the death of Muhammad. A hadith account on
the authority of Wahb ibn Munabbih (d. ca. 732) states that if a man
were simply to inscribe "In the name of God, the Compassionate, the

Merciful"—and write it well and carefully—God would pardon his sins.[1] Medieval accounts concerning respected scholars and religious figures reinforce the sacred nature of writing. For example, the renowned scholar of hadith traditions Taqi al-din al-Subki (d. 756) was once asked about the permissibility of stepping on holy words woven into a carpet: "What is your opinion concerning a man's placing his foot upon a carpet into which there are woven some letters of the alphabet arranged in meaningful words such as 'blessing,' 'bliss,' 'enduring strength'? Is it permissible for a man to step on the portions of the carpet where these words are found?" Al-Subki's considered opinion was that it was forbidden for a man to step on any part of the carpet (not just on the words), even though he was unable to find explicit textual proof for his opinion. In other words, he considered the sacredness of the words to be such that it extended to the medium on which they were inscribed. Other legal scholars have argued that pieces of paper that contain the name of God cannot also be used (or reused) to write profane things, however innocuous they may be.[2] The importance of keeping all religious writing and the medium on which it appears free from contamination is apparent in modern times in the tendency among Muslims in non-Arabic-speaking societies to treat all scraps of paper containing Arabic with respect. It is also true of the societal power of blasphemy charges in Pakistan—though almost always politically motivated, the perceived legitimacy of such charges often rests on the sacred nature of written words.[3]

Literary figures, aesthete courtiers, and calligraphers themselves have written works addressing various aspects of the importance of writing. The eleventh-century litterateur Abu Hayyan al-Tawhidi is credited with a treatise on calligraphy in which he addresses its aesthetic aspects along with purely technical ones. Al-Tawhidi considers writing and penmanship to be closely related to wisdom and morality, and provides a tradition to say: "Handwriting is the tongue of the hand. Style is the tongue of the intellect. The intellect is the tongue of good actions and qualities. And good actions and qualities are the perfection of man." He quotes two other authorities to describe writing as the "necklace of wisdom [which] serves to sort the pearls of wisdom" and writing instruments as the "pack animals of the minds, the

couriers of the natural faculties, the *avant-garde* of the part of the body in which thought and feeling are situated."[4] A similar attitude linking penmanship to morality is expressed by the Ottoman bureaucrat, historian, and litterateur Mustafa 'Ali (d. 1600), who provides several examples of calligraphers who would have excelled as artists if only they had possessed the necessary moral qualities.[5]

Writing on Writing

Calligraphy occupies such a central role in Islamic visual arts that it has often been identified as the most distinctively Islamic art form. Some scholars have gone so far as to suggest that monumental religious epigraphy could be manipulated so effectively in conveying specific messages to Muslim viewers that it functioned very much the way icons and representational images did for Christians.[6] Yet, if one is to judge by the written record, Muslims have not themselves been overly concerned with the use of calligraphy and inscriptions in architectural decoration, nor even with the religious significance of calligraphy itself. Few works are known to exist that address the cultural and religious importance of calligraphy, and those that are known represent varied historical periods and literary languages, especially Arabic and Persian.

A Persian treatise composed in the middle of the fifteenth century by a calligrapher from Shiraz, who found himself in the service of the Bahmani kingdom in the Deccan, is perhaps the earliest known work to shed light on the importance of the Arabic script among South Asian Muslims; it also explains the spiritual and aesthetic underpinnings of calligraphic practice. The author of the *Tuhfat al-muhibbīn* (The Bounty of Lovers), Siraj-i Hasani Shirazi, chose to dedicate the work not to a court patron but to his Sufi master, and even pointed out that his treatise was named after a work composed by the famous Sufi master of Shiraz, Ruzbihan Baqli (d. 1209), who was an ancestor of the author's own master in calligraphy.[7]

Among the distinguishing characteristics of the *Tuhfat al-muhibbīn* is the author's sustained attempt to trace the development of new

Arabic scripts in a religious context, characterizing it as the consequence of meditative experience designed to mimic divine creativity. According to his account, Ibn Muqla (who is widely credited with developing a new Arabic script) realized that writing could be made circular, the circle being the best of shapes and also the form in which the world is fashioned as explained by the saying: "The world is a circle, the earth is a dot, the heavens are bows, accidents are arrows, and man is a target; so where is one to flee?"[8] He quotes the fourteenth-century calligraphic master Sirafi-yi Tabrizi as maintaining that the movement from a square to a rounded Arabic hand resulted from an incident in the life of Ibn Muqla. One day the caliph's son went on an outing; when he returned to the palace, the caliph asked him whether he had brought back any souvenir from his adventure. The prince replied by reciting two couplets he had overheard in which a poet compared his beloved's teeth to the Arabic letter *sīn* and mouth to the rounded letter *mīm*, so that together they spelled "poison *(samm)*." The caliph remarked that it made no sense to compare a rounded mouth to the letter *mīm* (which would not be round in the angular Kufic script), so he summoned Ibn Muqla (who served as tutor to the young prince) to help him make sense of the poetic illusion. Ibn Muqla took leave to spend forty days in contemplation, during which time "he made use of the flashes of divine lights and sought the emanation from the contents filled with grace of [the divine saying] 'I kneaded the clay of Adam with my hands for forty days'.... He took a period of forty days in a retreat of meditation to imagine the kneading of the clay of letters possessing elegant forms, transferring them from the lines of Kufic to the heavenly form of round and circular lines."[9]

Two points are noteworthy in this account of the origins of the cursive Arabic script. First, that writing mimics the "script" of the creation of the world and that Ibn Muqla understands this through religious meditative techniques that are underlined by using the Qur'an and hadith as proof texts; and second, that Arabic writing is intrinsically iconographic in that it mimics visual forms. The second point is one that repeats itself frequently in Muslim epigraphic practice, especially in the systems of letter and number symbolism made famous by the Hurufis, the practice of making epigraphic pictograms (or

pictorial calligraphy), and in other iconographic practices that will be addressed later in this chapter. In the case of Siraj-i Hasani, a clear connection is drawn between the shapes of letters and their metaphysical meanings, with "letters of the alphabet [functioning] as ciphers for mysteries that are otherwise insoluble."[10] The longest section in the treatise addresses the hidden meanings of letter combinations; in most cases, the meanings comprise established Sufi ideas and are drawn without attribution from a famous lexicon of Sufi terminology composed by 'Abd al-Razzaq Kashani (d. 1329), a major exponent of Ibn al-'Arabi's school of thought.[11]

Another illustrative treatise addressing the importance of calligraphy is the *Ādāb al-mashq* (Manners of Practice), written by the celebrated Safavid calligrapher Baba Shah Isfahani (d. 1587–88), who was renowned for his mastery of the *nasta'līq* script. In addition to the *Ādāb al-mashq*, Baba Shah also wrote poetry extolling the virtues of calligraphy; this includes poetic puns that play on the ambiguity in the word *khatt* to mean both "script" and the down on a young man's cheek, thereby highlighting the beauty of calligraphy and the value of gazing at it as a means of contemplating divine beauty: "The pupil of the eye became all light in body as in soul, to look upon the sweet curls of his [*khatt*]."[12] Baba Shah's work is significant because it departs from most other writings on calligraphy by calligraphers, going beyond descriptions of the calligraphic craft and discussing the internal discipline and ethics involved in it as a practice. In keeping with widespread Islamic attitudes linking beauty to moral action, he states that any absence of moral and spiritual proportionality and balance displays itself in imperfect calligraphic art:

> Because blameable qualities in the soul are the sign of imbalance, God forbid that work proceed from an imbalanced soul, for there will be no balance in it.
>
> [Verse:] *The same thing that is in the jug pours out of it.*
>
> So the scribe should completely shun the blameable qualities and acquire the praiseworthy qualities, so that the luminous effects of these blessed qualities appear on the beauty's cheek of his writing, and it becomes sought after by the connoisseurs' temperament.[13]

Baba Shah details the stylistic and psychological foundations of calligraphy, going beyond issues of style and instead speaking both of artistic mastery (*usūl* or "principle") and purity *(safā')* as a quality of the heart that provides the inner beauty necessary for generating artistic beauty:

> "Principles" is a characteristic which is gained from the balance in composition of the [other parts of script]. All writing that contains even a little of this quality is precious, and easily will be held dearer than jewels. When this quality becomes conspicuous in writing, it is appropriate if it is loved more than life itself. It is no secret that the (first) nine parts of script are in the position of the body, and "principles" are in the position of the soul.

And concerning "purity," he writes:

> "Purity" is that condition which makes the temperament happy and refreshed, and makes the eye luminous. One cannot attain it without cleansing the heart. As the Mawlana (Sultan 'Ali) said,
>
> [Verse:] *Purity of writing is from purity of heart.*
>
> Through this quality there is complete possession of (the art of) writing. Just so the human face, no matter how proportionate, is not attractive if it lacks purity. It is no secret that if principles and purity are joined with "authority *(sha'n)*," some call it "taste *(maza)*," and some also call it "effect *(āsār)*."[14]

Baba Shah goes on to explain his notion of "authority" using terms that are readily familiar from Sufi thought; for an accomplished calligrapher, the act of writing is itself a form of contemplating divine beauty:

> "Authority" is that condition in which the scribe becomes enraptured from its display when it is found in writing, and he has done with egotism. When the scribe's pen possesses "authority," heedless of the pleasures of the world, he turns his heart toward practice *(mashq)*, and the luminous sparks of the real beloved's beauty appear to his vision. . . . And it is fitting, when such a scribe sets his hand to a white page and

writes a letter on it in his practice, that he reddens that pa-
per with bloody tears from the extremity of his love for that
letter. This characteristic... becomes the face *('āriz)* of the
human soul *(nafs),* and by the power of the pen its form is
drawn on the paper page. Not everyone can comprehend this
quality in writing, although he may be looking at it.[15]

There are many other instances of works addressing penmanship
and calligraphy, as well as of literary and visual examples that place
calligraphy and calligraphers in a variety of milieus including in their
ateliers and the company of aristocrats.[16] One need not belabor the
point that the examples of writings on calligraphy mentioned briefly
above (and others that go unmentioned) represent widely differing
historical and cultural contexts within the breadth of Islamic history.
What these diverse works prove, however, is the enduring importance
of writing and epigraphy in Islamic culture at a variety of social levels
and in different media. For the purposes of this discussion, I will sepa-
rate the treatment of writing into two categories, that of monumental
epigraphy (or writing as a feature of architecture) and that of writing
on paper, books, and other nonpublic and public media (including on
some kinds of private buildings in the modern period). The separation
of writing into these two categories is almost entirely for heuristic pur-
poses, since much of what I claim for writing on buildings applies to
certain uses of text in other media.[17]

This chapter is not concerned with the development of writing in
the Islamic world, but rather with its public visual role, and makes a
distinction between what might be called "everyday writing," includ-
ing highly ornate and ornamental styles used in important govern-
ment documents such as decrees, grants, and the award of honors on
the one hand, and ornamental writing on the other (with all the com-
plex significations it entails). At an important level, the distinction is
between plain text whose purpose is to communicate clear, textual
messages, and calligraphy, which has other primary purposes.[18] I cer-
tainly do not imply that the aims and significations of the two catego-
ries are absolutely distinct, but that, for the purposes of this book, one
needs to focus on writing that lends itself intentionally and readily to

the latter aim. Of course, calligraphy itself fulfills many different purposes in varied contexts. In addition to the uses of calligraphy discussed in this book, scriptural, quasi-scriptural, and other forms of writing are found on all manner of items of life, from coins and other instruments of state, to items of clothing such as handkerchiefs and talismanic undershirts, to other textiles, to items of jewelry, to a wide array of visual arts for elite as well as nonelite audiences. Furthermore, many scholars have written extensively on the place of calligraphy in the religious arts of the Islamic world, some of them with a decidedly romanticized notion of the connection between calligraphy and spirituality.[19]

Orality, Literacy, and Power

Key to understanding the different functions of writing and text in society are the nature of literacy and the relationship between oral and written uses of language. It goes without saying that, until the very recent advent of mass literacy, the majority of human beings were illiterate, and that, with few exceptions and complicating factors, levels of literacy correlated closely with gender and economic status as well as proximity to urban centers (with wealthy urban men most likely to be literate and poor rural women least likely). From this perspective, the oral, which is accessible to everyone including the highly literate, can be viewed as constituting a first order of language. In fact, Saussure stressed the importance of oral speech as the basis of all human communication despite the scholarly tendency to emphasize the written as the most fundamental form of communication.[20] From some academic perspectives, the basic orality of language is permanent, evident from the fact that of the many thousands of languages used by human beings barely a hundred have ever been written down to the extent that they can be considered to have produced a written literature, and the majority have never been written at all. And despite the importance of writing not only for conferring cultural status but also for restructuring thought and enlarging the potentialities of language, orality retains its status as the primary form of language. "Written

texts all have to be related somehow, directly or indirectly, to the world of sound, the natural habit of language, to yield their meanings. 'Reading' a text means converting it to sound, aloud or in the imagination, syllable-by-syllable in slow reading or sketchily in the rapid reading common to high-technology cultures. Writing can never dispense with orality."[21]

A thorough study of the relationship between orality and literacy must attempt to bring into focus the relationship between sounds, shapes, words, and meanings, as well as juxtapose a people completely untouched by any form of writing with ones who function entirely textually.[22] Happily, neither group is to be found in the major narratives describing Islamic society, nor of those cultures with which it came into sustained contact. It is more productive to think instead of cultural contexts in which the oral and written coexist, and which possess a visual culture in which the notion of those who operate purely orally functions as a substitute for the purely illiterate. In such contexts the distinction between the visual (pictures) and the textual (words) comprises the linguistic and semiotic divide between people. Illiteracy, more than pure orality, is a human state that is encountered frequently both in history and in the present, and one that has been the object of valuable study.[23] One important finding is that textual systems of memory differ from oral ones in that the latter have very substantial somatic components; for example, *madrasa* students sit and rock back and forth quite vigorously in their attempt to memorize the Qur'an (similar patterns are apparent in Jewish, Buddhist, and other modes of memorizing scripture). "The oral word . . . never exists in a simply verbal context, as a written word does. Spoken words are always modifications of a total, existential situation, which always engages the body. Bodily activity beyond mere vocalization is not adventitious or contrived in oral communication, but is natural and even inevitable."[24]

In primarily oral and (spoken) word-oriented societies—termed *verbomoteur*—individuals are significantly more word-oriented than object-oriented in "person-interactive contexts." However, Ong acknowledges that the distinction between words and objects is not absolute: "Words and objects are never totally disjunct: words represent objects, and perception of objects is in part conditioned by the store of

words into which perceptions are nested. Nature states no 'facts': these come only within statements devised by human beings to refer to the seamless web of actuality around them."[25] The focus in such scholarship is on the oral rather than the written; if one were to switch the focus such that the object of inquiry is the written text, with the oral (which is to say, nontextual) individual existing in relation to the written word *as well as* the spoken word, somatic experiences would not simply be ones referring to bodily activity accompanying the spoken word, but all bodily interaction that is attendant to the encounter with oral language. This includes the somatic interaction with objects, including visual ones. Indeed, the visual encounter with language can be seen as including the written word as a subset of all encounters with the visual, since, in ways discussed in Chapter 10, writing possesses the quality of acting as a visual signifier much in the same way that pictures or objects do.

Of course, writing does more than function as a pure visual sign for an object. Even in pictographic scripts, written words do more than represent objects mimetically. Instead, scripts represent *utterances*, words that exist relationally with other words to convey complex ideas. This is not to suggest that images are incapable of functioning in relation to other pictures (or text) or that they cannot convey complex ideas, but to underline the point that script—or written words—exist in the first place to be read, and that other uses are second-order functions of the written text. As such, written text exists primarily as a consequence of, and in relationship to, literacy, suggesting that all explorations of the place of writing must begin with an awareness of this relationship as well as the important consequential relationship of illiteracy to the written word.

Recent studies of literacy emphasize the point that it (and illiteracy) is not a static state categorically dividing those who read from those who don't.

> Literacy is not a single phenomenon but a highly variable package of skills in using texts: it may or may not include writing as well as reading and it is generally geared only to particular genres of texts, particular registers of language

and often to only some of the languages used within multi-
lingual societies. Moreover, literacy does not operate as an
autonomous force in history, whether for change, progress
and emancipation or for repression. Literacy does not of it-
self promote economic growth, rationality or social success.
Literates do not necessarily behave or think differently from
illiterates, and no Great Divide separates societies with writ-
ing from those without it. The invention of writing did not
promote a social or intellectual revolution, and reports of
the death of orality have been exaggerated.[26]

In the context of Islamic society, text exerts itself powerfully at vari-
ous points in history. On the one hand, the presence of a scripture
gives an enduring importance to words, although without necessarily
privileging their written form over their oral presence. But the Muslim
doctrine that not only does God speak but he speaks Arabic ended up
dovetailing with the use of Arabic by the military elite of the first two
centuries, resulting in the creation of a hierarchy of status among lan-
guages used by Muslims, with Arabic as the privileged language of so-
ciety at all levels and the one used almost exclusively for scholarship
for several centuries. During the first period of Islamic expansion, Ara-
bic asserted itself as the language of prestige over a number of other
language communities, including those of Aramaic, Greek, Hebrew,
and Syriac speakers, all of which were themselves textual languages
that existed in a contested power relationship with each other as well
as with some other languages of lesser prestige. In later times, Arabic
retained its status as the prestige language in a wider Islamicate cul-
tural zone, although in much of western, central, and southern Asia a
new, Islamic Persian asserted itself as a language of literature, subse-
quently of administration, and finally of certain kinds of religious
scholarship so as to create a "textual bilingualism" among the elites.
But the innate phenomenon of a hierarchical distinction between the
indigenous, spoken languages of the majority (or, at the very mini-
mum, a substantial minority) of the population and the society's tex-
tual language remained unchanged. As in Christian societies a few
centuries earlier, the written language served to construct power in

society through the use of shared texts, be they scriptural or of other varieties. Elites used them to legitimize themselves directly through their privileged facility in the written language, while other groups (such as artisans, merchants, record keepers, and tax collectors) also contested for status in ways that foregrounded the role of literacy.[27] "The spread of an elite culture obviously creates social caste markers and may also reinforce political and cultural coherence, or group identity . . . elite status can then be expressed in terms of literacy in a particular language, obliterating the ambiguities posed by issues such as the borderline between orality and literacy and obscuring the extent to which we can differentiate between bilingualism and bi-culturalism."[28]

The growth of written texts was rapid in the early Islamic world, but the oral transmission of texts continued as the preferred means of communicating important categories of knowledge through the entire formative period, and the importance of orality in instructional environments continues well into the present.[29] The practice of communicating sophisticated texts in key religious disciplines orally has ramifications on the relationship between literacy and access to knowledge. Amidst the differing levels of literacy as well as the varying ways in which Muslims and other subjects of the Islamic state related to the Arabic language, the Qur'an exerted its own influence on issues of orality, textuality, and literacy in the early Islamic state, and arguably continued to do so in frontier zones of the growing Islamic world. Muslims shared with Jews and Christians their belief in revelation and scripture, but the Muslim reverence for revelation *as text* surpassed that of other related religious communities, retaining for Arabic a prestige that is unrivaled for any other language in the history of Judaism or Christianity.[30]

The persistence of languages other than Arabic as well as of diglossic and idiolocal uses of Arabic dictates that one must view literacy and illiteracy not as static categories but as ones that can change over time and also as ones that are determined by context. Individuals gain literacy by learning to read and write a new language, a common and oft-repeated phenomenon in the spread of Islam. And literate people are rendered illiterate both by entering an environment where they do

not know the language or the script, and by reading texts (such as mathematical, scientific, or magical ones) that rely on highly specialized vocabulary, symbols, and formatting. In most cases, even the illiterate exist in a dynamic relationship with writing and can negotiate their way through a world in which text plays a central role. In the complete absence of an ability to read, the illiterate depend on the literacy of others.[31] They also possess varying degrees of contextual literacy along with the ability to see in text a variety of signifiers that render it meaningful to the nonreader.

The majority of the population in classical and medieval Islamic society would belong to the class and sex in which literacy was rarest, yet not only did illiterate women function in fulfilling ways within a world where scriptural literacy was valued highly, but anecdotes about the connection between female illiteracy and religious devotion ostensibly underscore the view that literacy has no correlation with virtue.[32] Among the references to holy women in Sufi biographical works, one reads of the illiterate Maymuna chasing after a ship's captain who had promised to teach her to read, walking on water as she repeated the formula "Maymuna knows God and God knows Maymuna!"[33] At a secondary level, this account underscores the true importance of literacy by linking successfully pious status with miraculous divine favor; in other words, underlying the message concerning the value of pure devotion is the implication that, under normal circumstances, religious status is only accessible to those who can read.

I have stressed the importance of words, text, and literacy because of the centrality of the written word in the material culture of the Islamic world. For a faith-based community organized around a scriptural text revealed by a God who speaks in words and that is preserved in written form from very early in the life of the community, written text plays a role that cannot be substituted with another medium.[34] In such a context, "writing often operates both as a form of symbol, comparable to images like monumental statues or icons, yet also as a form of communication comparable to speech."[35] The relative value of the symbolic and pragmatic uses of language is contested in many contexts, and the written word itself, especially when it appears twinned

to material objects that are themselves meant to be perceived visually, vacillates between being a word and an image.

Writing fulfills a variety of functions in Islamic society, and some of them it accomplishes simultaneously. Along with its mundane uses, writing has the capacity to inspire wonder; in fact, this is an explicitly desired goal of calligraphic art. The Safavid scholar Qadi Ahmad (d. ca. 1606) mentions an anecdote concerning a one-handed calligrapher named 'Umar Aqta' who used a microscript to write a Qur'an so miniscule that it could fit inside a signet ring. He presented this to Timur, who was left unimpressed. 'Umar Aqta' then wrote another copy in which each line was one cubit long, resulting in a book so big that he had to haul it to the court in a wheelbarrow. Timur was pleased with this wondrous object and rewarded the calligrapher for his gift.[36] In terms of their relationship to the calligraphic arts as well as in other ways, the cognitive processes relating to epigraphy in Islamic society extend beyond predictable functions of writing in the visual arts, forming "an original, diversified and polyvalent semantic relationship to the configuration in which it operates."[37]

The Birth of Arabic Calligraphy

The origins of Islamic calligraphy are said to lie in the environment of the chancery as opposed to that of a religious establishment, such that aesthetics rather than any religious doctrine would have played the primary role in its initial development. Even Ibn Muqla (d. 940) and Ibn al-Bawwab (d. 1021)—two calligraphers whose decisive role in the emergence of later Arabic scripts had theological ramifications that are discussed briefly below—both worked in the state bureaucracy.[38] It is unnecessary in this context to outline the evolution of the Arabic script itself, since this task has been undertaken ably by a number of scholars.[39] Perhaps the most important development from the perspective of the study of religion and visual culture is the change from an angular Kufic to a cursive script, starting first with manuscripts of the Qur'an in the tenth century and subsequently occurring in monumental

epigraphy. Not only did this change have a permanent impact on the calligraphic arts of the Islamic world but, as argued by Tabbaa, developments in calligraphic style directly addressed religious and political concerns of their day. From approximately 930 until the early decades of the eleventh century, Qur'anic calligraphy experienced major transformations that altered the physical appearance of the Qur'an, the most significant of them in this context being the transformation of the written Arabic script from an early Kufic to a semi-Kufic and subsequently to a fully cursive hand. The major difference between the two Kufic scripts was legibility, with the latter version of Kufic being easier to read; the significant change is with the development of cursive, which is easily legible by anyone literate in the Arabic language.[40]

The change in scripts is partially explained by technological factors, such as the arrival of paper in the Islamic world and its rapid adoption over the next two hundred years, leading to a proliferation both of written materials and of literacy and the consequent need to be able to engage in the act of reading. But these are not sufficient to explain the readiness with which Muslims abandoned the script that was as old as the written Qur'an and replaced it with one that originated in a courtly environment. The likely explanation is that religious and political changes in Islamic society rendered the Kufic script deficient in the eyes of the writing and reading population.[41]

Ibn Muqla, the calligrapher credited with the shift to the new script, was deeply involved in the theological debates of his day concerning the nature of the Qur'an. During the caliphate of al-Muqtadir, Ibn Mujahid (d. 936) established seven variant readings (qirā'āt) of the Qur'an that were considered canonical, and two prominent Qur'an reciters, Ibn Miqsam and Ibn Shannabudh, were tried in 934 for using nonsanctioned variants and forced to recant. Ibn Muqla was serving as the vizier at the time, and it was under his authority that significant portions of these trials took place.[42] The trials of Ibn Miqsam and Ibn Shannabudh occurred against a backdrop of important theological debates concerning the nature of the Qur'an, specifically over its created or uncreated nature and the rational accessibility of its meaning. The position championed by the theological circles patronized by the caliph and Ibn Muqla maintained that the Qur'an was uncreated and

possessed one immutable meaning across time; this contrasted with other positions, including that of the rival Ismaʻili caliphate based in Egypt, that the textual Qurʼan in human possession was existentiated in time, a position that potentially allowed for more options in interpretation. Equally importantly, Ismaʻili doctrine maintained that the Qurʼan existed at two levels, outer *(zāhir)* and inner *(bātin)*, with the textually manifest level not representing the ultimate meaning of scripture, a problem (from the Sunni perspective) compounded by the Ismaʻili use of a variant reading of the Qurʼan.[43]

The rise of a legible cursive script has been linked to the desire to promulgate the Sunni-sanctioned version of the Qurʼan and the parallel doctrine of the literal truth and inerrancy of scripture, and is the direct result of ideologically motivated decisions made by Ibn Muqla, which were popularized by Ibn al-Bawwab, the highly influential master calligrapher who followed him. It was the latter's version of the Qurʼanic script that displayed a readily legible hand that could be used (among other things) for promulgating the official version of the divine word in an unambiguous manner and which was adopted over subsequent centuries all across the Sunni-ruled Islamic world. In this capacity, "The actual image—not just the content—of the Word became the symbol of the most important principle of the Sunni revival, a movement that redefined the course of medieval Islam."[44] The relationship between calligraphy's quality as a visual signifier and the growth of Sunnism is attested to in the architectural record, although the paucity of textual sources concerning the production of inscriptions on buildings before the Ottoman period limits the confidence with which one can make these claims. The earliest officially sponsored cursive inscriptions date from the beginning of the eleventh century during the latter part of the reign of Mahmud of Ghazna, a great champion of Sunnism. These early inscriptions show the clear influence of Ibn al-Bawwab's style, in particular the use of a thin, trace of a line to connect letters that would normally be written independently.[45] A century later, cursive monumental epigraphy was widely seen, although it did not replace Kufic for some time, and the two scripts coexisted on the same building, most likely as a display of artistic virtuosity. This is especially common in examples from Seljuk

lands, where a distinctive script was developed on the basis of the cursive *thuluth* seen earlier in Ghazna, which probably derived from styles used in calligraphy on paper.[46] The spread was rapid in other parts of the Islamic world as well, such that by the last quarter of the twelfth century the cursive script was in use in monumental epigraphy not just in Iran and Central Asia, but also in Anatolia, Upper Mesopotamia, Syria, North Africa, and Spain.[47] "Without completely doing away with the dual nature of early Arabic official writing, especially as exemplified by the floriated Kufic, the new cursive script shifts the balance decisively in favor of the denotive over the connotive aspects of writing. Subsuming the mystical within the informational and the *bātin* within the *zāhir,* the new public inscriptions perfectly embodied and eloquently propagated the exoteric and encompassing tendencies of the Sunni revival."[48]

The connection between the visual qualities of calligraphy and religious doctrine is underscored by the observation that cursive monumental calligraphy did not make its way into the monumental inscriptions of Egypt until after the end of Fatimid Isma'ili rule, but became widely used very shortly after Egypt was integrated into the wider Sunni world under the nominal rule of the Baghdad caliphate.[49] It replaced a floriated Kufic script that was much harder to read and that was promulgated and perhaps even created by the Fatimids.[50]

Architectural and Epigraphic Signs

Such discussions of script, calligraphy, and their significations in Islamic society focus primarily on monumental epigraphy, which cannot be studied apart from broader issues in architectural iconography. The application of iconographic analysis to architecture is relatively recent, originating in the works of scholars such as Krautheimer, Bandmann, Wittkower, and others in the middle of the last century. By that time, Warburg's earlier attempts to deploy iconographic methodologies to situate art within a wider context of cultural expression had been reduced to little more than a process of decoding art-related subject matter as "programs" or "texts."[51] As a nonrepresentational art form, architecture was excluded from such scholarly review. Krautheimer's work, in

particular, recognized the mimetic qualities of architecture when he highlighted the practice of copying venerable earlier structures in medieval Europe—not as exact replicas but in ways that reproduced essential elements of the prototype so as to evoke their meaning or symbolism for the viewer. In this way, architectural representation could be used for political purposes as well as to evoke religious feeling or memory. And since architectural symbolism (in fact, all systems of symbolic signification) struck Krautheimer as imprecise, he argued that it would invoke a range of responses, and that such a multiregistered response was part of the intention of architectural projects.[52]

Krautheimer's observations concerning medieval Europe hold some validity for the study of Islamic architecture. He points out that the written record on medieval buildings does not concern itself with their design or even very much with construction. In contrast, practical functions are taken into consideration, which would suggest that, for religious buildings, issues of religious significance would probably have been central to architectural thinking.[53] Much of the recent scholarship on the symbolism of Islamic architecture presupposes various levels of intentionality on the part of the architects and patrons, both in terms of the edifice itself and the epigraphic and other decorative programs. A number of studies attempt to see such patterns of symbolism in architectural elements of mosques such as the *mihrab*, or in the many towers erected by Muslim rulers in various parts of the Persianate world.[54] I am not concerned here with the question of what iconographic elements render a building Islamic, although this issue is of great importance when thinking about how buildings are appropriated for religiously specific use in all time periods.[55] Instead, I focus on the use of epigraphy as a visual signifier in the complex social environments where epigraphically adorned buildings were conceived, built, used, and observed across centuries. I accept as a premise that buildings and their constitutive signifiers—like other elements of material and intellectual life—undergo a process of translation from one culture to another and also within wider religious and culture zones, such that not only do Islamic buildings borrow and "translate" into their own idiom from the Christian, Hindu, and other architectural and decorative traditions in their environment, but that the process of

translation also goes the other way.[56] The starting point for an explo-
ration of the place of monumental calligraphy in the visual religious
culture of the Islamic world is with the earliest surviving religious
monuments—the Dome of the Rock in Jerusalem, and the Umayyad
Mosque in Damascus—both of which have been the subject of consider-
able study. The former, constructed in 692 at the behest of the Umayyad
caliph 'Abd al-Malik, bears the earliest surviving monumental inscrip-
tion in Arabic; the latter, for which construction began in 706 under al-
Walid (who also constructed the Prophet's Mosque in Medina), is the
oldest monumental mosque in the Islamic world, and is distinctive for
its extensive pictorial mosaics. As Flood demonstrates in his study of
this edifice, the mosque was itself the conclusion of a complex and re-
peated system of translation and borrowing: built on the site of the Ca-
thedral of St. John, which had itself replaced a Temple of Jupiter before
it, the construction was the result of work done by artisans and workers
from Coptic, Persian, Indian, Greek, and North African backgrounds.[57]

Some scholars have speculated as to the purpose of the mosaics on
the mosque, especially the landscapes and cityscapes devoid of people
that adorn the façade above the main doorway and the galleries of the
western arcade (riwāq), suggesting variously that they represent either
a paradisiacal world awaiting dead believers or else an imagined map
of the great cities of the world. Without addressing the specific signifi-
cation of particular elements of the decorative program, it seems safe
to conclude that the *entire* mosque, not just its mosaics or epigraphy,
was part of an attempt to convey meaning to a spectrum of audiences,
both Muslim and Christian. Far from being a gesture signifying anti-
Christian policies or symbolizing the triumph of Islam, the Umayyad
Mosque served to articulate an emerging Islamic—and specifically
Umayyad—identity. As Flood argues,

> Al-Walīd's architectural patronage represented one response
> to these needs, implicitly accepting that it addressed a dual-
> ity of identity issues. In fact . . . the cultural issues at stake
> were much more complex, for the Muslim "self" was by no
> means a homogeneous entity, and the "other" whom it ad-
> dressed was itself a heterogeneous mix of Syrian Christians

(of different denominations), Syrian Jews, non-Muslim visitors to the Syrian capital, Byzantine envoys and even those living outside the *dār al-Islām* who would never set foot in Damascus. Nevertheless, the division of the audience into an "internal" Muslim one and an "external" non-Muslim one is a convenient shorthand, with the caveat that these are crude categories, eliding the distinctions between different types of readership while obscuring readings that transcended the general cultural predispositions of each group.[58]

Al-Muqaddasi summarizes one possible purpose of Umayyad religious monuments through an anecdote involving his own family:

> Now, talking to my father's brother one day, said I: "O my uncle, surely it was not fitting for al-Walīd to expend the resources of the Muslims on the mosque at Damascus. Had he expended as much in building roads, or the water tanks, or in repairing the fortresses, it would have been more proper and more to his credit." Said he: "You simply do not understand, my dear son. Al-Walīd was absolutely right, and it was open to him to do a worthy work. For he saw that Syria was a country settled by the Christians, and he noted there their churches so handsome with their enchanting decorations, renowned far and wide, such as are the Qumāma [Church of the Holy Sepulchre], and the churches of Ludd (Lydda) and al-Ruhā (Edessa). So he undertook for the Muslims the building of a mosque that would divert their attention from the churches, and make it one of the wonders of the world. Do you not realize how 'Abd al-Malik, seeing the greatness of the dome of the Qumāma and its splendour, fearing lest it should beguile the hearts of the Muslims, hence erected, above the Rock, the dome you now see there?[59]

The Umayyad Mosque clearly employs a variety of architectural elements familiar from late antique and Byzantine buildings, reinterpreting them for the new context. In this capacity, the architecture of the mosque conveys messages concerning the political aspirations of

al-Walid and his Umayyad successors at a diachronic historical scale at the same time that it communicates with a spectrum of viewers in the immediate synchronous environment of the Damascus of their day. To assume intentional messaging of a sort that makes cohesive sense of the architectural iconography of the mosque, including its mosaics and epigraphy, is to presuppose the existence of an educated viewership that was familiar not only with the literate traditions of the Muslim world (including that of Qur'anic exegesis) but also with the architectural and cultural legacy of the late antique world. Umayyad patricians could very well have constituted just such an audience, and therefore might have been the primary category of viewers the patron of the building had in mind.[60]

Similar iconological questions come up in an examination of the Dome of the Rock, which has been the subject of even more speculation as to its purpose than the Umayyad Mosque in Damascus. Grabar, in particular, made the Dome of the Rock a focus of study to which he returned several times throughout his career. Through an analysis of the interior mosaics as well as the content and location of the epigraphy, he argued that the architectural form and inscriptional message of the edifice explicitly served as a "forceful assertion of the power and of the strength of the new faith and of the state based on it."[61] He saw this as a response to the Christian practice of bringing "barbarians" to their sophisticated urban centers in an attempt to convert them by awing them with monumental churches, music, and the visual arts. As such, the Umayyad ruling class would be acting in a manner in keeping with established customs of using monumental architecture to impress other communities.[62]

Soucek suggests an alternate purpose to the Dome of the Rock, seeing it as symbolically referring to Solomon's Temple and what it and Solomon's prophethood (as distinct from kingship) represent in Muslim sources. She claims that the mosaics on the walls of the Dome of the Rock repeat motifs of fabulous precious stones and trees described as decorating Solomon's palace.[63]

The original intentions of the builders of the Dome of the Rock remain unknown as do those of its renovators, but we do have an early eleventh-century source that speaks of the significance of the monu-

ment and of the city of Jerusalem in general in the period before they became symbols of the Muslim nation during the First Crusade when Nur al-din ibn Zangi (d. 1174) and Salah al-din al-Ayyubi (d. 1193) asserted Sunni authority against the Isma'ili Fatimids in Egypt and Syria and reconquered Palestine from the crusaders. Abu Bakr al-Wasiti, a preacher *(khāṭib)* about whom little is known, composed a work of religious merits *(faḍā'il)*, a genre that was to become very popular with the advent of the crusades. His *Faḍā'il al-bayt al-muqaddas* gives a short account of the construction of the Dome of the Rock under 'Abd al-Malik and sheds light on the symbolic importance of the building's location.[64] Al-Wasiti quotes hadith traditions legitimizing the Muslim significance of Jerusalem, although few of them emphasize the role played by the Rock in stories of the ascension of Muhammad—a fact that is not at all surprising since the association of the *mi'rāj* with Jerusalem did not occur until somewhat later. What al-Wasiti does is emphasize the familiarity of many of the companions of the Prophet and early generations of his followers with Jewish sources. Indeed, Jewish converts to Islam such as Ka'b al-Ahbar contributed a deep knowledge of the eschatological significance of Jerusalem to the nascent Muslim community, which adopted a Jewish rather than Christian notion of its importance that often went hand in hand with anti-Christian polemic. Ka'b al-Ahbar reportedly advised two of his Jewish relatives who were going to Jerusalem to pray in a mosque rather than a church, saying: "Do not go to the Church of Mary or 'al-'Amudayn [the Two Columns?]' for these are seducers *(tāghūt)*. Whoever visits them loses the merits of his prayers unless he starts anew. May God fight the Christians, for they are impotent: they only built their Church in Wadi Jahannam."[65] Such sentiments might explain not only why the Umayyads chose to build the Dome of the Rock on a site sacred to Jews but abandoned by Christians, but also why the architectural iconography evokes Byzantine martyria yet is simultaneously very different from them, and most importantly, why the Qur'anic inscriptions covering the inner arcade include all verses that disavow Jesus's divine nature.[66]

Al-Wasiti's account of the reason behind the Dome of the Rock's construction is functional and matter of fact, attributed to 'Abd al-Malik's desire to "build a dome *(qubba)* over the Rock to shelter the

Muslims from cold and heat, and to construct the masjid [referring to the nearby Masjid al-Aqsa]."[67] Presumably, the Muslims were already gathering there for a reason, and one that was self-apparent to al-Wasiti to the point that he did not feel the need to explain it. Nor did he, or any of the other writers of *fadā'il* works that describe the Dome of the Rock, feel it worthwhile to describe or explain the epigraphy or mosaics on the structure.[68] Both facts suggest that the primary audience for the symbolism of the Dome of the Rock and its iconography was not exclusively Christian (or even Christians at all), but one composed of Muslims in the city of Jerusalem as well as in the wider Muslim community who were familiar both with the scriptural significance of the site to Jews as refracted in the self-image of the new religious community, and with the doctrinal relevance of the chosen Qur'anic verses appearing on the arcade. However, one must also recognize that such Muslims—who combined a knowledge of hadith, tales of the prophets *(Isrā'īliyyāt)*, and an intimate knowledge of scripture and its exegesis—could only represent a small elite, not the large groups of Muslims who were reportedly gathering on the mount by the Rock, even less so the ever-growing population of Muslims with a tenuous connection to Arabic, the text of the Qur'an, and the emerging literature of prophetic traditions. A more plausible explanation is that the Dome of the Rock was intended to function iconically at several registers—for an educated Muslim elite, for the wider population that was pledging allegiance to the new religion (and the regime that patronized it) in a variety of ways, *and* the Christian population of Jerusalem as well as of a wider Christian world who would, no doubt, hear of the new monument.[69]

Bierman has stressed the importance of multiple levels of signification in architectural iconography and epigraphy with specific reference to Fatimid Cairo, an Islamic counterpoint to the Sunni-ruled milieu of al-Wasiti. This was a territory inhabited by Sunni and Shi'i Muslims, Jews, and Christians, ruled over by an Isma'ili Shi'i elite. All religious groups represented in Fatimid Cairo possessed their own architectural spaces while simultaneously functioning in a place where they coexisted with other groups. Bierman distinguishes between so-called sectarian spaces such as mosques, churches, and synagogues, which were group-specific environments where co-religionists assembled formally,

and public spaces, which were accessible to the society as a whole, "ruling and ruled, traders, servants, foreigners, Muslims, Jews, Christians, men, and women."[70] Public spaces are the ones that projected societal power most directly, and it was here that epigraphy played its most important role as a signifier, although sectarian spaces also used epigraphy in complex ways. The writing on the interior of these spaces—regardless of creed—tended to be religion-specific, and the dominant epigraphic materials were taken from the particular scriptures of each group. However, in contrast to the sectarian spaces of the subject religious groups, Fatimid Isma'ili religious buildings functioned more directly as public spaces, intentionally conveying messages about Fatimid religious and political authority to a public audience, although this was done in a nuanced manner: the public texts placed inside structures such as the Mosque of al-Hakim were directed at Muslim (and especially Isma'ili) audiences while those on the outside spoke to the entire society. According to Bierman, the semantic content of the inscriptions on the exterior was accessible to viewers who not only were unfamiliar with the Qur'an but also might not even be Muslim.[71]

The decision on the part of the patrons and builders of the Mosque of al-Hakim to put Arabic writing on the building's exterior at pedestrian level and to inscribe it in large letters on the minaret suggests that they intended for the inscriptions to be read, or at least seen clearly.[72] However, in the absence of explicit evidence, it is ultimately pointless to speculate about authorial intent in the case of architectural projects and their epigraphic and figural decorative programs. Beyond very basic questions about the relationship between the creator's intent and the audience's interpretation for both art and literature, it is simplistic to the point of error to draw a straightforward division juxtaposing an educated, sophisticated audience of Muslim patricians against a non-Muslim population entirely unfamiliar with the significance the Qur'an holds for Muslims.

The Qur'an's status and symbolism is itself a subject of some complexity as has already been alluded to with reference to its importance in providing compelling support for the special role of Arabic in all aspects of Islamic culture. Several scholars have tried to make sense of the use of the Qur'an in monumental epigraphy as well as in calligraphy, either by

arguing—on the basis of their understanding of the general value of the Qur'an to Muslims—for an iconographic quality to the written word, or else using surveys of inscriptions to hypothesize about whether or not scriptural inscriptions function as text or some sort of nontextual signifier. As an example of the first, Thackston sees the Qur'an as a natural stimulus to meditative contemplation for all Muslims:

> The Qur'an, or any part thereof, in and on a mosque provides the viewer with a message and a focus of meditation. It may incidentally be ornamental or decorative, but a Qur'anic inscription has value in and of itself. Like the recitation of the Qur'an, an act of piety that has merit in and of itself and is completely divorced from any questions of understanding the lexicon and grammar of Arabic, the mere existence of a Qur'anic inscription is equivalent to a Christian icon: it serves as a visible representation of supernatural reality. In the case of quotations from the Qur'an, God's word is revealed in the guise of human speech. In view of this, it should not come as a surprise that much of the inscriptional material found in a mosque or any other religious building is not—and, from the builder's or designer's point of view, need not be—readable. Here we say "readable" and not "legible," for almost all inscriptions are "legible" in the sense that they are capable of being read—eventually if not immediately.[73]

He goes on to maintain that any Muslim in the premodern world who was "literate enough to care to read" a mosque inscription would have memorized the Qur'an in childhood and therefore would naturally be able to recall the entire passage just by recognizing one word in an inscription.[74] Assuming such a highly literate viewership leads Thackston to conclude that, for the most part, Qur'anic inscriptions are always "appropriate to the locations in which they are found" even though few passages appear predictably in specific places on a building. Even so, he maintains that the overall combination of specific textual choices could well present an attempt to convey a particular message on the part of the architect or patron of the building.[75]

At the other extreme from an understanding that presupposes the existence of a highly educated, literate viewership as the primary audience for monumental epigraphy and an attendant absolute divide between the completely unlettered and the (highly) literate for whom inscriptions made textual sense either individually or as part of an overall decorative program, some scholars have suggested that the *absence* of any obvious relationship between the use and content of scriptural inscriptions indicates that they were not meant to be read. An example of this approach is found in Robert Hillenbrand, who surveys architectural examples from across the Islamic world to suggest that, although certain verses became popular in architectural usage, no individual verse or collection of verses from the Qur'an attained the status of being considered necessary for use on a mosque, nor were verses used on mosques to the exclusion of other religious buildings such as *madrasas, khanqahs,* or mausoleums.[76] Recognizing that certain verses repeat themselves on different buildings, Hillenbrand hypothesizes that such repetition might not be the result of conscious intent so much as either extreme conservatism preventing innovation in inscriptional choices or else little more than creative laziness, with the designers of epigraphic bands simply copying what they had seen already in architectural use. Either way, the practice of copying gave both textual and artistic authority to the earliest verses chosen for epigraphy.[77] Hillenbrand's expectations of artistic creativity or theological adventurism color his discussion of an important subject:

> Those charged with devising epigraphic decoration in mosques were normally content with one or two verses which sheer repetition had rendered hackneyed. It was foreign to their whole approach to comb the Qur'an for relevant texts and to fashion them into an epigraphic collage that would in effect be a written commentary on the mosque and its functions. With a very few exceptions the challenge of such directed epigraphy was not confronted in mosque architecture; indeed, it was probably never perceived in the first place.[78]

Hillenbrand does acknowledge that certain verses do, in fact, appear repeatedly in locations that seem relevant to their content. For

example, the "Light Verse" (Qur'an 24:35) appears frequently on roughly half of surveyed mosques known to him, and in most cases the verse is located in some way associated with the *mihrab*, a phenomenon Hillenbrand explains by pointing to the imagery of light that dominates the verse, which would "naturally" evoke thoughts of mosques and their lamps.[79] Other verses such as 47:1-18 (from the chapter entitled "Muhammad" and dealing mostly with issues of the hereafter) and 3:15-17 (promising heaven for the righteous) also repeat themselves, with 47:1-6 being most popular. The only verse that seems to have been commonly considered appropriate for inscriptions on mosques is Qur'an 9:18 ("Only he who believes in Allah and the Hereafter, performs the prayers, gives the alms and fears no one but Allah, shall visit Allah's mosques. Those shall be reckoned among the rightly guided"), appearing almost four times as often as the "Throne Verse" (2:256), which is the next most common.[80]

The content of some of these verses makes their appropriateness as inscriptions obvious. The "Throne Verse," which succinctly encapsulates God's nature at the same time as it glorifies him, has emerged as the most popular long verse of the Qur'an and is frequently used in decorative arts as well as on pendants worn across the Muslim world. Similarly, Qur'an 47:1-6 refer explicitly to reward and punishment in the afterlife, and 9:18 to Muslim ritual and who should enter mosques. In noting that many Qur'anic inscriptions are placed in locations where they are impossible to read and others virtually illegible because of their intricacy, Hillenbrand suggests a hypothesis on the relationship between monumental epigraphy and religio-political agendas that echoes Tabbaa's thesis concerning script reform in the Umayyad period: inscriptions of verses with no particular significance could afford to be illegible (which is to say, purely ornamental), but ones that carried a doctrinal message were written with clarity, the earliest example being the use of diacritical marks on the verses on the Dome of the Rock that address Christological questions.[81]

But analyses of the textual content of religious monumental epigraphy explain the nature of religious art just as unsatisfactorily as accusations that patrons and artisans who fail to come up with new material do so because of indolence. Epigraphy, like other forms of religious

decoration, is repeated on different buildings *because it works*—in other words, the epigraphy is deemed efficacious in its context and therefore does not need to be replaced with something else. From the perspective of religious users, efficacy trumps other concerns in decoration, such as aesthetics or creativity; thus, to judge writing on buildings on the basis of these secondary criteria is to miss its point. Whether or not an example of monumental epigraphy is legible or not is secondary to its multiple functions as a visual religious signifier. Even completely legible inscriptions are intended to function very differently from texts in religious books and poems, in that their function as visual signifiers places them in a different category from these other kinds of writing.

10

Legibility, Iconicity, and Monumental Writing

> People quickly forget evil because they still haven't created a
> language to describe it so the world refuses to carry the bur-
> den, preferring to forget.
>
> That's why the devil appears openly in recognizable signs:
> horns and a tail are appended to a human figure. Right by
> fields full of wild sunflowers, the machinery of mass murder
> functioned smoothly in Hitler's camps. Who remembers the
> tyranny of death? Who feels its pain?
>
> Hitler is easy to draw, any kid can do it. All you have to do
> is make a circle for his head and add the moustache. With
> the passing of time, even Hitler has been turned into an in-
> nocuous sign.
>
> —S. MEHMEDINOVIĆ, *Sarajevo Blues*

As I have alluded to in previous chapters, several writers have noted
that a substantial portion of Islamic monumental epigraphy was not
meant to be read, not even by literate viewers familiar with the con-
tent of the words. Aside from the fact that ornate, sometimes over-
lapping, difficult-to-read calligraphic scripts are often used, inscrip-

tions are sometimes placed in locations that are impossible to see from the ground; this architectural use of script is similar to the use of epigraphy and images in Buddhist art mentioned in the Prologue and Chapter I.[1]

Various explanations have been put forward as to the purpose of such monumental epigraphy, with some suggesting that a portion of the writing on buildings—such as the epigraphic bands at the top of minarets or towers—is intended for God, while other, more legible, portions are intended for human beings. Others have hypothesized that monumental epigraphy should by understood iconographically rather than textually, or else that particular forms of epigraphy serve different purposes. The most plausible explanation of the place of monumental epigraphy must allow for historical specificity as well as substantial differences between the intent of patrons and builders on the one hand, and the vast majority of viewers of the epigraphy on the other. It is beyond debate that most of the viewers of public Muslim buildings across time could not read the inscriptions—regardless of the epigraphy's location or the complexity of the script—simply because they were illiterate. And even a major portion of the literate Muslim population would be unable to read Arabic with any fluency in important non-Arabic-speaking parts of the Islamic civilizational sphere such as Iran, Anatolia and the Balkans, Central and South Asia, as well as others. Thus, even if one allowed for a primarily inter-Muslim system of signification centered around text and calligraphy (to the exclusion of the substantial non-Muslim populations of many Islamic territories in specific periods of history), one would still have to acknowledge that the differences in Muslim identity, relationship to text, education, and power, as well as gender-based differential access to public space, would render futile any attempts to make singular sense of Islamic epigraphy.[2]

Certain monuments and their epigraphic programs make sense in historical context: just as one can understand the iconography of early Islamic coinage as it made the transition from Byzantine or Sassanian symbolism through the phased substitution of earlier religious and imperial symbols with Islamic ones and of Greek text with Arabic, so too can one comprehend the use of Qur'anic inscriptions referring to the glory of Islam on similarly diverse examples of "victory" monuments

such as the Dome of the Rock and the Buland Darwaza at Fatehpur Sikri, the latter built by Akbar around 1575 at the height of his reign and of Mughal power in India.[3] The Taj Mahal constitutes another example of particular relevance on account of its popularity with non-Muslims and Muslims alike and the romantic story that serves as the favored myth of its origin. Begley has argued convincingly, on the basis of historical evidence as well as the content of its Qur'anic inscriptions, that the Taj Mahal is meant as a replica of the divine throne situated at the center of a paradisiacal garden. This hypothesis makes a great deal of sense in light of what is known of Shah Jahan's views of himself as a millennial king whose person and reign had cosmic significance. However, such a plausible hypothesis concerning the Taj Mahal's origins, supported though it is by substantial epigraphic and historical evidence, has failed to have any impact on the majority of those who have seen or heard of the monument. Generations of Indians—both Muslims and non-Muslims—along with foreign travelers continue to believe that the Taj Mahal was constructed by Shah Jahan not as a symbol of his own grandeur but as a monument to love for his queen Mumtaz Mahal.[4]

There are numerous examples of monuments and mosques in South Asia that bear almost illegibly ornate inscriptions as well as writing that is located so high up as to be practically illegible.[5] As in other contexts, there can be little doubt that the builders who chose to place the inscriptions were aware of the problem of legibility, just as they would have been cognizant of the value of pre-Islamic or extra-Islamic visual and ornamental elements that they incorporated into their own architectural works. One can distinguish between the decorative and inscriptional program on the insides of buildings versus that on the outside, working on the assumption that it was the outside that constituted public space and was intended, even in a tertiary fashion, for a broad viewing public. Parallels can be drawn in this regard between the nature of monumental epigraphy in South Asia, especially in the Sultanate and early Mughal periods, and in Anatolia under the Rum Seljuks. Not only do the two cultural spaces share in Persianate civilization and in their patronage of Sunni institutions, but they also

functioned as active religious frontiers with large non-Muslim populations that were the object of significant propaganda on the part of those in power.[6] Furthermore, along with the overwhelming majority of the Muslim population, these non-Muslims would not have anything but the most passing familiarity with Arabic, which served as nothing other than a liturgical language for all but a small, scholarly section of the Muslim population. Seljuk rulers, paralleling their Indian counterparts, incorporated Byzantine trophies and spoils into their architecture in an attempt to connect themselves to a pre-Islamic imperial past and to participate in a local symbolic language of Anatolian kingship at the same time as they actively cultivated their image as Sunni Muslim rulers and cultural patrons.[7]

Several mosques and *madrasas* from Seljuk Anatolia stand out for their extensive use of epigraphy that is often completely integrated with other ornamental features, and many incorporate inscriptions that are difficult to read from ground level. Some of them were considered remarkable even during the Ottoman period: Evliya Çelebi (d. 1682) regarded the decoration on the three portals of the mosque and hospital complex in Divriği to be the most awe-inspiring of any buildings he had ever seen.[8] The use of epigraphy for complex iconographic purposes is most dramatic in the case of Seljuk *madrasas*, in particular the İnce Minareli Medrese in Konya, built in the third quarter of the thirteenth century under the patronage of Sahib Ata. The entire façade on either side of the main portal of this building is covered with a wide band of calligraphy carved into the stone and interspersed with natural and floral motifs.[9] The main inscription is in an ornate, overlapping *thuluth* style, but it is not hard for a viewer with knowledge of the Qur'an to see from which chapters the inscriptions are drawn. The students and faculty of this *madrasa* in Seljuk times most likely would have known (either by instruction or their own investigation) what the inscription said, but this would not have been the case for other viewers who passed by the public façade of what was otherwise an enclosed institution, just as it is not the case today for the majority of Turks who are illiterate in the Arabic script (Plate I).

Calligraphy as Image

Seljuk religious monuments collectively represent the most dramatic Islamic example of the use of epigraphy in multiple registers, including ones in which they are integrally linked to the nontextual ornamental facets of the buildings. Monumental epigraphy, as a whole, cannot be treated as separate from nontextual ornamentation but must be seen as part of a greater ensemble in which it is perceived and understood by viewers. As such, it operates polysemically, at one level functioning as text with its denoted or connoted meanings, while at others it can be seen as operating iconically as a visual art form inseparable from other elements of the decorative or illustrative program of which it forms a part. In both regards it also functions indexically, inasmuch as it is inseparable from the sociopolitical and religious realities of its context.[10] Beyond the indexical value of these works, their religious inscriptions undoubtedly play a part distinct in the minds of the designers and patrons from the function of other inscriptions (such as dedications and statements of endowment), even if such a distinction is not apparent to the majority of the viewership.

The religious epigraphic program of an Islamic building might best be understood in terms of tattooing. Even when the epigraphy is recognized as words, and words are recognized as possessing textual meaning, their affective power is not diminished. They function primarily as visual images with apotropaic powers and as iconically distinct signifiers. Like epigraphy, body tattooing commonly fulfills the dual functions of beautification (and relatedly of drawing attention to the body as a visual object) and of serving as prophylactic armor that wraps or seals the body against misfortune of supernatural or humanly inflicted kinds. In his study of tattooing among Polynesian societies, Gell has hypothesized that tattooing also serves to convey status differentials in a society, presuming as it does an engagement between the one possessing the tattoos and someone not from his or her immediate group.[11]

With some reservations, the social function of tattooing can be transferred to the use of monumental epigraphy in Islamic societies. Although the particulars of individual societies would have to be stud-

ied to bear this out empirically, as in the case of Polynesian tattooing, there appears to be a strong correlation between the proliferation of Islamic monumental epigraphy and contexts of heightened sociopolitical competition. Monumental epigraphy flourishes in moments of compromised individual or social authority when there is a heightened need to project a complex set of religious and/or political messages to an outside group (such as members of another religion or sect) or a competing political force.[12] Beyond an aesthetic desire to be attractive, there is no real need to project visually to oneself or to a narrow group of insiders. The motivation to project an individual or collective self-representation through architectural iconography depends on the existence of social distance from another with whom one wishes to communicate visually. Just like tattooing, architectural iconography in the form of epigraphy and related ornamentation is not especially effective in communicating messages concerning the sentiments that hold the "family" of one coherent community together.[13]

Furthermore, like in the case of tattooing, the technology entailed in monumental epigraphy is not culturally specific, such that architectural iconography has no "determinate symbolic meaning which can be posited in advance of specific details relating to specific cultural and political contexts."[14] In the case of Islamic architecture, one is struck by the seeming lack of concern on the part of patrons with the utilization of non-Muslim artisans to build religious buildings and create scriptural inscriptions.[15] The iconography is external to culture as well as religion, and its possible meanings are neither wholly a product of its cultural context, nor of its technical schema, but result interactively from both.[16]

The polysemic, iconic, and indexical qualities of monumental epigraphy, wherein it functions textually and visually to provide sociopolitical and religious messages, act prophylactically and possess aesthetic as well as wondrous qualities, as can be seen to varying degrees in all the buildings referred to above. In some cases, such as the seventeenth-century Sher Dor Madrasa in Samarkand and the Nadir Divan Begi Madrasa in Bukhara, religious inscriptions coexist with figural representations of animals and celestial objects whose significance is no longer known, leaving scholars to speculate as to the images' astrological

or imperial signification.[17] In other cases, the function of hard-to-read calligraphy as defining the "skin" of the edifice occurs in almost complete integration with other equally abstract designs and figures. In the case of the Karatay Medrese, built in Konya at the behest of the emir Jalal al-din Karatay in 1251, the carved stone portico is covered with bands of Qur'anic inscriptions in a legible (if overlapping) *thuluth* script, together with a variety of geometric and flowing patterns. The main doorway leads into an enclosed hall that is entirely enveloped with blue and white tile-work of Qur'anic and other religious epigraphy in a variety of calligraphic styles including a highly floriated, difficult-to-read Kufic. Most of the squinches are completely covered with tile-work displaying the names of important religious figures in Islam (such as Muhammad, the caliphs, and important prophets) in such a rectangular and abstract hand that they resemble a nontextual arabesque pattern.[18]

The Karatay Medrese, like many other Seljuk *madrasas,* is an enclosed space with high exterior walls, its few windows to the street small and placed high, and an imposing portico designed to be kept shut. This is an architecturally closed space that in both its day-to-day function and its symbolism maintains a distinction between the private space of the educational institution and the world of the street, such that the inside and outside have a discrete, if overlapping, viewership, since those with access to the inside would also have access to the public space of the exterior. Yet it is even to this audience, which includes in its ranks the very individuals who would be best able to read religious inscriptions, that the epigraphy presents an iconic face. The pervasive presence of abstract, repetitive, and difficult-to-decipher epigraphy on the interior of this *madrasa* serves a visual symbolic purpose in marking the religious space and reinforcing its "skin" to convey a variety of messages, not the least of which is apotropaic.

Text as Icon

Written text has, of course, long been used in the Islamic world in amulets and charms.[19] What appears to be a new practice—certainly in pervasive form—is the inscribing of religious phrases such as the *bas-*

mala ("In the name of God, the Compassionate, the Merciful") or traditionally apotropaic formulas such as "This is by the grace of my Lord *(hādhā min fadl rabbī)*" and "As Allah wishes *(mā' sha'llāh)*" conspicuously on one's home or place of business. In the first place, such phrases provide an excellent example of writing that functions both visually and textually, in that such phrases are common enough to be contextually legible to substantial numbers of people even in societies that do not speak Arabic, with many people recognizing the *shapes* of the script without understanding the words or letters. At the same time, such displays "help create a physical environment in which the unseen takes material form in written symbols that surround the urban audience as a constant backdrop."[20] Furthermore, the display of such formulas also telegraphs the attitudes, allegiances, and interests of those who choose to sponsor them. To paraphrase Starrett, displaying the name of God over the front door of one's house and displaying it on a lamppost mean very different things.[21]

In trying to understand calligraphic works that function as images, it might be helpful to use Gonzalez's distinction between works in which the image dominates the text and those in which the opposite holds true, the latter being referred to as the "scriptural regime" and the former the "figural or representational regime."[22] The distinction is an important one, in that it helps explain various aspects of architectural epigraphy together with fine arts such as album and miniature painting. Regardless of the contrast between the two categories, in the current context, I want to focus on the iconological value of text as well as image in situations where both categories function either in dialogue or independently of each other. These include examples of calligraphic arts in what is often referred to as pictorial calligraphy, where calligraphic words and phrases are shaped into representational forms.[23] In most cases, the pictures have no obvious connection to the content of the verses, with common formulas such as the profession of faith or the *basmala* formed into birds, boats, or other shapes. In other cases, there are obvious connections, such as when references to 'Ali, nicknamed the "Lion of God," are written in the shape of a lion.

A possible variation on the tradition of pictorial calligraphy, but one that can be understood very differently in semiotic terms, is the

tradition of imbuing the written text with a "visual equivalence" to its meaning. Such calligraphic examples—which enjoyed great popularity as religious artifacts in the Ottoman world—are comprehensible in iconological terms, in that they resemble that which they signify. They also represent an iconic form of onomatopoeia, one in which the word, as visual sign, mimics the sound and meaning of its object.[24] Among the most representative of such mimetic calligraphic works is an often-copied panel by the Ottoman calligrapher Mehmed Şefik Bey in which the pear-shaped text reads: "Mercy 'Ali, Fatima, Hasan, Husayn," refer-ring to the family of the Prophet (Plate II) (in fact, Muhammad is himself cryptically represented in this composition as the word *amān* [an interjection in common Turkish usage, meaning "security," "pro-tection," and "mercy"], which is numerologically equivalent to the name "Muhammad").[25] In the composition, the first letter of the name of the Prophet's daughter Fatima *(fa)* is inscribed within the first letter of the name of her husband 'Ali *('ayn)*. Schick has succinctly captured the visual significance of what, at first glance, seems like a somewhat awkward artistic choice:

> What is interesting is that the name of the first letter of Ali is a homonym of the Arabic word for "eye." Furthermore, there is, both in Arabic and Turkish, the expression "to be in some-one's eye," which means to be loved, to be esteemed, to be val-ued. So by placing Fatima into the *'ayn*/eye of Ali, this inscrip-tion is in fact giving the message that the Prophet's daughter was greatly beloved and esteemed by her spouse, the Caliph Ali. Visually, the calligraphic composition makes Fatima "the apple of Ali's eye"—an expression that has the same meaning in Turkish *(Ali'nin göz bebeği)* as it does in English.[26]

The representational and iconographic function of text is apparent in an important genre of book arts known as a *hilye-i nebi, hilye-i saadet,* or *hilye-i şerife,* the first example of which was composed in the late sev-enteenth century by the Ottoman calligrapher Hafiz Osman (d. 1698). A *hilye* comprises a verbal portrait of the Prophet's person, drawn in most cases from a tradition recorded by al-Tirmidhi (d. 892) and at-tributed to Muhammad's cousin 'Ali:

When 'Ali described the Messenger of God, he said: "he was neither too tall nor too short, rather he was of medium height among people. His hair was neither short and curly, nor was it long and straight, it hung in waves. His face was neither fleshy nor plump, but it had a roundness, rosy white, with very dark eyes and long eyelashes. He was large-boned as well as broad-shouldered, hairless except for a thin line that stretched down his chest to his navel. His hands and feet were coarse. When he walked, he would lean forward as if descending a hill. When he turned [toward someone], he turned with all his body. Between his two shoulders was the Seal of Prophethood, and he was the seal of the prophets."[27]

The Turkish name for these elaborate, embellished calligraphic panels is taken for the Arabic word for the physical appearance of a person (hilya), and is likely to have been inspired by a well-known poem by the sixteenth-century Ottoman poet Hakani (Khaqani) Mehmed Bey, which in turn was inspired by the hadith from al-Tirmidhi's collection quoted above. Al-Tirmidhi also records a prophetic account that states: "It is reported of 'Ali ibn Abi Talib, may God be pleased with them both, that he said: The Prophet of God, prayers upon him and peace, said: 'Whosoever sees my hilya after me, it is as if he had seen me; and whosoever sees it, longing for me, God prohibits Hell-fire from him and he will be protected from the trials of the grave, and he will not be resurrected naked on the Day of Judgment.'"[28] Hakani's poem speaks in detail about the physical qualities of the Prophet as well as his dress and comportment. And in a manner familiar from later accounts of the blessings of relics, Hakani declares that whoever possesses the hilye-i şerife is saved from punishment after death, Satan never enters his house, is guarded against all bodily ills, and is rewarded at a level equal to that of someone who has done the Hajj or has freed a slave.[29]

Veneration of the Prophet has been a central feature of Muslim piety from its formative period when both the tellers of prophetic tales and collectors of prophetic traditions gathered and promulgated minute details of Muhammad's life. It is on only one such famous collection of hadith, al-Tirmidhi's book entitled Shamā'il al-Mustafā containing

traditions concerning Muhammad's moral excellence together with detailed accounts of his physical characteristics, that the Ottoman examples mentioned above are ultimately based. By the eleventh century, these early texts had given rise to related genres of literature on the proofs of prophethood *(dalā'il al-nubuwwa)* and on Muhammad's physical and moral beauty *(shamā'il)*.[30] Such works, as well as others such as the famous "Ode to the Cloak *(qasīdat al-burda)*" that conjured up images of Muhammad's actual person, have been used by Muslims across the Islamic world as objects of informal prayer and contemplation, and as talismanic artifacts that are carried or worn to guard against misfortune. Writing a *hilye-i şerife* was itself viewed as an important act of piety, and at least some individuals believed that whoever composed one would be protected from misfortune by God.[31]

It is conceivable that the *hilye-i şerife* as a visual portrait might have arisen as a Muslim response to the icon in Orthodox Christianity. Intriguing though this idea may be, the fact is that not only do verbal descriptions of Muhammad's appearance predate the *hilye* calligraphic plates by many centuries, but so does the Muslim encounter with the tradition and use of Christian icons. Nevertheless, that this textual portrait is meant to be construed as a bodily representation is suggested by the fact that the components that together form a *hilye* panel are called the "place of the head" *(başmakam)*, belly *(göbek)* or body *(gövde)*, belt *(kuşak)*, and skirt *(etek)*.[32] In addition, the placement of four roundels containing the names of the first four caliphs (Abu Bakr, 'Umar, 'Uthman, and 'Ali) around the "head" and "belly" of the *hilye* suggest limbs, making the artifact not only linguistically referential to the appearance of a human body but physically so as well.

A similar transformation of textual signifiers into visual ones is encountered in an unusual Ottoman calligraphic work that, at first glance, appears to be a simple prayer (Plate III); on closer examination it turns out to be a textual representation of the "Seal of Prophethood" said to have been located between Muhammad's shoulders. As such, this artifact is the *textual* version of a *visual* sign that is itself known only through textual descriptions. The lower panel reads as follows in Turkish:

The benefit of this holy seal to those who visit it will be as follows: To those who look at it in the morning, having performed their ritual ablutions, it will last until the evening. And to those who look at it at the beginning of the month, until the end of the month. And to those who look at it at the beginning of the year, until the end of the year. And for those who look at it while on a journey, may their journey be blessed. And those who die in the year during which they have looked at it shall die with faith.[33]

Nowhere on the panel does the word "to read" appear. The addressees of the text are instructed *to see* the artifact, including in the prayer at the bottom where God's forgiveness is begged for the calligrapher, his parents, and "for all those who look at it." As Schick rightly notes, "the panel was not only regarded as written text, as well as devotional object, but also as an *image*."[34]

The textual representation of the prophetic seal, which itself becomes an object of visual contemplation, walks the fine line between a relic, its representation, and an icon through which the devotee accesses not just the seal on the Prophet's body, but also the set of doctrines concerning prophecy, Islam's relationship to Judaism and Christianity, and much more that is imbricated in the belief that Muhammad wore a physical mark of prophethood. Similar phenomena of visually representing Muhammad's relics are found in many parts of the Islamic world to this day, and Muslims in a broad range of societies purchase and possess cheaply reproduced chromolithographs that depict the Prophet's cloak or other garments, or else his sandal or footprint. Representations of his sandal or footprint are especially popular and are often depicted in a stylized—as distinct from realistic—form (see Plates V and VII). In virtually all cases, the visual representation of the relic is accompanied by text in a way that makes the two inseparable. Plate IV is of a poster from Pakistan reproducing an image of a footprint of the Prophet that is preserved in the collection of holy relics in the Topkapı Palace Museum in Istanbul. There are, in fact, shrines of the prophetic footprint in South Asia, but as implied by the

statement in the bottom-left panel on the poster acknowledging that the image of the footprint has been reproduced from an official Turkish pamphlet entitled "The Blessed Relics of Islam *(tabarrukāt-i Islām)*," the provenance of the relic in the Topkapı Museum lends it greater value than those found elsewhere.[35]

The upper half of the left-hand panel of this poster quotes a hadith of the Prophet according to which he said that whoever says one prayer for Muhammad, God blesses him or her ten times, forgives ten sins, and raises him or her up ten levels. The right-hand panel lists the blessings of the prophetic footprint:

> Whoever keeps it with them is honored; whichever caravan has it is not robbed; whichever ship has it does not sink; whichever property contains it remains protected. [Whoever has it with them] has the fortune of visiting the holy precinct or is honored by perceiving himself or herself visiting the sanctified presence of the Prophet (may peace be upon him) in a dream. Whatever need one approaches it with is fulfilled. Whoever is without child, should say five blessings on the Prophet *(durūd sharīf)* and pray with the mediation *(tawassut)* of the footprint, and God will bless them with offspring.

In this example, the writing functions as text, possessing both a descriptive function in explaining the value of the image of the footprint as well as an indexical value as a caption, which appears boldly across the top of the poster as "The Print of the Blessed Foot of the Most Noble Messenger, May Peace be Upon Him." The reference to the footprint is significantly ambiguous as a signifier since the Urdu term *naqsh-i pā* can mean both "footprint" and "picture of the foot" such that, at a particular level, the image is also a visual representation of the Prophet (albeit a partial one).

The polysemic value of text as well as the iconic value of such artifacts is even clearer in Plate V, which is of a poster depicting the stylized sandal of the Prophet *(na'l al-nabī)*, which is commonly seen either in print and painting, or in jewelry, and is used as an amulet across the Islamic world. This example, like that of the image of the footprint, is

from Pakistan, and bears more than a passing resemblance in its lay-
out to the most popular *hilye-i şerife* plates from the Ottoman Empire,
with four medallions at each corner, and a horizontal strap dividing
the upper and lower portions in much the same corporeally referential
way as they do in a *hilye-i şerife*. In this representation of the sandal, the
four medallions contain the names of four archangels (Jibra'il, Mika'il,
Israfil, and Azra'il) rather than of the first four caliphs, most probably
because of the poster's Shi'i associations, which are made clear by a
divine saying attributed to the Prophet appearing at the bottom: "I
have five through whom is quenched the heat of the crushing afflic-
tion: Mustafa, and Murtaza, and their two sons, and Fatima." The
angular border on either side of the sandal contains Urdu verses com-
monly seen together with this image: "If I could find the pure sandal
of his excellency to place on my head / Gladly would I declare: 'Yes, I
too wear a crown!'" and "The Qur'an swore by the dust on which it
tread / A million blessings upon the slipper of the sacred foot."[36]

As it is in many Muslim-majority countries, the symbol of the sa-
cred sandal is common enough in Pakistan, where it appears as a talis-
man, such that it is instantly recognizable by most members of society.
Yet the image of the sandal is captioned twice in this image, in Arabic
at the top ("This is the image [*mithāl*] of his sandal, prayers be upon
him and his family") and in Urdu/Persian at the bottom ("The image
[*naqsha*] of the blessed sandal of his excellency, the Master of Mankind,
according to the measurements of the noble Imams").

Based on the other text appearing on the poster, and especially the
writing concerning the provenance of the image, the title at the top is
redundant. However, it is extremely common to provide captions on
religious images in the Islamic world, whether they be of the venerated
saint Ahmadou Bamba in West Africa or of a multitude of saints in
South Asia.[37] In the latter case, saint posters frequently carry a textual
caption with the name of the saint despite the fact that, like Christian
saints and the posters of Hindu gods to which these images are closely
related both technologically and stylistically, the saints are normally
accompanied by visual cues that serve to identify them. The poster in
Plate VI depicts the popular saint of Pakistan, Shahbaz ("The Falcon")
Qalandar (d. 1274), in three different postures or moods: flying through

the air (appropriately for the patron saint of travelers), as an ecstatic Sufi, and as a pious Muslim. Not only is the entire poster captioned with his name, but each tableau has a textual reference to the qualities depicted in the image: devotion is represented by the vocative names "O Allah!" and "O Muhammad!" which appear together with images of the Ka'ba and Prophet's Mosque, a phenomenon which has its own iconographic significance as I shall discuss shortly with reference to trucks. The ecstatic Sufi is referred to textually with the lines of a popular Punjabi song in his honor: "Drunk in every breadth, 'Ali is foremost *(damadam mast qalandar / 'Ali dā pehlā numbar)*." The saint is also represented textually in verse: "The falcon flies through the air / he knows the hearts' secrets *(shahbāz karē parvāz / jānē rāz dilān dē)*."

In these examples, the text adds value to the image and vice versa. The same phenomenon is encountered in the practice of truck decoration in Pakistan and the case of Hajj paintings in Egypt. Among rural Egyptians, there is a custom of decorating the outsides of the homes and businesses of individuals who have gone on the Hajj pilgrimage in order to celebrate as well as advertise their completion of this important and expensive religious duty, and one that marks an important turning point in the lives of many pious believers. The visual displays vary tremendously, but key features in most of them are representations of the pilgrim, images of the journey—in many cases including its different stages such as the train ride to the coast and the ship or aircraft to Jeddah—and various aspects of the pilgrimage itself.[38] There are no set patterns of representing the pilgrim or the journey either in their contemporary, actual form, or as an idealized representation of a timeless Muslim going on Hajj (on a camel caravan for example). In many cases, the signifiers of modernity, particularly aircraft, feature prominently in the images, and are accompanied by the electronic goods presumably acquired by the pilgrim on his or her way home from Saudi Arabia, or else they represent the aspiration and expectation that whoever gets to go to the oil-rich countries of the Arabian Peninsula returns with such goods.

Text appears as an explanatory caption or title, most obviously when displaying the name of the pilgrim. Elsewhere it captions images depicting events, such as in the Abrahamic sacrifice, where text reading "sacri-

ficial ram," "Jibril [the angel]," and in rare cases "Isma'il, upon him be peace" and "Ibrahim the Friend of God, upon him be peace" appear alongside visual representations of each of them. In other examples, the scene is accompanied by a religious phrase, normally from scripture, that in and of itself evokes a particular station of the pilgrimage. For example, pictorial representations of the sacrifice are accompanied by the verse "And we ransomed him with a great sacrifice *(fa-fadaynāhu bi-dhibhin ʿazīmin)*" (Qur'an 37:107), and representations of the ambulatory ritual elements of the pilgrimage by the common saying concerning the power of the Hajj to erase all sins: "Hajj is accepted (by God) and sins are forgiven *(hajj mabrūūr wa-dhanb maghfūr),*" or else the formula repeated during those rituals: "At your command, O God, at your command *(lab-bayka Allahumma labbayk)!*" In these cases, the image and the text are not interchangeable so much as the text provides a "value-added" quality to the visual representation and vice versa. Each can and, in many cases, does function perfectly well independently of the other, but in these forms of visual art images are integrated with text, such that not only the signification of the visual display but also its status as an aesthetic phenomenon makes the "visible correlative to the legible by displacing or connecting up the sphere of language to that of icon."[39]

A similar phenomenon holds true for truck painting in Pakistan, a pervasive art culture that combines text with image, and the religious with a variety of other expressions of life, society, and individual as well as collective aspirations.[40] Pakistani trucks are covered in a complex arrangement of patterns, images, and texts that collectively represent a major visual regime of a large Islamic society and serve as a window into the structure and politics of this contemporary public sphere. Explicit religious signifiers and talismanically or religiously loaded symbols figure prominently in truck decoration; the former category includes the majority of the calligraphic program of the truck along with explicit religious symbols such as the Ka'ba and the Prophet's Mosque in Medina. Some of these religious symbols are mixed in their signification, such as a paired star and crescent that simultaneously represent Islam and Pakistan. Into this category also fall the names (and occasional images) of prominent or regional Sufi saints who are invoked for protection, although arguably these could be seen

as part of a religious calligraphic program as distinct from a primarily visual one. Talismanically or religiously loaded symbols account for the majority of decorative motifs on the truck, and they are both painted on during the initial design as well as added later in the form of stickers and smaller objects attached to the body of the truck. Common symbols are fish, which represent good fortune, and eyes, which function ambiguously to represent protection from the evil eye and as symbols of beauty.[41]

Many of the motifs occupy predictable places on the Pakistani truck, such that one can comfortably speak of a visual grammar governing its design. Explicit religious symbols and images are almost always located on the front of the truck; talismanic objects and symbols may be found on the back and occasionally on the sides, but the preponderance of such signs is also on the front of the truck.[42] Representational images and patterns typify the more visually striking aspects of the trucks' decorative program but—in almost all cases—they lack the power as signifiers to be readily understood or to provide any explicit or systematic message comprehensible to the majority of onlookers. Epigraphic material, it might be argued, is very clearly selected to be seen as well as read, and to provide explicit messages concerning the identity and concerns of the individuals associated with the truck. Text is used to impart mundane information such as the name of the owner and transportation company, but it is also text, rather than image, that is used to actively engage viewers in the most direct manner and to communicate a variety of messages.

One decorative element of the Pakistani truck for which this polysemy glaringly does not hold true is the pervasive display of the Ka'ba and the Prophet's Mosque. Images of them almost invariably appear on the front of the truck toward the top, sometimes accompanied by inscriptions reading "O Allah!" and "O Muhammad!" Almost without exception, the image of the Ka'ba appears on the left side and that of the Prophet's Mosque on the right. The purpose of this arrangement is almost certainly to be representational of what they symbolize—Allah and Muhammad—and mimic the way in which their names would be *seen* or *read* (as distinct from *written*): the name of God always precedes the name of his prophet, and an individual reading the Perso-Arabic

script would read from right to left while facing the truck.[43] In the case of the invocation of Allah and Muhammad on the front of a truck, the images of the Ka'ba and the Prophet's Mosque function iconically. But the text functions iconically in referring to God and His prophet as well—"picture and scripture are one and the same entity with two faces, two properties and two natures, one textual and the other figurative, i.e. a double ontology with a primary (scriptural/ideal) ontology and a secondary (figural/material) ontology."[44]

The iconic use of text is also encountered in book arts in the Ottoman Empire, where its application is reminiscent of the popular contemporary examples mentioned here. The early modern period witnessed a growth in the popularity of small, illustrated volumes that have sometimes been called prayer manuals, but which most likely fulfilled a variety of other functions (and crossed into other genres) such as souvenirs, ritual guides, relic records, and so on. These books frequently include captioned images, for instance pictorial representations of a tree with the title "Lote Tree of the Boundary" (with reference to a Muslim eschatological feature), or images of standards and weapons belonging to early Muslim heroes. They normally also contain a section comprised of holy names (such as those of Muhammad or the early caliphs), which are presented as large, ornately written Arabic names on a dark, plain field; they are thus imbued with a pictorial quality, seeing as how they are framed in the middle of the page, one at a time (Plate VIII). What makes them remarkable is that, in most cases, the name medallions carry a caption stating what the illustration is. Thus the medallion containing the name of Abu Bakr will have the caption "This is the name of his excellency Abu Bakr, may God be pleased with him," and the medallion containing the name of the Prophet or 'Ali will be laid out in much the same way.[45]

The caption on the name medallions would be completely superfluous and redundant unless one were to accept the hypothesis that the "name-that-is-named" does not function as text at all—it is not the *textual* rendition of the name but its *image*. The written word, in such examples, functions simultaneously in two capacities: as a caption, the name ("Abu Bakr") is textual and explanatory in a straightforward fashion; as the image of the name, it is visual, and operates exactly the

same way as an icon would in other, more conventionally pictorial, religious contexts.

Conclusion

It is impossible to overstate the importance of text, reading, and writing in Islamic societies. But in many cases, the written word functions as an image, such that whether or not the viewer can read or understand it, writing is visually recognizable as the signifier of a complex set of messages concerning the nature of religion and political authority as they exist within societal constructs. In many contexts, writing functions as a linguistic sign at a second, accessory level; at a primary level it is distinct from but analogous to nontextual visual arts, in that they are often "similarly invested with representational qualities and values."[46]

Literacy is important to understanding the place of text and writing in Islamic art, but one should not assume that the possession of the ability to read the language of an epigraphic piece necessarily makes an individual's experience qualitatively different from that of other viewers who are unable to do so. Each individual epigraphic example does not have to be "readable" to the viewer. Epigraphy works on the *expectation* of meaningfulness, in that whether one can read the inscriptions or not, or even if one's senses are dulled to their presence so that one doesn't even bother to, the presence of the Arabic script in any calligraphic form on a building of religious significance is appropriate to its presence, reaffirming not only the importance of all that the building signifies but also the iconographic and other symbolism of the script. Qur'anic inscriptions belong on Islamic buildings in the eyes of Muslim and non-Muslim viewers the same way pseudo-Arabic belongs on the Mudéjar architecture of Spain and in representations of imagined Islamic architecture in orientalist paintings—most famously in the work of Gérôme—because it is appropriate to its context.[47]

In such uses of text, individuals populate the visual text with their individual intentions independent of the original intent of the builder, artist, or patron. To borrow Bakhtin's argument on language and apply it to images, text and image do not exist as a "neutral and impersonal

language"; instead, they exist "in other people's mouths, in other people's contexts, serving other people's intentions." Individual viewers then take these visual examples and make them their own, inhabiting the visual text with their own intentions and meanings that result from the context of the viewer rather than that of an author.[48]

The written word functions in such contexts not as text but as a visual sign—the "image of the word" to use a term coined by Dodd and Khairallah—where the interplay of the textual and the visual reflects a form of "iconic augmentation" in which one adds value to the power of the other as a signifier.[49] Gonzalez has suggested that visual religious art of this sort represents a form of visual remembrance of or meditation on God *(dhikr)*, in that it prepares the viewer mentally and psychically for remembering the divine, and also allows for the indefinite repetition of God's name.[50] Whether or not it constitutes a form of visual meditative practice, the multiple uses of text in Islamic religious art and formal as well as informal religious life push the limits of our understanding of representational art in Islamic society, lending themselves most readily to an iconological explanation rather than one that distinguishes between text and art, or word and image.

Epilogue

But in 2500 B.C. Harappa,
who cast in bronze a servant girl?
No one keeps records of soldiers and slaves.
The sculptor knew this,
polishing the ache
off her fingers stiff
from washing the walls
and scrubbing the floors,
from stirring the meat
and the crushed asafoetida
in the bitter gourd.
But I'm grateful she smiled at the sculptor,
as she smiles at me
in bronze . . .
 —AGHA SHAHID ALI, *The Country without a Post Office*

One might have hoped that somewhere in the vast and rich intellec-
tual traditions of the Islamic world, or in its bejeweled social history,
there was to be found a Rosetta Stone, a *clavis interpretandi* by which to

make sense of the nature of the visual image in Islam. Such a key is not to be found; but more to the point, the search for such an interpretive key is a conceptual error because, were a text providing a doctrine or theory of images in Islam to be located, it would only shed light on the attitude toward images of its author in his or her context. The existence of one, or even a handful, of texts on a theology of images or the religious status of artists and the visual arts (what has been a quest for more than a few art historians) would do little to locate visual and material culture within Islamic societies across their historical and geographical expanse. Indeed, the search for such texts says more about the scholar looking for them than about the history of Islamic visual culture, since it is premised upon treating Christianity as *the* normative religious tradition. Sweeping theological works on the nature of the religious image are not to be found in Buddhism or Hinduism—two highly textual and scholarly religions that possess a rich visual culture, nor do they exist for Judaism or for other religions with a more limited textual record.

One could argue, therefore, that it is Christianity that represents the exception, in the sense that it possesses articulate theologies of the image that are a direct result of two internal moments of crisis in which imaged form played a central part, these being the so-called Iconoclast Era of iconomachical movements in the eighth and ninth centuries, and the Protestant Reformation in the sixteenth and seventeenth. Islam and other religions have not experienced such moments for a constellation of social and historical reasons, and consequently lack similar theologies of images born out of apologetic debate. But it is also conceptually problematic to take the textual expressions of the iconodules and iconophobes of the eighth century (or the antipapists of the sixteenth) and generalize about a universal Christian theology of images. The writings of St. John of Damascus or a Nicene Council are no more relevant to attitudes toward images among the majority of Christians in North America today than a tenth-century Muslim theological treatise would be to the practices and attitudes of today's Muslims. And furthermore, any understanding drawn primarily from a nominal reading of such a text cannot adequately incorporate the many exegetical and hermeneutical devices employed by Muslims (as well as by many others) throughout history.

Among the various ways in which Muslims have reacted to (and continue to react to) visual images, expressions of anxiety, ambivalence, aversion, and fascination manifest themselves simultaneously on occasion. The fascination for images might be an obvious and innate part of the human constitution, but so too, it appears, is the fear of images, as has been demonstrated repeatedly in this book. As such, no theory of imagery can be separated from a recognition of the fear of images, since not only are iconophilia and idolatry the conjoined twins of iconophobia and iconoclasm, but they often exist simultaneously in the same individuals and the same societies.[1] There is no easy explanation of why this anxiety with images exists, beyond some very general notions, such as the need of one group to differentiate itself from another (and therefore from its gods), some primordial fear of the uncontrolled and uncontrollable that continues as an evolutionary by-product, an acknowledgment of the power of the image, or something else. But any explanation that attributes the fear and fascination with images to an innate human need does little to provide a specific satisfactory explanation, and acknowledging the power of images as something innate to the images themselves, rather than to the human perception of them, avoids the question entirely.

Mitchell has provocatively suggested that the anxiety concerning images centers around the nature of resemblance, and that the fear of images is, at root, a fear of clones, or "clonophobia." The fear of clones (as apparent in medical ethics as it is in film and literature) is based in a concern with images:

> It is not just the resemblance to fears of the "other," whether racial or sexual; not just the fear of violating natural or divine law, of transgressing the codes of evolution on the one side, or revelation on the other; it is not just the horror of desecrating the sacredness of life, or of erasing human individuality, or denying death for a static immortality, nor of turning human creatures into commodities. . . . At bottom the fear of cloning is rooted in the fear of images and image-making, arguably one of the most durable phobias that hu-

man beings have ever developed for themselves. Cloning is a realization, a literalization of the most ancient fear—and (significantly) the most ancient hope—about images, and that is that we might bring them to life.[2]

The observation that clonophobia is but one manifestation of iconophobia sheds little light on the nature of iconophobia itself or on the human attitude toward images, except to highlight that iconophobia "in its most primitive, archaic manifestations already contains premonitions of cloning."[3] Representation and mimesis—as expressed both in the Bible and in the Qur'an—reflect an element of cloning, with Adam made "in the image" of God, and the many condemnations of making imaged form mentioned in this book center around the threat of making human creators *like God* through the act of *creating images* that are *like the images* God creates.

That it is the human concern with the nature of resemblance that underlies our fear and fascination with images commends itself as a plausible, broad explanation for the visual phenomena covered in this book. Attitudes toward visual images and resemblance harbored by Muslims as well as others are frequently contradictory, and it is only through a process of what has been termed "multi-think"[4] that viewer-devotees condemn the use of religious images while simultaneously venerating those visual images that they themselves possess.

Vision—and the images and concepts of resemblance and representation that rely on it—are fundamentally somatic matters of "the flesh."[5] As is clear from the overview of Islamic optical theories in Chapter 6, not only perception but also representation was explicitly understood in such a way by premodern Muslim thinkers, and the images in dream visions as well as in the imagination as discussed in Islamic philosophy and Sufi metaphysics argued for a similar corporeal location to the whole affair of seeing. The physicality of experiencing visual objects—indeed, the very materiality of objects themselves—is sanitized in human experience through the passage of time: "memory makes images acceptable to a broad religious culture that is otherwise given to declaring itself anti-iconic."[6] And the physical objects of the past, that in

their actual presence threaten the autonomous existence of prototypes through their properties of resemblance, primarily live on in later times only as images.[7] Within this process of somatic detachment from the fleshiness of seeing, the equally physical (and even visual) text and the book assume a place of virtual primacy in Islamic material culture; this occurs through the written word manifesting the "body" of the divine and of absent religious heroes, to the point that some forms of text function entirely visually for their viewers who cannot access the words, or else they function the way modern sheet music does, unintelligible to most until it is brought alive through sounds produced by those who understand its symbolism.

One major goal of this book has been to reframe the study of resemblance, seeing, and visual images and their use through a counterintuitive focus on Islamic materials, since prevailing wisdom would suggest that a religious culture that places visual images at a doctrinal periphery would constitute a less valuable field of inquiry than one that was obviously rich in images. Through the exploration of visuality and representational concerns where they are not self-evident, one can better understand the role of the visual image as something that goes beyond straightforward questions of mimesis.

In the end, even though we know that "those who live by the pen and those who live by the brush or chisel work to separate agendas,"[8] the text and image intersect in many ways in the history of religious visual culture in the Islamic world, and several of the hypotheses put forward in the course of this book would appear to hold true: first, that examples of visual art (including textual ones) need to be looked at as objects or entities that are perceived and interpreted, and not simply as objects for aesthetic appreciation. Second, that notions of representation as they emerge from a study of Islamic writings help us understand how Muslims might perceive religious objects in their midst, and that this understanding cannot be reduced to simple questions of whether or not Muslims tolerate visual religious art. Third, that the definition of what is considered Islamic religious art needs to be expanded so that one can develop a new understanding of the nature of ritual and practice, aesthetics and art, as well as material and social culture in Islamic society. And lastly and more generally, it is

very productive to look at art objects as technological products that serve as mediums of communication within societies. Such an understanding of art is not reductive, in the sense that it devalues aesthetic questions of appreciation and patronage or of artistic and technical virtuosity. On the contrary, such a view removes the multifaceted appreciation of the object from the confines of detached appreciation and brings it to the center of social and religious life.

Notes

Prologue: The Promise of a Meaningful Image

Epigraph: Agha Shahid Ali (1991), *A Nostalgist's Map of America,* New York, W. W. Norton, 75–76.

1. There were widespread demonstrations across the Islamic world following the release of *The Message,* which was banned in several countries. Dramatically, the leader and supporters of a small African-American Muslim group occupied three buildings in Washington, D.C. (one government building, the Islamic Center, and the headquarters of the B'nai B'rith) on March 9, 1977, and held 132 hostages for 38 hours. The crisis ended with the extensive involvement of the ambassadors from Egypt, Iran, and Pakistan, but not before the deaths of a reporter and a policeman. The release of *The Message* was listed among the grievances of the hostage takers, and it is broadly understood to have been the catalyst that instigated the attack ("Terrorism: The 38 Hours: Trial by Terror," *Time,* March 21, 1977 [http://www.time.com/time/magazine/article/0 ,9171,946751-1,00.html]). *South Park* began to toy with representing Muhammad shortly after the Danish cartoon controversy of 2005, drawing attention to political problems in depicting Muhammad that do not exist with representing other religious figures such as Jesus and the Buddha. At no point did the cartoon ever show Muhammad; in fact, the

character in a bear suit that was said to be Muhammad was eventually revealed to be Santa Claus (for synopses of the episodes, visit http://www.southparkstudios.com/full-episodes/ and search for "Super Best Friends" and "201").

2. Elias (2007), 13–17. See also Flood (2002), 641–659.

3. Clément (2002), 218–220.

4. Centlivres (2002), 75–77.

5. Mullah 'Umar's initial declaration ordering the destruction was made on 2 Dhu'l-hijja, five days before the start of the Hajj pilgrimage and eight days before Eid al-adha. For an outline of the timeline of these events in the Islamic calendar, see Elias (2007), 16–19.

6. This statement has gained much popularity among Muslim admirers of Mahmud of Ghazna, although it does not accurately reflect his words as they appear in the historical work from which they are drawn. The influential, though temporally remote, early seventeenth-century chronicle *Tārīkh-i firishta* describes Mahmud as being concerned with the judgment of posterity and declaring his preference for being remembered as a destroyer of idols. See Firishta (1905), 1:33; Firishta (1829; rpt. 1990), I: 43–44. For more on the destruction of the temple of Somnath, see Chapter 4.

7. Elias (2007), 24–25.

8. Klausen (2009), 13.

9. Ibid. A timeline of the events following the initial publication of the cartoons is found on pp. 185–199.

10. The Danish controversy had ongoing consequences related to Islam and representation. The matter of the television show *South Park* and depictions of Muhammad has already been mentioned. On May 20, 2010, a cartoonist from Seattle organized a Facebook event entitled "Everyone Draw Mohammed Day." This drew a sharp reaction from sections of the global Muslim community, including threats to the cartoonist that were deemed serious enough for her to go underground and change her identity ("On the Advice of the FBI, Cartoonist Molly Norris Disappears from View," *Seattle Weekly*, September 15, 2010 [http://www.seattleweekly.com/2010-09-15/news/on-the-advice-of-the-fbi-cartoonist-molly-norris-disappears-from-view/]).

11. *Sahīh al-Bukhārī, Kitāb bad' al-khalq*, 3052; 4:54:447. I have utilized a hybrid system of referring to individual hadith accounts, including a numerical reference (favored by contemporary translations) for each account after the more traditional manner of referring to the section name and

hadith number: 4:54:447 refers to volume 4, book 54, hadith number 447 of al-Bukhari's collection.

12. *Sahīh al-Bukhārī, Kitāb al-libās*, 5610; 7:72:838. Other close variants of this hadith do not mention the conversion of the tapestry into cushions: "The Prophet returned from a journey when I had hung a thick curtain with images. He ordered me to remove it and I removed it" (*Sahīh al-Bukhārī, Kitāb al-libās*, 5611; 7:72:839).

13. *Sahīh al-Bukhārī, Kitāb al-libās*, 5615; 7:72:843, with a very similar version in *Kitāb bad' al-khalq*, 3055; 4:54:450.

14. *Sahīh al-Bukhārī, Kitāb bad' al-khalq*, 3053; 4:54:448.

15. *Sahīh al-Bukhārī, Kitāb ahādīth al-anbiyā'*, 3173; 4:55:570.

16. *Sahīh al-Bukhārī, Kitāb ahādīth al-anbiyā'*, 3174; 4:55:571.

17. *Sahīh al-Bukhārī, Kitāb al-libās*, 5608; 7:72:836.

18. *Sahīh al-Bukhārī, Kitāb al-libās*, 5606; 7:72:834.

19. *Sahīh al-Bukhārī, Kitāb al-libās*, 5607; 7:72:835. Other variants of this hadith include *Sahīh al-Bukhārī, Kitāb al-libās*, 5609; 7:72:837: "[from Abu Zur'a]: I went with Abu Hurayra into a house in Medina where he saw a man making images at the top of the house. [Abu Hurayra] said: 'I heard the Messenger of God say [that Allah said], "Who is more wrongful than one who attempts to create the like of My creations? Let him create a grain, let him create the smallest ant!"'"

20. *Sahīh al-Bukhārī, Kitāb al-libās*, 5613; 7:72:841.

21. *Sahīh al-Bukhārī, Kitāb al-buyū'*, 2112; 3:34:428.

22. *Sahīh al-Bukhārī, Kitāb bad' al-khalq*, 3054; 4:54:449.

23. *Sahīh al-Bukhārī, Kitāb al-libās*, 5612; 7:72:840, with a close variant in 5616; 7:72:844.

24. *Sahīh al-Bukhārī, Kitāb manāqib al-ansār*, 1415; 5:58:235. For more on the topic of images and dream-visions, see Chapter 7.

25. *Sahīh al-Bukhārī, Kitāb al-libās*, 5614; 7:72:842.

26. Mitchell (1986), 72.

27. Hoffman (2000), 44. For a fuller discussion of Arabic illustrated manuscripts of a scientific nature, see Contadini (2007). An interesting subcategory of Arabic illustrated books deals with the technology of *automata*, itself a category of physical form, though not a religious one. Islamic culture had a highly developed tradition of constructing and imagining devices such as fountains and water clocks in the form of animals and human beings. This technological tradition made its way to Europe through the court of Frederick II in Sicily, becoming part of a secular courtly tradition (Camille [1989], 247).

28. Among the notable works exploring the nature of medieval popular culture in the Islamic world are Shoshan (1991), 67-107; and J. E. Lindsay (2008), *Daily Life in the Medieval Islamic World*, Indianapolis, Hackett Publishing. For a reevaluation of early Islamic history with importance given to the sociopolitical periphery, see Bulliet (1994).

29. This point has been made in the case of comparable Christian illustrated manuscripts in Brubaker (1989a), 27.

30. Ibid., 28. The question of the place of miniature painting in Muslim culture is a broader one than I have space to discuss in this context. Quite apart from important questions related to the role played by aesthetics in determining the place of such images, it is difficult to argue for any major didactic role to these images when only a limited group of viewers—functionally all of whom could read with facility—had access to them.

31. Solomon (1991), 1-14. One needs to bear in mind that notions of beauty, sentimentality, value, and so on are not static even within a specific society, such that the distinction between high art and kitsch drawn here would not be binding in the past, especially as regards issues of sentimentality evoked by the image.

32. Gell (1992b), 42.

33. Rotman (2009), 5-6; Gell (1998), 6-7.

34. M. Miles (1985), 27.

35. Argan (1975), 302.

36. Belting (1994), xxii. "Objects are meaningful not in their individual relations to human purpose, but in their collective consumption, their relations to other objects as a field of signifiers. Insofar, then, as religious commodities are to be understood as material things, they have two networks of signification in which they can act as markers of difference: first, with regard to other objects defined as religious, and second, with regard to the field of commodities as a whole" (Starrett [1995a], 53).

37. Schmitt (1993), 131-138.

38. For more on the concept of "corpothetics," see Chapter 5; cf. Pinney (2004), 194-200.

39. Morgan (1998), 33.

40. Mitchell (1986), 90-91.

41. Cutler (2001), 250. In addition to Bourdieu and his ideas of habitus as a set of dispositions that shape and are shaped by the individual, other scholarship on the concept of ritual also bears on the present discussion. Catherine Bell has pointed out that many modern scholars of religious behavior have categorized ritual as integrating two irreducible

symbolic aspects, "the conceptual (worldview) and the dispositional (ethos)," which would suggest that ritual practices actually hold meaning to the scholarly observer, not to the practitioner herself or himself (Bell [1992], 31). Stanley Tambiah has also argued for a sedimentation of meaning in ritual, in that the components of ritual create a context of "ritual involution" in which the repetitive nature of rituals serves as a replica of each previous enactment back to the purported first act that they commemorate (Tambiah [1979, rpt. 1985], 123–166). Stated differently, each ritual enactment involving the use of visual and material objects is connected in a syntagmatic chain of almost identical links going back to that prototype, such that each enactment mimics the prototype sufficiently for the signification it derives from the original to be apparent to the participants. For Bourdieu's influential concept of habitus, see Bourdieu (1977, rpt. 2006), 72ff.; and Bourdieu (1990), especially the third chapter.

42. St. George (1998), 3–4.
43. Mitchell (1986), 31, italics in the original.
44. Belting (1994), 3.
45. Rotman (2009), 271, note 7.
46. Brown (1997), 98.
47. Ibid., 71–73.
48. Ibid., 65, 73, 98.
49. Rotman (2009), 179–180.
50. Ibid., 179–180; 273, note 16.
51. See Chapter 10 for a discussion of popular images of saints. Norman Bryson explicates the distinction between narrative and iconic art using the example of a stained-glass window in the apse of the Canterbury Cathedral: "By the 'discursive' aspect of an image, I mean those features which show the influence over the image of language—in the case of the window at Canterbury, the biblical texts which precede it and on which it depends, the inscriptions it contains within itself to tell us how to perceive the different panels, and also the new overall meaning generated by its internal juxtapositions. By the 'figural' aspect of the image, I mean those features which belong to the image as visual experience independent of language—its 'being-as-image.' With the window this would embrace all those aspects as we can still appreciate if we have forgotten the stories of the Grapes of Eschol and of the last plague of Egypt, or are not at all familiar with the technique of 'types' and 'antitypes,' but are nonetheless moved by the beauty of the window as light, colour, and design'" (Bryson [1981], 6).

52. Starrett (1995a), 59.
53. Mitchell (1986), 113.
54. Baudrillard (1994), 5; Camille (1989), 350.
55. Mitchell (1986), 158.

1. Representation, Resemblance, and Religion

Epigraph: Lewis Carroll (1971), *Alice's Adventures in Wonderland,* Norton Critical Edition, ed. D. J. Gray, New York, Norton and Co., 55-56.

1. Camille (1989), 42-44.
2. Gadamer (1989), 143, 153, and more generally 134-159.
3. Danto (1999), 215-216.
4. Barthes (1981), 5.
5. Janowitz (2002), 101-102.
6. Distinctions between figurative and nonfigurative dominate aspects of Oleg Grabar's thinking, for example: "a nonfigurative art, even if the nonfigurative aspect is not total, contains ipso facto an arbitrary element that somehow escapes the normal rules of communicating a visual message (O. Grabar [1973], 100). Gonzalez, despite her sophisticated use of semiotic methodologies, seems to take a narrow view of the nature of mimetic art when she says: "Art imitates but cannot reproduce nature and it is neither possible nor legitimate to attempt to interchange the two. Indeed, as we know, mimetic art was never really customary in Islam after the formative period under the Umayyads" (Gonzalez [2001], 41). Such formal distinctions between figurative and nonfigurative representations, or between iconic and noniconic or aniconic representations, are not limited to art historians of course, nor to studies of Islam. In his landmark investigation of the role of images in early Judaism, Tryggve Mettinger (1995, especially pp. 21-22) relies heavily on such a differentiation, using the distinction between iconic and aniconic representation as the basis of an otherwise sophisticated semiological classification system.
7. Mettinger refers to the first category as "material aniconism" and the second as "empty-space aniconism," 19.
8. Camille (1989), 205.
9. Kitzinger (1954), 146.
10. Morgan (1998), 38-39.
11. Ibid., 43.
12. For a detailed study of the role of tradition and systems of change in the representation of Hindu gods in modern poster art, see Pinney (2004) and Jain (2007).

13. Babb (1981), 393; Pinney (2004), 192. The tactility of the visual senses in *darshan* bears some resemblance to medieval Islamic theories of vision, which are discussed in Chapter 6. For a brief introduction to the concept of *darshan*, see Eck (1981).
14. Meister (1995), 193-194.
15. Davis (1997), 263.
16. Kinnard (1999), 43.
17. Rotman (2009), 184. For more on aniconism and representation in early Buddhism, see Tanaka (1998).
18. Gombrich (1971), 4-5.
19. Tambiah (1984), 204.
20. Ibid.; see also 4-5, 132.
21. Kinnard (1999), 26. In Mahayana monastic practice, as distinct from philosophical writing, the Buddha was believed to fully inhabit images, such that he was counted in monastic roll calls. For more on the continued presence of the Buddha in images, see Schopen (1990), 181-217; reprinted (1997) as chapter 12 in *Bones, Stones and Buddhist Monks: Collected Papers on the Archaeology, Epigraphy, and Texts of Monastic Buddhism in India,* Honolulu, University of Hawa'i Press.
22. Rotman (2009), 186.
23. Ibid., 182.
24. Kinnard (1999), 177.
25. Ibid., 179.
26. Brown (1997, 1998b).
27. Rotman (2009), 272, note 10.
28. Morgan (1998), 34.
29. Kinnard (1999), 43.
30. For a study and examples of Iranian coffeehouse paintings, see Seyf (1990). For more on Hajj paintings, see Chapter 10. Storytelling and entertainment are, of course, not mutually exclusive categories; there is also a long-standing tradition of shadow-puppetry in many Middle Eastern and Balkan Islamic societies, in which the puppets occupy an interesting, if unstudied, representational semiotic space (see Saad [1993]).
31. Soucek (1988), 193-209. The argument for a religious context to the images in *Kitāb al-aghānī* is made in Farès (1946), 1-4, i-iii; this view is countered in Rice (1953), 128-135. Much of the debate on early religious imagery in Islamic society continues to be hampered by outdated notions of categorizing images as religious or not.
32. There are many books and catalogs that reproduce paintings depicting Muhammad as well as other religious subjects. For reproductions

of albums with paintings of Muhammad's life, see Séguy (1977), Tanındı (1984), and Gruber (2010a). For examples of paintings depicting other religious figures in addition to Muhammad, including previous prophets and Sufi saints, see Uluç (2000), 569-602.

33. For an introduction to the place of figural art in Islamic society, see Barry (2004), especially chapter 2.

34. Papadopoulo (1979), 56.

35. Leaman (2004), 167.

36. Grabar (1977), 50-51; al-Maqrizi (1869 rpt.), 2:318.

37. For more on Hurufism, see S. Bashir (2005), *Fazlullah Astarabadi and the Hurufis*, Oxford, UK, Oneworld Publications. For examples of Hurufi and Hurufi-inspired images, see Aksel (1967), especially pp. 106-109.

38. Kappeler (1986), 3.

39. Brubaker (1989b), 27.

40. Gadamer (1989), 143.

41. Pinney (2004), 190.

2. The Icon and the Idol

Epigraph: W. J. T. Mitchell (2005), *What Do Pictures Want? The Lives and Loves of Images*, Chicago, University of Chicago Press, 30.

1. Barasch (1992), 52.

2. "O father, never will I come as an assistant to the mice in trouble, since they have done me many ills, having befouled my garlands, and lamps, for the sake of the oil. But this thing, such as they have done, has particularly eaten into my soul, they have nibbled away a garment, which I had worked with my own toil, and they have made holes in it. But the weaver presses me, and demands usury of me, [and] on this account I am worn out. For having borrowed, I worked it, and have not the wherewithal to pay back. But even thus I shall not be willing to aid the frogs ... but yesterday ... when I was very tired, and wanted to sleep, they, making a noise, would not suffer me to close my eyes even for a minute, and I lay sleepless with a headache, until the cock crowed" (Buckley [1869], 344); Barasch (1992), 54.

3. Bryce and Campbell (1871), 291 (Book VI, chapter 16); Barasch (1992), 55-56.

4. Bryce and Campbell, 291 (Book VI, chapter 16); Barasch (1992), 56.

5. Gell (1998), 124, from E. Bevan (1940), *Holy Images*, London, George Allen and Unwin, 34.

6. Barnard (1974), 82.

7. "One should not object that it would have been better not to erect before men any statue or any image of the gods on the pretext that we should turn our eyes only towards heavenly things. These things, that are above, every being endowed with reason adores, every man who believes in the blessed gods, even though he only sees them from afar. But thanks to that desire which draws us to the divine there is in all men a passionate longing to honour and serve the divinity, to draw near to it, to lay hold upon it with assurance, to bring to it sacrifices and garlands. Just as little children separated from their father and their mother long for them, need them sorely and often in their dreams stretch out their arms towards them in their loneliness, so men, who rightly love the gods for their benefits towards them and because of the kinship which unites them to the divine, desire in every way to be in their presence and to company with them" (Barnard [1974], 82-83).

8. Baynes (1955), 130, note 2; Barnard (1974), 83.

9. Barnard (1974), 85.

10. Brubaker (1989a), 61-62.

11. Ibid., 65-66. The same point was made by Nikephoros in very similar words.

12. Bland (2000), 149.

13. Ibid., 62.

14. His rebuke of William, Abbot of St. Thierry, was worded as follows: "I say nothing of the vast height of your churches, their immoderate length, their superfluous breadth, the costly polishings, the curious carvings and paintings which attract the worshipper's gaze and hinder his attention, and seem to me in some way to imitate ... the ancient Jewish rite" (Bland [2000], 65).

15. Bland (2000), 59-60.

16. Mettinger (1995), 16.

17. Ibid., 24-25.

18. Bland (2000), 61.

19. Colson and Whitaker (1929; rpt. 1968), 475; Wolfson (1948), 1:29-30, note 22.

20. Bland (2000), 106.

21. Ibid., 131. For Rashi and other Jewish scholars' discussion of the Golden Calf and its problematic associations with idolatry, see pp. 116-129. This is, of course, in complete contradiction of the polemical Christian view, according to which Jews were transformed into devilish bodies for the sin of having worshipped the calf.

22. Barnard (1975), 8.

23. Bland (2000), 115.

24. Ibid. There are undoubtedly similarities between the development of the attitude toward images among Jews from the Second Temple and medieval periods and their Muslim counterparts. However, the Islamic and Jewish attitudes toward images have departed from each other in significant ways in the subsequent centuries, understandably so because of the different historical and social trajectories of the two faith communities.

25. Compare this to a description of idolatry found in a work of anti-Christian polemic written by a Muslim around the ninth century CE: "a nation *(umma)* which had not previously been given a scripture or a prophet; sunk in an ignorance *(jāhiliyyīn fī jahāla)* in which it was unaware that there is a Lord and reckoning after death; on the wrong path and given to creating falsehoods; its people were enemies one to another and in mutual hatred; disobedient to God and lacking in fear of Him; worshipping idols and eating carrion and blood; allowing what should be prohibited, rejecting the right path and complacent in error; its people killing one another and shedding their own blood; disregarding the prohibited degrees in matters of sexual relations; heedless of ties of kinship; causing harm to its own children and . . . in the worst evil. Thus it remained until God sent them this Prophet" (Sourdel [1966], 25, 32; English translation from Hawting [1999], 99). A similar passage—without the reference to harming children—is found in Ibn Hisham's biography of the Prophet: "Ja'far b. Abū Tālib answered: O King, we were an uncivilized people, worshipping idols, eating corpses, committing abominations, breaking natural ties, treating guests badly, and our strong devoured our weak" (Ibn Hisham [1955a], trans. Guillaume, 151 [original folio 219]).

26. Mettinger (1995), 195.

27. J. Ries (2005).

28. Barnard (1974), 81.

29. Camille (1989), 9.

30. Ibid., 115. The immensely popular *Golden Legend (Aurea Legenda)* has saints destroying idols in a number of ways: some use the power of the Word, others miracles like gusts of wind, while Saint Felix used his mind: "He destroyed every image to which he was led by breathing upon it. The priest of the idols came to him and said 'Lord bishop, my god has fled at the sight of thee, saying that he could not bear thy holiness'" (Camille 1989, 120, note 72).

31. Gabrieli (1969), 148-149. For more on Muslim iconoclasm and the impact of the crusades, see Jacoby (1992), 13-24.

32. Camille (1989), 233.

33. Tolan (2002), 105-106. See also Tolan (1999), 97-117.

34. The patriarch Germanus of Constantinople (d. 730) accused Muslims of litholatry in connection with the Ka'ba: "they, up to our own days, venerate in the desert an inanimate stone . . . which is called Khobar." A similar accusation is made by John of Damascus in his *Peri haireseōn,* where he claims that the stone represents the head of Aphrodite (Vasiliev [1956], 26-27).

35. Tolan (2002), 109.

36. Ibid., 118-119. Elsewhere, Muslims are described as engaging in idolatry in Solomon's temple, probably meaning the Dome of the Rock, which is cleansed by the crusaders in a massacre so great that the knights were riding with blood up to their knees. The *Gesta Tancredi* of Raoul glorifies Tancred for having destroyed the large silver idol of "Mahummet" in the temple, then melting down the precious metal (ibid., 119).

37. Ibid., 122. Muslim accounts of the Temple of Somnath describe the idol as suspended in the air with the help of magnets (see Chapter 4). This naturalistic explanation for a magical or miraculous phenomenon is found as far back as the fourth century in Rufinus of Aquilea's account of the Serapis of Alexandria (cf. Tolan [1998], 53-72; Eckhardt [1949], 77-88). The construction of Saracen idolatry as "anti-Christianity" is pervasive in the *Chanson d'Antioche;* the poem provides a detailed account of an embassy to "Mieque," which is home to a golden idol of Mahomes and is ruled over by three brothers with a religious parliament presided over by the "Apostle Califes of Bauda" (Baghdad, perhaps). The Saracens have used magic to make a demon named Sathanas reside in the idol, and it speaks to them about their superiority over the Christians, after which the "Apostle Califes of Bauda" declares a "rich pardon that Mahons will give us," a clear parallel to the indulgences granted to the crusaders by Urban II (Tolan [2002], 122).

38. Tolan (2002), 125.

39. Camille argues that, in the case of pagan antiquity at least, idolatry lost its negative connotations in the *chansons de geste:* "In this realm of texts and images, pagan antiquity and Islam were not subject to denigration but were rather sources of inspiration for writers and artists. It is significant that the same exotic practices of idolatry described so negatively in historical writing and in the epic tradition, should, in the newer genre of romance, lose their sinister implications and take on the glamorous

garb of the fantastic. In romances set in the ancient world of pagan Rome and in the mysterious East, the gods appear as neutral magical intercessors in human affairs, and the idols have a much more poetically suggestive role to play in the narrative" (Camille [1989], 242).

40. Ibid., 71.

41. Cameron (1994), 209. The forging of documents became such a widespread and recognized problem during this period that the Council of Hierea relied exclusively on books and not on *florilegia* (collections of excerpts purported to be from prominent religious figures) (ibid., 205); Brubaker (2010), 331.

42. Brubaker (2010), 323. For a comprehensive history of Byzantine iconoclasm, see Brubaker and Haldon (2011).

43. Cameron (1992), 2–5; Cameron (1994), 199.

44. Cameron (1992), 33; Cameron (1994), 212.

45. Brubaker (2010), 328; Brubaker and Haldon (2011), 94–105.

46. John of Damascus (Saint) (1980; rpt. 2002); Barasch (1992), 185–253. John of Damascus is widely viewed as the first Christian author to treat Muslim doctrine and practice seriously. This distinction is better deserved by Anastasios of Sinai, who anticipated John by approximately fifty years and who referred to Muslim ideas concerning Jesus in his *Hodegos,* or *Viae Dux* (Griffith [1987], 341–358).

47. The Patriarch Germanus was deposed and declared "anathema" at this council as a "worshipper of wood" (Vasiliev [1956], 27; Brubaker [2010], 330–331).

48. Vasiliev (1956), 31–33.

49. Kitzinger (1954), 89–90.

50. Ibid., 90–91.

51. Brubaker and Haldon (2011), 9–29, 531–572.

52. Kitzinger (1954), 122–123.

53. Ibid., 86–87.

54. Ibid., 96. The first pilgrim in Palestine to mention explicitly the veneration of images is Antoninus Piacenza (ca. 570 CE), who reported that there was a picture of Jesus, said to have been painted in his lifetime, in the Praetorium of Pilate (ibid., 97).

55. Cameron (1992), 5. The icons of St. Catherine's monastery in Sinai representing the Virgin and Child as well as Christ Pantocrator and St. Peter are the best examples of images from this period.

56. Kitzinger (1954), 98.

57. Cameron (1992), 2. Kitzinger has the phrase as "so that we may perceive through it the depth of the humiliation of God in the World and be

led to the remembrance of His life in the flesh, His Passion and His death, and of the redemption which it brought to the world" (Kitzinger [1954], 121).

58. Kitzinger (1954), 107.

59. Ibid., 112.

60. The first known text dealing directly with theoretical questions related to images is a letter written by Bishop Hypatius of Ephesos to his suffragan, Julian of Atramytion, in the first half of the sixth century (Kitzinger [1954], 135).

61. Ibid., 137.

62. Barnard (1974), 93-94; Kitzinger (1954), 137-138. Issues of the relationship between physical objects and the prototypes they might represent are dealt with in Chapter 8 with reference to Sufi metaphysics, which bears more than a passing resemblance to the concepts explored by Pseudo-Dionysius.

63. Kitzinger (1954), 139-140.

64. Ibid., 142. For an overview of the place of icons in the theology of the Orthodox Church, see Ouspensky (1992).

65. Brubaker (1989a), 40.

66. Kitzinger (1954), 137.

67. Barnard (1974), 47.

68. There seems to be little evidence that Leo III was actually influenced directly by any Muslim attitudes toward images. See Barnard (1981), 29-37. The notion of a Semitic iconophobic "germ" is found in a number of works including an important early essay on Islam and the religious image by Marçais in which he states that Arabs are not capable of observing nature and were not suited to the observation and creation of objects of "fictions vivantes" (Marçais [1932], 161-183). Besançon acknowledges that Jewish and Muslim opposition to images might not derive from the same source, but he is reductive in his analysis nonetheless: "For Islam, it is God's insurmountable distance that renders impossible the fabrication of an image worthy of its object; for Judaism, it is God's intimate familiarity" (Besançon [2000], 2). Such teleological caricatures of "Semitic" attitudes toward images are, in fact, commonplace. According to Hegel, the supposed Jewish and Muslim lack of images is a sign of those religions' adherents' inability to think or worship abstractly: ". . . everything genuine in spirit and nature alike is inherently concrete and, despite its universality, has nevertheless subjectivity and particularity in itself. Therefore the Jews and the Turks [sic] have not been able by art to represent their God, who does not even amount

to such an abstraction of the Understanding, in the positive way that the Christians have. For in Christianity God is set forth in his truth, and therefore as thoroughly concrete in himself, as person, as subject, and, more closely defined as spirit (Hegel [1975], 1:70).

69. Barnard (1974), 38.

70. Ibid.; for a detailed treatment of the role of Leo III, see Brubaker and Haldon (2011), chapter 2.

71. Barnard (1974), 41–42.

72. Vasiliev (1956), 27–28. The Islamic accounts of Yazid's edict are embellished over time, most likely reflecting influence from Christian understandings of the importance of the dictate. Al-Kindi does not make it clear that the images in question are Christian, but writing five centuries later, al-Maqrizi explicitly states that Yazid II ordered the destruction of churches, crosses, and Christian images (ibid., 39).

73. Ibid., 30–31. For more on the influence of supposed Semitic iconophobia on iconoclastic Byzantine emperors, see Barnard (1981).

74. For more on the relationship between the Byzantines and Muslims during this period, see Kennedy (1992), 133–143; El Cheikh (2004). As von Grunebaum points out, not only did Muslim antagonism toward images deepen as time went on and was not especially strong in the eighth and ninth centuries, but an anti-image attitude existed within the Byzantine church long before Islam emerged (von Grunebaum [1962], 1–10). For more general information on Christians under Islamic rule, see Griffith (2008).

75. For a detailed study of this important actor in the early developments of Christianity under Islamic rule, see Lamoreaux (2005).

76. Among the many examples of conscious translation by Muslims of things with significance in Christianity is the figure of John the Baptist, whose relics and the iconography associated with him are important signifiers deployed to mark the religious and political ascendency of Islam relative to Christianity (see Khalek [2011], 111–119).

77. Welch (1977), 66–67.

78. Grabar (1973), 105.

79. Griffith (1990), 250.

80. Griffith (1985), 56. See also Griffith (1990).

81. Ibid., 68.

82. Ibid., 61.

83. "If there is any Christian opposed to making prostration to [the image of Christ], I would like an image of his father to be painted by the door of the Church of the image of Christ. I would then invite everyone

who makes prostration to the image of Christ, when he comes out from its presence, to spit in the face of the image of the father, especially if his father was the one who bequeathed it to him that he should not make prostration to the holy image—until I see if he gets angry or not" (ibid., 59).

84. St. Thomas Aquinas (1920; online ed. 2008). Aquinas distinguishes between three relative degrees of veneration that depend on the object: the crucifix—as the most exalted sign—demands *latria*, representations of Jesus in human form require *hyperdulia*, and images of saints, *dulia*.

85. Camille (1989), 205.

86. Ibid., 347.

87. Kaufman (1995), 128.

88. Camille (1989), 347.

89. Luther (1970, ed. Lehman), 178-179.

90. Michalski (1993), 2-3.

91. Quoted from ibid., 5.

92. Ibid., 6. The *foris/intus* opposition between invidious idolatry of intention that is harbored in the heart and the more pedestrian idolatry of the idolaters is also found frequently in Muslim writings which emphasize purity of intent over that of action as the benchmark of true belief.

93. Ibid., 15.

94. Luther (1958, trans. Bergendoff), 40:91; German original Martin Luther (1957), *Ausgewählte Werke*, ed. S. S. Borcherdt and G. Merz, Munich, Chr. Kaiser Verlag, 4:78-81.

95. Luther (1958), 40:99-100.

96. Garside (1966), 76-87.

97. Calvin (1989, trans. Henry Beveridge), 1:100. For more on the iconoclasts of the Protestant Reformation, see Michalski (1993), especially pp. 443-474. For Protestant attitudes toward visual religious art before the nineteenth and twentieth centuries more generally, see Belting (1994), particularly chapter 20; Eire (1986); and Christensen (1977).

98. Morgan (1998), 55.

99. Ibid., 183.

100. Ibid.

101. Ibid., 192-194.

102. Ibid., 195.

103. Cameron (1994), 211-212; Brubaker (1989a), 32.

104. Brubaker (1989b), 26.

105. Anastos (1954), 153.

106. Brubaker (1989a), 34.

107. Anastos (1954), 153–154.

108. Ibid., 158.

109. Ibid., 155.

110. Ibid.

111. Brubaker (1989b), 31.

112. Ibid., 32.

113. Ibid., 20–24.

114. Quoted in Brubaker (1989b), 25 (square brackets are from Brubaker). Cf. Barber (1993), 7–16, who argues that the end of the iconoclastic period saw a separation of acts of worship from the notion of art, and therefore marked a beginning of viewing Byzantine images as art objects.

115. Brubaker (1989b), 26. Cf. Pentcheva (2006), 631–655, who emphasizes that the icon was perceived not just visually but *synesthetically*, that is, by the whole body through the use of multiple senses.

116. Brubaker (1989a), 25–26.

117. Ibid., 33, note 33; (1989b), 27, note 38 [Mansi XIII, 244B, 4–6, from the *Acts of the Ecumenical Council* of 787]; English trans. from Sahas (1986), 77. Another source commenting on the Second Council of Nicaea states that "the image of Christ was not honored as a god but as a stimulus to higher effort through the thought of the incarnation" (Barnard [1974], 47).

118. Brubaker (1989a), 34. For more of John's statements concerning images, see St. John of Damascus (1980, rpt. 2002).

119. Brubaker (1989a), 34–35. Nickephoros's argument constitutes a refutation of the equation of the painting of a thing with its circumscription—in this understanding of mimesis, *resembling* a thing does not mean the same as *being identical* to it.

120. Ibid., 59; Brubaker and Haldon (2011), 260–276.

3. Iconoclasm, Iconophobia, and Islam

1. A concern with Muslim as well as Jewish criticism of Christians is found in some of the earliest documents dealing with Christian image veneration, specifically in a letter from the patriarch Germanos to Thomas of Kaludioupolis, in which the patriarch condemns Thomas for removing icons from his church, and accuses him of providing an opportunity to the Muslims and Jews to slander the church (Brubaker [2010], 324; see also Crone [1980], 59–95).

2. Brubaker (2010), 327.

3. Von Grunebaum is one of the earliest scholars of Islam to point out that Byzantine iconoclasm substantially predates the rise of Islam, and also

to argue that the Jews themselves were using pictorial representations in the sixth century, thereby disproving any alleged Semitic predisposition against the use of images (von Grunebaum [1962], 4).

4. Sourdel (1966), 17, 25, 33, 34; translation quoted from Hawting (1999), 83.

5. Hawting (1999), 84-85.

6. Ibn Abi Usaybi'a (1981), 2:153-154. See also La'ibi (2001), 48-49.

7. Ibn Abi Usaybi'a (1981), 2:155-156.

8. Ibid., 2:148-149.

9. Gregorious al-Malati, better known as Ibn al-'Ibri or Bar Hebraeus (d. 1286) (1958), 145; see also La'ibi (2001), 48.

10. Brubaker (1989a), 38.

11. Al-Dinawari (1960), 18-19.

12. Ibid.; Grabar and Natif (2003/4), 23-24. Another early version of the account dates from the last decade of the ninth century and is found in Ibn al-Faqih's *Kitāb al-buldān*, where it appears in the section on Byzantium. Ibn al-Faqih does not mention the name of the emperor and lacks many of the details found in the accounts of al-Dinawari and later authors (Ibn al-Faqih [1996], 187-189).

13. Brinner (2002), 447; al-Tha'labi (1985), 266; Grabar and Natif (2003/4), 27, note 38.

14. Al-Kisa'i (1978), 82.

15. Al-Isfahani (1970), 1:59-64; al-Bayhaqi (1985), 1:386-390. An account of the mission to Heraclius that omits the description of an image of the prophet is found in both Guillaume's translation of Ibn Hisham (1955a) (652-659) and al-Tabari (1985) (98-115). Grabar and Natif's treatment of this celebrated event is misleading and somewhat convoluted: in Ibn Ishaq's version as well as that of al-Tabari (who relies on Ibn Ishaq), the envoy to Heraclius is not Hisham ibn al-'As al-Umawi but one Dihya ibn Khalifa al-Kalbi al-Khazraji. Neither of these versions have any mention of an image of the Prophet on a cube or fabric or otherwise; they simply recount the mission and the letters exchanged.

16. Grabar and Natif (2003/4), 20; al-Bayhaqi (1985), 1:387. This story has been studied from a historical perspective by several authors, perhaps the most important treatment being El Cheikh (1999), 5-21.

17. Al-Isfahani (1970), 1:60; al-Bayhaqi (1985), 1:388; Grabar and Natif (2003/4), 20-21. The remaining compartments contain images of Moses, Aaron, Lot, Isaac, Jacob, Isma'il (whom Heraclius refers to as "the ancestor of your prophet"), Joseph, David, Solomon, and Jesus, some of whom are wrapped in black silk, others in white. Al-Bayhaqi claims that Noah's hair was like that of cats *(qitat),* but this is most likely a misreading of

the word "Copt" *(qubt)* in al-Isfahani's account. Cf. the versions of this event according to Ibn Ishaq and al-Tabari, in which Heraclius simply says, "You know, by God, that this man is a prophet who has been sent. We find him in our book. We know him by the description whereby he has been described to us" (al-Tabari [1985], 8:106).

18. Al-Isfahani (1970), 1:62; al-Bayhaqi (1985), 1:390.

19. Al-Isfahani (1970), 1:54-55; al-Bayhaqi (1985), 1:384-385; Grabar and Natif (2003/4), 22. The similarity between al-Bayhaqi and al-Isfahani's versions of the story are discussed in Schimmel (1985), 32-34; and Asani (1995), 64-65. Al-Bayhaqi (1985) provides another version in which a Meccan merchant is taken to a house, rather than a monastery, where he is shown paintings of Muhammad.

20. Al-Maqrizi (1991), 3:25; Grabar and Natif (2003/4), 28.

21. Grabar and Natif (2003/4), 30; Thackston (2001), 11.

22. Al-Mas'udi (1965), 1:169-170 (paragraph 345); Grabar and Natif (2003/4), 25.

23. Grabar and Natif (2003/4), 28. The role of these stories in justifying the religious and political legitimacy of Islam is discussed in Miquel (1975), 458-461.

24. Grabar and Natif (2003/4), 26.

25. For more on the Christian emotional response to icons, see Brubaker (1989a) and (1989b).

26. Sachau (1888; rpt. 2005), 1:111; see Chapter 4 of this book for more discussion.

27. Al-Aflaki al-'Arifi (1976), 1:425-426; Soucek (2000), 102-103.

28. Al-Aflaki al-'Arifi (1976), 1:552-553. At the end of the story, 'Ayn al-dawla repents and becomes a Muslim.

29. For more on the interaction between Muslims and Christians in medieval Anatolia, see Ocak (1985) and Wolper (2003).

4. Idols, Icons, and Images in Islam

Epigraph: Mawlana Jalal al-din Rumi (1925; rpt. 1986), *Mathnawī-yi ma'nawī*, edited by R. A. Nicholson, Tehran, Intishārāt-i Mawlā, 1:178. Translated by the author.

1. For more on the concept of *jāhiliyya* in Islam, see Goldziher (1967), 1:201-208 (orig. 1888-1890, 1:219-228).

2. For more on the concept of *shirk* and of terms relating to heresy, see Lewis (1953), 1:43-63, and Hawting (1999), 48-50.

3. Cf. Qur'an 6:74, 7:138, 14:35, 21:57, 26:71, and 29:2. Ibn al-Kalbi draws a distinction between idols referred to as *asnām* and *awthān*, but this dif-

ference does not appear to be maintained in other writings (Ibn al-Kalbi [1964]; Ibn al-Kalbi [1969]).

4. Cf. Qur'an 2:257, 4:51, 4:60, 4:76, 5:65, 16:36, and 39:17.

5. Hawting (1999), 49 (the author provides no reference for this account).

6. Yaqut ibn 'Abd Allah al-Hamawi (1993). References to the *Kitāb al-asnām* are found throughout Yaqut's work; a convenient source that brings them together is Wellhausen (1897), especially pp. 10-13. The *Kitāb al-asnām* was not entirely unfamiliar to Muslim scholars in the medieval through early modern periods, for several of them drew extensively from this work. Most significantly, Ibn al-Jawzi (d. 1200) abridged it in his *Naqd al-'ilm wa'l-'ulamā'* [= *Talbīs Iblīs*], and 'Abd al-Qadir al-Baghdadi (d. 1682) reproduced its principal contents in his *Khazīnat al-ādāb wa-lubb lubāb lisān al-'arab* (Ibn al-Kalbi [1969]: xii). Other early works that mention the idols of pre-Islamic Arabia include *al-Sīra al-nabawiyya* of Ibn Hisham ([1955a], 24, 35-40, 176, 207-208, 565-566, 775-776; and [1955b], 1:47, 76-89, 384, 452-453; 2:436-437, 427; Ibn Habib (d. 859) (1942), 309-318; and Ibn Hazm (d. 1064) (1962), 491-494.

7. For discussions of the origin and composition of the text, see Nyberg (1939), 346-366, and Hawting (1999), 89-92. See also Al-Tawil (1993).

8. Ibn al-Kalbi (1964), 33; cf. al-Azraqi, who claims that travelers would prostrate themselves in front of the idol of Hubal in the Ka'ba and circumambulate it before departing on a journey (1978), 1:117.

9. Ibn al-Kalbi (1969), 4-5.

10. al-Mas'udi (1965), 1:173-174, 371 (paragraphs 962-964, 1372); 2:204; Ibn al-Kalbi (1964), 8, 13, 50.

11. Ibn al-Kalbi (1964), 9, 29-30; al-Azraqi (1978), 1:119-120.

12. al-Azraqi (1978), 1:122.

13. Ibn al-Kalbi (1964), 42.

14. Ibid., 38-40, 48; Ibn al-Kalbi (1969), 42. Cf. also Hoyland (2001), 152; Bellamy (1951), 234.

15. Ibn al-Kalbi (1964), 36-37, and (1969), 32. A similar story is told of the god Su'ayr belonging to the 'Anazah tribe (Ibn al-Kalbi [1969], 35).

16. Ibn al-Kalbi (1964), 20-21. This allegation is reminiscent of passages in the Wisdom of Solomon (13:10-13) and Isaiah (44:9-12) that speak of a person who uses part of his piece of wood to make a fire for cooking and part to make an idol for worship (Hawting [1999], 105).

17. Ibn al-Kalbi (1964), 18, 27.

18. Ibid., 24-26; Ibn al-Kalbi (1969), 21-22; *al-'uzzā* literally means "most venerated" or "most cherished"—there is a play on words in this statement attributed to Muhammad.

19. Ibn Sa'd (1904), vol. I, pt. 2, 49. For more examples of the humiliation of idols and their subsequent abandonment by their worshippers, see Lecker (1993), 333, 336, 338, 339-340.

20. Ibn 'Uqba (1994), 310-313. Cf. Ibn Hisham (1955a), 616-617, and (1955b), 1:540-542, where Mughira destroys Allat (perhaps al-Rabba); al-Waqidi (1966), 3:972; and Hawting (1999), 107, note 56.

21. Ibn Hisham (1955a, trans. Guillaume), 45, 62-64, 66-68, and (1955b), 1:110-111, 142-143, 151-155; al-Azraqi (1978), 1:117; the name of 'Amr ibn Luhayy is only mentioned in Ibn al-Kalbi's *Book of Idols* ([1969], 6-7). Hawting states, on the authority of Ibn Hisham and al-Azraqi, that the idol's name was Hubal, but this does not appear in the reference he cites (Hawting [1999], 22).

22. Ibn Hisham (1955a), 35-36, and (1955b), 76-78; al-Azraqi (1978), 1:116; Ibn al-Kalbi (1969), 4-5; Hawting (1999), 24-25.

23. Al-Azraqi makes this identification in the context of describing the arrival of idols in Mecca: "The Prophet said that ['Amr b. Luhayy] was the first who ... set up idols around the Ka'ba and changed the *hanīfiyya*, the religion of Abraham" (al-Azraqi [1978], 1:117-119, translation from Hawting [1999], 36).

24. Ibn al-Kalbi (1969), 4-5; al-Azraqi (1978), 1:116.

25. al-Azraqi (1978), 1:123.

26. Ibn al-Kalbi (1964), 31.

27. Ibid., 23.

28. Hawting (1999), 68-69; al-Waqidi (1966), 841-842; see also al-Azraqi (1978), 1:122-123. See Hawting (1999), chapter 3, for a discussion of parallels between Muslim accusations of *shirk* and similar phenomena in Judaism and Christianity. There are several studies of contexts in which charges of idolatry were leveled against Christians, Muslims, and Jews, some of which are discussed elsewhere in this book.

29. Ibn Hisham (1955a), 36-37, and (1955b), 1:80-81; Ibn al-Kalbi (1964), 43. On the idol 'Umyanis, cf. Goldfeld (1973), 108-119.

30. The inscriptions in question most likely date from the time of the Dome of the Rock's construction at the command of 'Abd al-Malik in 691. See O. Grabar (1959), 52-58; Kessler (1970), 2-4. See also Max van Berchem (1894), *Matériaux pour un corpus inscriptionum arabicarum*, 3 vols., Cairo, L'Institut français d'archéologie, 223-371.

31. al-Mas'udi (1965), 2:253-254 (paragraphs 1123-1126). Al-Shahrastani has a very similar description, only with somewhat greater detail (al-Shahrastani [1982], 2:244).

32. al-Mas'udi (1965), 2:254 (paragraph 1125). For an analysis of al-Mas'udi's historiography, see Khalidi (1975).

33. Hawting (1999), 138.

34. Ibid., note 16. Cf. al-Waqidi, who talks about her head and calls her "the lady" *(al-Rabba)* (al-Waqidi [1966], 971).

35. Friedmann (1975), 214–215; al-Tabari (1965), 1:121; Ibn al-Kalbi (1969), 46–47; Ibn al-Jawzi (1948/49), 55–56; for the tradition on Indian Brahmins coming to Mecca, see Firishta (1905), 1:32.

36. Davis (1997), 54; see also Davis (1993), 22–48, and (1994), 151–177; and Flood (2009), 28–29. For a theoretically dense discussion of similar image appropriation and destruction in the ancient Near East, especially Mesopotamia, see Bahrani (1995), 363–382.

37. For useful discussions of the various categories of Islamic writings on India's wonders and religious practices, see (besides Friedmann [1975]), Lawrence and al-Shahrastani (1976), 17–32, and E. Rehatsek (1878–1880), 29–70. For the period after al-Biruni, see Jahn (1963), 185–197.

38. Al-Ramhurmuzi (1987) and (1980, trans. Freeman-Grenville). For other accounts of seafaring on the western coast of India, see Hourani (1995), 65–68. Accounts of the wonders of India are also found in Miquel (2001), especially pp. 116–132.

39. Al-Mas'udi (1965), 2:379–380 (paragraphs 1370–1371).

40. Ibid., 2:392 (paragraph 1392).

41. Ibid., 5:152 (paragraphs 3260–3261); Minorsky (1937; rpt. 1970), 347, note 21.

42. Al-Mas'udi (1965), 5:152 (paragraphs 3260–3261). The idol of the Kabul Shah was also said to have been displayed for three days in Mecca eighty years earlier, suggesting a formal or ritualized treatment of idols and perhaps even their disposal (Flood [2009], 31–32; Ibn al-Zubayr (1959), 44–45, and (1996, trans. al-Qaddumi), 88; al-Tabari (1992), 265.

 As Flood points out, the idol's nickname is not only denotative of its role as a *cause* of distraction but also of the very attention of which it became the focus. "The reception of this looted image thus opens up a space between the figurative and literal reduction of idolatry and its objects, pointing to more ambivalent and expansive practices of responses, which adumbrate the idea of the golden idol as a sign of fundamental incommensurability, lurching between adoration and denigration as it circulated from east to west" (Flood [2009], 37).

43. Al-Muqaddasi (2001, trans. Collins), 390.

44. For a brief and preliminary discussion of the distinction between monotheism and monolatry in Muslim contexts, see J. J. Elias (2010), "God,"

in *Key Themes for the Study of Islam,* ed. J. J. Elias, Oxford, Oneworld, 161–181.

45. Sachau (1888, rpt. 2005), I:III.

46. Ibid., I:III–112.

47. Ibid., I:112. Al-Biruni also claims that Romulus erected a monument to the sun; still alleged to be in Rome at al-Biruni's time, it comprised four images—each representing one of the elements—on four horses.

48. Ibid., I:112–113.

49. Friedmann (1975), 214.

50. Sachau (1888, rpt. 2005), I:116–117.

51. Ibid., I:122.

52. Ibid.

53. Ibid., I:124.

54. Gardizi (1968), 200–215; the chapter on India was translated into English by Minorsky (1948 [rpt. 1964]), 625–640; Friedmann (1975), 216. On one occasion, while referring to the practices of Indian idolaters, Gardizi says: "May God be exalted above what they say!" *(taʿālā Allāh ʿammā yaqūlūn).*

55. Minorsky (1948), 627–628.

56. Faqih-i Balkhi (1997), 46.

57. For the most likely sources of al-Shahrastani's description of Indian religions, see Lawrence and al-Shahrastani (1976), 17–29, and Lawrence (1973), 60–73.

58. Lawrence and al-Shahrastani (1976), 52.

59. Ibid., 221; see pp. 212–221 for a study of the relationship of al-Shahrastani's version of this narrative to those of Ibn al-Nadim, Gardizi, Marvazi, and al-Muqaddisi.

60. Al-Idrisi (1960), 10–11. Al-Idrisi's principal sources are the *Kitāb al-masālik waʾl-mamālik* of Ibn Hawqal (d. ca. 977) and the work of the same name by Abuʾl-Qasim ibn Khurdadhbih (d. 911), as well as several works from the "book of wonders" *(kitāb al-ʿajāʾib)* genre of Arabic literature (ibid., 12–18).

61. Al-Idrisi (1954), 23, and (1960), 37; Waardenburg (2004), 213, 224.

62. Al-Idrisi (1954), 25, and (1960), 39. A "sect" called the Barāhima served an important function for Muslim heresiographers as well as others, and it is likely that this religious group is constructed as a complete fiction, invented as a polemical foil demonstrating the superiority of prophetic religions (cf. Calder [1994], 40–51, and Stroumsa [1985], 229–241).

63. Al-Idrisi (1960), 49–50.

64. Ibid., 50.

65. Al-Qazwini (1848–1849b), 85–87.

66. Ibid., 63.

67. Ibid., 63–64.

68. For more information see Eaton (2000), 246–281.

69. Babur (1993), 3:728–729.

70. An illustration of Babur's visit to Urwahi shows the naked statues very conspicuously using their hands to cover their genitals in an interesting example of how subsequent accounts of the event carry Babur's disapproval to the next obvious step (Baburname, c. 1590, British Library, Or 3714, f. 478a, reproduced in J. M. Rogers [1993], *Mughal Miniatures,* New York, Thames and Hudson, 51). Cf. Baily (1931), 279–283.

71. Friedmann (1975), 214; al-Baladhuri (1956), 1:278; Sachau (1888, rpt. 2005), 1:124.

72. Bosworth (1984), 5–7. Al-Baladhuri and other writers describe the shrine of Zhun (or Shu-na) as "the Mecca of the local people, set on a hill, the *Jabal al-Zūn.* . . . The God's embodiment was an idol of gold, with rubies for its two eyes. Set up before the temple was the gigantic bone or vertebrae of some fish or monster. The cult was highly organized, with many priests who claimed magical and curative powers, and if occasion arose, maleficent and demoniacal ones" (from Bosworth [1984], 5–6).

73. Flood (2009), 37–38; Minorsky (1942), 49.

74. Stern (1955), 14–16; Halm (1996), 389; Flood (2009), 42, note 201.

75. Flood (2009), 35. For example, 'Ala' al-din Khalji (d. 1316) ordered the melting down of silver and gold vessels and their conversion into coinage at the same time as he had gilded porcelains and wine bottles smashed in front of the Badaun Gate of Delhi, the very place where, on occasion, Hindu images were tossed to be trampled upon by the people.

76. Ibid., 36

77. Ibid., 28.

78. Ibid., 36

79. Al-'Utbi (2008), 579; unpublished English translation by Everett Rowson; Flood (2009), 36.

80. Firishta (1905), 1:33. 'Attar included a section on Mahmud's destruction of the Temple of Somnath in his famous "Conference of the Birds" ('Attar [1963], 174–175, and [1984], 161–162). For more on Mahmud of Ghazna's role as an exemplary Muslim warrior and king, see Davis (1997), 96–102, and Bosworth (1966), 85–92.

81. Friedmann (1972), 177–178. Another account, *Al-Jumān fī akhbār al-zamān* by al-Shatibi, takes a critical note in stating that 'Abd al-Malik agreed to this policy out of a desire for money *(raghbatan fi'l-māl).*

82. Flood (2009), 28, note 93, from al-Tabari (1990), 194.

83. Ibn Zubayr (1959), 37, (1996, trans. al-Qaddumi), 83–84.
84. The thirteenth-century Delhi court historian Minhaj-i Siraj has a synthetic account in which Mahmud has the idol broken into four pieces, one of which was thrown in front of the palace, the second in front of the great mosque of Ghazna, and the other two sent to Mecca and Medina (Raverty [1881], 1:82; Davis [1997], 109).
85. Flood (2009), 34.
86. Stern (1949), 302, (1955), 23–24; Sachau (1888, rpt. 2005), 1:116.
87. Friedmann (1972), 176–177.
88. Ibid., 177.
89. Flood (2009), 277, note 123; also (2002), 650–651.
90. Flood (2009), 34.
91. Davis (1997), 109.
92. Flood (2009), 29–30. Other sources of the period refer to this artifact as a golden jewel-encrusted idol *(sanam),* wearing a crown and seated on a silver throne. It was sent to al-Ma'mun either by the Hindu Shahi ruler or by an anonymous "king of Tibet" as a recognition of his conversion to Islam. Flood suggests that the idol might have been the tutelary deity of the Kabul Shahs, which would explain the confusion between the throne and the crown in the sources. Al-Biruni speaks of gold and silver idols rather than monarchic symbols of a crown and throne (Sachau [1888, rpt. 2005], 1:57).
93. Ernst (2000), 107. Ernst emphasizes that the author sees the caves as a political product rather than one of the many minor curios he lists at the end of his book. Ernst also provides an interesting discussion of other Muslim visitors to the Ellora caves, not the least of whom was the Mughal Emperor Aurangzeb, somewhat unjustifiably notorious for being an avid destroyer of Hindu temples and idols. Aurangzeb describes the Ellora caves in a letter as a divine creation: "one of the wonders of the work of the true transcendent Artisan *(az ʿajāʾibāt-i sunʿ-i sāniʿ-i ḥaqīqī subhānahu)*" (ibid., 109).
94. Ibn al-Zubayr (1996), 98 (paragraph no. 65).
95. Ibid., 172 (paragraph no. 194).
96. Ibid., 238 (paragraph no. 403).
97. Ibid., 171 (paragraph no. 191), 177 (paragraph no. 208).

5. Beauty, Goodness, and Wonder

Epigraph: Walter Andrews, Najaat Black, and Mehmet Kalpaklı, eds. and trans. (2006), *Ottoman Lyric Poetry: An Anthology,* expanded edition, Seattle, University of Washington Press, 35.

1. This is not to say that medieval Christendom was completely lacking in theories of art, but that those that are known to have existed were concerned with theorizing practice and formal composition, not issues of emotion and expression (Eco [1986], 41).

2. Among the many anthropological critiques of scholarship that treats the concept of art as purely aesthetic and noncontextual, see Geertz (1976), 1473–1499; reprinted in Geertz (1983), *Local Knowledge: Further Essays in Interpretive Anthropology*, New York, Basic Books, 94–120.

3. Campbell (2001), 122; cf. Pinney, "Piercing the Skin of the Idol" in the same volume, 161–162.

4. Camille (1993), 43–44.

5. Cassidy (1993), 6–7.

6. Ibid., 7.

7. Thomas (2001), 4.

8. Campbell (2001), 123.

9. Behrens-Abouseif (1998), 131. Oleg Grabar has rightly noted that, in the absence of any real evidence of the ways in which a society affects the making of works of art, it is problematic to assume particular theoretical explanations for the place of the visual (Grabar [1992], 20).

10. Behrens-Abouseif (1998), 184.

11. Ibid., 131.

12. Necipoğlu (1995), 196–197.

13. Perhaps the best—or, at least, most accessible—discussion of Plato's ideas regarding visual aesthetics in the English language is by Iris Murdoch, and the following outline is largely drawn from her work.

14. Murdoch (1977), 5–6. Artists could conceivably also multiply the amount of goodness in the world but, according to Plato's logic in this context, it is easier to imitate a bad person than a good one because the former is more entertaining and dynamic. See also Besançon (2000), 37–52, for a discussion of Plato's critique of artists and images, together with those of other thinkers such as Aristotle, Cicero, and Plotinus. For more on aesthetics and philosophy in the Islamic world, see Mahdi (1980), 43–48.

15. Murdoch (1977), 32; Plato, *Republic*, X.599c.

16. Plato celebrates the form of beauty in the *Phaedrus* and the *Symposium*, and the form of good in the *Republic* where it is treated as a creative and enlightening first principle. "Though pure beauty has no moral message, the instinctive enjoyment of natural beauty is the mark of a good soul: the forms of natural beauty are spiritually superior to those of art" (Murdoch [1977], 19, 3).

17. Ibid., 17–18.

18. Ibid., 57; Plato, *Timaeus*, 68-69 (the mortal soul), 47c-d (on audition), 28a (on the eternal nature of the world). The *Timaeus* was to become one of Plato's best-known works in the Islamic world.

19. Murdoch (1977), 65.

20. Ibid., 9. Plato's *Laws* contains several sections on the didactic functions of art and games: 797b (on children's games), 657 and 799 (on music and song), 957d (the Laws as the ideal literary paradigm).

21. Lessing (1969), 63; cf. Mitchell (1986), 106, 111.

22. Cf. Camille (1989), 78, note 9. The notion of art for its own sake is not an invention of enlightenment thinking but plays an important part in medieval reactions to classical art, eloquently stated in the Theodosian Code (16.10.8 "Pagans, Sacrifices, and Temples"), which claims that images should be "measured by the value of their art rather than by their divinity" (Pharr, trans. [2001], 473; Geertz [1973], 111).

23. Efimova (1997): "Thus the modern science of aesthetics, understood as detached contemplation rather than instinctual cognition, functions as a form of anesthetization, a way for numbing the human sensorium, overwhelmed by the shock of war or the shock of industrialization" (162-163); Pinney (2001), 160; Camille (1989), 78-79. The labeling of modern aesthetics as anathetics is done by Susan Buck-Morss in her analysis of Benjamin's essay on the work of art (Buck-Morss [1992], 3-41).

24. Morgan (1998), 27.

25. Campbell (2001), 118.

26. Gell (1998), 3.

27. Mitchell (1986), 93.

28. Morgan (1998), 17-18.

29. Ibid., 26.

30. Ibid., 30.

31. Mitchell (1986), 151.

32. Ibid., 157-158.

33. Bourdieu (1993), 33, 50; Kinnard (1999), 49-50. For more on the importance of Bourdieu's concept of habitus as it pertains to the practice of life, see Bourdieu (1977; rpt. 2006), 72. The concept is developed further with reference to art and material culture in Bourdieu (1990), especially the third chapter. For a discussion of Bourdieu's theories with specific application to material culture in the Islamic world, see Elias (2011), 13-14.

34. Behrens-Abouseif (1998), 41. At the other extreme, attempts to find a universal Islamic aesthetic border on the ridiculous, as in the following assertion concerning nonvisual aesthetics: "In nonvisual arts the Mus-

lim prefers simple tunes over that of the symphony, for instance, whirl-ing dervishes over the ballet, and lyric poetry over dramatic literature" (Gocer [1999], 683).

35. Gonzalez (2001), 25.

36. For more on this issue see Sachiko Murata (1992), *The Tao of Islam: A Sourcebook on Gender Relationships in Islamic Thought*, Albany, State University of New York Press.

37. There are other words that appear in the Qur'an and early Muslim litera-ture that can mean "beauty," although they are not commonly used for this purpose. *Wasīm* refers to the physical beauty of human beings, while *malīh*, a more common word, carries the connotation of "delectable" or "tasty," since it literally refers to something to which salt has been added, something flavorful (Behrens-Abouseif [1998], 17). The question of what place ornament occupies in Islamic art is an important one that cannot be discussed at length in this book. Arguably, ornament represents the singular element of art that is endowed with the capacity of carrying beauty and conveying pleasure. It is also an important concept in Arabic literature and literary theory, where terms such as *naqqasha* ("to cover with decoration"), *zawwaqa* ("to embellish"), and *isti'āra* ("to use meta-phorically") signify distinct ideas concerning artistic and aesthetic prac-tice, all being positive in their judgment and implying the effective trans-fer of meaning from one form to another (O. Grabar [1992], 25-26, 222).

38. Muhammad was said to be the most beautiful of God's creations with the nicest face, which looked like the moon, or alternatively as if the sun shone across it (Ibn al-Qayyim al-Jawziyya [2008], 275, 273-274; several other works provide variants on the same theme).

39. *Munāsib li'l-nafs al-mudrika fa-taltadhdhu bi-idrāk mulā'imihā* and *kamāl al-munāsaba wa'l-wad' wa-dhālika huwa ma'nā al-jamāl wa'l-husn fī kull madrak* (Ibn Khaldun [n.d.], 423-428, chapter on singing [*fī sinā' al-ghinā*]); Behrens-Abouseif (1998), 38, note 65.

40. Ibn Khaldun (n.d.), 423-428, chapter on singing *(fī sinā' al-ghinā);* Ibn Khaldun (2005), 329, "The Craft of Singing and Music."

41. Behrens-Abouseif (1998), 38-39.

42. Translated by G. Necipoğlu from Ahmed ibn Mustafa Taşköprüzade (1895), *Mevzū'ātü'l-'ulūm*, Istanbul, Ahmet Cevdet, vol. 1. (Necipoğlu [1995], 193, note 46).

43. Al-Farabi (1985; rpt. 1998), 79-81, 83-85.

44. Ibn Sina (1985), 281; Gonzalez (2001): 14.

45. Ibn Sina (1985), 281; Gonzalez (2001), 13-14.

46. Corbin (1960), 149–150; Ibn Sina (1889), 20–21. Ibn Sina speaks of divine beauty and its ability to inspire love in a number of other treatises. He claims that the "rational soul recognizes that the closer a thing is to the First Object of love, the more steadfast it is in its order, and the more beautiful in its harmony" (E. Fackenheim [1945], 7: 220). He also addresses divine beauty and perfection in his *Metaphysics,* and the *Kitāb al-najāt* contains a chapter entitled "That in Itself, It is the Beloved and the Lover, The Object of Pleasure and the Subject of Pleasure, and that Pleasure is the Perception of the Good and the Properly Proportioned" (Ibn Sina [1985], 281–282).

47. Arberry (1951), 64–76. "As for the question how far the human soul needs to be capable of conceiving intelligible distraction, so that it may pass beyond the point where this misery is bound to befall, and in transgressing which that happiness may be justly hoped for: this is a matter upon which I can only pronounce approximately. I suppose this position is reached when a man achieves a true mental picture of the incorporeal principles, and believes in them implicitly because he is aware of their existence through logical demonstration" (ibid., 71).

48. Cantarino (1975), 133; Necipoğlu (1995), 213, note 112. "The imaginatively-creative representation and the true-to-life presentation are both a kind of acceptance, except that the imaginative representation is an acceptance of the astonishment and delight in the discourse itself, while the objective presentation is an acceptance of the object just as it is said to be" (Cantorino [1975], 133, translated from Abdurrahman Badawi, ed. [1953], *Aristūtālīs: fann al-shi'r,* Cairo, 161–165; 167–171).

49. Ibn Hazm (1953), 28; Necipoğlu (1995), 187, note 12. For more on Ibn Hazm, see Chejne (1992).

50. Ibn Hazm (2007), 61; Gonzalez (2001), 8–9.

51. Gonzalez (2001), 15.

52. The best overview of Ibn al-Haytham's thought is found in Ibn al-Haytham (1989, ed. and trans. Sabra); see also Sabra (1978), 160–185, and Omar (1977). Aspects of his psychology are dealt with in Nazif (1942).

53. Ibn al-Haytham (1989), 200–203. A discussion of Ibn al-Haytham's views on beauty is found in Gonzalez (2001), 19–22.

54. Ibn al-Haytham (1989), 204–205. Ibn al-Haytham considers ugliness to be the absence of beauty: "As for ugliness, it is a [property of the] form from which all beautiful properties are absent. For it has been shown that the particular properties produce beauty but not in every situation nor in every form, but in some forms rather than others. Proportionality also

exists not in all forms but in some rather than others. Therefore, beauty will be lacking from forms in which no particular properties produce beauty either singly or in conjunction, and in which no proportionality exists among the parts. Thus ugliness of form is the absence of beauty from it. There may exist in one and the same form both beautiful and ugly properties, and in this case sight will perceive their respective beauty and ugliness once it has distinguished and contemplated the properties in the form. But sight will perceive ugliness from the privation of beauty when perceiving forms from which all beautiful features are absent. And likewise for all ugly things" (Ibn al-Haytham [1989], 206).

55. Shiloah (1978), 65–68, 257–296; al-Bustani (1957), 183–24; Necipoğlu (1995), 187, note 11. The Ikhwan al-Safa' considered hearing and sight to be superior to the other physical senses.

56. Necipoğlu (1995), 187.

57. Ibid., 188.

58. Abu Deeb (1979), 282; al-Jurjani (1954), 136.

59. Behrens-Abouseif (1998), 38, note 63.

60. Abu Deeb (1979), 275–277; Behrens-Abouseif (1998), 100, note 227.

61. Necipoğlu (1995), 213.

62. Not only is the distinction between philosophy and Sufi metaphysics overblown in many such representations, but there is substantial evidence to suggest that al-Ghazali continued to write philosophical works after his famous "conversion," and that such treatises were part of the philosophical curriculum in the medieval Islamic world. For more on this question, see the Persian and English introductions to Pourjavady (2002).

63. Ettinghausen (1947), 160–165. Since that time, al-Ghazali's thought has been discussed by several art historians including O. Grabar (most significantly in [1977]), Necipoğlu (1995), Behrens-Abouseif (1998), and Soucek (2000). Ettinghausen's short article on al-Ghazali's attitudes toward beauty and aesthetics was comprised for the most part of a synthetic English translation of German and French translations of the *Kīmiyā-yi sa'ādat* presented as accurate reflections of al-Ghazali's words (although Ettinghausen explicitly acknowledged his sources and their limitations). Despite its shortcomings and the greater availability of al-Ghazali's *Kīmiyā-yi sa'ādat* since the essay's publication, Ettinghausen's flawed translation has been very influential and often quoted in Islamic art historical circles. C. Hillenbrand's essay on al-Ghazali's aesthetics is a welcome corrective (C. Hillenbrand [1992], 249–260).

64. Al-Ghazali (1957; rpt. 1985), 4: 289–290, and (2009), 9–10, 32.

65. Al-Ghazali (1957; rpt. 1985), 4: 290–92; Behrens-Abouseif (1998), 23. For more on al-Ghazali's conception of "tasting" *(dhawq)*, see Treiger (2012), 48–55.

66. Al-Ghazali (1975; rpt. 2001), 1: 45–46, and (1909; rpt. 1997), 10.

67. Al-Ghazali (1975; rpt. 2001), 2: 586, and (1909; rpt. 1997), 78.

68. Al-Ghazali (1975; rpt. 2001), 2: 576–577, and (1909; rpt. 1997), 74.

69. Al-Ghazali (1975; rpt. 2001), 2: 572–573, and (1909; rpt. 1997), 73–74; cf. al-Ghazali (1957; rpt. 1985), 4: 288–289.

70. Al-Ghazali (1975; rpt. 2001), 2: 576.

71. Al-Ghazali (1957; rpt. 1985), 2: 291.

72. Ibid., 4: 295; C. Hillenbrand (1994), 256.

73. Al-Ghazali (1957; rpt. 1985), 4: 292; C. Hillenbrand (1994), 256. Soucek draws attention to the ambiguity of the nature of the wall painting to which al-Ghazali compares prophetic beauty; Soucek concludes that he was comparing depictions of human beings (in other words, portraiture) to the mental apprehension of prophetic qualities (Soucek [2000], 102, note 33).

74. Al-Ghazali (1957; rpt. 1985), 4: 292.

75. Leaman (2004), 76.

76. Kilito (1985), 58–60, and (2001, trans. Cooperson), 52–54.

77. Kemal (1991), 153; Dahiyat (1974), 4, 63 (i.e., chapter 1, commenting on the introductory chapter of Aristotle, paragraph 4, p. 63).

78. Cantarino (1975), 218–220; Necipoğlu (1995), 213, note 113.

79. Cantarino (1975), 164; Necipoğlu (1995), 213, note 114.

80. Kemal (1991), 154–169; Necipoğlu (1995), note 115.

81. Kemal (1991), 161–162, from Dahiyat (1974), 7, XXII.8, 115; Necipoğlu (1995), 214, note 116.

82. Bynum (1997), 6. The twelfth-century Englishman Master Gregory's account of the marvels of Rome opens with a confession of the deep impact made on him by the ruins and temples as well as the images within them. He thanks God for "[rendering] the works of man wondrously and indescribably beautiful" (Camille [1989], 81).

83. Bynum (1997), 14.

84. Ibid., 15.

85. Necipoğlu (1995), 197. Artistic creation is sometimes seen as divine inspiration, normally, but not exclusively, with reference to textual arts. For example, al-Tawhidi compares the creative work of the calligrapher Ibn Muqla (d. 939) to that of a bee, hearkening to the Qur'an, which has a chapter entitled "the Bee" (Sura 16): "He is a prophet in the field of hand-

writing; it was poured upon his hand, even as it was revealed to the bees to make their honey cells hexagonal" (Rosenthal [1948], 13: 9).

86. Necipoğlu (1995), 192, note 41; Behrens-Abouseif (1998), 22, 109.

87. Ibn Sina (1892), 207, cf. 204–206. An English translation of Part 1 (on logic) is available in Inati (1984), and of Part 4 (on mysticism) in Inati (1996). Inati's translations of Part 2 (Physics) and Part 3 (Metaphysics) were prepared for publication but never actually produced, so far as I am aware.

88. For a discussion of the term *'ibra*, its meaning, as well as its importance as a concept in the study of history, see Mahdi (1957), 63–70.

89. Al-Qazwini (1848–1849a), 5–6, and (1986) (partial German translation by Alma Giese). For the place of al-Qazwini at the center of a rich tradition of inducing wonderment through art in the Islamic world, see P. Berlekamp (2011).

90. Ibn al-Zubayr (1996), 238.

91. Ibid., 171.

92. Ibid.

93. Ibid., 177.

94. Thomas (2001), 3. The "enchanting" power of technology can be seen as exemplifying "an ideal of magical efficacy that people struggle to realize in other domains."

95. Haarmann (1991a), 57–67. Haarmann has edited the treatise in ibid. (1991b).

96. Haarmann (1991a), 67.

97. Ibid., 58.

98. O. Grabar (1973), 87–88.

99. Necipoğlu (1995), 199–201.

100. This point has been made convincingly by David Morgan in his study of American Protestantism (Morgan [1998], 31–34).

101. Pinney (2004), 194.

102. Ibid., 200.

6. Alchemy, Appearance, and Essence

Epigraph: Mawlana Jalal al-din Rumi (1925; rpt. 1986), *Mathnawī-yi ma'nawī*, edited by R. A. Nicholson, Tehran, Intishārāt-i Mawlā, 1:198. Translated by the author.

1. Ullmann (1972), 146. Ullmann's work is by far the most exhaustive treatment of the subject, and I will be following it closely in my discussion here. He also has a partner volume to this work that deals with the history of medicine ([1970], *Medizin im Islam*, Leiden, E. J. Brill).

2. For example, *al-san'a al-ilāhiyya* ("the divine Art") corresponds to *hē theia technē*, and *al-'amal al-a'zam* ("the grand work") to *to mega ergon;* metals are referred to as "the bodies" *(al-ajsād)* and mercury and sulfur as "the spirits" *(al-arwāh)*, corresponding to the Greek *ta sōmata* and *ta pneumata* respectively, and so on for the names of devices and methods. Furthermore, as argued by Ullmann, the Arabic alchemical poems of many of the famous early alchemists, such as Pseudo-Khalid, Ibn Umayl, Ibn Arfa' Ra's, and others, are modeled on the works of Greeks such as Heliodorus, Theophrastus, Hierotheos, and Archelaos (Ullmann [1972], 148–149).

3. Ibid., 153–154. Archelaos's works are entitled *Mushaf al-jamā'a* and *Risāla madd al-bahr dhāt al-ru'ya*. See Faivre (1995).

4. Ullmann (1972), 155–157. Aristotle is also regarded as an alchemist, although with less justification than other philosophers.

5. Ibid., 193: The four books are *Kitāb al-kharazāt* (The Book of Glass Beads); *Kitāb al-sahīfa al-kabīr* (The Greater Book of the Scroll); *Kitāb al-sahīfa al-saghīr* (The Lesser Book of the Scroll); and *Kitāb wasiyyatihi ilā ibnihi fī'l-san'a* (The Book of Testament to His Son on the Art). The collection of poetry is entitled *Kitāb firdaws al-hikma* (Book on the Paradise of Wisdom). To these may be added a treatise on alchemy and magic entitled *Risāla fī'l-san'a al-sharīfa wa-khawāssihā* (Treatise on the Noble Art and Its Properties).

6. These are the *Liber de septuaginta* and the *Liber misericordiae*, which are translations of the *Kitāb al-sab'īn* and the *Kitāb al-rahma* respectively (ibid., 198). The identity of Jabir remains a question of some debate, as does the relationship of his works to Latin alchemical writings. The most likely case is that the *Summa perfectionis magisterii*, which is attributed to him and which enjoyed wide popularity in the Latin West, has no Arabic equivalent and is therefore not attributable to an early Islamic author, but two other works attributed to Jabir do enter Latin from Arabic. A dissenting opinion on the corporate nature of the writings attributed to Jabir and their authenticity is presented by Fuat Sezgin, who claims the historicity of both the person of Jabir and his works. Sezgin argues that Jabir was born sometime before 725 and died around 812, and that the Jabirian writings are the work of a single author. This is based on the view that the first translations of spiritual and scientific works from Greek, Syriac, and Middle Persian go back to at least the seventh century and therefore that Islamic sciences date from that time (Sezgin [1971], 152; cf. also Sezgin [1964], 255–268). For more on Jabir, see Marquet (1988) and Nomanul Haq (1994). For transla-

tions of his works, see Ibn Hayyan (1983; rpt. 1996). The definitive work concerning the Jabirian corpus is still Kraus (1942).

7. Ullmann (1972), 218–219; see also Ruska (1936), 310–342. Al-Jildaki considered the *Kitāb miftāḥ al-ḥikma al-'uzma* (Key to the Great Wisdom) to be Ibn Umayl's most important work, but he also composed alchemical verses in a number of different collections.

8. Ullmann (1972), 222.

9. Other alchemical works by al-Tughra'i include *Kitāb jāmi' al-asrār, Kitāb tarākīb al-anwār, Kitāb sirr al-ḥikma,* as well as some poetry (ibid., 230–231). The *Kitāb ḥaqā'iq al-istishhād* has been published in a critical edition: Mu'ayyid al-din al-Tughra'i (1982), *Kitāb ḥaqā'iq al-istishhād: risāla fī ithbāt al-kīmiyā' wa'l-radd 'alā Ibn Sina,* ed. Razuq Faraj Razuq, Baghdad, Manshūrāt wizārat al-thiqāfa wa'l-a'lām.

10. Ullmann (1972), 211–212.

11. For more on al-Jildaki's works, see Ullmann (1972), 238–239.

12. Ibid., 241.

13. Ibid., 242–243.

14. Ibid., 246.

15. Ibid., 247–248.

16. "We say: *al-kīmiyā'* is a Greek word. . . . Some people apply the expression 'hermetic art' to alchemy, others the expression 'matter of the priests'. Its inventor was the Egyptian Hermes the 'three-fold'. He taught it to the priests. Afterward it spread and arrived to the Greeks also and they wrote books and treatises on chemistry. Finally it came to the Muslims, and many [more] books and epistles were also written on it. The purpose and goal of alchemy was the rectification of minerals and their transformation of the corrupting to the improving. . . . Then, however, the Teuton Paracelsus came, and gave the art of chemistry a new purpose and made it a part of medicine, and he called her *spagyria* in Latin, which means 'collection and division of differences'. This expression applies particularly to the art of chemical medicine" (Ullmann [1972]: 248).

17. There are small compendia of treatises dealing with alchemy that have been translated into Ottoman Turkish, such as MS 1012, Bağdatlı Vehbi Ef., Süleymaniye Kütüphanesi, Istanbul. The late nineteenth-century ruler of Morocco, Sultan al-Hasan I, was also deeply interested in alchemy (see Salmon [1906]).

18. Berlekamp (2003), 54–55.

19. Janowitz (2002), 111, note 10.

20. Ibid., 109.

21. Al-Simawi (1923), 5-6. Al-Razi has a different classification of substances as "mineral," "animal," and "vegetable," with mineral substances being subdivided into "spirits," "bodies," "stones," "vitriols," "boraxes," and "salts." Acids and oils were included in the animal and vegetable categories.
22. Ullmann (1972), 236.
23. Al-Simawi (1923), 35.
24. Ibid., 12.
25. Ibid., 17-18. The issue of whether or not essences are immutable, with changes occurring in appearance only, is one that appears to have been open to some debate in medieval Islamic intellectual circles. Other scientific thinkers argued that essences are themselves subject to decay and putrefaction, and that the destruction of the essence of one thing results in the coming into being of another (cf. 'Ali ibn Rabban al-Tabari [1928], 16-18).
26. Al-Simawi (1923), 34.
27. Ibid., 33-34.
28. Ibid., 34.
29. Ibid., 55.
30. Ibid. An example of the first sort would be to describe the human being as "the rational animal"; it is completely straightforward, in that it captures its meaning perfectly without allegory, and can be reversed as well as generalized, as in "all rational animals are human beings" and "all human beings are rational animals." An example of the second sort would be to describe a human being simply as an animal, since the statement would not hold true if it was reversed or generalized: "all animals are human beings" is not a true statement, but the partial converse, "some animals are human beings," is true. The second sort is more obscure than the first as a form of description.
31. Ibid., 55-66. "Of their description by 'necessary association' we have an example in their phrase 'Eastern Mercury'. They mean by this the mercury extracted from their stones, and this is a phrase of 'necessary association', for the Eastern Mercury which is extracted from rocks, in contrast to the Western Mercury which is extracted from soft earth. Now if any characteristic of Eastern Mercury is found in their mercury they know it by this name. Understand that, therefore. . . . [t]he term 'Land of India' is also employed by them to mean a substance in proper equilibrium, resembling the land of India in the equilibrium of its climate. The terms 'heaven' and 'earth' are intended by them to mean two substances, one of them volatile like the heaven and the other stable like the earth."

32. Abu Deeb (1979), 264–265.

33. Ullmann (1972), 149. Al-Sijistani is believed to have written an alchemical work entitled *al-Kitāb al-gharīb fī maʿnā al-iksīr* (The Wondrous Book on the Meaning of the Elixir), which might be the same as the *Kitāb maʿrifat al-iksīr* (ibid., 208).

34. Al-Jildaki reproduced several alchemical theories attributed to ʿAli as well as a poem believed to have been composed by Jaʿfar, who is also said to have composed a treatise entitled *Risālat Jaʿfar al-Sādiq fī ʿilm al-sināʿa waʾl-hajar al-mukarram* (The Treatise of Jaʿfar al-Sadiq on the Science of the Art) (Ullmann [1972], 195–196). A preliminary discussion of the relationship between religious—specifically Shiʿi—and scientific esotericism is found in Nomanul Haq (2002), 19–32.

35. Ullmann (1972), 208; Ibn al-Nadim (2002), 552–553; English translation in ibid. (1970), 867. To the list of Shiʿi alchemists should be added Abu Bakr ʿAli al-Khurasani, called al-Shaikh al-ʿAlawi, and Muhammad ibn Umayl. For more on the relationship between alchemy and esoteric Shiʿi thought, see Lory (1989).

36. Ibn al-Nadim attributes two alchemical books to Dhuʾl-Nun, the *Kitāb al-rukn al-akbar* (The Greater Book of the Element) and *Kitāb al-thiqa fīʾl-sanʿa* (The Book of Reliability in the Art); al-Junayd is supposed to have written *Kitāb tadbīr al-hajar al-mukarram* (Ullmann [1972], 196–197).

37. For more on Ibn al-Qayyim's critique of alchemy, see Livingston (1992).

38. Janowitz (2002), 114.

39. M. Ullmann (1979), "al-Kīmiyāʾ," *Encyclopaedia of Islam*, 2nd ed., vol. 5, Leiden, E. J. Brill, 110–115; Ibn Sina (1965, eds. Mustansir et al., 22–23; Anawati (1971), 285–341. Later alchemists, especially al-Jildaki and al-Tughraʾi, made Ibn Sina the target for polemics on account of this critique.

40. A. M. Smith (2004), 180–181; Lindberg (1976), 207.

41. A. M. Smith (2004), 194. Medieval optics is oculocentric as distinct from the luminocentric optics of Kepler and his followers. Although recognizing that Lindberg's representation of the development from classical to Keplerian optics has become widely accepted, Smith argues that Lindberg misrepresents the place of Ptolemy's *Optics* in the development of the field (cf. A. M. Smith [1988], 188–207).

42. Ibn al-Haytham (1989), lvi. In his *Commentary on the First Book of Euclid's Elements*, Ptolemy attributes this theory to the first-century BCE Germinus.

43. Ibid., lvi–lviii. Perhaps as a consequence, al-Farabi does not address the phenomenon of refraction.

44. Lindberg (1978), 136. See also Lindberg (1976), 18–32; Travaglia (1999).

45. Lindberg (1978), 140–141. It is worth noting that the Arabic originals of al-Kindi's work on optics are not known to survive and are only accessible through their Latin translations (*de radiis* and *de aspectibus*). Probably as a result, they are better integrated into the academic traditions of the Latin West than those of science in the Islamic world.

46. Ibid., 146. Lindberg is drawing largely on the sixth book of part four of Ibn Sina's *Kitāb al-shifā'*, which was translated into Latin as a separate work known commonly as *De Anima* (critical edition by Simone Van Riet [1972], *Avicenna Latinus: Liber de anima seu sextus de naturalibus, I–III*, Louvain, Belgium, Peeters).

47. Lindberg (1978), 150.

48. Ibid. This theory is virtually identical to what Aristotle writes in his *De Anima*: "Colour moves the transparent medium, e.g. the air, and this, being continuous, acts upon the sense organ. . . . For vision occurs when the sensitive faculty is acted upon; as it cannot be acted upon by the actual colour which is seen, there remains only the medium to act on it. . . ." (Lindberg [1978], 150–151, note 62; [1975], *De Anima*, II.7.419a 13–19, trans. W. S. Hett, rev. ed., Loeb Classical Library series, London, 107. For the Greek, see W. D. Ross, trans. (1959), *De Anima*, Oxford, Oxford University Press).

49. M. Miles (1983), 127. "The visual ray of the physical eye which unites the soul to the objects of its habitual attention provided Augustine with a powerful description of the vision of God, a coordination of physics and metaphysics which grounded his 'vision' of the process and goal of human life" (ibid., 142).

50. Sabra (1978), 160.

51. Ibn al-Haytham (1989), liv–lv. His rebuttal to the extramissionists' critique of intromission is as follows: "Because the visible object is perceived in its own place, the upholders of the doctrine of the ray came to believe that vision occurs by means of a ray issuing from the eye and ending at the object, and that vision is achieved by the end points of the ray. They argued against natural scientists, saying: if vision takes place by a form that comes from the object to the eye, and if the form exists inside the eye, then why is the object perceived in its own place outside the eye while its form exists in the eye? But these people forgot that vision is not accomplished by pure sensation alone, but is rather accomplished by means of discernment and prior recognition, and that without these no vision can be effected by sight, nor would sight perceive what the visible object is at the moment of seeing it" (Sabra [1978], 179).

52. Sabra (1978), 167.
53. Ibid., 169.
54. Ibid., 170.
55. Ibid., 174. Ibn al-Haytham refers to a specific kind of perception as that of recognition *(idrāk bi'l-maʿrifa)* through which the cognitive faculty recognizes an individual object of vision—including a person—as belonging to a species or as the same individual seen previously. Memory is an essential factor in this kind of perception, because it allows recognition beyond the comparison of identical visual factors.
56. Ibn al-Haytham (1989), 208.
57. Ibid., 213–214.
58. Sabra (1978), 175.
59. A. M. Smith (2004), 188.
60. Ibn al-Haytham (1989), lxiv–lxv.
61. Ibid., lxix–lx.
62. This point has been made convincingly for the case of Christian Europe in Denery (2005), 4–9.

7. Dreams, Visions, and the Imagination

Epigraph: Faiz Ahmad Faiz (1984), "Zindān kī ik subh," from *Dast-i sabā,* reprinted in *Nuskhahā-yi wafā,* Lahore, Kārvān, 181–182. Translated by the author.

1. One notable exception that makes some preliminary observations concerning the relationship between dreaming and mimesis in art is Al-Bagdadi (2006).
2. Rahman (1966), 410. The Jewish scholar Maimonides also compared the dream visions generated by the imagination to prophecy; such visions were seen in the mind's "inner eye," an organ cultivated by Jewish mystics and philosophers (Bland [2000], 6).
3. Miller (1994), 5.
4. For important discussions of the place of dreams in contemporary Islamic societies (Egypt and Pakistan in particular), see Mittermaier (2011) and Ewing (1990).
5. Marlow (2008), 15.
6. Von Grunebaum (1966), 15. The only available statement from the early Islamic period that is categorically critical of dreams and their interpretation is ascribed to Abu Sulayman al-Darani (d. 830): "Devilish insinuation *(waswās)* and much dreaming come only to the weak person. When he devotes himself to God, dreaming and insinuations from the devil leave him ... I have sometimes remained for many years without

dreaming" (Kinberg [1994], 47; from *Al-Bidāya wa'l-nihāya*, 10:257; *Hilyat al-awliyā'*, 9:260; *al-Kawākib al-durriyya* 1:253).

7. Makdisi (1956).

8. Lamoreaux (2002), 11. For information on the history of dreaming in premodern Islamic culture, see also Felek and Knysh (2011); Abdel Daïm (1958); and Schimmel (1998). The latter work is valuable for the emphasis it places on dreaming in Persian and Turkish culture. The early Islamic oneirocritical tradition also influenced scholarship on dreams and dreaming in the Byzantine world (see Mavroudi [2002]).

9. Marlow (2008), 9.

10. Al-Bagdadi (2006), 124; Ibn Khadun, *Muqaddima:* "The Science of Dream Interpretation," section 17 of chapter 6 ("The Various Kinds of Science"); translation by F. Rosenthal (1958), *The Muqaddimah: An Introduction to History,* New York, Pantheon Books, 103–110.

11. Kinberg (1994), 44–46.

12. Von Grunebaum (1966), 7, 10. The question of true versus false dreams is addressed (somewhat tangentially) in Abdel Daïm (1958).

13. Kinberg (2008), 26–27, including notes 6 and 7. Variants of this hadith are listed in Zaghlul (1989), 8:271–272. The issue of whether the Prophet can be seen in forms not resembling his physical one is addressed in Ibn Hajar al-'Asqalani (1978), 26:233; Ibn Hajar reproduces the relevant hadith account with an important addition: "Whoever has seen me in a dream has certainly seen me in wakefulness, *because I can be seen in any form*" [emphasis added].

14. Kinberg (2008), 27. Kinberg argues that the interpretation of "good tidings" to mean dreams *(ru'yā)* must date from at least the middle of the eighth century, since it is mentioned by Muqatil ibn Sulayman (d. 767) in his commentary on the Qur'an. The link between the verb "to see" *(ra'ā)* and the noun for "dream" *(ru'yā)* was already made by Abu Zakariyya Yahya ibn Ziyad al-Farra' (d. 822) in his exegetical work, as was the connection between the verbal nouns *nawm* ("sleep") and *manām* ("dream"). In this context, the words *ru'yā* and *manām* are used interchangeably to denote that all righteous individuals can attain good dreams.

It can be argued that prophethood is so central to Islam that it becomes the defining characteristic of Muslim notions of time, where all of human history from the era of Adam onward is countable in units marked by generations of prophets. Thus, living in a post-prophetic age following the death of Muhammad is an almost incomprehensible shift in the conceptualization of history; ongoing prophecy becomes a religious necessity that, in light of the doctrinal finality of Muhammad's

prophet mission, can only be accommodated for most Muslims by arguing for a continued presence of Muhammad in this world (for more on notions of prophetic authority in Islam, see D. Stewart [2010], "Prophecy," in *Key Themes for the Study of Islam*, ed. J. J. Elias, Oxford, Oneworld, 281-303).

15. Kinberg (2008), 29.
16. Lamoreux (2002), 28.
17. Ibid., 29.
18. Ibid., 85.
19. Al-Bagdadi (2006), 134.
20. For a discussion of this issue in the specific context of Sufi dreaming, see Ewing (1990).
21. See, for example, G. Hagen, "Dreaming 'Osmāns: Of History and Meaning," in Felek and Knysh (2011), 99-122.
22. Bashir (2011a), "Narrating Sight: Dreaming as Visual Training in Persianate Sufi Hagiography," in Felek and Knysh (2011), 245.
23. Among the Jewish scholars influenced by the Arabic version of *De divinatione per somnum* are Moshe ibn Ezra (d. ca. 1140), the author of the *Kitāb al-muhādara wa'l-mudhākar*, which deals with the subject of poetical inspiration occurring during sleeping states, and Rabbi Zerahyah ben Isaac ben Sheltiel Hen (flourished in the second half of the thirteenth century), who wrote an important commentary on Maimonides's *Guide of the Perplexed* (Hansberger [2008], 64-66).
24. Hansberger (2008), 54.
25. Ibid., 55.
26. Ibid., 56-57.
27. Ibid., 57.
28. Ibid., 58.
29. Ibid., 58-59.
30. Ibid., 73.
31. Al-Farabi (1985; rpt. 1998), 210-213. For more on al-Farabi's notions of mimesis as they apply to ethics and imagination, as well as their Aristotelian roots, see Daiber (1986), 2:729-41.
32. Al-Farabi (1985; rpt. 1998), 210-211.
33. Ibid., 218-219.
34. Ibid., 220-223.
35. Ibid., 222-225.
36. Ibid., 224-227. Al-Farabi also uses the faculty of representation to explain madness as a flaw in the process of representing reality accurately: "It also may happen to people that their temperament is ruined in certain

circumstances and their powers of representation impaired; they see then, as the outcome of the combinations which the faculty of representation performs in these ways, things which are neither real nor imitate reality. These are the bilious *(mamrūrīn),* insane and madmen *(majānīn)* and their like" (ibid., 226-227).

37. Rahman (1966), 410, Ibn Sina's *al-Risala al-adhawiyya.*

38. Rahman (1966), 410. Al-Farabi (1985; rpt. 1998), chap. 14; Ibn Sina (1959), 4:2; cf. Rahman (1958), 36-38. See also Pines (1974).

39. Rahman (1966), 413.

40. Ibid., 419.

41. Ibid., 416-17.

42. Ibid., 417.

8. Sufism and the Metaphysics of Resemblance

Epigraph: J. J. Elias, trans. (1998), *Death before Dying: The Sufi Poems of Sultan Bahu,* Berkeley, University of California Press, 25.

1. N. Ardalan and L. Bakhtiar (1973), *The Sense of Unity: The Sufi Tradition in Persian Architecture,* Chicago, University of Chicago Press, xi; from Necipoğlu (1995), 76-77, note 71. For sustained discussions of the anti-intellectual, romantic tendency to find universal meaning in Islamic art see the seventh chapter of O. Grabar (1973) and Necipoğlu (1995), 76-80. An unsuccessful attempt to link Sufism to aesthetics is found in Afrasiyabpur (2001).

2. S. H. Nasr (1976), *Islamic Science: An Illustrated Study,* Westerham, UK, World of Islam Festival Publishing, 75.

3. I. R. al-Faruqi (1970), "On the Nature of the Work of Art in Islam," *Islam and the Modern Age* 1:2 (August), 78.

4. Ibid., 79. A similar universalizing view of art is applied to modern media in M. Aziza (1978).

5. T. Burckhardt (1967), *Sacred Art in East and West: Its Principles and Methods,* trans. Northbourne, London, Perennial Books. Burckhardt has a number of other works that promote a similarly convoluted view of the relationship between the arts and Islamic spirituality, including (1954) "The Spirit of Islamic Art," *Islamic Quarterly* 1:212-18; see also (1984), "The Void in Islamic Art," *Studies in Comparative Religion: Titus Burckhardt Memorial Issue* 16 (Winter-Spring): 79-82; and with R. Michaud (1976), *Art of Islam: Language and Meaning,* London, World of Islam Festival Publishing; Necipoğlu (1995), 78, note 78. The most egregious prose in this regard is found in Burckhardt (1987), *Mirror of the Intellect: Essays on Traditional Science and Sacred Art,* trans. and ed. by W. Stoddart, Cambridge, Quinta

Essentia, which shows how a so-called Sufi "symbolist" perspective helps explain not just Islamic art, but also chess, Russian icons, and the Native American Sun Dance.

6. See Reynolds (2001), 119–131.

7. For more on visions of Sufi masters and guides as part of the normal contours of the master-disciple relationship in Persianate Sufism, see Bashir (2011b). See also Alexandrin (2011). A study of dreaming in the context of a specific North African Sufi figure is found in Katz (1996); a somewhat unsatisfactory attempt to study the place of dreaming in Sufism is undertaken in Llewellyn Vaughan-Lee (1990), *The Lover and the Serpent: Dreamwork within a Sufi Tradition*, Shaftesbury, UK, Element Books. The dream manual of the influential early-modern Sufi, al-Nabulsi (d. 1731) is available in a printed edition: al-Nabulsi (1940).

8. Ormsby (2008), 146; al-Ghazali (1973), 147; English translation in Watt (1953; rpt. 1982), 65–66; and al-Ghazali (2000; rpt. 2004), 85.

9. Ormsby (2008), 144.

10. Al-Bagdadi (2006), 131.

11. Jabre (1970), 27–28; al-Ghazali (1973), 146; Al-Bagdadi (2006), 131.

12. Al-Bagdadi (2006), 131.

13. Al-Ghazali (1964), 49; al-Ghazali (1998, trans. Buchman), 10–11.

14. Al-Ghazali (1973), 145; al-Ghazali (2000; rpt. 2004), 83–84; Watt (1953; rpt. 1982), 64.

15. Al-Ghazali (1964), 79–80; al-Ghazali (1998), 29–30: "The science of dream interpretation makes known to you the way similitudes are struck, since dreams are a part of prophecy" (29).

16. Watt (1953; rpt. 1982), 24; al-Ghazali (1973), 85; al-Ghazali (2000; rpt. 2004), 57.

17. Al-Ghazali (1957; rpt. 1985), 3:6; al-Ghazali (2010, trans. Skellie), 15; Al-Bagdadi (2006), 129.

18. Al-Ghazali (1957; rpt. 1985), 1:276; Al-Bagdadi (2006), 129.

19. Al-Ghazali (1957; rpt. 1985), 3:24; al-Ghazali (2010), 113–114.

20. Al-Ghazali (1957; rpt. 1985), 4:23; Al-Bagdadi (2006), 129–130.

21. See Chapter 5, note 63, in this volume. for a brief discussion of this work and its relationship to al-Ghazali's corpus. The possibility that the "real" *al-Madnūn* is a largely unknown philosophical treatise found in a compilation in Maragha notwithstanding, even the well-known treatise attributed to al-Ghazali exists in two redactions, *al-Madnūn al-saghīr* and *al-Madnūn bihi 'alā ghayr ahlihi*; Hughes (2002), 41, note 12.

22. Hughes (2002), 41.

23. Ibid.

24. Ibid., 42. Hughes translates *mithl* as "resemblance," but in the context of the current discussion, "similitude" is a more appropriate and equally valid translation for the Arabic term.
25. Ibid.
26. Ibid.
27. Ibid., 44.
28. Al-Ghazali (1957; rpt. 1985), 4:174; Ormsby (2008), 145.
29. Ormsby (2008), 147.
30. Ibid., 146.
31. Ibid., 147–149.
32. Al-Ghazzali (1985), 24–25.
33. Elias (1995), 94–96.
34. For more on the importance of the *Fusūs al-hikam,* see Chittick (1982). For a general appraisal of the influence of Ibn al-'Arabi's thought, see Benaïssa (1999); cf. also Coates (2002).
35. Chittick (1989), 39; Ibn al-'Arabi (1911), II: 508.5.
36. Izutsu (1984), 30.
37. Rahman (1966), 415. He goes on to argue that Ibn al-'Arabi attempted to "secularize" the concept of the *'alam al-mithāl* so as to use it primarily for artistic purposes which, though interesting as an idea, did not enjoy much popularity.
38. For more on Ibn al-'Arabi's thought in general, see (among other things) Chittick (1994), and the same author's topically arranged, selected translations of Ibn al-'Arabi's works: the aforementioned (1989), and (1998). The Perfect Human Being *(al-insān al-kāmil)* also represents an interstitial entity or *barzakh* between the divine and physical realms as the only creature that unites the two perfectly. This Perfect Human Being is a cosmic, metaphysical entity, distinct from perfected human beings in the physical world. In the case of the latter, "spiritual realization has opened up the imagination to the actual vision of the embodiment of God when He discloses Himself in theophany. He does not know 'how' God discloses Himself but he sees Him doing so. He understands the truth of God's similarity with all things through a God-given vision, seeing clearly that all things are neither/nor, both/and, but never either/or" (Chittick [1989], 29).
39. Chittick (1994), 116–117. According to Chittick, the two terms gain the greatest etymological proximity in the concept of *tamaththul,* meaning "to appear in the image of" or "to become imaginalized."
40. Ibid., 52, 71.
41. Ibn al-'Arabi (1946; rpt. 1980), 85–86; Ibn al-'Arabi (2004), 68–72; Ibn al-'Arabi (1980), 99–100.

42. *Himma* is difficult to define succinctly; among the more straightforward explanations of the term are "the utmost concentration of the heart *(qalb)* upon God," which does not seem to be exactly what Ibn al-'Arabi is referring to (Nicholson [1967], 118, note 1), and an "extraordinary power" or a "concentrated spiritual energy" (Izutsu [1984], 273).

43. Ibn al-'Arabi (1911), I:304.23–26, 29–30, from Bashier (2004), 89.

44. Chittick (1994), 72.

45. Ibn al-'Arabi (1911), I:306.13–20, quoted in Chittick (1989), 122. As Chittick notes, these associations have precedents in hadith (397, note 14).

46. Ibn al-'Arabi (1911), III:38.20–23, quoted in Chittick (1998), 338; II.609.17–21, quoted in Chittick (1998), 260. Ibn al-'Arabi draws a distinction between a "nondelimited" and "bound" imagination (*al-khayāl al-mutlaq* versus *al-khayāl al-muqayyad*), the nondelimited being so because it situates all of existence in a designated fashion. The "Bound Imagination" serves as the interstitial space between the spiritual and physical worlds. The "Bound Imagination" is further distinguished into the two categories of "Contiguous Imagination" and "Discontiguous Imagination" (*al-khayāl al-munfasil* and *al-khayāl al-muttasil*). The form "Contiguous Imagination" refers to the soul-as-imagination, which is the location of dream visions as distinct from prophetic visions, which occur in the "Discontinuous Imagination" that exists as an interstitial realm independent of the individual viewer (Chittick [1989], 117–118; 126; see also Chittick [1998], 332–355).

47. Like in Ibn al-'Arabi's other works, visions of various kinds feature prominently in the *Fusūs al-hikam*. A vision is a central aspect of how the author experiences the prophets he mentions, as is clear from the discussion in the chapter on Hūd: "Know that when the Reality revealed to me and caused me to witness the essential realities of His apostles [on whom be peace] and prophets of humanity from Adam to Muhammad [peace and blessings be on all of them] at an assembly in Cordova in the year 586 (1190 CE), none addressed me from among them save Hūd, who informed me of the reason for their gathering together. I saw him as a stout man, fair of form, subtle of converse, a gnostic, a discloser of the realities" (Ibn al-'Arabi [1980], 133–134); Ibn al-'Arabi (1946), 110.

48. Ibn al-'Arabi (1946), 139–140; Ibn al-'Arabi (1980), 175–176; Ibn al-'Arabi (2004), 159–161.

49. "The cosmos is two worlds and the Presence is two Presences, though a third Presence is born between the two from the totality. The first Presence is the Presence of the absent, and it possesses a world called the 'world of the absent'. The second Presence is the Presence of sensation

and the witnessed; its world is called the 'world of the witnessed' *('ālam al-shahāda)* and it is perceived by eyesight *(al-basar)*, while the world of the absent is perceived by insight *(al-basīra)*. That which is born from the coming together of the two is a Presence and a world. The Presence is the Presence of the imagination, and the world is the world of the imagination. It is the manifestation *(zuhūr)* of meanings *(al-maʿānī)* in sensory moulds *(qawālib)*, like knowledge in the form *(sūra)* of milk, perseverance in religion in the form of a fetter, [Islam] in the form of a pillar, faith in the form of a handle, and Gabriel . . . [becoming imaginalized to Mary in the form of a well-proportioned mortal (Qur'an, 19:17)]" (Ibn al-ʿArabi [1911], III:42.5-10, quoted in Chittick [1998], 258-59).

50. Ibn al-ʿArabi (1946), 100; Ibn al-ʿArabi (1980), 121-122; Ibn al-ʿArabi (2004), 96. The importance of perspective in how something is perceived is also brought up in Ibn al-ʿArabi's chapter on Joseph: "Joseph, upon him be peace said, 'I saw eleven stars, the sun, and moon; I saw them prostrating to me' (Qur'an, 12:4). He saw his brothers in the form *(sūra)* of stars and saw his father and aunt as the sun and the moon. This is from the perspective of Joseph; had it been from the perspective of the perceived, the appearance of his brothers in the form *(sūra)* of stars and the appearance of his father and aunt in the form of the sun and the moon would have been intended by them. But since they had no knowledge of what Joseph saw, Joseph's perception took place in the store house of his imagination *(khizānat al-khayāl)*" (Ibn al-ʿArabi [1946], 100; Ibn al-ʿArabi [1980], 122; Ibn al-ʿArabi [2004], 96-97).

51. Ibn al-ʿArabi (1946), 138; Ibn al-ʿArabi (1980), 175; Ibn al-ʿArabi (2004), 157-158.

9. Words, Pictures, and Signs

Epigraph: J. Baudrillard (1996), *The System of Objects,* trans. J. Benedict, London and New York, Verso: 197.

1. Rosenthal (1948), 10; reprinted in Rosenthal (1971).

2. Rosenthal (1961), 15-16.

3. Among the many examples of how the very presence of supposedly sacred words can cause sin if the object is mishandled, in December 2010, a Muslim doctor in Karachi who threw a medical sales representative's business card in the garbage was arrested on blasphemy charges because the card was inscribed with the word *Muhammad* (which happened to be the salesman's name) ("Doctor Arrested for Blasphemy: Police," *Dawn,* December 12, 2010, http://www.dawn.com/2010/12/12/doctor-arrested-for -blasphemy-police.html).

4. Rosenthal (1948), I, 11–12.

5. Akın-Kıvanç (2011), 124–25.

6. O. Grabar (1973), 135; Behrens-Abouseif (1998), 139. For more on the importance of text and writing in Islamic society, especially as it relates to calligraphy, see Schick (2010).

7. Ernst (2009), 431–432. The *Tuhfat al-muhibbīn* is regarded as the second-oldest independent Persian treatise dealing with the Arabic script, coming after a fourteenth-century work by 'Abd Allah Sirafi Tabrizi whom Siraj-i Hasani quotes extensively (Ernst [2009], 434). The treatise is available in a Persian edition: Ya'qub ibn Hasan Siraji-i Shirazi (1997), *Tuhfat al-muhibbīn (dar ā'īn-i khushnawīsī wa latā'if-i ma'nawī-yi ān)*, ed. M. Taqi Danish-Pazhuh, K. Rana Husayni, and I. Afshar, Daftar-i nashr-i mīrath-i maktūb, 'Ulūm wa funūn, no. 8, Tehran, Nuqta.

8. Ernst (2009), 436–437.

9. Ibid.

10. Ibid., 441.

11. Ibid., 439–441.

12. Ernst (1992), 281. There has been confusion over the authorship of the *Ādāb al-mashq*, with some manuscripts erroneously attributing it to Mir 'Imad al-Hasani (d. 1615), perhaps the most famous master of the *nasta'līq* script.

13. Ibid., 283.

14. Ibid.

15. Ibid., 284. Baba Shah describes the process of apprenticeship through which one learns the art of calligraphy in terms that are very similar to the master-disciple relationship in the Sufism of his time.

16. There is no definite answer as to why works on calligraphy started to be written from the fifteenth century onward. In all likelihood, it is related to the proliferation of artisanal guilds as a social phenomenon in the Persianate world. If such a relationship does indeed hold true, it would appear that an intellectualizing discourse on specific practices of art and writing only came about as a consequence of the emergence of a sociohistorical sodality invested in cultivating such a discourse. Preceding or in the absence of such a social structure, art practices may have been exceedingly widespread yet did not demand any rhetorical underpinning or intellectual justification.

For works that depict calligraphers, painters, and practitioners of the visual arts, see (among others) Porter (1988) and Taragan (2008). There are isolated passages on calligraphy and painting in a number of works, perhaps the best known being from the *Ā'īn-i Akbarī* by Abu'l-Fazl, who

also provides a detailed description of the *taswīr khāna,* or the royal painting atelier (Abu'l-Fazl Nagori [1872], 1:111-118). The Ottoman Mustafa 'Ali also considered calligraphy much more important than the pictorial arts, and only devoted a section of one of the five chapters in his *Manāqib-i hunarwarān (Epic Deeds of Artists)* to painters (Akın-Kıvanç [2001], 261-281, 398-417).

17. Oleg Grabar, among other scholars, has tried to highlight commonalities in the place of writing in the premodern Islamic world despite the substantial differences in attitudes and expectations concerning its societal function. He also distinguishes between two overlapping currents in the use of writing in classical Islam, the first promoted by the courtly milieu in which professional scribes were employed to produce sophisticated products for the appreciation, use, and consumption of an elite; the second was a populist current in which a more "exuberant," if less legible, style was utilized broadly to carry a variety of religious as well as secular messages (O. Grabar [1992], 84, 113-114).

18. Gonzalez (2000), 314. Grabar suggests two other facts that emerged in the growth of scripts in the early Islamic centuries. "One is the notion of a beautiful or at least expensive-looking book and the other one is that writing carries information no doubt but also identifies categories of taste (and therefore of patronage) and can be used on all sorts of objects other than books" (O. Grabar [1992], 69).

19. Among the most important early examples of works that uncritically connect calligraphy to spiritually (often of a Sufi sort) are those by Titus Burckhardt, beginning with his (1947), "Principles and Methods of Traditional Art," in *Art and Thought: Issued in Honour of Dr. Ananda K. Coomaraswamy on the Occasion of His 70th Birthday,* ed. K. Bharatha Iyer, London, Luzac and Co., 17-22, and most significantly T. Burckhardt and R. Michaud (1976), *Art of Islam: Language and Meaning,* trans. J. P. Hobson, London, World of Islam Festival Publications; and Lings (1976; rpt. 1987). More recently, Librande has tried to make sense of the place occupied by calligraphy in the spiritual lives of Muslims (Librande [1979]), and Schimmel has written a flavorful and broad-reaching survey with more cultural specificity (Schimmel [1984]).

20. Saussure (1983; rpt. 1986), 24-27; Ong (1982; rpt. 1991), 5. The idea that literacy represents a higher level of intellectual and social development than illiteracy—which forms a dyad with orality—is deeply ingrained in academic as well as popular thinking.

21. Ong (1982; rpt. 1991), 7-8.

22. For a discussion that creates a dichotomy between such forms of orality and literacy, see Ong (1982; rpt. 1991), 11–14. Despite occasional statements of mitigation, Ong maintains a clear (and value-ridden) distinction between the function of oral and written communication: "Oral communication unites people in groups. Writing and reading are solitary activities that throw the psyche back on itself" (ibid., 69).

23. Ong's influential work on how literacy leads to a ground-shift in the thought processes and outlook of individuals and whole societies draws on the research of the Soviet scholar Alexander Luria conducted among Muslim populations in Uzbekistan in the 1930s. Ong injects a methodological awareness of the importance of context and ethnocentrism in notions of literacy and illiteracy in an attempt to draw broader conclusions on the role of language in society (Ong [1982; rpt. 1991], 51–61). For an appraisal of the relationship between the work of Luria and Ong, see B. Daniell (1988), "Re-Reading Ong: Literacy and Social Change," paper presented at the Annual Meeting of the Conference on College Composition and Communication, St. Louis, March 17–19, 1988. Ong has studied the relationship between orality and literacy in the text cultures of medieval Europe, but the differences in the material nature of the book and its uses between the Latin Christian West and the medieval Islamic world are sufficient to limit the usefulness of his arguments in this context (Ong [1984]).

24. Ong (1982; rpt. 1991), 67–68.

25. Ibid., 68. Ong adopts Jousse's term *verbomoteur*, expanding it to "include all cultures that retain enough oral residue to remain significantly word-attentive in a person-interactive context (the oral type of context) rather than object-attentive" (cf. Jousse [1925]).

26. Bowman and Woolf (1994), 2–3. Bowman and Woolf reject the validity of most of Ong's writing on the subject, although they take a less negative view of his later work. Related cultural phenomena include the distinction between vocalized and silent reading and its relationship to the emergence of literacy, as well as the movement of texts from ones primarily read out loud and experienced as oral words by the audience that *hears* them, to texts that are read by an individual (or small groups of individuals), implying that all who interact with the words possess the power to read. Little scholarship has been done on reading cultures in the Islamic world, the most important work being Hirschler (2012), which explores the history of reading in the medieval Arabic-speaking world, demonstrating how the proliferation of paper and subsequently

of books had a tremendous impact on the spread of literacy beyond the narrow circles of a scholarly elite. See also Messick (1993), which studies modern Arab religious textual cultures. For information on the rise of silent reading in the late antique and medieval Christian worlds, some of which is applicable to Islamic society, see Knox (1968), and Saenger (1982) and (1997).

27. Cf. Bowman and Woolf (1994), 2, 6.

28. Bowman and Woolf (1994), 12. A somewhat similar situation pertained in Syria in late antiquity, where a substantial portion of the population was bilingual in Aramaic and Greek, although it is difficult to ascertain whether they were bicultural as well. As in the case of the rise of modern Persian, it was its association with Christianity that afforded Syriac the prestige to compete with Greek, although in this arena the relationship between languages is reversed, since, unlike in the case of Arabic and Persian, Syriac did not pose a challenge to Greek outside the narrow confines of religious literature (Brock [1994], 153–154).

29. For more on the relationship of the oral to the written in the early Islamic centuries, see Schoeler (2009), especially chapters 1 and 7.

30. It is true that Jews share with Muslims the notion that divine revelation is attached to a specific language (Hebrew in the case of Jews), but Muslims have been far more energetic than Jews in their insistence that the scripture be kept in the language of its revelation and that translation be avoided entirely or else be treated as lesser order interpretations of the divine word. Jews have historically insisted on the importance of learning Hebrew, yet they have acknowledged that many Jews do not understand Hebrew and have accepted the value (or at least the pragmatic necessity) of translations for a long time, going back to the Greek translations in the Septuagint and the emergence of Aramaic summary-translations of scripture in the post-Exhilic Septuagint. In contrast, with isolated exceptions, Muslims remained extremely resistant to the spread of translations of the Arabic Qur'an until modern times and the majority continue to maintain the exclusive legitimacy of Arabic in ritual settings (Graham [1987], 84–85). See also W. A. Saleh (2010), "Word," in *Key Themes for the Study of Islam,* ed. J. J. Elias, Oxford, Oneworld, 356–376. For an informative, if somewhat dated, overview of the importance of the Qur'an in Muslim ritual life, see van Nieuwenhuijze (1962).

31. Camille (1985), 32.

32. A similar point could be made concerning the correlation of literacy with class and sex in medieval Europe (cf. Fox [1994], 128).

33. A. Schimmel (1975; rpt. 1981), *Mystical Dimensions of Islam*, Chapel Hill, University of North Carolina Press, 430.

34. Cf. Fox (1994), 129, where the same point is made for Judaism and Christianity.

35. Bowman and Woolf (1994), 15.

36. Minorsky (1959), 64; O. Grabar (1992), 85; Gonzalez (2000), 322.

37. Gonzalez (2001), 97–98.

38. Behrens-Abouseif (1998), 140–141.

39. The birth and early development of the Kufic script is outlined in George (2010), 55–60. Some of the best works on Islamic calligraphy are listed in O. Grabar (1992), 250–251, note 8. To these should be added (in addition to works referred to directly in this book), as a nonexhaustively representative list nor one that subdivides works into the categories used by Grabar: Blair (2006); Derman (1998a); Alparslan (1999; rpt. 2004); Gündüz and Taşkale (2000); and Petrosyan, ed. (1995), *Pages of Perfection: Islamic Paintings and Calligraphy from the Russian Academy of Sciences, St. Petersburg*, Lugano, Switzerland, ARCH Foundation.

40. Tabbaa (2001), 28; Tabbaa (1991), 140b–141a; cf. Blair (1998), 88.

41. Tabbaa (2001), 43–44; Tabbaa (1991), 141a. Other observations concerning the Kufic script include that it was easier to carve in stone than the cursive *naskh* (Leaman [2004], 49), and that its popularity in certain later circles might have something to do with its resemblance to the squarish Mongolian script called Phagspa introduced by Qubilay Khan in 1269 (Blair [1998], 85).

42. Melchert (2000), 5–22, especially p. 20; Tabbaa (1991), 141b; Tabbaa (2001), 42–43. See also Melchert (1996), 316–342.

43. Tabbaa (1991), 142b; Tabbaa (2001), 50. For more on the debates over the origin of the Qur'an, see Peters (1976).

44. Tabbaa (2001), 52. For more on the influence of Ibn al-Bawwab on calligraphers and the appreciation of calligraphy after his time, see Roxburgh (2003b).

45. Tabbaa (1994), 127a–128a; Tabbaa (2001), 59.

46. Tabbaa (1994), 128b; Tabbaa (2001), 59. An excellent example of this is found on the exterior of the *mihrab* dome of the Great Mosque of Isfahan (dated 1086–1087).

47. Tabbaa (1994), 133a; Tabbaa (2001), 60.

48. Tabbaa (1994), 139a; cf. Tabba (2001), 71–72.

49. Tabbaa (1994), 140a; Tabbaa (2001), 71-2. Tabbaa argues that most previous scholarship on monumental epigraphy in the early Islamic centu-

ries is deficient, in that (in Oleg Grabar's case) it does not address the specifics of historical context and (in the case of Ettinghausen and Dodd) it views calligraphic complexity as either an insignificant feature or else nothing more than a hindrance to legibility rather than a symbolic representation of official ideology (Tabbaa [2001], 5, 26).

50. Tabbaa (1994), 124a, 126a; Tabbaa (2001), 71. For a discussion of inscriptions using the floriated Kufic script, see Blair (1998), 77-93.

51. Crossley (1988), 116a.

52. Crossley (1998), 116b. Krautheimer (1942), 7-9; reprinted in Krautheimer (1969). In his excellent, short critique of the origins of architectural iconography, Crossley argues that Bandmann, in contrast to Krautheimer, tried to identify precise "intended meanings" behind architectural projects, a problematic idea since public buildings allow for a variety of interpretations. "Bandmann placed early medieval architecture half-way between the magical symbolism of primitive societies, where the work of art is one and the same as the magical essence it 'stands for', and the purely aesthetic values of rationally sophisticated cultures, where the work of art has become 'the object and goal of its own reality'" (Crossley [1998], 117b). Panofsky similarly argued for a singular intentionality, or a priori meaning, behind architecture.

53. Krautheimer (1942), 1.

54. On the iconography of the *mihrab,* see G. C. Miles (1952); also various essays in Papadopoulo (1988), especially Bakirer (1988), "Aspects généraux des mihrâb du XIIIème au XVIème siècles dans l'architecture religieuse d'Anatolie," 99-114, and Daoulatli (1988), "Le mihrâb: Signe ou symbole?," 76-79. The symbolic importance of pillars is discussed in Flood (2003) and Asher (1997); see also Irwin (1989). Pillars and columns were also used to symbolize victory in the Middle Ages in Europe, especially in Italy (Camille [1989], 343). For larger studies on architectural iconography and its place in Islamic art and society, see Alami (2011) and Rabbat (2010).

55. Questions of what makes a building "Islamic" are dealt with in O. Grabar (1988), also in the chapter "What Makes Islamic Art Islamic?" in O. Grabar (2006b), 247-251. The question of how to make an existing structure appropriately Islamic continues to be relevant today, with the frequent purchase and reuse of existing buildings as mosques and Islamic community centers, and the pressure felt by minority Muslim communities to make their buildings conform to the expectations of the dominant community.

56. The theoretical point of artistic and architectural cultural translation in Islamic art was first made by Grabar, and has been developed and

utilized effectively by Flood (see Flood [2003] and Flood [2001a], 10-12, 203-206). Less has been done on the process of artistic translation from the Islamic to other cultural spheres, except perhaps to point out that simply subsuming Byzantine and other Eastern Christian arts and practices into a wider "Western" category gives short shrift to Arabic, Syriac, and other "proto-Islamic" artistic contributions (see, for example, Lou'aybi [also known as La'ibi] [2001], 9-41, 63-71). Attempts to link architecture to Islamic metaphysics have been undertaken by Akkach with limited success (Akkach [2005] and [1997]).

57. Flood (2001a), 1-2.
58. Ibid., 214. A critique of those analyses of the mosque that treat it as possessing a monolithic iconographic meaning is found in Rabbat (2003), 90-91. According to Flood, the mosaics in the western arcade represent reworkings of Byzantine iconography adjusted for Muslim needs (2001a, 239).
59. Al-Muqaddasi (1906), 159; al-Muqaddasi (2001), 135-136.
60. Flood (2001a), 233; Rabbat (2003), 94. Flood argues that there is a high degree of thematic unity to the iconography of the mosque, with the Qur'anic verses—especially those on the *qibla* wall—conforming in their eschatological vision with the pictorial decorations (2001a, 238-239).
61. O. Grabar (1959), 57. For Grabar's studies of this important monument, see also O. Grabar (2006a).
62. O. Grabar (1959), 55, 57. Byzantine pilgrims continued to visit Damascus after it came under Islamic rule. For a discussion of the Byzantine practice of using impressive monuments to awe and seduce visitors, see Cormack (1992), 221.
63. Soucek (1976).
64. Rabbat (1989), 13-14.
65. Quoted in Rabbat (1989), 16.
66. Ibid. For a discussion of the inscriptions on the Dome of the Rock, see George (2010), 60-68. Kessler (1970) has discussed the inscriptions in a historical perspective, drawing attention to the fact that the verses that polemically address Christological issues have many more diacritical marks than the rest of the epigraphy, although she demurs from speculating about the significance of this observation.
67. Rabbat (1993), 68. Welch credits 'Abd al-Malik, the first caliph to have been born into the new religious environment amidst Muslim competition with the Byzantines, with setting in motion a new Muslim aesthetic regime centering around the use of epigraphy to signify religious and political authority over the course of his twenty-year rule (Welch [1977], 66-67).

68. Rabbat (1993), 70. Ibn Kathir (d. 1373) takes a much more polemical tone in his discussion of the Dome of the Rock's construction and decoration; along with condemning the behavior of the people who assemble there, he accuses ʿAbd al-Malik of constructing it in order to distract Muslims from pilgrimage to Mecca and encouraging them to visit Jerusalem as a means of increasing his own stature (Ibn Kathir [1998], 12:41–44).

69. Bierman, in rightly taking issue with Grabar's hypothesis that the inscriptions on the Dome of the Rock were meant primarily to humiliate Christians and induce them to convert or submit politically, suggests that different aspects of the structure fulfill different functions, with the Qurʾanic inscriptions directed at Muslims of various sectarian groups and the overall aesthetic aspects intended to impress Christians and missionize (Bierman [1998], 58–59).

70. Ibid., 4, 8.

71. Ibid., 18.

72. Ibid., 4.

73. Thackston (1994), 44–45.

74. Ibid., 45. Cf. Grabar who also argues that the Muslim beholder of Qurʾanic inscriptions would know the Qurʾan by heart and would have found a "minimal 'sign' sufficient" (O. Grabar [1973], 136).

75. Thackston (1994), 44, 46–47.

76. R. Hillenbrand (1986), 172.

77. Ibid., 173. "The virtually total neglect of the rest of the Qurʾan as a quarry for inscriptions says little for the enterprise and imagination of those who decided what texts should be used" (ibid., 175) speaks more to this author's limited understanding of the nature and function of material and visual objects than it does to the talents or intentions of those to whom he refers.

78. R. Hillenbrand (1986), 175. In contrast to Hillenbrand, Dodd sees in the diversity of verses used for architectural epigraphy proof of a "variety and ingenuity" displaying that "they are chosen with intelligent, or at the least, intelligible associations and are intimately related to the overall conception of the decoration" (Dodd and Khairallah [1981], 1:61–62). Atanasiu has taken the novel, if somewhat esoteric, approach of using computer modeling to examine the frequency of appearance of Arabic letters in monumental calligraphy to argue for an intrinsic mystical meaning (Atanasiu [1999]).

79. R. Hillenbrand (1986), 174.

80. Ibid., 175–176. Other verses seem to have gained regional popularity for reasons that are not readily explainable. For another survey of architectural inscriptions, see Dodd and Khairallah (1981).

81. R. Hillenbrand (1986), 178, note 8. Bierman (1998) also links calligraphic script to ideology in her claim that the almost illegible floriated Kufic script was developed to reflect aspects of Fatimid ideology, in particular the belief that esoteric levels of knowledge were accessible only to an Isma'ili elite.

10. Legibility, Iconicity, and Monumental Writing

Epigraph: S. Mehmedinović (1998), *Sarajevo Blues,* translated from the Bosnian by A. Alcalay, San Francisco, City Lights Books, 82. Reprinted by permission of City Lights Books.

1. Among others, these observations have been made in R. Ettinghausen (1974), 297–317; Dodd and Khairallah (1981), 24–25; Fu, Lowry, and Yonemura (1986), 107; and R. Hillenbrand (1986), 178–179.
2. There are marked similarities between the non-Arabic-speaking Islamic world—the major portion of Muslim lands by far—and the Latin West in this regard (cf. Ong [1982], 113). Arabic functioned as a chirographically controlled language that was read and written (with varying degrees of competence) by everyone with a traditional Muslim education; however, with the exception of a highly educated religious elite and a smattering of merchants and travelers, there were no oral users of Arabic in these societies. Written elements in medieval Christian pictures are often unreadable on account of their size, position, or location, such that the text was present in order to authenticate the image. Furthermore, images of saints, even though they had a well-defined language of signs through which they could be identified, were still captioned with text in a pattern of redundancy (Camille [1985], 33) that I discuss later in the chapter in an Islamic context.
3. The Buland Darwaza ("High Gate") has inscriptions of verses Qur'an 39:73–75 (referring to the gates of paradise through which the righteous will be led), 41:53–54 (referring to God showing his signs to the unbelievers), and 41:30–31 (referring to entry into paradise and the angels as protectors) (Thackston [1994], 46). Much has been written about the iconographic changes in early Islamic coinage; of particular interest is the thesis that many Sassanian symbols were replaced by Islamic ones during the reign of 'Abd al-Malik, such as the depiction of Sassanian imperial headgear with the phrase "Caliph of God *(khalīfat Allah)*" and the Zoroastrian fire altar *(gabrī)* with the *mihrab* (G. C. Miles [1952], 159–151). Another very interesting period of shifting signification in Islamic coinage, but which has received little attention from scholars of Islamic art, is that of Ilkhanid rule in the thirteenth century (cf. T. Aykut and Ş. Aydın, eds. [1992], *Ak Akçe: Moğol ve İlhanlı Sikkeleri/Mongol*

and Ilkhanid Coins, English trans. V. T. Saçlıoğlu, Istanbul, Yapı Kredi Yayınları).

4. Begley (1979b). A thorough study of the Taj Mahal's inscriptions as well as historical references to the building is found in Begley and Desai (1989). Begley has been criticized by some art historians for not allowing for multivalent interpretations of the Qur'anic inscriptions on the mausoleum (Blair [1998], 65). For a well-illustrated overview of the Taj Mahal complex, see E. Koch (2006), *The Complete Taj Mahal and the Riverfront Gardens of Agra,* New York, Thames and Hudson.

5. See in this regard Siddiq (2009a) and (2009b); Begley (1985); Nath (1979); Khan (1990); Hasan (2007); and Flood (2010).

6. On the religiously diverse social milieu of Anatolia, see Wolper (2003) and Ocak (1985).

7. For more on the Seljuk attempt to relate to a Byzantine and late antique past, see Redford (1993). For discussions of Seljuk architectural patronage, see Crane (1993).

8. Evliya Çelebi (1896), 213; Bates (1994), 260–261, note 25. For more on the status of Seljuk architecture during the Ottoman period, see Atçekin (1998). For an example of a Seljuk inscription located high on a minaret, see O'Kane (1994).

9. This *madrasa* has not been the subject of concerted study as far as I know. For a brief discussion, see Kuban (2002), 170–172; Karpuz (2001), 52–53.

10. Schick (2008), 209.

11. Gell (1993), 121.

12. Ibid., 217. As Blair has noted, the increased complexity and elaboration of the Arabic script coincided with the proliferation of smaller, regional dynasties (Blair [1998], 80).

13. Gell (1993), 298.

14. Ibid., 303.

15. The role of non-Muslim labor in the construction of the Dome of the Rock and Umayyad Mosque in Damascus has already been mentioned. A similar phenomenon also holds true for South Asian Islamic architecture (Siddiq [2009b], 230).

16. Gell (1993), 303.

17. For a study of architectural examples from Anatolia that combine epigraphy and representations of real or mythical animals in similar ways, though perhaps not for the same purpose, as these *madrasas* from Central Asia, see Gierlichs (2009). See also Diez (1949).

18. An attempt at deciphering the entire epigraphic program of the Karatay Medrese is made in Eminoğlu (1999). See also Kuban (2002), 168–169.

19. The best catalog of such Islamic objects, albeit one limited to artifacts from Anatolia, is Işın (2003; rpt. 2006). See also Farès (1959).

20. Starrett (1995b), 10.

21. Ibid.

22. Gonzalez (2000), 313–340.

23. Examples of pictorial calligraphy, or calligraphic pictures, are found in virtually all publications on Islamic calligraphic arts. They have been the focus of study by Aksel (1967). See also Touati (2003).

24. Schick (2008), 213.

25. Ibid., 214–215.

26. Ibid., 215.

27. Abu 'Isa M. ibn 'Isa al-Tirmidhi (2000), 36–37.

28. Hakani Mehmed Bey (1991), 38; Schimmel (1985). 36; Schick (2008), 211–212. There are numerous other literary works on the physical characteristics of the Prophet and other early Muslim heroes. Among the ones composed in the Ottoman Empire after the *Hilye-i Hakani* are the *Hilye-i çehâryâr-ı güzîn* of İbrahim Cevri Çelebi (d. 1655), *Hilye-i enbiyâ* by Neşati Ahmed Dede (d. 1674), *Nüzhet'ül ahyârfi tercümet iş-şemail* of Nahifi Süleyman Efendi (d. 1738), and *Nâzire-i Hakani* by Arif Süleyman Bey (d. 1769).

29. Al-Tirmidhi's *Shamā'il* was translated into English by Hidayat Hussain in (1933–34), *Islamic Culture*, 7:395–409, 561–572; 8:46–54, 273–289, 364–386, 531–549. Schimmel (1985), 39; Hakani (1991), 40.

30. For more on this subject, see Schimmel (1985), 33–35.

31. From the *Hilyetül-Enver* of Süleyman Nahifi, MS. 2622, İstanbul Üniversitesi Kütüphanesi, Istanbul, according to H. Subaşı (1991), 3:284.

32. Taşkale and Gündüz (2006), 41–43. For other works on the *hilye*, see Taşkale (1990), 7:90–95; Derman (1998b); and Derman (1998c), 34–37, note 3; Acar (1999), 151–161, English text 219–224; Acar (1997), 42:94–100; Gruber (2010b), 130–133. Illustrations of examples from what is probably the finest collection of *hilyes* today are found in Bilgi (2004).

33. Schick (2008), 209–210.

34. Ibid., 210.

35. For a study of the importance of the footprint of the Prophet in South Asia, see Hasan (1993). For a study of the shrine to the footprint of the Prophet in Delhi, see Welch (1997).

36. *"Khō sar par rakhnay kō mil jāy na'l-i pāk-i huzūr / to phir keheyn gay ke hān tājdār ham bhī heyn"* and *"khāī qur'ān nay khāk-i guzar kī qasam / is kaf-i pā-yi hurmat pe lākhōn salām."* For more on prophetic relics, including the footprint and the sandal, see Wheeler (2006), 71–98, and Schimmel (1985), 39–42. There are many works written across the Islamic world in

praise of the sandal of the Prophet. See, for example, the seventeenth-century work by al-Tilimsani (2006). Al-Tirmidhi devotes a chapter to the sandal of the Prophet in his *Shamā'il* ([2000], 69–73).

37. For examples, see Roberts and Roberts (2003) and (2000), and Frembgen (2006) and (1998).

38. For examples of such paintings, see Parker and Neal (1995). The paintings are often a collective enterprise, made in the pilgrim's absence and usually completed in under a week (Campo [1987], 287).

39. Gonzalez (2000), 314. Cf. Campo (1987), who claims that the paintings comprise two semiotic classes for the most part, distinguishing between "epigraphic formulae in Arabic" and "iconic figures" (291): "The thematic divisions in each class are not mutually exclusive. Nor is one class completely independent of the other. For example, the degree of unity attained among epigraphic formulae becomes apparent when it is recalled that God is the ultimate agent of blessing and victory, the creator of space (sacred and otherwise) and authority behind the institution of pilgrimage rites, and that Muhammad—founder of the community and mosque at Medina, pilgrimage reformer, and conqueror of Mecca—is his instrument. Within the class of iconic figures, flowers can be linked with little difficulty to talismanic figures, to native definitions of femininity and family life, and to the symbology of holy places as gardens and earthly bits of paradise." Ibid., 295.

40. See Elias (2011), especially chapters 7, 8, and 9.

41. Ibid., 114–116.

42. Ibid., 119–122. See also Elias (2003). Aside from the religious motifs and symbols, those representing an idealized or imagined life and scenes from modern life appear mostly on the sides and the back—they are very rarely seen on the front. The name of the truck company and other spatial and locational signifiers normally appear on the sides, which is also where most naturalistic pictures are likely to be (the name of the truck typically appears on the front, and might include the company's name, but here it functions as an identity marker rather than a spatial one). Humorous statements are almost invariably on the back of the truck and serious ones (particularly poetry) on the front, although witticisms and examples of folk wisdom do appear on the rear, but very seldom on the sides.

43. Elias (2003), 192–193.

44. Gonzalez (2000), 319.

45. Schick (2008), 210. An example of such a book being referred to as a prayer manual is found in Gruber (2010).

46. Gonzalez (2000), 320.

47. The phenomenon of pseudo-Arabic is discussed briefly in Gonzalez (2001), 99, and Behrens-Abouseif (1998), 141.

48. Bakhtin (1981), 293-294; St. George (1998), 4.

49. I am borrowing this term from Ricoeur (1976), 40.

50. Gonzalez (2000), 330-331.

Epilogue

Epigraph: Agha Shahid Ali (1997), *The Country without a Post Office*, New York, W. W. Norton, 65.

1. Mitchell (1986), 157-158.

2. Mitchell (2011), 31.

3. Ibid., 33.

4. Krautheimer (1969), 149; Crossley (1988), 121b.

5. Merleau-Ponty (1964), 170; cf. Rotman (2009), 19.

6. Morgan (1998), 202.

7. Guha-Thakurta (2003), 110.

8. Cassidy (1993), 10.

Bibliography

Abdel Daïm, A. (1958). *L'oniromancie arabe d'après Ibn Sirin*. Damascus: Presses Universitaires de Damas.

Abu Deeb, Kamal (1979). *Al-Jurjānī's Theory of Poetic Imagery*. Approaches to Arabic Literature, no. 1. London: Aris and Phillips.

Abu'l-Fazl Nagori (1872). *Ā'īn-i Akbarī*. Edited by H. Blochmann. 2 vols. Calcutta: Baptist Mission Press.

Acar, M. Şinasi (1997). "Hilyeler." *Antik ve Dekor* 42: 94–100.

—— (1999). *Türk Hat Sanatı: Araç, Gereç ve Formlar* [Turkish Calligraphy: Materials, Tools and Forms]. Istanbul: Antik.

Aertsen, Jan A. (2006). "The Triad 'True-Good-Beautiful': The Place of Beauty in the Middle Ages." Paper presented at *Intellect et imagination dans la philosophie médiévale / Intellect and Imagination in Medieval Philosophy / Intelecto e imaginação na Filosofia Medieval. Société Internationale pour l'Étude de la Philosophie Médiévale, Rencontres de Philosophie Médiévale, 11, 1, Porto, 2002*. Vol. 1. Edited by Maria Candida Pacheco and José F. Meirinhos. Porto: Brepols, 415–435.

Aflaki al-'Arifi, Shams al-din A. al- (1976). *Manāqib al-'ārifīn*. Edited by Tahsin Yazıcı. 2 vols. Türk Tarih Kurumu Yayınları, 3rd series, no. 3. Ankara: Türk Tarih Kurumu Basımevi.

Afrasiyabpur, ʿAli Akbar (2001). *Zībāi parastī dar ʿirfān-i islāmī*. Tehran: Intish-ārāt-i Tuhūrī.

Akimushkin, Oleg F., Anas B. Khalidov, and Efim A. Rezvan (1995). "The Triumph of the Qalam." In *Pages of Perfection: Islamic Paintings and Calligraphy from the Russian Academy of Sciences, St. Petersburg*. Edited by Yuri A. Petrosyan et al. Lugano: ARCH Foundation, 35–75.

Akın-Kıvanç, Esra, ed. and trans. (2011). *Mustafa ʿÂli's Epic Deeds of Artists: A Critical Edition of the Earliest Ottoman Text about the Calligraphers and Painters of the Islamic World*. Islamic History and Civilization, vol. 87. Leiden: E. J. Brill.

Akkach, Samer (1997). "The World of Imagination in Ibn ʿArabi's Ontology." *British Journal of Middle Eastern Studies* 24(1): 97–113.

—— (2005). *Cosmology and Architecture in Premodern Islam*. Suny Series in Islam. Edited by S. H. Nasr. Albany: SUNY Press.

Aksel, Malik (1967). *Türklerde Dinî Resimler: Yazı-Resim*. Istanbul: Elif Yayınları.

Al-Bagdadi, N. (2006). "The Other Eye: Sight and Insight into Arabic Classical Dream Literature." *The Medieval History Journal* 9: 115–141.

Al-Faruqi, Lois Ibsen (1985). "An Islamic Perspective on Symbolism in the Arts: New Thoughts on Figural Representation." In *Art, Creativity, and the Sacred: An Anthology in Religion and Art*. Edited by Diane Apostolos-Cappadona. New York: Crossroad, 164–178.

Alam, Muzaffar, and Sanjay Subrahmanyam (2007). *Indo-Persian Travels in the Age of Discoveries, 1400–1800*. Cambridge: Cambridge University Press.

Alami, Mohammed Hamdouni (2011). *Art and Architecture in the Islamic Tradition: Aesthetics, Politics and Desire in Early Islam*. London: I. B. Tauris.

Alexandrin, Elizabeth R. (2011). "Witnessing the Lights of the Heavenly Dominion: Dreams, Visions and the Mystical Exegeses of Shams al-Dīn al-Daylamī." In *Dreams and Visions in Islamic Society*. Edited by Özgen Felek and Alexander D. Knysh. Albany: SUNY Press, 215–231.

Alfarabi. *See* Farabi, Abu Nasr al-.

Ali, Wijdan (2001). "From the Literal to the Spiritual: The Development of the Prophet Muhammad's Portrayal from 13th Century Ilkhanid Miniatures to 17th Century Ottoman Art." In *Proceedings of the 11th International Congress of Turkish Art, Utrecht—the Netherlands, August 23–28, 1999*. Edited by M. Kiel, N. Landman, and H. Theunissen. No. 7: 1–24.

Allen, Terry (1988). *Five Essays on Islamic Art*. Sebastopol, CA: Solipsist Press.

—— (1993). *Imagining Paradise in Islamic Art*. Sebastopol, CA: Solipsist Press.

Alparslan, Ali (1999; rpt. 2004). *Osmanlı Hat Sanatı Tarihi*. Istanbul: Yapı Kredi Yayınları.

Al-Tawil, Hashim (1993). "Early Arabic Icons: Literary and Archaeological Evidence for the Cult of Religious Images in Pre-Islamic Arabia." PhD dissertation. University of Iowa.

Anastos, Milton V. (1954). "The Ethical Theory of Images Formulated by the Iconoclasts in 754 and 815." *Dumbarton Oaks Papers* 8: 151–160.

Anawati, Georges (1971). "Avicenne et alchemie." In *Convegno internazionale* 9–15, April 1969, Accademia Nazionale dei Lincei, Atti 13, Rome, 285–341.

Apostolos-Cappadona, Diane, ed. (1985). *Art, Creativity and the Sacred: An Anthology in Religion and Art.* New York: Crossroads.

Aquinas, St. Thomas (1920; online ed. 2008). *The Summa Theologica of St. Thomas Aquinas.* 2nd edition. Translated by the Fathers of the English Dominican Province. Online edition K. Knight (http://www.newadvent.org/summa/index.html).

Arberry, Arthur J. (1951). *Avicenna on Theology.* London: John Murray.

Ardalan, Nader (1980). "The Visual Language of Symbolic Form: A Preliminary Study of Mosque Architecture." In *Architecture as Symbol and Self-Identity: Proceedings of Seminar Four in the Series Architectural Transformations in the Islamic World, Held in Fez, Morocco, October 9–12, 1979.* Edited by Jonathan G. Katz and Robert Miller. Cambridge, MA: Aga Khan Awards, 18–36.

Argan, Giulio Carlo (1975). "Ideology and Iconology." Translated by Rebecca West. *Critical Inquiry* 2:2 (Winter): 297–305.

Arkoun, M., Jacques Le Goff, Toufic Fahd, and Maxime Rodinson (1978). *L'etrange et le merveilleux dans l'Islam médiéval.* Paris: Editions J. A. and l'Institut du Monde Arabe.

Armstrong, Robert Plant (1971). *The Affecting Presence: An Essay in Humanistic Anthropology.* Urbana: University of Illinois Press.

—— (1981). *The Powers of Presence: Consciousness, Myth and Affecting Presence.* Philadelphia: University of Pennsylvania Press.

Arnheim, Rudolf (1971). *Visual Thinking.* Berkeley: University of California Press.

—— (1974). *Art and Visual Perception: A Psychology of the Creative Eye.* Berkeley: University of California Press.

Arnold, Thomas W. (1965). *Painting in Islam: A Study of the Place of Pictorial Art in Muslim Culture.* New York: Dover Publications.

Asani, Ali S. (1995). *Celebrating Muhammad: Images of the Prophet in Popular Muslim Piety.* Columbia: University of South Carolina Press.

Asher, Catherine B. (1997). "Appropriating the Past: Jahāngīr's Pillars." *Islamic Culture* 71:4 (October): 1–16.

Atanasiu, Vlad (1999). *De la fréquence des lettres et de son influence en calligraphie arabe.* Paris: L'Harmattan.

Atçekin, Zeki (1998). *Konya'daki Selçuklu Yapılarının Osmanlı Devrinde Bakımı ve Kullanılması.* Türk Tarih Kurumu Yayınları, vol. 46. Ankara: Türk Tarih Kurumu Basımevi.

'Attar, Farid al-din (1963). *Mantiq al-tayr.* Edited by S. S. Gowharin. Tehran: Shirkat-i intishārāt-i 'ilmi wa farhangī.

—— (1984). *The Conference of the Birds.* Translated by Afkham Darbandi and Dick Davis. London: Penguin.

Avicenna. *See* Ibn Sina, 'Abu Ali.

Aziza, Mohamed (1978). *L'image et l'Islam: L'image dans la société arabe contemporaine.* Paris: Albin Michel.

Azraqi, Abu al-Walid Muhammad al- (1978). *Akhbār Makka wa-mā jā'a fīhā min al-āthār.* Edited by Rushdi al-Salih Malhas. 2 vols. Mecca: Matābi' dār al-thiqāfa.

Babb, L. Alan (1981). "Glancing: Visual Interaction in Hinduism." *Journal of Anthropological Research* 37(4): 378–410.

Babur, Zahiruddin M. (1993). *Baburnama.* Edited with Persian trans. of 'Abd al-Rahim Khankhanan by W. M. Thackston. 3 vols. Sources of Oriental Language and Literatures, no. 18. Cambridge, MA: Department of Near Eastern Languages and Civilizations, Harvard University.

Baer, Eva (2004). *The Human Figure in Islam Art: Inheritances and Islamic Transformations.* Bibliotheca Iranica, Islamic Art and Architecture Series, no. 11. Costa Mesa: Mazda Publishers.

Bahrani, Zainab (1995). "Assault and Abduction: The Fate of the Royal Image in the Ancient Near East." *Art History* 18:3 (September): 363–382.

Baily, F. W. (1931). "The Word 'But' in Iranian." *Bulletin of the School of Oriental and African Studies* 6(2): 279–283.

Baker, Patricia L. (2003). *Islam and the Religious Arts.* London: Continuum Books.

Bakhtin, Mikhail M. (1981). *The Dialogic Imagination: Four Essays.* Edited by Michael Holquist. Translated by M. Holquist and Caryl Emerson. University of Texas Press Slavic Series, no. 1. Austin: University of Texas Press.

Bakirer, Ö. (1988). "Aspects généraux des mihrâb du XIIIème au XVIème siècles dans l'architecture religieuse d'Anatolie." In *Le mihrāb dans l'architecture et la religion musulmanes.* Edited by Alexandre Papadopoulo. Leiden: E. J. Brill, 99–114.

Baladhuri, A. ibn Y. ibn Jabir al- (1956). *Kitāb futūh al-buldān.* 3 vols. Edited by Salah al-din al-Munjid. Cairo: Maktaba al-nahda al-misriyya.

Bar Hebraeus. *See* Ibn al-'Ibri, Gregorios al-Malati.

Barasch, Moshe (1992). *Icon: Studies in the History of an Idea*. New York: New York University Press.

Barber, Charles (1993). "From Transformation to Desire: Art and Worship after Byzantine Iconoclasm." *Art Bulletin* 75:1 (March): 7–16.

Barnard, Leslie W. (1974). *The Graeco-Roman and Oriental Background of the Iconoclastic Controversy*. Byzantina Neerlandica, vol. 5. Leiden: E. J. Brill.

—— (1975). *Iconoclasm: Papers Given at the Ninth Spring Symposium of Byzantine Studies, University of Birmingham*. Edited by A. Bryer and J. Herrin. Birmingham, UK: Center for Byzantine Studies, University of Birmingham, 7–13.

—— (1981). "The Sources of the Byzantine Controversy: Leo III and Yazid II–A Reconsideration." In *Überlieferungsgeschichtliche Untersuchungen*. Edited by Franz Paschke. Berlin: Akademie-Verlag, 29–37.

Barrucand, Marianne (1995). "Les fonctions de l'image dans la société islamique du moyen-age." In *L'image dans le monde arabe*. Edited by Gilbert Beaugé and Jean-François Clément. Paris: CNRS, 59–68.

Barry, Michael (2004). *Figurative Art in Medieval Islam and the Riddle of Bihzad of Herat (1465–1535)*. Paris: Flammarion.

Barthes, Roland (1967). *Elements of Semiology*. Translated by Annette Lavers and Colin Smith. New York: Hill and Wang.

—— (1977; rpt. 1989). *Image–Music–Text*. Translated by Stephen Heath. New York: Noonday Press.

—— (1981). *Camera Lucida: Reflections on Photography*. Translated by Richard Howard. New York: Hill and Wang.

—— (1982). *Empire of Signs*. Translated by Richard Howard. New York: Hill and Wang.

Bashier, Salman H. (2004). *Ibn al-'Arabi's Barzakh: The Concept of the Limit and the Relationship between God and the World*. Albany: SUNY Press.

Bashir, Shahzad (2011a). "Narrating Sight: Dreaming as Visual Training in Persianate Sufi Hagiography." In *Dreams and Visions in Islamic Societies*. Edited by Özgen Felek and Alexander D. Knysh. Albany: SUNY Press, 233–247.

—— (2011b). *Sufi Bodies: Religion and Society in Medieval Islam*. New York: Columbia University Press.

Bates, Ülkü (1994). "Evliya Çelebi's Comments on the Saljūqs of Rūm." In *The Art of the Saljuqs in Iran and Anatolia*. Edited by Robert Hillenbrand. Costa Mesa: Mazda Publishers, 257–262.

Baudrillard, Jean (1988). *Selected Writings*. Edited by Mark Poster. Stanford: Stanford University Press.

—— (1994). *Simulacra and Simulation*. Translated by Sheila Faria Glaser. Ann Arbor: University of Michigan Press.

—— (1996). *The System of Objects*. Translated by James Benedict. London: Verso.

Bayhaqi, Abu Bakr Ahmad ibn al-Husayn al- (1985). *Dalāʾil al-nubuwwa*. Edited by ʿAbd al-Muʿti Qalʿaji. Beirut: Dār al-kutub al-ʿilmiyya.

Baynes, Norman Hepburn. (1955). *Byzantine Studies and Other Essays*. London: Athlone Press.

Beaugé, Gilbert, and Jean-François Clément, eds. (1995). *L'image dans le monde arabe*. Collection "Études de l'Annuaire de l'Afrique du Nord." Paris: CNRS.

Begley, Wayne E. (1979a). "Amanat Khan and the Calligraphy on the Taj Mahal." *Kunst des Orients* 12: 5–60.

—— (1979b). "The Myth of the Taj Mahal and a New Theory of Its Symbolic Meaning." *Art Bulletin* 61: 7–37.

—— (1985). *Monumental Islamic Calligraphy from India*. Preface by Z. A. Desai. Villa Park, IL: Islamic Foundation.

Begley, Wayne E., and Z. A. Desai (1989). *Taj Mahal, the Illumined Tomb: An Anthology of Seventeenth-Century Mughal and European Documentary Sources*. Cambridge, MA: Aga Khan Program for Islamic Architecture.

Behrens-Abouseif, Doris (1998). *Beauty in Arabic Culture*. Princeton Series on the Middle East. Princeton: Markus Wiener.

Bell, Catherine (1992). *Ritual Theory, Ritual Practice*. New York: Oxford University Press.

Bellamy, J. A. (1951). "The *Kitāb ar-Rumūz* of Ibn Abī Sarh." *Journal of the American Oriental Society* 81(3): 224–246.

Belting, Hans (1994). *Likeness and Presence: A History of the Image before the Era of Art*. Translated by Edmund Jephcott. Chicago: University of Chicago Press.

Benaïssa, Omar (1999). "The Diffusion of Akbarian Teaching in Iran During the 13th and 14th Centuries." *Journal of the Muhyiddin Ibn ʿArabi Society* 26: 89–109.

Berlekamp, Persis (2003). "Painting as Persuasion: A Visual Defense of Alchemy in an Islamic Manuscript of the Mongol Period." *Muqarnas* 20: 35–59.

—— (2011). *Wonder, Image and Cosmos in Medieval Islam*. New Haven: Yale University Press.

Besançon, Alain (2000). *The Forbidden Image: An Intellectual History of Iconoclasm*. Translated by Jane Marie Todd. Chicago: University of Chicago Press.

Bierman, Irene A. (1998). *Writing Signs: The Fatimid Public Text*. Berkeley: University of California.

Bilgi, Hülya, ed. (2004). *Gönülden bir Tutku: Sevgi Gönül Hat Koleksiyonu* [A Heartfelt Passion: The Sevgi Gönül Calligraphy Collection]. Istanbul: Vehbi Koç Vakfı.

Blair, Sheila (1996). "Timurid Signs of Sovereignty." La Civiltà Timuride come Fenomeno internazionale. *Oriente Moderno,* new series 15: 551–576.

—— (1998). *Islamic Inscriptions.* New York: New York University Press.

—— (2006). *Islamic Calligraphy.* Edinburgh: Edinburgh University Press.

Bland, Kalman P. (2000). *The Artless Jew: Medieval and Modern Affirmations and Denials of the Visual.* Princeton: Princeton University Press.

Bosworth, Clifford E. (1965). "Notes on the Pre-Ghaznavid History of Eastern Afghanistan." *Islamic Quarterly* 9: 12–24.

—— (1966). "Mahmud of Ghazna in Contemporary Eyes and in Later Persian Literature." *Iran* 4: 85–92.

—— (1968). "The Development of Persian Culture under the Early Ghaznavids." *Iran* 6: 33–44.

—— (1984). "The Coming of Islam to Afghanistan." In *Islam in Asia.* Edited by Y. Friedmann. Jerusalem: Magnes Press, Hebrew University, 1–22.

Bourdieu, Pierre (1977; rpt. 2006). *Outline of a Theory of Practice.* Cambridge Studies in Social and Cultural Anthropology, vol. 16. Cambridge: Cambridge University Press.

—— (1990). *The Logic of Practice.* Translated by Richard Nice. Stanford: Stanford University Press.

—— (1993). *The Field of Cultural Production: Essays on Art and Literature.* Edited by Randal Johnson. New York: Columbia University Press.

Bouyges, Maurice (1959). *Essai de chronologie des oeuvres de al-Ghazali (Algazel).* Edited by Michel Allard. Recherches, vol. 14. Beirut: Imprimerie Catholique.

Bowman, Alan K., and Greg Woolf (1994). *Literacy and Power in the Ancient World.* Cambridge: Cambridge University Press.

Boyce, Mary (1975). "Iconoclasm among the Zoroastrians." In *Christianity, Judaism and Other Greco-Roman Cults: Studies for Morton Smith at Sixty.* Edited by Jacob Neusner. Leiden: E. J. Brill, 93–111.

Brinner, William M., trans. (2002). *'Arā'is al-majālis fī qisas al-anbiyā', or "Lives of the Prophets" as Recounted by Abū Ishāq Ahmad ibn Muhammad ibn Ibrāhīm al-Tha'labī.* Studies in Arabic Literature, vol. 24. Leiden: E. J. Brill.

Brock, S. P. (1994). "Greek and Syriac in Late Antique Syria." In *Literacy and Power in the Ancient World.* Edited by Alan K. Bowman and Greg Woolf. Cambridge: Cambridge University Press, 149–160.

Brown, Robert L. (1997). "Narrative as Icon: The Jātaka Stories in Ancient Indian and Southeast Asian Architecture." In *Sacred Biography in the Buddhist Traditions of South and Southeast Asia.* Edited by Juliane Schober. Honolulu: University of Hawai'i Press, 64–109.

—— (1998a). "Expected Miracles: The Unsurprisingly Miraculous Nature of Buddhist Images and Relics." In *Images, Miracles, and Authority in Asian*

Religious Traditions. Edited by Richard H. Davis. Boulder: Westview Press, 23–35.

—— (1998b). "The Miraculous Buddha Image: Portrait, God, or Object?" In *Images, Miracles, and Authority in Asian Religious Traditions*. Edited by Richard H. Davis. Boulder: Westview Press, 37–54.

Brubaker, Leslie (1989a). "Byzantine Art in the Ninth Century: Theory, Practice and Culture." *Byzantine and Modern Greek Studies* 13: 23–93.

—— (1989b). "Perception and Conception: Art, Theory and Culture in Ninth-Century Byzantium." *Word and Image* 5: 19–32.

—— (2010). "Icons and Iconomachy." In *A Companion to Byzantium*. Edited by Liz James. Oxford: Wiley-Blackwell, 323–337.

Brubaker, Leslie, and John Haldon (2011). *Byzantium in the Iconoclast Era c. 680–850: A History*. Cambridge: Cambridge University Press.

Bryce, A. H., and H. Campbell, trans. (1871). *The Seven Books of Arnobius Adversus Gentes*. Ante-Nicene Christian Library, no. 19. Edinburgh: T. and T. Clark.

Bryson, Norman (1981). *Word and Image: French Painting of the Ancien Régime*. Cambridge: Cambridge University Press.

Buckley, Theodore Alois, ed. (1869). *The Odyssey of Homer, with the Hymns, Epigrams, and Battle of the Frogs and Mice*. London: Bell and Daldy.

Buck-Morss, Susan (1992). "Aesthetics and Anaesthetics: Walter Benjamin's Artwork Essay Reconsidered." *October* 62 (Autumn): 3–41.

Bulliet, Richard W. (1994). *Islam: The View from the Edge*. New York: Columbia University Press.

Burks, Arthur (1949). "Icon, Index and Symbol." *Philosophy and Phenomenological Research* 9: 673–689.

Bustani, Butrus al-, ed. (1957). *Rasā'il Ikhwān al-Safā' wa-khillān al-wafā*. Beirut: n.p.

Bynum, Caroline (1997). "Wonder." *American Historical Review* 102:1 (February): 1–26.

Calasso, G. (1992). "Les ramparts et la loi, les talismans et les saints." *Bulletin d'Études Orientales* 44: 83–104.

Calder, Norman (1994). "The Barāhima: Literary Construct and Historical Reality." *Bulletin of the School of Oriental and African Studies* 51: 40–51.

Calvin, John (1989). *Institutes of the Christian Religion*. Translated by Henry Beveridge. Grand Rapids: Eerdmans.

Cameron, Averil (1992). "The Language of Images: The Rise of Icons and Christian Representation." In *The Church and the Arts*. Edited by Diana Wood. Oxford: Blackwell Publishers, 1–42.

—— (1994). "Texts as Weapons: Polemic in the Byzantine Dark Ages." In *Literacy and Power in the Ancient World*. Edited by Alan K. Bowman and Greg Woolf. Cambridge: Cambridge University Press, 198–215.

Camille, Michael (1985). "Seeing and Reading: Some Visual Implications of Medieval Literacy and Illiteracy." *Art History* 8(1): 26–49.

—— (1989). *The Gothic Idol: Ideology and Image-Making in Medieval Art.* Cambridge New Art History and Criticism. Cambridge: Cambridge University Press.

—— (1993). "Mouths and Meanings: Towards an Anti-Iconography of Medieval Art." In *Iconography at the Crossroads: Papers from the Colloquium Sponsored by the Index of Christian Art, Princeton University, 23–24 March 1990.* Edited by Brendan Cassidy. Princeton: Index of Christian Art, Department of Art and Archaeology, Princeton University, 43–54.

Campbell, Shirley (2001). "The Captivating Agency of Art: Many Ways of Seeing." In *Beyond Aesthetics: Art and the Technologies of Enchantment.* Edited by Christopher Pinney and Nicholas Thomas. Oxford: Berg, 117–135.

Campo, Juan E. (1987). "Shrines and Talismans: Domestic Islam in the Pilgrimage Paintings of Egypt." *Journal of the American Academy of Religion* 55(2): 285–305.

Cantarino, Vincente (1975). *Arabic Poetics in the Golden Age: Selection of Texts accompanied by a Preliminary Study.* Leiden: E. J. Brill.

Cassidy, Brendan, ed. (1993). *Iconography at the Crossroads: Papers from the Colloquium Sponsored by the Index of Christian Art, Princeton University, 23–24 March 1990,* Index of Christian Art, Occasional Papers II. Princeton: Index of Christian Art, Department of Art and Archaeology, Princeton University.

Centlivres, Pierre (2002). "Life, Death, and Eternity of the Buddhas in Afghanistan." In *Iconoclash: Beyond the Image Wars in Science, Religion, and Art.* Edited by Bruno Latour and Peter Weibel. Karlsruhe and Cambridge, MA: ZKM and MIT Press, 75–77.

Centlivres, Pierre, and Micheline Centlivres-Demont (1997). *Imageries populaires en Islam.* Geneva: Georg Editeur.

Chejne, A. G. (1992). *Ibn Hazm.* Chicago: Kazi Publications.

Chidester, David (1992). *Word and Light: Seeing, Hearing, and Religious Discourse.* Urbana: University of Illinois Press.

Chittick, William C. (1982). "Ibn 'Arabi's Own Summary of the *Fuṣūs:* The Imprint of the Bezels of Wisdom." *Journal of the Muhyiddin Ibn 'Arabi Society* 1: 30–93.

—— (1989). *The Sufi Path of Knowledge: Ibn al-'Arabi's Metaphysics of Imagination.* Albany: SUNY Press.

—— (1994), *Imaginal Worlds: Ibn al-'Arabī and the Problem of Religious Diversity.* Albany: SUNY Press.

—— (1998). *The Self-Disclosure of God: Principles of Ibn al-'Arabi's Cosmology.* Albany: SUNY Press.

Christensen, C. C. (1977). *Art and the Reformation in Germany*. Athens: Ohio University Press.

Clément, Jean-François (2002). "The Empty Niche of the Bāmiyān Buddha." In *Iconoclash: Beyond the Image Wars in Science, Religion, and Art*. Edited by Bruno Latour and Peter Weibel. Karlsruhe and Cambridge, MA: ZKM and MIT Press, 218-220.

Coates, Peter (2002). *Ibn 'Arabi and Modern Thought: The History of Taking Metaphysics Seriously*. Oxford: Anqa Publishing.

Colson, F. H., and G. H. Whitaker, trans. (1929; rpt. 1968). *Philo II: On the Giants*. Cambridge, MA: Loeb Classic Library.

Contadini, Anna, ed. (2007). *Arab Painting: Text and Image in Illustrated Arabic Manuscripts*. Handbuch der Orientalistik, vol. 90. Leiden: E. J. Brill.

Corbin, Henry (1960). *Avicenna and the Visionary Recital*. Translated by Willard R. Trask. Bollingen Series, no. 66. New York: Pantheon Books.

—— (1966). "The Visionary Dream in Islamic Spirituality." In *The Dream and Human Societies*. Edited by Gustav von Grunebaum and Roger Caillois. Berkeley: University of California Press, 381-408.

Cormack, Robin (1992). "But Is It Art?" In *Byzantine Diplomacy: Papers from the Twenty-Fourth Spring Symposium of Byzantine Studies, Cambridge, March 1990*. Edited by Jonathan Shepard and Simon Franklin. Aldershot, UK: Variorum, 219-236.

Crane, H. (1993). "Notes on Saldjūk Architectural Patronage in Thirteenth Century Anatolia." *Journal of the Economic and Social History of the Orient* 36(1): 1-57.

Creswell, K. A. C. (1946). "The Lawfulness of Painting in Early Islam." *Ars Islamica* 11-12: 159-166.

Crone, Patricia (1980). "Islam, Judeo-Christianity and Byzantine Iconoclasm." *Jerusalem Studies in Arabic and Islam* 2: 59-95.

Crossley, Paul (1988). "Medieval Architecture and Meaning: The Limits of Iconography." *Burlington Magazine*, February: 116-121.

Csikszentmihalyi, Mihaly (1993). "Why We Need Things." In *History from Things: Essays on Material Culture*. Edited by Steven Lubar and W. David Kingery. Washington, DC: Smithsonian Institution Press, 20-29.

Cutler, Anthony (2001). "Gifts and Gift Exchange as Aspects of the Byzantine, Arab, and Related Economies." *Dumbarton Oaks Papers* 55: 245-276.

Daghir, Sharbal (or Shirbel) (1990). *Al-Hurūfiyya al-'arabiyya: al-fann wa'l-huwiyya*. Beirut: Sharikat al-matbū'at li'l-tawzī' wa'l-nashr.

—— (1998). *Madhāhib al-husn: qirā'a mu'jamiyya tā'rīkhiyya li'l-funūn fi'l-'arabiyya*. Amman: Royal Society of Fine Arts (al-Jam'iyya al-malakiyya li'l-funūn al-jamīliyya) and Al-markaz al-thiqāfī al-'arabī.

Dahiyat, Ismail M. (1974). *Avicenna's Commentary on the Poetics of Aristotle: A Critical Study with an Annotated Translation of the Text.* Leiden: E. J. Brill.

Daiber, Hans (1986). "Prophetie und Ethik bei Fārābī (gest. 339/950)." In *L'homme et son univers au Moyen Age: Actes du septième Congrès international de philosophie médiévale (30 Août–4 Septembre 1982).* Edited by Christian Wenin. Lovain-La-Neuve: 2:729–741.

Danishpazhuh, M. T. (1977). "Rang-sāzī dar kāghaz wa rang zadā'ī az ān." *Hunar wa mardum* 86–87: 16–36.

Danto, Arthur C. (1999). "Moving Pictures." In *Philosophizing Art: Selected Essays.* Berkeley: University of California Press, 205–232.

Daoulatli, Abdelaziz (1988). "Le mihrâb: Signe ou symbole?" In *Le mihrâb dans l'architecture et la religion musulmanes.* Edited by Alexandre Papadopoulo. Leiden: E. J. Brill, 76–79.

Davis, Richard H. (1993). "Indian Art Objects as Loot." *Journal of Asian Studies* 52(1): 22–48.

—— (1994). "Trophies of War: The Case of the Chalukya Intruder." In *Perceptions of South Asia's Visual Past.* Edited by Catherine B. Asher and Thomas R. Metcalf. Delhi: Oxford University Press, 151–177.

—— (1997). *Lives of Indian Images.* Princeton: Princeton University Press.

——, ed. (1998). *Images, Miracles, and Authority in Asian Religious Traditions.* Boulder: Westview Press.

Denery, Dallas G., II (2005). *Seeing and Being Seen in the Later Medieval World: Optics, Theology and Religious Life.* Cambridge Studies in Medieval Life and Thought. Cambridge: Cambridge University Press.

Derman, M. Uğur (1998a). *The Art of Calligraphy in the Islamic Heritage.* Translated by M. Zakariya and M. Asfour. Istanbul: IRCICA.

—— (1998b). "Hilye." In *İslam Ansiklopedisi,* vol. 18. Istanbul: Türkiye Diyanet Vakfı, 44–51.

—— (1998c). *Letters in Gold: Ottoman Calligraphy from the Sakip Sabancı Collection, Istanbul.* Translated by M. Zakariya. New York: Metropolitan Museum of Art.

Diez, Ernst (1949). "The Zodiac Reliefs at the Portal of the Gök Medrese in Siwas." *Artibus Asiae* 12(1–2): 99–104.

Dinawari, Ahmad ibn Da'ud al- (1960). *Al-akhbār al-tiwāl.* Edited by 'Abd al-Mun'im 'Amir. Cairo: Wizārat al-thiqāfa wa'l-irshād al-qawmī.

Dinawari al-Qadiri, Abu Sa'd Nasr ibn Ya'qub al- (1997). *Kitāb al-ta'bīr fī'l-ru'yā aw al-qādirī fī'l-ta'bīr.* Edited by Fahmi Sa'd. 2 vols. Beirut: 'Ālam al-kitāb.

Dodd, Erica Cruikshank (1969). "The Image of the Word: Notes on the Religious Iconography of Islam." *Berytus* 18: 35–79.

Dodd, Erica Cruikshank, and Shereen Khairallah (1981). *The Image of the Word: A Study of Quranic Verses in Islamic Architecture.* 2 vols. Beirut: American University of Beirut.

Eaton, Richard M. (2000). "Temple Desecration and Indo-Muslim States." In *Beyond Turk and Hindu: Rethinking Religious Identity in Islamicate South Asia.* Edited by David Gilmartin and Bruce B. Lawrence. Gainesville: University Press of Florida, 246–281.

Eck, Diana L. (1981). *Darśan: Seeing the Divine Image in India.* Chambersburg, PA: Anima Books.

Eckhardt, Alexandre (1949). "Le cercueil flottant de Mahomet." In *Mélanges de philologie roman et de littérature médiévale offert à E. Hoepffner.* Strasbourg: Publication de la Faculté des Lettres de l'Université de Strasbourg, fasc. 113: 77–88.

Eco, Umberto (1976; rpt. 1979). *A Theory of Semiotics.* Edited by Thomas A. Sebeok. Bloomington: Indiana University Press.

—— (1986). *Art and Beauty in the Middle Ages.* New Haven: Yale University Press.

—— (1990; rpt. 1994). *The Limits of Interpretation.* Edited by Thomas A. Sebeok. Bloomington: Indiana University Press.

Efimova, Alla (1997). *Communist Nostalgia: On Soviet Aesthetics and Post-Soviet Memory.* PhD dissertation. University of Rochester: Department of Art and Art History.

Eire, Carlos M. N. (1986). *War against the Idols: The Reformation of Worship from Erasmus to Calvin.* Cambridge: Cambridge University Press.

El Cheikh, Nadia M. (1999). "Muhammad and Heraclius: A Study in Legitimacy." *Studia Islamica* 89: 5–21.

—— (2004). *Byzantium Viewed by the Arabs.* Harvard Middle Eastern Monographs, vol. 36. Cambridge, MA: CMES of Harvard University.

Elias, Jamal J. (1995). *The Throne Carrier of God: The Life and Thought of 'Alā' ad-dawla as-Simnānī.* Albany: SUNY Press.

—— (2003). "On Wings of Diesel: Spiritual Space and Religious Imagination in Pakistani Truck Decoration." *RES: Anthropology and Aesthetics* 43 (Spring): 187–202.

—— (2005). "Truck Decoration and Religious Identity: Material Culture and Social Function in Pakistan." *Material Religion* 1:1 (March): 48–71.

—— (2007). "Un/Making Idolatry: From Mecca to Bamiyan." *Future Anterior: Journal of Historic Preservation* 4:2 (Winter): 12–29.

—— (2011). *On Wings of Diesel: Trucks, Identity and Culture in Pakistan.* Oxford: Oneworld Publications.

Elkins, James (1996). *The Object Stares Back: On the Nature of Seeing.* San Diego: Harcourt.

Eminoğlu, Mehmet (1999). *Karatay Medresesi Yazı İnciler.* Konya: Arı Ofset.

Erkal, Abdülkadir (1991). "Türk Edebiyatında Hilye ve Cevri'nin 'Hilye-i Çâr Yâr-ı Güzîn'i'." *Atatürk Üniversitesi Türkiyat Araştırmalar Enstitüsü Dergisi* (Erzurum) 12: 111–131.

Ernst, Carl W. (1992). "The Spirit of Islamic Calligraphy: Baba Shah Isfahani's Adab al-Mashq." *Journal of the American Oriental Society* 112:2 (April–June): 279–286.

—— (2000). "Admiring the Works of the Ancients: The Ellora Temples as Viewed by Indo-Muslim Authors." In *Beyond Turk and Hindu: Rethinking Religious Identities in Islamicate South Asia.* Edited by David Gilmartin and Bruce B. Lawrence. Gainesville: University Press of Florida, 98–120.

—— (2009). "Sufis and the Aesthetics of Penmanship in Sirāj Al-Shīrāzī's *Tuhfat Al-Muhibbīn* (1454)." *Journal of the American Oriental Society* 129(3): 431–442.

Erzen, Jale Nejdet (2007). "Islamic Aesthetics: An Alternative Way of Knowledge." *Journal of Aesthetics and Art Criticism* 65:1 (Winter). Special Issue on Global Theories of the Arts and Aesthetics, 69–75.

Esnoul, Anne-Marie, et al., eds. (1959). *Les songes et leur interprétation.* Paris: Éditions du Seuil.

Ettinghausen, Richard (1947). "Al-Ghazzālī on Beauty." In *Art and Thought: Issued in Honor of Dr. Ananda K. Coomaraswamy on the Occasion of His 70th Birthday.* Edited by K. Bharatha Iyer. London: Luzac, 160–165.

—— (1956). "Early Realism in Islamic Art." In *Studi orientalistici in onore di Giorgio Levi Della Vida.* Rome: Instituto per l'oriente, 250–273.

—— (1974). "Arabic Epigraphy: Communication or Symbolic Affirmation." In *Near Eastern Numismatics, Iconography, Epigraphy and History: Studies in Honor of George C. Miles.* Edited by Dickran K. Kouymjian. Beirut: American University of Beirut, 297–317.

Evliya Çelebi (1896). *Seyāhatnāme,* vol. 3. Edited by Ahmet Cevdet. Istanbul: İqdām Matbaʻası.

Ewing, Katherine P. (1990). "The Dream of Spiritual Initiation and the Organization of Self Representations among Pakistani Sufis." *American Ethnologist* 17:1 (February): 56–74.

Fackenheim, Emil (1945). "A Treatise on Love by Ibn Sina." *Medieval Studies* 7: 208–228.

Fahd, Toufic (1959). "Les songes et leur interprétation selon l'Islam." In *Les songes et leur interprétation.* Edited by Anne-Marie Esnoul et al. Paris: Éditions du Seuil, 125–158.

—— (1966a). "The Dream in Medieval Islamic Society." In *The Dream and Human Societies.* Edited by Gustav von Grunebaum and Roger Caillois. Berkeley: University of California Press, 351–363.

—— (1966b; rpt. 1987). *La divination arabe: Études religieuses, sociologiques, et folkloriques sur le milieu natif de l'Islam.* Paris: Sindbad.

Faivre, Antoine (1995). *The Eternal Hermes: From Greek God to Alchemical Magus.* Translated by Joscelyn Godwin. Grand Rapids: Phanes Press.

Faqih-i Balkhi, Abu'l-ma'ali M. ibn Ni'mat-i 'Alawi (1997). *Bayān al-adyān.* Edited by M. T. Danishpazhuh and Qudrat Allah Pishnamazzadah. Tehran: Bunyād-i mawqūfāt-i Doktar Mahmūd Afshār.

Farabi, Abu Nasr al- (1985; rpt. 1998). *On the Perfect State (Mabādi' ārā' ahl al-madīna al-fāḍila).* Revised text with introduction, translation, and commentary by Richard Walzer. Chicago: Kazi Publications / Great Books of the Islamic World.

Farès, Bishr (1946). "Une miniature nouvelle de l'école de Bagdad datée 614 Hég./1217–8 figurant le Prophète Muhammad." *Bulletin de l'Institut de'Egypte* 28: 1–4, i–iii.

—— (1952). *Essai sur l'esprit de la décoration islamique.* Cairo: L'Institut Français d'Archéologie Orientale.

—— (1957). "Philosophie et jurisprudence illustrées par les arabes: La querelle des images en Islam." In *Mélanges Louis Massignon.* 3 vols. Damascus: Institut français de Damas, 2: 77–109, plus plates.

—— (1959). "Figures magiques." In *Aus der Welt der Islamischen Kunst: Festschrift für Ernst Kühnel zum 75. Geburtstag am 16.10.1957.* Berlin: Verlag Gebr. Mann, 154–162.

Farisi, Kamal al-din Abu'l-Hasan al- (1984). *Kitāb tanqīh al-manāzir li-dhawī al-absār wa'l-basā'ir.* Edited by Mustafa Hijazi. Cairo: Al-Hay'a al-misriyya al-'āmma li'l-kitāb.

Felek, Özgen, and Alexander D. Knysh (2011), eds. *Dreams and Visions in Islamic Societies.* Albany: SUNY Press.

Firishta, Muhammad Qasim (1829; rpt. 1990). *History of the Rise of the Mohammedan Power in India.* Translated by John Briggs. 4 vols. Delhi: Low Price Publications.

—— (1905). *Tārīkh-i Firishta.* 2 vols. Lucknow: n.p.

Fisher, Carol G. (1981). "The Pictorial Cycle of the 'Siyer-i Nebi': A Late Sixteenth Century Manuscript of the Life of Muhammad." PhD dissertation. Michigan State University.

Flood, Finbarr Barry (2001a). *The Great Mosque of Damascus: Studies on the Makings of an Umayyad Visual Culture.* Islamic History and Civilization, vol. 33. Leiden: E. J. Brill.

—— (2001b). "The Medieval Trophy as an Art Historical Trope: Coptic and Byzantine 'Altars' in Islamic Contexts." *Muqarnas: An Annual on Islamic Art and Architecture* 18: 41–72.

—— (2002). "Between Cult and Culture: Bamiyan, Islamic Iconoclasm, and the Museum." *The Art Bulletin* 84:4 (December): 641–659.

—— (2003). "Pillars, Palimpsests, and Princely Practices: Translating the Past in Sultanate Delhi." *RES: Anthropology and Aesthetics* 43 (Spring): 95–116.

—— (2009). *Objects of Translation: Material Culture and Medieval "Hindu-Muslim" Encounter.* Princeton: Princeton University Press.

Fox, Robin Lane (1994). "Literacy and Power in Early Christianity." In *Literacy and Power in the Ancient World.* Edited by Alan K. Bowman and Greg Woolf. Cambridge: Cambridge University Press, 126–148.

Freedberg, David (1989). *The Power of Images: Studies in the History and Theory of Response.* Chicago: University of Chicago Press.

Frembgen, Jürgen Wasim (1998). "Saints in Modern Devotional Poster-Portraits: Meanings and Uses of Popular Religious Folk Art in Pakistan." *RES* 34 (Autumn): 183–191.

—— (2006). *The Friends of God: Sufi Saints in Islam—Popular Poster Art from Pakistan.* Karachi: Oxford University Press.

Friedmann, Yohanan (1972). "The Temple of Multān: A Note on Early Muslim Attitudes to Idolatry." *Israel Oriental Studies* 2: 176–182.

—— (1975). "Medieval Muslim Views of Indian Religions." *Journal of the American Oriental Society* 95:2 (April–June): 214–221.

Frodon, Jean-Michel (2002). "The War of Images, or the Bāmiyān Paradox." In *Iconoclash: Beyond the Image Wars in Science, Religion, and Art.* Edited by Bruno Latour and Peter Weibel. Karlsruhe and Cambridge, MA: ZKM and MIT Press, 221–223.

Fu, Shen, Glenn D. Lowry, and Ann Yonemura (1986). *From Concept to Context: Approaches to Asian and Islamic Calligraphy.* Washington, DC: Smithsonian Institution.

Gabrieli, Francesco (1969). *Arab Historians of the Crusades.* Translated by E. J. Costello. Berkeley: University of California Press.

Gadamer, Hans-Georg (1989). *Truth and Method.* Revised edition. Translated by Joel Weinsheimer and Donald G. Marshall. New York: Crossroad.

Gardizi, 'Abd al-Hayy (1968). *Zayn al-akhbār.* Edited by 'Abd al-Hayy Habibi. Tehran: Intishārāt-i bunyād-i farhang-i Iran.

Garside, Charles, Jr. (1966). *Zwingli and the Arts.* Yale Historical Publications, Miscellany no. 83. New Haven: Yale University Press.

Geertz, Clifford (1973). *The Interpretation of Cultures.* New York: Basic Books.

——, ed. (1974). *Myth, Symbol, and Culture.* New York: Norton.

—— (1976). "Art as a Cultural System." *Modern Language Notes* 91(6): 1473–1499. Reprinted in Geertz (1983). *Local Knowledge: Further Essays in Interpretive Anthropology.* New York: Basic Books, 94–120.

Gell, Alfred (1992a). *The Anthropology of Time: Cultural Constructions of Temporal Maps and Images.* Oxford: Berg.

—— (1992b). "The Technology of Enchantment and the Enchantment of Technology." In *Anthropology, Art and Aesthetics.* Edited by Jeremy Coote and Anthony Shelton. Oxford: Clarendon Press, 40–63.

—— (1993). *Wrapping in Images: Tattooing in Polynesia.* Oxford Studies in Social and Cultural Anthropology. Oxford: Clarendon Press.

—— (1998). *Art and Agency: An Anthropological Theory.* Oxford: Clarendon Press.

George, Alain (2010). *The Rise of Islamic Calligraphy.* London: Saqi Books.

Germano, David, and Kevin Trainor, eds. (2004). *Embodying the Dharma: Buddhist Relic Veneration in Asia.* Albany: SUNY Press.

Gero, Stephen (1975). "Hypatius of Ephesus on the Cult of Images." In *Christianity, Judaism and Other Greco-Roman Cults: Studies for Morton Smith at Sixty.* Edited by Jacob Neusner. Leiden: E. J. Brill, 208–216.

Ghazali, Abu Hamid Muhammad al- (1909; rpt. 1997). *The Alchemy of Happiness.* Translated by Claud Field. Lahore: Sh. Muhammad Ashraf.

—— (1957; rpt. 1985). *Ihyā' 'ulūm al-dīn.* Introduction by Badawi Tabana. 4 vols. Cairo: Dār ihyā' al-kutub al-'arabiyya; rpt. Istanbul: Çağrı Yayınları.

—— (1964). *Mishkāt al-anwār.* Edited by Abu'l-'Ala 'Afifi. Cairo: Al-Dār al-qawmiyya li'l-tabā'a wa'l-nashr.

—— (1965). *Book of Fear and Hope.* Translated by William McKane. Leiden: E. J. Brill.

—— (1973). *Al-Munqidh min al-dalāl.* Edited by J. Saliba and K. 'Ayyad. Beirut: Dār al-Andalus.

—— (1975; rpt. 2001). *Kīmiyā-yi sa'ādat.* 2 vols. Edited by Husayn Khadivjam. Tehran: Shirkat-i intishārāt-i 'ilmī wa farhangī.

—— (1985). *The Mysteries of the Human Soul.* Translated by Abdul Qayyum "Shafaq" Hazarvi. Delhi: Noor Publishing House.

—— (1998). *The Niche of Lights (Mishkāt al-anwār): A Parallel English-Arabic Text.* Translated by David Buchman. Provo: Brigham Young University Press.

—— (2000; rpt. 2004). *Deliverance from Error: Five Key Texts Including His Spiritual Autobiography, al-Munqidh min al-Dalal.* Translated by R. J. McCarthy. Louisville, KY: Fons Vitae.

—— (2009). *Revivification des science de la religion: Le livre de l'amour.* Translated by Antoine Moussali. Paris: Maison d'Ennour.

—— (2010). *The Marvels of the Heart: Science of the Spirit, Book XXI of the Ihya 'ulum al-din.* Translated by Walter James Skellie. Louisville, KY: Fons Vitae.

Gierlichs, Joachim (2009). "A Victory Monument in the Name of Sultan Malik-Shāh in Diyarbakir: Medieval Figural Reliefs Used for Political Propaganda?" *Islamic Art: Studies on the Art and Culture of the Muslim World* 6: 51–79.

Gocer, Asli (1999). "A Hypothesis concerning the Character of Islamic Art." *Journal of the History of Ideas* 60(4): 683–692.

Gökçiğdem, Elif (2001). "The 'World-Revealing' Cup of King Kayhusrev: Thoughts on Seljuk Visual Imagery." *Sanat Tarihi Defterleri:* 35–42.

Goldfeld, Isaiah (1973). "Umyānis the Idol of Khawlān." *Israel Oriental Studies* 3: 108–119.

Goldziher, Ignaz (1967). "What Is Meant by 'al-Jāhiliyya'." In *Muslim Studies*. Translated by C. R. Barber and S. M. Stern. 2 vols. Albany: SUNY Press (orig. [1888–1890]. *Muhammedanische Studien.* 2 vols. Halle: M. Niemeyer).

Gombrich, Richard F. (1971). *Precept and Practice: Traditional Buddhism in the Rural Highlands of Ceylon.* Oxford: Clarendon Press.

Gonzalez, Valérie (1995a). "The Aesthetics of Islamic Art: Toward a Methodology of Research." *Al-'Usūr al-Wustā, the Bulletin of Middle East Medievalists* 7: 28–29.

—— (1995b). "Réflexions esthétiques sur l'approche de l'image dans l'art Islamique." In *L'image dans le monde arabe.* Edited by Gilbert Beaugé and Jean-François Clément. Paris: CNRS, 69–78.

—— (2000). "The Double Ontology of Islamic Calligraphy: A Word-Image on a Folio from the Museum of Raqqada (Tunisia)." In *M. Uğur Derman Armağanı: Altmışbeşinci Yaşı Münasebetiyle Sunulmuş Tebliğler / M. Uğur Derman Festschrift: Papers Presented on the Occasion of His Sixty-Fifth Birthday.* Edited by İrvin C. Schick. Istanbul: Sabancı Üniversitesi, 313–340.

—— (2001). *Beauty and Islam: Aesthetics in Islamic Art and Architecture.* London: I. B. Tauris.

—— (2002). *Le piège de Salomon: La pensée de l'art dans le Coran.* Paris: Albin Michel.

Goodman, Nelson (1976). *Language of Art: An Approach to a Theory of Symbols.* Indianapolis: Hackett Publishing.

Goody, Jack (1973). "Literacy and the Non-Literate." In *The Future of Literacy.* Edited by R. Disch. Englewood Cliffs, NJ: Prentice Hall.

—— (1977). *The Domestication of the Savage Mind.* Cambridge: Cambridge University Press.

—— (1987; rpt. 1991). *The Interface between the Written and the Oral.* Cambridge: Cambridge University Press.

Gouda, Yehia (1991). *Dreams and Their Meanings in the Old Arab Tradition.* New York: Vantage Press.

Grabar, André (1968). *Christian Iconography: A Study of Its Origins.* A. W. Mellon Lectures in the Fine Arts, 1961. Bollingen Series, no. 10. Princeton: Princeton University Press.

Grabar, Oleg (1959). "The Umayyad Dome of the Rock in Jerusalem." *Ars Orientalis: The Arts of Islam and the East* 3: 33–62.

—— (1973). *The Formation of Islamic Art.* New Haven: Yale University Press.

—— (1974). "The Inscriptions of the Madrasa-Mausoleum of Qaytbay." In *Near Eastern Numismatics, Iconography, Epigraphy and History: Studies in Honor of George C. Miles.* Edited by Dickran K. Kouymjian. Beirut: American University of Beirut, 465–468.

—— (1976). "What Makes Islamic Art Islamic." In *Art and Archaeology Research Papers,* April: 1–3.

—— (1977). "Islam and Iconoclasm." In *Iconoclasm: Papers Given at the Ninth Spring Symposium of Byzantine Studies, University of Birmingham.* Edited by Anthony Bryer and Judith Herrin. Birmingham, UK: Centre for Byzantine Studies, 45–52.

—— (1978). "Islamic Art: Art of Culture or Art of Faith." *Art and Archaeology Research Papers* 13: 1–6.

—— (1980). "Symbols and Signs in Islamic Architecture." In *Architecture as Symbol and Self-Identity: Proceedings of Seminar Four in the Series Architectural Transformations in the Islamic World, Held in Fez, Morocco, October 9–12, 1979.* Edited by Jonathan G. Katz and Robert Miller. Cambridge, MA: Aga Khan Awards, 1–11. Also published (1983). In *Architecture and Community: Building in the Islamic World Today.* Edited by Renata Holod and Darl Rastorfer. Millerton, NY: Aperture for the Aga Khan Award for Architecture, 25–32.

—— (1988). "The Iconography of Islamic Architecture." In *Content and Context of Visual Arts in the Islamic World.* Edited by Priscilla Soucek. University Park: Pennsylvania State University Press, 51–65.

—— (1992). *The Mediation of Ornament.* Bollingen Series, no. 38. Princeton: Princeton University Press.

—— (2006a). *The Dome of the Rock.* Cambridge, MA: Belknap Press of Harvard University Press.

—— (2006b). *Islamic Art and Beyond: Constructing the Study of Islamic Art,* vol. 3. Ashgate Collected Studies Series. Hampshire, UK: Ashgate.

—— (2006c). *Islamic Visual Culture, 1100–1800: Constructing the Study of Islamic Art,* vol. 2. Ashgate Collected Studies Series. Hampshire, UK: Ashgate.

Grabar, Oleg, and Mika Natif (2003/4). "The Story of Portraits of the Prophet Muhammad." *Studia Islamica* 96, Écriture, calligraphie et peinture: 19–38, vi–ix.

Graham, William A. (1987). *Beyond the Written Word: Oral Aspects of Scripture in the History of Religion.* Cambridge: Cambridge University Press.

Griffith, Sidney H. (1985). "Theodore Abū Qurrah's Arabic Tract on the Christian Practice of Venerating Images." *Journal of the American Oriental Society* 105:1 (January–March): 53–73.

—— (1987). "Anastasius of Sinai, the *Hodegos* and the Muslims." *Greek Orthodox Theological Review* 3(4): 341–358.

—— (1990). "Islam and the Summa Theologiae Arabica: Rabīʿ I, 264 A.H." *Jerusalem Studies in Arabic and Islam* 13: 225–264.

—— (2008). *The Church in the Shadow of the Mosque: Christians and Muslims in the World of Islam.* Princeton: Princeton University Press.

Gruber, Christiane J. (2003). "L'ascension *(Miʿrāj)* du Prophète Mohammed dans la peinture et la littérature islamique." *Luqman* 39:1 (Fall–Winter): 55–79.

—— (2005). "The Keir *Miʿraj:* Islamic Storytelling and the Picturing of Tales." *Central Asian Studies Review* 4(1): 35–39.

—— (2010a). *The Ilkhanid Book of Ascension: A Persian-Sunni Devotional Tale,* BIPS Persian Studies Series. London: I. B. Tauris.

——, ed. (2010b). *The Islamic Manuscript Tradition: Ten Centuries of Book Arts in Indiana University Collections.* Bloomington: Indiana University Press.

Guha-Thakurta, Tapati (2003). "The Compulsions of Visual Representation in Colonial India." In *Traces of India: Photography, Architecture, and the Politics of Representation, 1850–1900.* Edited by Maria Antonella Pelizzari. New Haven: Yale University Press, 108–139.

Guillaume. *See* Ibn Hisham, ʿAbd al-Malik.

Gündüz, Hüseyin, and Faruk Taşkale (2000). *Rakseden Harfler: Türk Hat Sanatı'ndan Seçme Eserler* [Dancing Letters: A Selection of Turkish Calligraphic Art]. Istanbul: Antik A. Ş. Kültür Yayınları.

Gutman, Joseph, ed. (1971). *No Graven Images: Studies in Art and the Hebrew Bible.* New York: KATV Publishing House.

Haarmann, Ulrich (1991a). "In Quest of the Spectacular: Noble and Learned Visitors to the Pyramids around 1200 A.D." In *Islamic Studies Presented to Charles J. Adams.* Edited by Wael B. Hallaq and Donald P. Little. Leiden: E. J. Brill, 57–67.

——, ed. (1991b). *Kitāb anwār ʿulwiyy al-ajrām fī l-kashf ʿan asrār al-ahrām (Das Pyramidenbuch des Abu Gaʿfar al-Idrisi).* Beiruter Texte und Studien, vol. 38. Beirut: Franz Steiner.

Hakani Mehmed Bey (1991). *Hilye-i Saadet.* Edited by İskender Pala. Ankara: Türkiye Diyanet Vakfı Yayınları.

Halbertal, Moshe, and Avishai Margalit (1992). "Idolatry and Representation." *RES* 22 (Autumn): 19–32.

Halm, Heinz (1996). *Empire of the Mahdi: The Rise of the Fatimids*. Translated by Michael Bonner. Leiden: E. J. Brill.

Hansberger, Rotraud E. (2008). "How Aristotle Came to Believe in God-Given Dreams: The Arabic Version of *De Divinatione Per Somnum*." In *Dreaming across Boundaries: The Interpretation of Dreams in Islamic Lands*. Edited by Louise Marlow. Cambridge MA: Harvard University Press, 50–77.

Harris, Clare (2001). "The Politics and Personhood of Tibetan Buddhist Icons." In *Beyond Aesthetics: Art and the Technologies of Enchantment*. Edited by Christopher Pinney and Nicholas Thomas. Oxford: Berg, 181–199.

Hasan, Perween (1993). "The Footprint of the Prophet." *Muqarnas* vol. 10, Essays in Honor of Oleg Grabar: 335–343.

—— (2007). *Sultans and Mosques: The Early Muslim Architecture of Bangladesh*. London: I. B. Tauris.

Hawting, G. R. (1999). *The Idea of Idolatry and the Emergence of Islam: From Polemic to History*. Cambridge Studies in Islamic Civilization. Cambridge: Cambridge University Press.

Hegel, G. W. F. (1975). *Aesthetics: Lectures on Fine Art*. Translated by T. M. Knox. 2 vols. Oxford: Clarendon.

Hillenbrand, Carole (1994). "Some Aspects of Al-Ghazālī's Views on Beauty." In *Gott ist Schön und Er liebt die Schönheit: Festschrift in Honour of Annemarie Schimmel*. Edited by Alma Giese and J. Christoph Bürgel. Bern: Peter Lang, 249–265.

Hillenbrand, Robert (1986). "Qur'anic Epigraphy in Medieval Islamic Architecture." *Revue des Études Islamiques* 54: 171–187.

—— (1987). "La Dolce Vita in Early Islamic Syria of Later Umayyad Palaces." *Art History* 5: 1–35.

——, ed. (1994). *The Art of the Saljūqs in Iran and Anatolia*. Islamic Art and Architecture, no. 4, edited by Abbas Daneshvari. Costa Mesa: Mazda Publishers.

Hirschler, Konrad (2012). *The Written Word in the Medieval Arabic Lands: History of Reading Practices*. Edinburgh: Edinburgh University Press.

Hodgson, Marshall G. S. (1964). "Islâm and Image." *History of Religions* 3 (Winter): 220–260.

Hoffman, Eva R. (2000). "The Beginnings of the Illustrated Arabic Book: An Intersection between Art and Scholarship." In *Muqarnas: An Annual on the Visual Culture of the Islamic World*. Edited by David J. Roxburgh. Leiden: E. J. Brill, 37–52.

Holly, Michael Ann (1993). "Unwriting Iconology." In *Iconography at the Crossroads: Papers from the Colloquium Sponsored by the Index of Christian Art, Prince-*

ton University, 23–24 March 1990. Edited by Brendan Cassidy. Princeton: Index of Christian Art, Department of Art and Archaeology, Princeton University, 17–31.

Hopkins, Arthur John (1934). "Transmutations by Color: A Study of Earliest Alchemy." In *Studien zur Geschichte der Chemie: Festgabe Edmund P. V. Lippman*. Edited by J. Ruska. Berlin: Springer.

Hourani, George F. (1995). *Arab Seafaring in the Indian Ocean in Ancient and Early Medieval Times*. Revised and expanded by John Carswell. Princeton: Princeton University Press.

Hoyland, Robert G. (2001). *Arabia and the Arabs: From the Bronze Age to the Coming of Islam*. London: Routledge.

Huart, Clément (1975). *Anîs el-ʿochchâq: Traité des termes figurés relatifs à la description de la beauté*. Paris: F. Vieweg.

Hughes, Aaron (2002). "Imagining the Divine: Ghazali on Imagination, Dreams, and Dreaming." *Journal of the American Academy of Religion* 70(1): 33–53.

Ibn Abi Dunya (1994). *Morality in the Guise of Dreams: A Critical Edition of Kitāb Al-Manām with Introduction*. Edited by H. Daiber and D. Pingree. Islamic Philosophy, Theology and Science vol. 18, Leah Kinberg, editor. Leiden: E. J. Brill.

Ibn Abi Usaybiʿa (1981). *ʿUyūn al-anbāʾ fī tabaqāt al-atibbāʾ*. Beirut: Dār al-thiqāfa.

Ibn al-ʿArabi, Muhyi al-din (1911). *Al-Futūhāt al-makkiyya*. 4 vols. Cairo: n.p.

—— (1946; rpt. 1980). *Fusūs al-hikam*. Edited by Abuʾl-ʿAla ʿAfifi. Beirut: Dār al-kutub al-ʿarabī.

—— (1980). *The Bezels of Wisdom*. Translated by R. W. J. Austin. Ramsey, NJ: Paulist Press.

—— (2004). *The Ringstones of Wisdom (Fusūs al-hikam)*. Translated by Caner Dagli. Chicago: Great Books of the Islamic World—Kazi Publications.

Ibn al-Faqih, Abu ʿAbd Allah A. ibn M. al-Hamadani (1996). *Kitāb al-buldān*. Edited by Yusuf al-Hadi. Beirut: ʿĀlam al-kutub.

Ibn Habib, Abu Jaʿfar M. (1942). *Kitāb al-muhabbar*. Edited by Ilse Lichtenstadter. Hyderabad: Osmania Publications.

Ibn Hajar al-ʿAsqalani (1978). *Fath al-bārī bi-sharh sahīh al-Bukhārī*. Edited by Al-Sayyid Muhammad ʿAbd al-Muʿti et al. Cairo: Maktabat al-kulliyyāt al-azhariyya.

Ibn al-Haytham, H. (1983). *Kitāb al-manāzir*. Edited by A. I. Sabra. Kuwait: Al-Majlis al-watanī liʾl-thiqāfa waʾl-funūn waʾl-adab.

—— (1989). *The Optics of Ibn Al-Haytham*. Translated with introduction and commentary by A. I. Sabra. 2 vols. Studies of the Warburg Institute, vol. 40, edited by J. B. Trapp. London: Warburg Institute, University of London.

Ibn Hayyan, Jabir (1983; rpt. 1996). *Dix traités d'alchimie: Les dix premiers traités du Livre des Soixante-dix*. Translated by Pierre Lory. 2nd edition. Paris: Sindbad.

Ibn Hazm, 'Ali ibn Ahmad (1953). *The Ring of the Dove: A Treatise on the Art and Practice of Arab Love*. Translated by A. J. Arberry. London: Luzac.

—— (1962). *Jamharat ansāb al-'arab*. Edited by 'Abd al-Salam M. Harun. Cairo: Dhakhā'ir al-'arab.

—— (2007). *Kitāb al-akhlāq wa'l-siyar*, also known as the *Risāla fī mudāwāt al-nufūs*. Jablah, Syria: Bidāyāt li'l-nashr.

Ibn Hisham, 'Abd al-Malik (1955a). *The Life of Muhammad: A Translation of Ibn Ishāq's Sīrat rasūl Allah*. Translated by A. Guillaume. London: Oxford University Press.

—— (1955b). *Al-Sīra al-nabawiyya* of Ibn Hisham. Edited by Muhammad al-Saqqa et al. Cairo: Dār ihyā' al-turāth.

Ibn al-'Ibri, Gregorios al-Malati, *also known as* Bar Hebraeus (1958). *Tā'rīkh mukhtasar al-duwal*. Beirut: Catholic Press.

Ibn al-Jawzi (1948/49). *Talbīs Iblīs*. Beirut: Dār al-kutub al-'ilmiyya.

Ibn al-Kalbi, Abu'l-Mundhir (1964). *Kitāb al-asnām*. Edited by Ahmad Zaki. Cairo: Al-Dār al-qawmiyya li'l-tibā'a wa'l-nashr.

—— (1969). *The Book of Idols*. Translated by N. Amin Faris. Princeton: Princeton University Press.

Ibn Kathir (1998). *Al-Bidāya wa'l-nihāya*. Edited by 'Abd Allah ibn 'A. al-Turki. 21 vols. Cairo-Giza: Dār Hajr.

Ibn Khaldun (n.d.). *Al-Muqaddima*. Cairo: Matba'a Mustafa Muhammad.

—— (1958). *The Muqaddimah: An Introduction to History*. Translated by Franz Rosenthal. New York: Pantheon Books.

—— (2005). *The Muqaddimah*. Translated by Franz Rosenthal, abridged by N. J. Dawood. Princeton: Princeton University Press.

Ibn al-Nadim, Abu'l-Faraj M. (1970). *The Fihrist of al-Nadīm: A Tenth-Century Survey of Muslim Culture*. Edited and translated by Bayard Dodge. 2 vols. New York: Columbia University Press.

—— (2002). *Al-Fihrist*. Edited by A. Shams al-din. Beirut: Dār al-kutub al-'ilmiyya.

Ibn al-Qayyim al-Jawziyya (2008). *Rawdat al-muhibbīn wa-nuzhat al-mushtāqīn*. Edited by Rafi' Yusuf. Cairo: Dār al-Farūq.

Ibn Rushd (1961). *Talkhīs kitāb al-hiss wa'l-mahsūs (Die Epitome der Parva naturalia des Averroes)*. Edited by Helmut Gätje. Wiesbaden: Otto Harrassowitz.

Ibn Sa'd, Muhammad (1904). *Kitāb tabaqāt al-kubrā*. Edited by E. Sachau. 9 vols. in 15. Leiden: E. J. Brill.

Ibn Shahin, Khalil. *Tafsīr al-a'lām al-musammā al-ishārāt fī 'ilm al-'ibārāt*. Edited by Al-Sa'id al-Manduh. 2 vols. in 1. Cairo: Dār al-kutub.

Ibn Sina, Abu ʿAli (1889). *Traités mystiques d'Abou Ali al-Hosain b. Abdallah b. Sina: L'allégorie mystique Hay ben Yaqzan.* Edited by M. A. F. Mehren. Part I. Leiden, E. J. Brill.

—— (1892). *Kitāb al-ishārāt waʾl-tanbīhāt.* Edited by J. Forget. Leiden: E. J. Brill.

—— (1959). *De Anima: Being the Psychological Part of Kitāb al-shifāʾ.* Edited by Fazlur Rahman. London: Oxford University Press.

—— (1965). *Kitāb al-shifāʾ, al-tabīʿiyyāt,* vol. 5. Edited by A. H. Montasir et al. Cairo: Al-matbaʿa al-āmiriyya.

—— (1985). *Kitāb al-najā fiʾl-hikma al-mantiqiyya waʾl-tabīʿiyya waʾl-ilāhiyya.* Edited by Majid Fakhri. Beirut: Dār al-āfāq al-jadīda.

—— (1992). *Al-najā fiʾl-mantiq waʾl-ilāhiyyāt.* Edited by ʿAbd al-Rahman ʿUmayara. Beirut: Dār al-Jayl.

Ibn Sirin, M. (1995). *The Voluminous Interpretation of Dreams (Tafsīr al-aʿlām al-kabīr).* Translated by S. Abi Azar and F. Amira Zrein Matraji. Beirut: Dar el Fikr.

Ibn ʿUqba, Musa (1994). *Maghāzī.* Edited by M. Baqshish Abu Malik. Agadir: Jāmiʿat Ibn Zahr.

Ibn al-Zubayr, al-Qadi Ahmad ibn Rashid (1959). *Kitāb al-dhakhāʾir waʾl-tuhaf.* Edited by M. Hamid Allah. Al-thurāt al-ʿarabī, no. 1. Kuwait: Matbaʿa hukūmat al-Kuwayt.

—— (1996). *Book of Gifts and Rarities (Kitāb al-hadāya wa al-tuhaf): Selections Compiled in the Fifteenth Century from an Eleventh-Century Manuscript on Gifts and Treasures.* Edited and translated by Ghada al-Hijjawi Qaddumi. Harvard Middle Eastern Monographs, vol. 29. Cambridge, MA: Harvard University Press for the Center for Middle Eastern Studies of Harvard University.

Ibrić, Almir (2008). *For a Philosophy of Aniconism in Islam.* Translated by Viktoria Stopa. Vienna and Berlin: Lit.

—— (2010a). *Bilder und Tätowierungen im Islam: Eine Einführung in die Ethik und Ästhetik des Polytheismusverbots.* Religionswissenschaft, vol. 19. Vienna and Berlin: Lit.

—— (2010b). *Islamisches Bilderverbot vom Mittel- bis ins Digitalzeitalter.* Religionswissenschaft, vol. 12. Vienna and Münster: Lit.

Idrisi, Muhammad ibn M. al-Sharif al- (1954). *Wasf al-hind wa-mā yujāwiruhā min al-bilād.* Edited by S. Maqbul Ahmad. Aligarh: Aligarh Muslim University.

—— (1960). *India and the Neighbouring Territories in the Kitāb nuzhat al-mushtāq fiʾkhtirāq al-ʾāfāq of Al-Sharīf Al-Idrīsī.* Translated by S. Maqbul Ahmad. Foreword by V. Minorsky. De Goeje Fund, no. 20. Leiden: E. J. Brill.

Inati, S. C. (1984). *Ibn Sina's Remarks and Admonitions (Part 1: Logic).* Toronto: Pontifical Institute of Mediaeval Studies.

—— (1996). *Ibn Sina and Mysticism: Remarks and Admonitions, Part 4.* London: Kegan Paul.

İpşiroğlu, M. Ş. (1973; rpt. 2000). *İslâm'da Resim: Yasağı ve Sonuçları.* Türkiye İş Bankası Kültür Yayınları, no. 137, Sanat Dizisi, no. 14. Istanbul: Doğan Kardeş Matbaacılık Sanayii.

Irwin, John (1989). "Islam and the Cosmic Pillar." In *South Asian Archaeology 1985.* Copenhagen: Nordic Institute of Asian Studies, 397–406.

Isfahani, Abu Nu'aym al- (1970). *Dalā'il al-nubuwwa.* Edited by Muhammad Rawwas Qal'aji. Aleppo: Al-Maktaba al-'arabiyya Muhammad Talali'i.

Işın, Ekrem, ed. (2001). *Alâeddin'in Lambası: Anadolu'da Selçuklu Çağı Sanatı ve Alâeddin Keykubâd* [Aladdin's Lamp: Sultan Alâeddin Keykubâd and the Art of the Anatolian Seljuks]. Istanbul: Yapı Kredi Yayınları.

—— (2003; rpt. 2006). *Elemterefiş: Anadolu'da Büyü ve İnanışlar* [Magic and Superstition in Anatolia]. Exhibition Catalog. Istanbul: Yapı Kredi Kültür Sanat Yayıncılık.

Issa, Ahmad M. (1996). *Painting in Islam: Between Prohibition and Aversion.* Istanbul: İSAR Vakfı.

Izutsu, Toshihiko (1984). *Sufism and Taoism: A Comparative Study of Key Philosophical Concepts.* Berkeley: University of California Press.

Jabre, Farid (1970). *Essai sur le lexique de Ghazali: Contribution à l'étude de la terminologie de Ghazali dans ses principaux ouvrages à l'exception du Tahâfut.* Beirut: Université Libanaise.

Jacoby, Zehava (1992). "Ideological and Pragmatic Aspects of Muslim Iconoclasm after the Crusader Advent in the Holy Land." In *L'art et les revolutions.* Edited by Sergiusz Michalski. Strasbourg: Société Alsacienne pour le développement de l'histoire de l'art, 13–24.

Jahn, K. (1963). "On the Mythology and Religion of the Indians in the Mediaeval Moslem Tradition." In *Mélanges d'orientalisme offerts à Henri Massé à l'occasion de son 75ème anniversaire.* Tehran: Imprimerie de l'université, 185–197.

Jain, Kajri (2007). *Gods in the Bazaar: The Economies of Indian Calendar Art.* Durham: Duke University Press.

Janowitz, Naomi (2002). *Icons of Power: Ritual Practices in Late Antiquity.* The Magic in History Series. University Park: Pennsylvania State University Press.

John of Damascus (Saint) (1980; rpt. 2002). *On the Divine Images: Three Apologies against Those Who Attack the Divine Images.* Translated by David Anderson. Crestwood, NY: St. Vladimir's Seminary Press.

Jousse, Marcel (1925). *Études de psychologie linguistique: Le style oral rythmique et mnémotechnique chez les verbomoteurs.* Paris: Travaux du Laboratoire d'anthropologie rythmo-pédagogique de Paris.

Jurjani, 'Abd al-Qahir al- (1954). *Asrār al-balāgha*. Edited by Helmut Ritter. Istanbul: Istanbul University Press.

Kappeler, Suzanne (1986). *The Pornography of Representation*. Minneapolis: University of Minnesota Press.

Karpuz, Haşim (2001). *Anadolu Selçuklu Mimarisi*. Konya: Selçuk Üniversitesi Yaşatma ve Geliştirme Vakfı.

Katz, Jonathan (1996). *Dreams, Sufism and Sainthood: The Visionary Career of Muhammad Al-Zawâwî*. Studies in the History of Religions, vol. 71, edited by H. G. Kippenberg and E. T. Lawson. Leiden: E. J. Brill.

Kaufman, Thomas D. (1995). *Court, Cloister, and City: The Art and Culture of Central Europe, 1450–1800*. Chicago: University of Chicago Press.

Kazwini. *See* Qazwini, Zakariya ibn Muhammad al-

Kemal, Salim (1991). *The Poetics of Alfarabi and Avicenna*. Islamic Philosophy, Theology and Science: Texts and Studies, vol. 9, edited by H. Daiber and D. Pingree. Leiden: E. J. Brill.

Kennedy, Hugh (1992). "Byzantine-Arab Diplomacy in the Near East from the Islamic Conquests to the Mid-Eleventh Century." In *Byzantine Diplomacy: Papers from the Twenty-Fourth Spring Symposium of Byzantine Studies, Cambridge, March 1990*. Edited by Jonathan Shepard and Simon Franklin. Aldershot, UK: Variorum, 133–143.

Kessler, Christel (1970). "'Abd Al-Malik's Inscription in the Dome of the Rock: A Reconsideration." *Journal of the Royal Asiatic Society of Great Britain and Ireland* 3: 2–14.

Khalek, Nancy (2011). *Damascus after the Muslim Conquest: Text and Image in Early Islam*. New York: Oxford University Press.

Khalidi, Tarif (1975). *Islamic Historiography: The Histories of Mas'ūdī*. Albany: SUNY Press.

Khan, A. N. (1990). *Islamic Architecture of Pakistan: An Analytical Exposition*. Vol. 1: *Arab and Central Asian Contribution*. Islamabad: National Hijra Council.

Kilito, Abdelfattah (1985). *L'auteur et ses doubles: Essai sur la culture arabe classique*. Paris: Éditions du Seuil.

——(2001). *The Author and His Doubles: Essays on Classical Arabic Culture*. Translated by Michael Cooperson. Syracuse: Syracuse University Press.

Kinberg, Leah (1993a). "The Legitimization of the *Madhāhib* through Dreams." *Arabica* 32: 47–79.

—— (1993b). "Literal Dreams and Prophetic *Hadīths* in Classical Islam—a Comparison of Two Ways of Legitimation." *Der Islam* 70: 279–300.

—— (1994). *Ibn Abī Dunyā: Morality in the Guise of Dreams: A Critical Edition of Kitāb Al-Manām with Introduction*. Islamic Philosophy, Theology and Science, vol. 18, edited by H. Daiber and D. Pingree. Leiden: E. J. Brill.

—— (2008). "Qur'ān and Hadīth: A Struggle for Supremacy as Reflected in Dream Narratives." In *Dreaming across Boundaries: The Interpretation of Dreams in Islamic Lands*. Edited by Louise Marlow. Cambridge, MA: Harvard University Press, 25–49.

King, G. R. D (1985). "Islam, Iconoclasm, and the Declaration of Doctrine." *Journal of the School of Oriental and African Studies* 48(2): 267–277.

Kinnard, Jacob N. (1999). *Imaging Wisdom: Seeing and Knowing in the Art of Indian Buddhism*. Richmond, UK: Curzon.

Kisa'i, al- (1978). *The Tales of the Prophets of al-Kisa'i*. Translated by Wheeler M. Thackston, Jr. Library of Classical Arabic Literature, vol. 2. Boston: Twayne Publishers.

Kitzinger, Ernst (1954). "The Cult of Images before Iconoclasm." *Dumbarton Oaks Papers* 8: 83–150.

Klausen, Jytte (2009). *The Cartoons that Shook the World*. New Haven: Yale University Press.

Knox, Bernard M. W. (1968). "Silent Reading in Antiquity." *Greek, Roman and Byzantine Studies* 9: 421–435.

Knysh, Alexander D. (1999). *Ibn 'Arabi in the Later Islamic Tradition*. Albany: SUNY Press.

Kraus, Paul (1942). *Jabir ibn Hayyan: Contribution à l'histoire des idées scientifiques dans l'Islam*. 2 vols. Cairo: Mémoires de l'Institut d'Égypte.

Krautheimer, Richard (1942). "Introduction to an 'Iconography of Mediaeval Architecture.'" *Journal of the Warburg and Courtauld Institutes* 5: 1–33.

—— (1969). *Studies in Early Christian, Medieval and Renaissance Art*. New York: New York University Press.

Kuban, Doğan (1995). *Türk ve İslâm Sanatı üzerine Denemeler*. Istanbul: Arkeoloji ve Sanat Yayınları.

—— (2002). *Selçuklu Çağında Anadolu Sanatı*. Istanbul: Yapı Kredi Yayınları.

La'ibi, Shakur (also Shaker Lou'aybi) (1998). *Soufisme et art visuel: Iconographie du sacré*. Paris: L'Harmattan.

—— (2001). *Al-fann al-islāmī wa'l-masīhiyya al-'arabiyya: dawl al-masīhiyyīn al-'arab fī takwīn al-fann al-islāmī (Islamic Art and Arab Christianism)*. Beirut: Riad al-Rayyes Books.

Lammens, Henri (1915). "L'attitude de l'Islam primitif en face des arts figurés." *Journal Asiatique*, 2nd Series, 6: 274–279.

Lamoreaux, John C. (2002). *The Early Muslim Tradition of Dream Interpretation*. Albany: SUNY Press.

——, trans. (2005). *Theodore Abū Qurrah*. Library of the Christian East, vol. 1. Provo: Brigham Young University Press.

Lawrence, Bruce B. (1973). "Shahrastānī on Indian Idol Worship." *Studia Islamica* 38: 60–73.

Lawrence, Bruce B., and Muhammad ibn 'Abd al-Karim al-Shahrastani (1976). *Shahrastānī on the Indian Religions*. Religion and Society, no. 4. The Hague: Mouton.

Leaman, Oliver (2004). *Islamic Aesthetics: An Introduction*. Notre Dame: University of Notre Dame Press.

Lecker, Michael (1993). "Idol Worship in Pre-Islamic Medina (Yathrib)." *Le Muséon* 106(3–5): 331–346.

Lessing, Gotthold E. (1969). *Laocoon: An Essay upon the Limits of Poetry and Painting*. Translated by Ellen Frothingham. New York: Farrar, Straus and Giroux. For the German original, see Herbert G. Gropfert et al., eds. (1974). *Lessing's Werke*. Munich: Carl Hanser.

Lewis, Bernard (1953). "Some Observations on the Significance of Heresy in the History of Islam." *Studia Islamica* 1: 43–63.

Librande, Leonard (1979). "The Calligraphy of the Qur'ān: How It Functions for Muslims." *Religion* 9 (Spring): 36–58.

Lindberg, David C. (1967). "Alhazen's Theory of Vision and Its Reception in the West." *Isis* 58:3 (Autumn): 321–341.

—— (1976). *Theories of Vision from Al-Kindi to Kepler*. Chicago: University of Chicago Press.

—— (1978). "The Intromission-Extramission Controversy in Islamic Visual Theory: Alkindi versus Avicenna." In *Studies in Perception: Interrelations in the History of Philosophy and Science*. Edited by Peter K. Machamer and Robert G. Turnbull. Columbus: Ohio State University Press, 137–159.

Lings, Martin (1987). *The Quranic Art of Calligraphy and Illumination*. 1st American edition. New York: Interlink Books.

Livingston, John W. (1992). "Science and the Occult in the Thinking of Ibn Qayyim Al-Jawziyya." *Journal of the American Oriental Society* 112:4 (October–December), 598–610.

Long, Charles H. (1986). *Significations: Signs, Symbols, and Images in the Interpretation of Religion*. Philadelphia: Fortress Press.

Lory, Pierre (1989). *Alchimie et mystique en terre d'Islam*. Paris: Gallimard.

—— (2003). *Le rêve et ses interprétations en Islam*. Paris: Albin Michel.

Lou'aybi, Shaker. *See* La'ibi, Shakur.

Luther, Martin (1958). *Luther's Works*. Translated by Conrad Bergendoff. Philadelphia: Muhlenberg.

—— (1970). *Luther's Works*, vol. 39. Edited by Helmut T. Lehman. Translated by Eric W. Gritsch and Ruth C. Gritsch. Philadelphia: Fortress Press.

Maguire, Henry (1996). *The Icons of Their Bodies: Saints and Their Images in Byzantium*. Princeton: Princeton University Press.

—— (1998). *Rhetoric, Nature and Magic in Byzantine Art*. Variorum Collected Studies Series. Aldershot, UK: Ashgate.

Mahdi, Muhsin (1957). *Ibn Khaldun's Philosophy of History: A Study in the Philosophic Foundation of the Science of Culture*. London: George Allen and Unwin.

—— (1980). "Islamic Philosophy and the Fine Arts." In *Architecture as Symbol and Self-Identity: Proceedings of Seminar Four in the Series Architectural Transformations in the Islamic World, Held in Fez, Morocco, October 9–12, 1979*. Edited by Jonathan G. Katz and Robert Miller. Cambridge, MA: Aga Khan Awards, 43–48.

Makdisi, George (1956). "Autograph Diary of an Eleventh-Century Historian of Baghdad." *Bulletin of the School of Oriental and African Studies* 18: 9–31, 239–260; 19: 13–48, 281–303, 426–443.

Maqrizi, Taqi al-din A. ibn ʿAli al- (1869 rpt.). *Kitāb al-mawāʿiz waʾl-iʿtibār bi-dhikr al-khitat waʾl-āthār* [better known as *al-Khitat al-maqrīziyya*]. 2 vols. Cairo: Maktaba al-thiqāfa al-dīniyya.

—— (1991). *Kitāb al-muqaffāʾ al-kabīr*. Edited by M. al-Yalawi. 8 vols. Beirut: Dār al-gharb al-islāmī.

Marçais, G. (1932). "La question des images dans l'art musulman." *Byzantion: Revue Internationale des Études Byzantines* 7: 161–183.

—— (1938). "Remarques sur l'esthétique musulmane." *Annales de l'Institut d'Études Orientales* 4: 55–71.

—— (1942–1947). "Nouvelles remarques sur l'esthétiques musulmane." *Annales de l'Institut d'Études Orientales* 6: 33–52.

Marlow, Louise, ed. (2008). *Dreaming across Boundaries: The Interpretation of Dreams in Islamic Lands*. Ilex Foundation Series, Boston, Massachusetts and Center for Hellenic Studies, Washington, DC. Cambridge, MA: Harvard University Press.

Marquet, Yves (1988). *La philosophie des alchimiste et l'alchimie des philosophes: Jabir Ibn Hayyan et les "Frères de la Pureté."* Paris: Maisonneuve et Larose.

Martin, Henri-Jean (1994). *The History and Power of Writing*. Translated by Lydia G. Cochrane. Chicago: University of Chicago Press.

Masʿudi, Abuʾl-Hasan ʿAli al- (1965). *Murūj al-dhahab wa-maʿādin al-jawhar*. Edited by Charles Pellat. 7 vols. Beirut: Publications de l'Université Libanaise.

Mathews, Thomas F. (1993). *The Clash of the Gods: A Reinterpretation of Early Christian Art*. Princeton: Princeton University Press.

Mavroudi, Maria (2002). *A Byzantine Book on Dream Interpretation: The Oneirocriticon of Achmet and Its Arabic Sources*. The Medieval Mediterranean, vol. 36. Leiden: E. J. Brill.

Meister, Michael (1995). "Seeing and Knowing: Semiology, Semiotics and the Art of India," in *Los discursos sobre el arte*, edición a cargo de Juana Gutiérrez Haces, XV Coloquio internacional de historia del arte. Mexico City: Instituto de investigaciones estéticas, Universidad Nacional Autónoma de México, 193–194.

Melchert, Christopher (1996). "Religious Policies of the Caliphs from al-Mutawakkil to al-Muqtadir, AH 232–295/AD 847–908." *Islamic Law and Society* 3(3): 316–342.

—— (2000). "Ibn Mujāhid and the Establishment of Seven Qurʾanic Readings." *Studia Islamica* 91: 5–22.

Melikian-Chirvani, A. S. (1984). "The Buddhist Ritual in the Literature of Early Islamic Iran." In *South Asian Archaeology 1981*. Edited by Bridget Allchin. Cambridge: Cambridge University Press, 272–279.

Merleau-Ponty, Maurice (1964). *The Primacy of Perception: And Other Essays on Phenomenological Psychology, the Philosophy of Art, History and Politics*. Edited by James M. Edie. Evanston: Northwestern University Press.

Mesbahi, Mohamed (2006). "Ibn ʿArabi: De l'interférence de deux systèmes d'imagination: Le système philosophique et le système gnostique." Paper presented at *Intellect et Imagination dans la Philosophie Médiévale / Intellect and Imagination in Medieval Philosophy / Intelecto e Imaginação na Filosofia Medieval*, Société Internationale pour l'Étude de la Philosophie Médiévale, Rencontres de Philosophie Médiévale, 11:1, Porto, 2002: 272–279.

Messick, Brinkley (1993). *The Calligraphic State: Textual Domination and History in a Muslim Society*. Comparative Studies on Muslim Societies. Berkeley: University of California Press.

Mettinger, Tryggve N. D. (1995). *No Graven Image? Israelite Aniconism in Its Ancient Near Eastern Context*. Coniectanea Biblica Old Testament Series, no. 42. Stockholm: Almqvist and Wiskell.

Michalski, Sergiusz (1993). *The Reformation and the Visual Arts: The Protestant Image Question in Western and Eastern Europe*. Christianity and Society in the Modern World, edited by Hugh McLeod and Bob Scribner. London: Routledge.

Miles, George C. (1952). "Mihrāb and ʿAnazah: A Study in Early Islamic Iconography." In *Archaeologica Orientalia in Memoriam Ernst Herzfeld*. Edited by George C. Miles. Locust Valley, NY: J. J. Augustin, 156–171.

Miles, Margaret R. (1983). "Vision: The Eye of the Body and the Eye of the Mind in Saint Augustine's *De Trinitate* and *Confessions*." *Journal of Religion* (April): 125–142.

—— (1985). *Image as Insight: Visual Understanding in Western Christianity and Secular Culture*. Boston: Beacon Press.

—— (1996). *Seeing and Believing: Religion and Values in the Movies*. Boston: Beacon Press.

Miller, Patricia Cox (1994). *Dreams in Late Antiquity: Studies in the Imagination of a Culture*. Princeton: Princeton University Press.

—— (2009). *The Corporeal Imagination: Signifying the Holy in Late Antiquity*. Philadelphia: University of Pennsylvania Press.

Milstein, Rachel, Karin Rührdanz, and Barbara Schmitz (1999). *Stories of the Prophets: Illustrated Manuscripts of Qisas al-Anbiyā'*. Islamic Art and Architecture Series, no. 8. Costa Mesa: Mazda Publishers.

Minissale, Gregory (2006). *Images of Thought: Visuality in Islamic India, 1550–1750*. Cambridge: Scholars Press.

Minorsky, V. (1937; rpt. 1970). *Hudūd al-ʿĀlam*. Karachi: Indus Publications.

—— (1948). "Gardīzī on India." *Bulletin of the School of Oriental and African Studies* 12(3–4): 625–640. Reprinted in (1964) *Iranica: Twenty Articles*.

——, trans. and ed. (1959). *Calligraphers and Painters: A Treatise by Qāḍī Aḥmad, Son of Mīr Munshī, ca. A.H. 1015/A.D. 1606*. Introduction by B. N. Zakhoder, trans. from the Russian by T. Minorsky. Freer Gallery of Art Occasional Papers, vol. 3:2. Washington, DC: Smithsonian Institution.

Miquel, André (1975). *La géographie humaine du monde musulman jusqu'au milieu du XIe siècle*. Paris: Mouton.

—— (2001). *Du monde et de l'étranger*. La Bibliothèque Arabe. Paris: Sindbad.

Mirza, Younus (2005). "Abraham as an Iconoclast: Understanding the Destruction of 'Images' through Qur'anic Exegesis." *Islam and Christian-Muslim Relations* 16(4): 413–428.

Mitchell, W. J. T., ed. (1974; rpt. 1980). *The Language of Images*. Chicago: University of Chicago Press.

—— (1986). *Iconology: Image, Text, Ideology*. Chicago: University of Chicago Press.

—— (1994). *Picture Theory: Essays on Verbal and Visual Representation*. Chicago: University of Chicago Press.

—— (2005). *What Do Pictures Want? The Lives and Loves of Images*. Chicago: University of Chicago Press.

—— (2011). *Cloning Terror: The War of Images, 9/11 to the Present*. Chicago: University of Chicago Press.

Mittermaier, Amira (2011). *Dreams That Matter: Egyptian Landscapes of the Imagination*. Berkeley: University of California Press.

Moline, Judi (1994). "Saljūq Minarets in Iran: Developments in the Decorative Scheme." In *The Art of the Saljūqs in Iran and Anatolia: Proceedings of a Symposium Held in Edinburgh in 1982*. Edited by Robert Hillenbrand. Costa Mesa: Mazda Publishers, 38–45.

Moore, Albert (1977). *Iconography of Religions: An Introduction*. Philadelphia: Fortress Press.

Morgan, David (1998). *Visual Piety: A History and Theory of Popular Religious Images*. Berkeley: University of California Press.

—— (2005). *The Sacred Gaze: Religious Visual Culture in Theory and Practice*. Berkeley: University of California Press.

Moxley, Keith (1993). "The Politics of Iconology." In *Iconography at the Crossroads: Papers from the Colloquium Sponsored by the Index of Christian Art, Princeton University, 23–24 March 1990*. Edited by Brendan Cassidy. Princeton: Index of Christian Art, Department of Art and Archaeology, Princeton University, 27–31.

Muqaddasi, M. ibn Ahmad al- (1906). *Kitāb ahsan al-taqāsīm fī maʿrifat al-aqālīm*. Edited by M. J. de Goeje. Leiden: E. J. Brill.

—— (2001). *The Best Divisions for Knowledge of the Regions*. Translated by Basil Collins. The Center for Muslim Contribution to Civilization. Reading, UK: Garnet.

Murdoch, Iris (1977). *The Fire and the Sun: Why Plato Banished the Artists*. Oxford: Clarendon Press.

Nabulsi, ʿAbd al-Ghani al- (1940). *Taʿzīm al-anām fī taʿbīr al-manām*. Cairo: Maktaba Mustafa al-Babi al-Halabi.

Naef, Silvia (1992). *L'art de l'écriture arabe: Passé et présent*. Translated by Faïka Croisier, edited by Simon Jargy. Collection Arabiyya, no. 12. Geneva: Editions Slatkine.

—— (2004). *Y a-t-il une "question de l'image" en Islam?* Paris: L'Institut d'Études de l'Islam et des Sociétés du Monde Musulman (IISMM).

Nasr, Seyyed Hossein (1987). *Islamic Art and Spirituality*. Albany: SUNY Press.

—— (1995). "Oral Transmission and the Book in Islamic Education: The Spoken and the Written Word." In *The Book in the Islamic World: The Written Word and Communication in the Middle East*. Edited by George N. Atiyeh. Albany: SUNY Press, 57–70.

Nath, R. (1979). *Calligraphic Art in Mughal Architecture*. Calcutta: Iran Society.

Nazif, Mustafa (1942). *Al-Hasan ibn al-Haytham*. 2 vols. Cairo: n.p.

Necipoğlu, Gülrü (1995). *The Topkapı Scroll: Geometry and Ornament in Islamic Architecture*. Santa Monica: Getty Center for the History of Art and the Humanities.

Nelson, Robert S. (2000). *Visuality before and beyond the Renaissance: Seeing as Others Saw*. Cambridge Studies in New Art History and Criticism, edited by Norman Bryson. Cambridge: Cambridge University Press.

Nicholson, R. A. (1967). *Studies in Islamic Mysticism*. Cambridge: Cambridge University Press.

Nomanul Haq, S. (1994). *Names, Natures and Things: The Alchemist Jābir Ibn Hayyān and His Kitāb Al-Ahjār (Book of Stones).* Boston Studies in the Philosophy of Science, edited by Robert S. Cohen. Dordrecht and Boston: Kluwer Academic Publishers.

—— (2002). "Greek Alchemy or Shīʿī Metaphysics? A Preliminary Statement concerning Jābir Ibn Hayyān's *Zāhir* and *Bātin*." *Bulletin of the Royal Institute for Inter-Faith Studies* 4:2 (Autumn/Winter): 19–32.

Nyberg, H. S. (1939). "Bemerkungen zum 'Buch der Götzenbilder' von Ibn al-Kalbī." In *Dragma: Martino P. Nilsson A.D. IV id. iul. MCMXXXIX dedicatum.* Lund: C. W. K. Gleerup, 346–366.

Ocak, Ahmet Yaşar (1985). *İslam-Türk İnançlarında Hızır yahut Hızır-İlyas Kültü.* Ankara: Ankara Üniversitesi Basımevi.

O'Kane, Bernard (1994). "The Minaret of Vārbkent." In *The Art of the Saljūqs in Iran and Anatolia: Proceedings of a Symposium Held in Edinburgh in 1982.* Edited by Robert Hillenbrand. Costa Mesa: Mazda Publishers, 46–58.

Omar, Saleh Beshara (1977). *Ibn Al-Haytham's Optics: A Study of the Origins of Experimental Science.* Studies in Islamic Philosophy and Science. Minneapolis: Bibliotheca Islamica.

Ong, Walter (1982; rpt. 1991). *Orality and Literacy: The Technologizing of the Word.* London: Routledge.

—— (1984). "Orality, Literacy, and Medieval Textualization." *New Literary History* 16:1 (Autumn): 1–12.

Ormsby, Eric (2008). "The Poor Man's Prophecy: Al-Ghazālī on Dreams." In *Dreaming across Boundaries: The Interpretation of Dreams in Islamic Lands.* Edited by Louise Marlow. Cambridge MA: Harvard University Press, 142–152.

Ouspensky, Leonid (1992). *Theology of the Icon,* 2 vols. Translated by Anthony Gythiel and Elizabeth Meyendorff. Crestwood, NY: St. Vladimir's Seminary Press.

Pandit, S. (1977). *An Approach to the Indian Theory of Art and Aesthetics.* New Delhi: Sterling Publishers.

Panofsky, Erwin (1939; rpt. 1972). *Studies in Iconology: Humanistic Themes in the Art of the Renaissance.* Boulder: Westview Press.

Papadopoulo, Alexandre (1979). *Islam and Muslim Art.* New York: H. N. Abrams.

——, ed. (1988). *Le mihrāb dans l'architecture et la religion musulmanes.* Leiden: E. J. Brill.

Paret, Rudi (1958). *Symbolik des Islam.* Symbolik der Religionen, edited by Ferdinand Hermann. Stuttgart: Anton Hiersemann.

—— (1960). "Textbelege zum Islamischen Bilderverbot." In *Das Werk des Künstlers: Studien zur Ikonographie und Formgeschichte. Hubert Schrade Zum 60. Ge-*

burtstage Dargebracht von Kollegen und Schülern. Edited by Hans Fegers. Stuttgart: W. Kohlhammer Verlag, 36–48.

—— (1976–1977). "Die Entstehungszeit des Islamischen Bilderverbots." *Kunst des Orients* 11: 158–181.

Parker, Ann, and Avon Neal (1995). *Hajj Paintings: Folk Art of the Great Pilgrimage*. Washington, DC: Smithsonian Institution Press.

Parmentier, Richard (1994). *Signs in Society: Studies in Semiotic Anthropology*. Bloomington: Indiana University Press.

Peirce, Charles S. (1931–1958). "The Icon, Index, and Symbol." In *Collected Papers*, 8 vols. Edited by Charles Hartshorne and Paul Weiss. Cambridge, MA: Harvard University Press.

—— (1940; rpt. 1955). *Philosophical Writings of Peirce*. Edited by Justus Buchler. Mineola, NY: Dover.

—— (1985). "Logic as Semiotic: The Theory of Signs." In *Semiotics: An Introductory Anthology*. Edited by Robert E. Innis. Bloomington: Indiana University Press, 1–23.

Pelikan, Jaroslav (1987). *Imago Dei: The Byzantine Apologia for Icons*. A. W. Mellon Lectures in the Fine Arts, 1987. Bollingen Series, no. 36. Princeton: Princeton University Press.

Pentcheva, Bissera V. (2006). "The Performative Icon." *The Art Bulletin* 88:4 (December): 631–655.

Peters, J. R. T. M. (1976). *God's Created Speech: A Study of the Speculative Theology of the Muʿtazili Qāḍī l-Quḍāt Abū l-Hasan ʿAbd al-Jabbār ibn Ahmad Al-Hamadānī*. Leiden: E. J. Brill.

Peters, Rudolph (1996). "The Lions of Qasr Al-Nil Bridge: The Islamic Prohibition of Images as an Issue in the 'Urabi Revolt." In *Islamic Legal Interpretation: Muftis and Their Fatwas*. Edited by M. Khalid Masud, Brinkley Messick, and David S. Powers. Cambridge, MA: Harvard University Press, 214–320.

Pharr, Clyde, trans. (2001). *The Theodosian Code and Novels and the Sirmondian Constitutions*. Union, NJ: Lawbook Exchange.

Philo (1929; rpt. 1968). *Philo II: On the Giants*. Translated by F. H. Colson and G. H. Whitker. Cambridge, MA: Loeb Classic Library.

Pines, Shlomo (1974). "The Arabic Rescension of *Parva Naturalia* and the Philosophical Doctrine concerning Veridical Dreams according to *al-Risala al-Manamiyya* and other sources." *Israel Oriental Studies* 4: 104–153.

Pinney, Christopher (1992). "The Iconography of Hindu Oleographs: Linear and Mythic Narrative in Popular Indian Art." *RES* 22: 33–61.

—— (2001). "Piercing the Skin of the Idol." In *Beyond Aesthetics: Art and the Technologies of Enchantment*. Edited by Christopher Pinney and Nicholas Thomas. Oxford: Berg, 157–179.

—— (2004). *Photos of the Gods: The Printed Image and Political Struggle in India.* London: Reaktion Books.

Porter, Yves (1988). "Notes sur le Golestān-e Honar de Qâzi Ahmad Qomi." *Studia Iranica* 17(2): 207-223.

—— (2000). "From the 'Theory of the Two Qalams' to the 'Seven Principles of Painting': Theory, Terminology, and Practice in Persian Classical Painting." In *Muqarnas: An Annual on the Visual Culture of the Islamic World.* Edited by David J. Roxburgh. Leiden: E. J. Brill, 109-118.

Pourjavady, Nasrollah (1996). *Rū'yat-i māh dar āsmān: Bar rasī-yi tārīkhī-yi mas'ala-yi liqā' Allāh dar kalām wa tasawwuf.* Tehran: Markaz-i nashr-i dānishgāhī.

——, ed. (2002). *Majmū'a-yi falsafī-yi Marāgha (A Philosophical Anthology from Maraghah).* Tehran: Iran University Press.

Preston, James L. (1985). "Creation of the Sacred Image: Apotheosis and Destruction in Hinduism." In *Gods of Flesh, Gods of Stone: The Embodiment of Divinity in India.* Edited by Joanne P. Waghorne and Norman Cutler. New York: Columbia University Press, 9-30.

Qazwini, Zakariya ibn Muhammad al- (1848-1849a). *Kitāb 'ajā'ib al-makhlūqāt (El-Cazwini's Kosmographie).* Edited by Ferdinand Wüstenfeld. Göttingen: Dietrich.

—— (1848-1849b). *Kitāb āthār al-bilād,* 2nd vol. of *Zakarija Ben Muhammad Ben Mahmud el-Cazwini's Kosmographie.* Edited by F. Wüstenfeld. Göttingen: Dietrich.

—— (1944). *Le livre des merveilles du monde.* Introduction by Henri Massé. Paris: Les éditions Chène.

—— (1986). *Die Wunder des Himmels under der Erde.* Translated by Alma Giese. Bibliothek Arabischer Klassiker. Stuttgart: Thienemann.

Rabbat, Nasser (1989). "The Meaning of the Umayyad Dome of the Rock." *Muqarnas: An Annual on Islamic Art and Architecture* 6: 12-21.

—— (1993). "The Dome of the Rock Revisited: Some Remarks on Al-Wasiti's Accounts." *Muqarnas: An Annual on Islamic Art and Architecture,* vol. 10, Essays in Honor of Oleg Grabar: 67-75.

—— (2003). "The Dialogic Dimension of Umayyad Art." *RES: Anthropology and Aesthetics* 43 (Spring): 79-94.

—— (2010). *Mamluk History through Architecture: Monuments, Culture and Politics in Medieval Egypt and Syria.* London: I. B. Tauris.

Rahman, Fazlur (1958). *Prophecy in Islam: Philosophy and Orthodoxy.* London: George Allen and Unwin.

—— (1966). "Dream, Imagination, and 'Ālam al-Mithāl." In *The Dream and Human Societies.* Edited by Gustav von Grunebaum and Roger Caillois. Berkeley: University of California Press, 409-419.

Ramhurmuzi, Buzurg ibn Shahryar al- (1980). *The Book of the Wonders of India: Mainland, Sea and Islands*. Edited and translated by G. S. P. Freeman-Grenville. London: East-West Publications.

—— (1987). *'Ajā'ib al-Hind: Barruhu wa-bahruhu wa-jazā'iruhu*. Edited by M. Said Tarihi. Beirut: Dār al-Qārī'.

Rami, Sharif al-din. *See* Huart, Clément.

Raverty, H. G., trans. (1881). *Tabakāt-i-Nāsirī: A General History of the Muhammadan Dynasties of Asia, Including Hindūstān*. Bibliotheca Indica, vol. 78. 2 vols. London: Gilbert and Rivington.

Redford, Scott (1991). "The Alaeddin Mosque in Konya Reconsidered." *Artibus Asiae* 51(1–2): 54–74.

—— (1993). "The Seljuqs of Rum and the Antique." *Muqarnas: An Annual on Islamic Art and Architecture* 10: 148–156.

—— (2007). "Words, Books and Buildings in Seljuk Anatolia." In *Identity and Identity Formation in the Ottoman Middle East and the Balkans: A Volume of Essays in Honor of Norman Itzkowitz*. Edited by Bakı Tezcan and Karl K. Barbir. Center for Turkish Studies at the University of Wisconsin. Madison: University of Wisconsin Press, 7–16.

Rehatsek, E. (1878–1890). "Early Moslem Accounts of the Hindu Religion." *Journal of the Bombay Branch of the Royal Asiatic Society* 14: 29–70.

Renard, John (1993). *Islam and the Heroic Image: Themes in Literature and the Visual Arts*. Studies in Comparative Religion. Columbia: University of South Carolina Press.

—— (2001). "Picturing Holy Places: On the Uses of Architectural Themes in Ornament and Icon." *Religion and the Arts* 5(4): 399–428.

Reynolds, Dwight, ed. (2001). *Interpreting the Self: Autobiography in the Arabic Literary Tradition*. Berkeley: University of California Press.

—— (2005). "Symbolic Narratives of Self: Dreams in Medieval Arabic Autobiographies." In *On Fiction and Adab in Medieval Arabic Literature*. Edited by Phillip F. Kennedy. Wiesbaden: Harrassowitz, 261–286.

Rice, D. S. (1953). "The Aghani Miniatures and Religious Painting in Islam." *Burlington Magazine* 95:601 (April): 128–135.

Ricoeur, Paul (1976). *Interpretation Theory: Discourse and the Surplus of Meaning*. Fort Worth: Texas Christian University Press.

—— (1978). "The Metaphorical Process as Cognition, Imagination and Feeling." *Critical Inquiry* 5: 143–159.

Ries, Julien (2005). "Idolatry." *Encyclopedia of Religion*. 2nd edition. Detroit: Thomas Gale, 7: 4359–4360.

Roberts, Alan F., and Mary Nooter Roberts (2000). "'Paintings Like Prayers': The Hidden Side of Senegalese Reverse-Glass 'Image/Texts.'" *Research in*

African Literatures 31:4 (Winter), Special Issue on Poetics of African Art: 76–96.

—— (2003). *A Saint in the City: Sufi Arts in Urban Senegal.* Los Angeles: UCLA Fowler Museum of Cultural History.

Rogers, J. M. (1965). "The Çifte Minare Medrese at Erzurum and the Gök Medrese at Sivas: A Contribution to the History of Style in the Seljuk Architecture of the 13th Century." *Anatolian Studies* 15: 63–85.

—— (1970). "The Genesis of Safawid Religious Painting." *Iran: Journal of the British Institute of Persian Studies* 8: 125–139.

—— (1976). "Waqf and Patronage in Seljuk Anatolia: The Epigraphic Evidence." *Anatolian Studies* 26: 69–103.

Rosenthal, Franz (1948). "Abu Haiyan Al-Tawhīdī on Penmanship." *Ars Islamica* 13–14: 1–30.

—— (1961). "Significant Uses of Arabic Writing." *Ars Orientalis* 4: 15–23.

—— (1971). *Four Essays on Art and Literature in Islam.* The L. A. Mayer Memorial Studies in Islamic Art and Archeology, vol. 2. Leiden: E. J. Brill.

Rotman, Andy (2009). *Thus Have I Seen: Visualizing Faith in Early Indian Buddhism.* New York: Oxford University Press.

Roxburgh, David J. (2000a). "Kamal al-Din Bihzad and Authorship in Persianate Painting." In *Muqarnas: An Annual on the Visual Culture of the Islamic World.* Edited by David J. Roxburgh. Leiden: E. J. Brill, 119–146.

—— (2000b). "The Study of Painting and the Arts of the Book." In *Muqarnas: An Annual on the Visual Culture of the Islamic World.* Edited by David J. Roxburg. Leiden: E. J. Brill: 1–16.

—— (2001). *Prefacing the Image: The Writing of Art History in Sixteenth Century Iran.* Leiden: E. J. Brill.

—— (2003a). "Micrographia: Toward a Visual Logic of Persianate Painting." *RES: Anthropology and Aesthetics* 43 (Spring): 12–30.

—— (2003b). "On the Transmission and Reconstruction of Arabic Calligraphy: Ibn al-Bawwab and History." *Studia Islamica* 96, Éctriture, calligraphie et peinture: 39–53.

—— (2005). *The Persian Album, 1400–1600: From Dispersal to Collection.* New Haven: Yale University Press.

Ruggles, D. Fairchild, ed. (2011). *Islamic Art and Visual Culture: An Anthology of Sources.* Malden, MA: Wiley-Blackwell.

Ruska, Julius (1936). "Studien zur Muhammad Ibn Umail al-Tamīmi's Kitāb al-Mā' al-Waraqī wa'l-Ard an-Najmīyah." *Isis* 24:2 (February): 310–342.

Saad, Farouk (1993). *Khayāl al-zill al-'arabī* [Arabic Shadow Theater]. Beirut: Sharika al-matbū'āt li-tawzi' wa'l-nashr.

Sabra, Abdelhamid I. (1978). "Sensation and Inference in Alhazen's Theory of Perceptual Vision." In *Studies in Perception: Interrelations in the History of Philosophy and Science*. Edited by Peter K. Machamer and Robert G. Turbull. Columbus: Ohio State University Press, 160–185. *See also* Ibn al-Haytham.

Sachau, Edward C. (1888; rpt. 2005). *Alberuni's India*. 2 vols. in 1. Elibron Classics. Boston: Adamant Media.

Saenger, Paul (1982). "Silent Reading: Its Impact on Late Medieval Script and Society." *Viator* 13: 367–414.

—— (1997). *Space between Worlds: The Origins of Silent Reading*. Stanford: Stanford University Press.

Safadi, Y. H. (1987). *Islamic Calligraphy*. New York: Thames and Hudson.

Saggar, Mohammed Saïd (1995). "Introduction à l'étude de l'évolution de la calligraphie arabe." In *L'image dans le monde arabe*. Edited by Gilbert Beaugé and Jean-François Clément. Paris: CNRS, 99–106.

Sahas, Daniel J. (1986). *Icon and Logos: Sources in Eighth-Century Iconoclasm*. Toronto: University of Toronto Press.

Salmon, Georges (1906). "Note sur l'alchimie à Fès." *Archives Marocaines* 7: 451–452.

Saussure, Ferdinand de (1983; rpt. 1986). *Course in General Linguistics*. Edited and translated by Roy Harris. Peru, IL: Open Court Publishing.

Sauvaget, Jean, ed. and trans. (1948). *Akhbār as-Sīn wa l-Hind: Relation de la Chine et de l'Inde*. Collection arabe publiée sous le patronage de l'association Guillaume Budé. Paris: Société d'édition "Les Belles Lettres."

Schick, İrvin C., ed. (2000). *M. Uğur Derman Armağanı: Altmışbeşinci Yaşı Münasebetiyle Sunulmuş Tebliğler / M. Uğur Derman Festschrift: Papers Presented on the Occasion of His Sixty-Fifth Birthday*. Istanbul: Sabancı Üniversitesi.

—— (2001). "Writing the Body in Islam." *Connect* 3: 44–54.

—— (2007). "Hat Ve / Veya Tasvir." *Journal of Turkish Studies / Türklük Bilgisi Araştırmaları* 31(2): 209–224.

—— (2008). "The Iconicity of Islamic Calligraphy in Turkey." *RES* 53/54 (Spring/Autumn): 209–222.

—— (2010). "Text." In *Key Themes for the Study of Islam*. Edited by Jamal J Elias. Oxford: Oneworld Publications, 321–335.

—— (2011). *Bedeni, Toplumu, Kâinatı Yazmak: İslâ, Cinsiyet ve Kültür Üzerine*. Translated by Pelin Tünaydın. Istanbul: İletişim.

Schimmel, Annemarie (1970). *Islamic Calligraphy*. Leiden: E. J. Brill.

—— (1984). *Calligraphy and Islamic Culture*. Hagop Kevorkian Series on Near Eastern Art and Civilization. New York: New York University Press.

—— (1985). *And Muhammad Is His Messenger: The Veneration of the Prophet in Islamic Piety.* Studies in Religion, edited by Charles H. Long. Chapel Hill: University of North Carolina Press.

—— (1998). *Die Träume des Kalifen: Träume und ihre Deutung in der Islamischen Kultur.* Munich: C. H. Beck.

Schmitt, Jean-Claude (1993). "L'historien et les images aujourd'hui." *Xoana: Images et Science Sociales* 1: 131–138.

Schoeler, Gregor (2009). *The Genesis of Literature in Islam: From the Aural to the Read.* Edited by C. Hillenbrand. Revised edition in collaboration with and translated by Shawkat M. Toorawa. The New Edinburgh Islamic Surveys. Edinburgh: Edinburgh University Press.

Schopen, Gregory (1990). "The Buddha as an Owner of Property and Permanent Resident in Medieval Indian Monasteries." *Journal of Indian Philosophy* 18(3): 181–217.

Schuon, Frithjof (1947). "Concerning Forms in Art." In *Art and Thought: Issued in Honour of Dr. Ananda K. Coomaraswamy on the Occasion of His 70th Birthday.* Edited by K. Bharatha Iyer. London: Luzac, 5–13.

Séguy, Marie-Rose (1977). *The Miraculous Journey of Mahomet: Mirâj Nâmeh.* New York: George Braziller.

Şekerci, Osman (1974). *İslam'da Resim ve Heykelin Yeri.* Istanbul: Fatih Gençlik Vakfı Matbaa İşletmesi.

Seyf, Hadi (1990). *Naqqāshī-yi qahwa khāna* [Coffee-house Painting]. Tehran: Reza Abbasi Museum.

Sezgin, Fuat (1964). "Das Problem des Ğābir ibn Hayyān im Lichte neu gefundener Handschriften." *Zeitschrift der Deutschen Morgenländischen Gesellschaft* 114: 255–268.

—— (1971). *Geschichte des arabischen Schrifttums.* Vol. 4, *Alchimie—Chemie—Botanik— Agrikultur bis ca. 430 H.* Leiden: E. J. Brill.

Shahrastani, Muhammad ibn 'Abd al-Karim al- (1982). *Al-milal wa'l-nihal.* Edited by M. Sayyid Kilani. Beirut: Dār al-maʿrifa.

Shiloah, Amnon (1978). *The Epistle on Music of the Ikhwān al-Safāʾ.* Tel Aviv: Tel Aviv University Press.

Shirazi, Yaʿqub ibn Hasan Siraj (1997). *Tuhfat al-muhibbīn (Dar āyīn-i khush-nawīsī wa latāʾif-i maʿnawī-yi ān).* Edited by Araj Afshar and Karamat Raʿna Husayni. Tehran: Nuqta in collaboration with Daftar-i nashr-i mīrās-i maktūb.

Shoshan, Boaz (1991). "High Culture and Popular Culture in Medieval Islam." *Studia Islamica* 73: 67–107.

Siddiq, Mohammad Yusuf (2009a). *Historical and Cultural Aspects of the Islamic Inscriptions of Bengal: A Reflective Study of Some New Epigraphic Discoveries.*

Studies in Bengal Art Series, no. 10. Dhaka: International Centre for Study of Bengal Art.

—— (2009b). "Inscription as an Important Means for Understanding the History of the Islamic East: Observations on Some Newly Discovered Epigraphs of Muslim Bengal. Part One: Importance of Epigraphy of Muslim Bengal." *Journal of Islamic Studies* 20(2): 213–250.

Simawi al-'Iraqi, Abu'l-Qasim M. ibn A. al- (1923). *Kitāb al-'ilm al-muktasab fī zirā'at al-dhahab: Book of Knowledge Acquired concerning the Cultivation of Gold.* Edited and translated by E. J. Holmyar. Paris: Paul Geuthner.

Smith, A. Mark (1988). "The Psychology of Visual Perception in Ptolemy's Optics." *Isis* 79:2 (June): 188–207.

—— (2004). "What Is the History of Medieval Optics Really About?" *Proceedings of the American Philosophical Society* 148:2 (June): 180–194.

Smith, H. Daniel (1995). "Impact of 'God Posters' on Hindus and their Devotional Traditions." In *Media and Transformation of Religion in South Asia.* Edited by Lawrence A. Babb and Susan S. Wadley. Philadelphia: University of Pennsylvania Press, 24–50.

Solomon, Robert C. (1991). "On Kitsch and Sentimentality." *Journal of Aesthetics and Art Criticism* 49:1 (Winter): 1–14.

Soucek, Priscilla P. (1972). "Nizami on Painters and Painting." In *Islamic Art in the Metropolitan Museum of Art.* Edited by R. Ettinghausen. New York: Metropolitan Museum of Art, 9–21.

—— (1976). "The Temple of Solomon in Islamic Legend and Art." In *The Temple of Solomon: Archaeological Fact and Medieval Tradition in Christian, Islamic and Jewish Art.* Edited by Joseph Gutmann. Missoula: Scholars Press, 73–123.

—— (1988). "The Life of the Prophet: Illustrated Versions." In *Content and Context of Visual Arts in the Islamic World: Colloquium in Memory of Richard Ettinghausen.* Edited by P. Soucek. University Park: Pennsylvania State University Press, 193–209.

—— (2000). "The Theory and Practice of Portraiture in the Persian Tradition." In *Muqarnas: An Annual on the Visual Culture of the Islamic World.* Edited by David J. Roxburgh. Leiden: E. J. Brill, 97–108.

Sourdel, Dominique (1966). "Un pamphlet musulman anonyme d'époque 'abbāside contre les chrétiens." *Revue des Études Islamiques* 34: 1–33.

Sourdel-Thomine, Janine, Bertold Spuler, and Klaus Brisch (1973). *Die Kunst des Islam,* Propyläen-Kunstgeschichte, vol. 4. Berlin: Propyläen-Verlag.

St. George, Robert Blair (1998). *Conversing by Signs: Poetics of Implication in Colonial New England.* Chapel Hill: University of North Carolina Press.

Starrett, Gregory (1995a). "The Political Economy of Religious Commodities in Cairo." *American Anthropologist* 97:1 (March): 51–68.

—— (1995b). "Signposts along the Road: Monumental Public Writing in Egypt." *Anthropology Today* 11(4): 8–13.

—— (2003). "Violence and the Rhetoric of Images." *Cultural Anthropology* 18(3): 398–428.

Stern, S. M. (1949). "Ismaili Propaganda and Fatimid Rule in Sind." *Islamic Culture* 23: 298–307.

—— (1955). "Heterodox Ismāʿīlism at the Time of al-Muʿizz." *Bulletin of the School of Oriental and African Studies* 17: 10–33.

Stewart, Susan (1984). *On Longing: Narratives of the Miniature, the Gigantic, the Souvenir, the Collection.* Baltimore: Johns Hopkins University Press.

Stroumsa, Sarah (1985). "The Barāhima in Early Kalām." *Jerusalem Studies in Arabic and Islam.* 6: 229–241.

Subaşı, Hüsrev (1991). "Türk Hat San'atında Hilyeler." In *IX. Uluslararası Türk San'atları Kongresi (9th International Congress of Turkish Art), 23–27 September, 1991.* 3 vols. Bildiri Özetleri, no. 160. Istanbul: T. C. Kültür Bakanlığı Yayınları: 3, 283–286.

Subtelny, Maria, and Anas B. Khalidov (1995). "The Curriculum of Higher Learning in Timurid Iran in the Light of the Sunni Revival under Shah-Rukh." *Journal of the American Oriental Society* 115:2 (April–June): 210–236.

Sviri, Sara (1999). "Dreams Analyzed and Recorded: Dreams in the World of Medieval Islam." In *Dream Cultures: Explorations in the Comparative History of Dreaming.* Edited by David Schulman and Guy G. Stroumsa. New York: Oxford University Press, 252–273.

Swietochowski, Marie (1974). "The Development of Traditions of Book Illustration in Pre-Safavid Iran." *Iranian Studies* 7(1–2). Studies on Isfahan: Proceedings of the Isfahan Colloquium, Part I (Winter–Spring 1974): 49–71.

Tabari, Abu Jaʿfar M. al- (1965). *Tāʾrīkh al-rusul waʾl-mulūk,* vol. 1. Edited by de Goeje. Beirut: Maktaba Khayyal.

—— (1985). *The History of al-Tabarī.* Vol. 8, *The Victory of Islam.* Translated by Michael Fishbein. Albany: SUNY Press.

—— (1990), *The History of al-Tabarī.* Vol. 23, *The Zenith of The Marwānid House.* Translated by Martin Hinds. Albany: SUNY Press.

—— (1992), *The History of al-Tabarī.* Vol. 36, *The Revolt of the Zanj.* Translated by D. Waines. Albany: SUNY Press.

Tabari, ʿAli ibn Rabban al- (1928). *Firdaws al-hikma fiʾl-tibb.* Edited by M. Z. Siddiqi. Berlin: Sonne.

Tabbaa, Yasser (1991). "The Transformation of Arabic Writing: Part 1: Qurʾanic Calligraphy." *Ars Orientalis* 21: 119–148.

—— (1994). "The Transformation of Arabic Writing: Part 2: The Public Text." *Ars Orientalis* 24: 119–146.

—— (2001). *The Transformation of Islamic Art during the Sunni Revival*. Publications on the Near East. Seattle: University of Washington Press.

Tambiah, Stanley J. (1979). "A Performative Approach to Ritual." *Proceedings of the British Academy* 65: 113–69; reprinted in (1985). *Culture, Thought, and Social Action: An Anthropological Perspective*. Cambridge, MA: Harvard University Press, 123–166.

—— (1984). *The Buddhist Saints of the Forest and the Cult of Amulets*. Cambridge: Cambridge University Press.

Tanaka, Kanoko (1998). *Absence of the Buddha Image in Early Buddhist Art: Towards Its Significance in Comparative Religion*. New Delhi: D. K. Printworld.

Tanındı, Zeren (1984). *Siyer-i Nebî: İslam Tasvir Sanatında Hz. Muhammed'in Hayatı*. Istanbul: Hürriyet Vakfı Yayınları.

Taragan, Hana (2008). "Constructing a Visual Rhetoric: Images of Craftsmen and Builders in the Umayyad Palace at Qusayr 'Amra." *Al-Masaq* 20(2): 141–160.

Taşkale, Faruk (1990). "Hilyeler." *Antik ve Dekor* 7: 90–95.

Taşkale, Faruk, and Hüseyin Gündüz (2006). *Hat Sanatında Hilye-i Şerîfe: Hz. Muhammed'in Özellikleri (Characteristics of the Prophet Muhammed in Calligraphic Art)*. Istanbul: Antik A. Ş. Kültür Yayınları.

Thackston, Wheeler M. (1994). "The Role of Calligraphy." In *The Mosque: History, Architectural Development and Regional Diversity*. Edited by Martin Frishman and Hasan-Uddin Khan. London: Thames and Hudson, 43–53.

—— (2001). *Album Prefaces and Other Documents on the History of Calligraphers and Painters*. Leiden and Boston: E. J. Brill.

Tha'labi, Abu Ishaq A. ibn M. al- (1985). *Qisas al-anbiyā'*. 4th edition. Beirut: Dār al-kutub al-'ilmiyya. *See also* Brinner, William M.

Thomas, Nicholas (2001). "Introduction." In *Beyond Aesthetics: Art and the Technologies of Enchantment*. Edited by Christopher Pinney and Nicholas Thomas. Oxford: Berg, 1–12.

Tilimsani, Abu'l-'Abbas al-Maqqari al- (2006). *Fath al-mat'āl fi madh al-na'āl*. Edited by Ahmad Farid al-Mazidi. Cairo: Dār al-kutub al-'ilmiyya.

Tilley, Christopher, ed. (1990). *Reading Material Culture: Structuralism, Hermeneutics and Post-Structuralism*. Oxford: Blackwell.

Tirmidhi, Abu 'Isa M. ibn 'Isa al- (2000). *Shamā'il al-nabī*. Edited by Mahir Yasin Fahl and Bishar 'Awad Ma'ruf. Beirut: Dār al-gharb al-islāmī.

Tolan, John V. (1998). "Un cadavre mutilé: Le déchirement polemique de Mahomet." *Le Moyen Âge* 104: 53–72.

—— (1999). "Muslims as Pagan Idolaters in the Chronicles of the First Crusade." In *Western Views of Islam in Medieval and Early Modern Europe: Perception*

of Other. Edited by David R. Blanks and Michael Frassetto. New York: St. Martin's Press, 97–117.

——— (2002). *Saracens: Islam in the Medieval European Imagination.* New York: Columbia University Press.

Touati, Houari (2003). "Introduction: La calligraphie islamique entre écriture et peinture." *Studia Islamica* 96, Écriture, calligraphie et peinture: 5–18, iii–iv.

Travaglia, Pinella (1999). *Magic, Causality, and Intentionality: The Doctrine of Rays in al-Kindi.* Florence: Edition del Galluzzo, Società internazionale per lo Studio del Medioevo latino.

Treiger, Alexander (2012). *Inspired Knowledge in Islamic Thought: Al-Ghazālī's Theory of Mystical Cognition and its Avicennian Foundation.* Culture and Civilization in the Middle East, no. 27. Edited by Ian Richard Netton. London: Routledge.

Tucci, Giuseppe (1963). "An Image of a Devi Discovered in Swat and Some Connected Problems." *East and West,* new series, 14: 146–182.

Tughra'i, Mu'ayyid al-din al- (1982). *Kitāb haqā'iq al-istishhād: risāla fī ithbāt al-kīmiyā' wa'l-radd 'alā Ibn Sina.* Edited by Razuq Faraj Razuq. Baghdad: Manshūrāt wizārat al-thiqāfa wa'l-a'lām.

Ullmann, Manfred (1972). *Die Natur- und Geheimwissenschaften im Islam.* Handbuch der Orientalistik. Leiden: E. J. Brill.

Uluç, Lale (2000). "The Majâlis al-'Ushshâq: Written in Herat, Copied in Shiraz, Read in Istanbul." In *M. Uğur Derman Armağanı: Altmışbeşinci Yaşı Münasebetiyle Sunulmuş Tebliğler / M. Uğur Derman Festschrift: Papers Presented on the Occasion of His Sixty-Fifth Birthday.* Edited by İrvin C. Schick. Istanbul: Sabancı Üniversitesi, 569–602.

'Utbi, M. ibn 'Abd al-Jabbar (2008). *Al-Yamīnī fī akhbār dawlat al-malik Yamīn al-dawla Abi'l-Qāsim Mahmūd ibn Nāsir al-dawla Abī Mansūr Sabuktakīn.* Edited by Yusuf al-Hadi. Tehran: Mirās-i maktūb.

van Nieuwenhuijze, C. A. O. (1962). "The Qur'ān as a Factor in the Islamic Way of Life." *Der Islam* 38(3): 216–257.

Vasiliev, A. A. (1956). "The Iconoclastic Edict of the Caliph Yazid II, A.D. 721." *Dumbarton Oaks Papers* 9: 23–47.

Vernoit, Stephen (1994). "Scholarly Enquires into Islamic Art and Architecture in the Nineteenth Century." In *The Edward Hincks Bicentenary Lectures.* Edited by Kevin J. Cathcart. Dublin: Department of Near Eastern Languages, University College Dublin, 195–215.

von Grunebaum, Gustav E. (1962). "Byzantine Iconoclasm and the Influence of the Islamic Environment." *History of Religions* 2:1 (Summer): 1–10.

—— (1966). "Introduction to the Cultural Function of the Dream as Illustrated by Classical Islam." In *The Dream and Human Societies*. Edited by Gustav von Grunebaum and Roger Caillois. Berkeley: University of California Press, 3–21.

Waardenburg, Jacques (1974). "Islam Studied as a Symbol and Signification System." *Humaniora Islamica* 2: 267–285 (revised as [2007]. *Muslims as Actors: Islamic Meanings and Muslim Interpretations*. Berlin: Walter de Gruyter, chapter 2).

—— (1978). "Official and Popular Religion in Islam." *Social Compass* 25(3–4): 315–341.

—— (2004). "Muslim Studies of Other Religions." In *Muslims and Others in Early Islamic Society*. Edited by Robert Hoyland. Burlington: Ashgate, 211–239.

Waghorne, Joanne Punzo, and Norman Cutler, eds. (1985). *Gods of Flesh, Gods of Stone: The Embodiment of Divinity in India*. New York: Columbia University Press.

Waqidi, Muhammad ibn 'Umar al- (1966). *Kitāb al-maghāzī*. Edited by J. Marsden. 3 vols. London: Oxford University Press.

Watt, W. Montgomery (1953; rpt. 1982). *The Faith and Practice of Al-Ghazali*. Chicago: Kazi Publications.

Welch, Anthony (1977). "Epigraphs as Icons: The Role of the Written Word in Islamic Art." In *The Image and the Word: Confrontations in Judaism, Christianity and Islam*. Edited by Joseph Gutman. Missoula, MT: Scholars Press, 63–74.

—— (1979). *Calligraphy in the Arts of the Muslim World*. Austin: University of Texas Press.

—— (1997). "The Shrine of the Holy Footprint in Delhi." *Muqarnas* 14: 166–178.

Wellhausen, J. (1897). *Reste arabischen Heidetums*. 2nd edition. Berlin: Druck und Verlag von Georg Reim.

Wheeler, Brannon (2006). *Mecca and Eden: Ritual, Relics and Territory in Islam*. Chicago: University of Chicago Press.

Wink, André (1990). *Al-Hind: The Making of the Indo-Islamic World*. Leiden: E. J. Brill.

Wisnovsky, Robert (2003). *Avicenna's Metaphysics in Context*. Ithaca: Cornell University Press.

Wolfson, Harry A. (1948). *Philo: Foundations of Religious Philosophy in Judaism, Christianity and Islam*. 2 vols. Cambridge, MA: Harvard University Press.

Wolper, E. Sara (2003). *Cities and Saints: Sufism and the Transformation of Urban Space in Medieval Anatolia*. University Park: Pennsylvania State University Press.

Woolf, Greg (1994). "Power and the Spread of Writing in the West." In *Literacy and Power in the Ancient World*. Edited by Alan K. Bowman and Greg Woolf. Cambridge: Cambridge University Press, 84–98.

Ya'qubi, Ahmad ibn Abi Ya'qub ibn Ja'far al- (1960). *Tā'rīkh al-Ya'qūbī*. Beirut: Dār Sādir.

Yaqut ibn 'Abd 'Allah al-Hamawi (1993). *Mu'jam al-buldān*. Edited by Ihsan 'Abbas. 7 vols. Beirut: Dār al-gharb al-islāmī.

Zaghlul, Abu Hajar Muhammad al-Sa'id ibn Basyuni (1989). *Mawsū'a atrāf al-hadīth al-nabawī al-sharīf.* 11 vols. Beirut: 'Ālam al-turāth.

Zargar, Cyrus Ali (2008). "Aesthetic Principles of Islamic Mysticism: Beauty and the Human Form in the Writings of Ibn 'Arabī and 'Irāqī." PhD dissertation. University of California, Berkeley.

Acknowledgments

This book is the result of several years of research and writing, and would not have taken shape without the involvement of many individuals and the support of several institutions. My employers during the course of this project, the University of Pennsylvania and Amherst College, provided a congenial, supportive, and stimulating environment in which to study and write. Portions of the work included here have been presented at a number of institutions, including Cornell University, McGill University, the Massachusetts Institute of Technology, New York University, Stanford University, Amherst College, and the University of Pennsylvania, and I would like to acknowledge the importance of criticisms I received from members of the audience. I would also like to acknowledge the considerable input of students in my seminars on Islam and visual culture over the years.

Among the many individuals who have contributed directly to my thoughts on the subject matter of the book, I owe a special debt to Leslie Brubaker, Richard Clay, Michael Cooperson, Iftikhar Dadi, Devin DeWeese, Arindam Dutta, Jürgen W. Frembgen, Farooq Hamid, Renata Holod, Anna Kim, Marianna Klar, Michael Kasper, Cem Kızıltuğ, E. Ann Matter, Michael Meister, John Pemberton III, Nasser Rabbat, Kishwar

Rizvi, Everett Rowson, Anna Sloan, and E. Sarah Wolper. Rose Muravchick, Nicholas Harris, and Jeffery Arsenault worked tirelessly and enthusiastically as research assistants at different stages of this project, and they have contributed materially to its quality. Sharmila Sen at Harvard University Press has been a supportive and enthusiastic editor throughout, and I am thankful to her and to Heather Hughes for their patience.

In addition to being delightful conversation partners on many aspects of this book as on many other things, I am grateful to Shahzad Bashir and Andy Rotman for their close reading of the entire manuscript. And finally, I would like to express my gratitude to İrvin C. Schick for his friendship and intellectual generosity from the very beginning of the project; his enthusiasm for the completion of "Ayşe'nin minderi" has often been as great as mine, and this book would be much less than it is without his willingness to share his ideas along with artistic works from his collection.

Index